THE
SOVIET
IMAGE

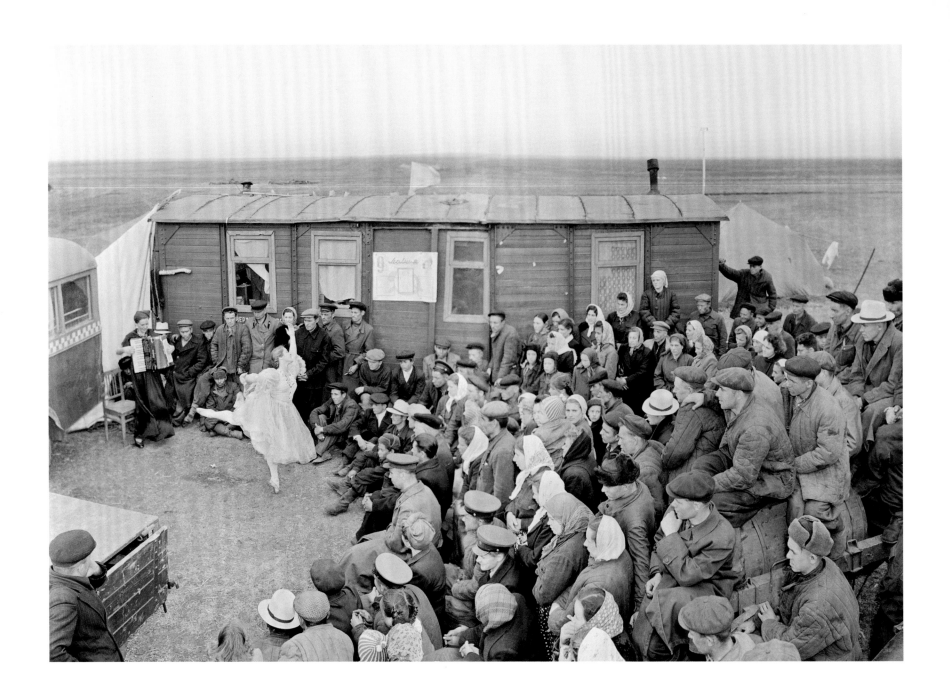

By Peter Radetsky
with Sam Radetsky
Foreword by Philip Longworth

A Hundred Years of Photographs from
Inside the TASS Archives

THE SOVIET IMAGE

CHRONICLE BOOKS
SAN FRANCISCO

Library of Congress Cataloging-in-Publication Data:

Radetsky, Peter.
 The Soviet image : a hundred years of photographs from inside the
Tass archives / by Peter Radetsky / foreword by Philip Longworth.
 p. cm.
 Includes bibliographical references and index.
 ISBN-13: 978-0-8118-5798-7
 ISBN-10: 0-8118-5798-0
 1. Soviet Union—History—Pictorial works. 2. Telegrafnoe agentstvo
SSSR—Archives. I. Title.

 DK266.R33 2007
 947.084—dc22 2007012282

Manufactured in China

Designed by Ed Anderson

Distributed in Canada by Raincoast Books
9050 Shaughnessy Street
Vancouver, British Columbia V6P 6E5

10 9 8 7 6 5 4 3 2 1

Chronicle Books LLC
680 Second Street
San Francisco, California 94107
www.chroniclebooks.com

PAGE 2
Making Do in the Virgin Lands
A Leningrad dancer, to accordion accompaniment, entertains farmers at
the Borkovsky State Grain Farm in the virgin lands of Kazakhstan in 1955.
She dances en pointe on the bare ground, a rough go for a ballerina.

For Nancy.
For Sam, Jessica, Stella, and Sascha.
And for Justine.

ACKNOWLEDGMENTS

A book like this requires the efforts of many. Heartfelt thanks to all involved. In particular . . .

In Russia, thanks to Zamir Gotta for masterminding the project. Thanks to Felix Shmaiger and his colleagues at ITAR-TASS for making these memorable photos available to us, and to Svetlana Pukhova for helping to select them. Thanks to Irina Krivaya and Anna Zaitseva for your translation and liaison efforts.

In the U.S., thanks to Robert Gottlieb and Paul Fedorko at Trident Media Group—Robert for initiating and facilitating the project, and Paul for your unflagging good nature while placing the book so well. Thanks to Olga Gottlieb for helping present the photos. Thanks to Professor Peter Kenez of the University of California, Santa Cruz, Department of History for applying your scholarly eye to ensure the manuscript's accuracy. Thanks to Steve Mockus at Chronicle Books, as reasonable, responsive, and patient an editor as any writer could wish.

And thanks to my son, Sam Radetsky, for your indispensable research and writing. It was my joy to work with you.

CONTENTS

FOREWORD . 8

INTRODUCTION . 12

THE LIFE OF A PEOPLE

CHAPTER ONE . 14

ROYALTY TO REVOLUTION, 1905 – 1917

CHAPTER TWO . 50

ESTABLISHING POWER, 1917 – 1927

CHAPTER THREE . 84

THE MAN OF STEEL, 1927 – 1941

CHAPTER FOUR . 118

THE GREAT PATRIOTIC WAR, 1941 – 1953

CHAPTER FIVE . 148

THE THAW, 1953 – 1964

CHAPTER SIX . 186

STAGNATION, 1964 – 1984

CHAPTER SEVEN . 210

THE LAST DAYS, 1984 – 1991

CHAPTER EIGHT . 242

THE NEW RUSSIA, 1991 – 2005

SELECTED BIBLIOGRAPHY . 281

INDEX . 285

THE SOVIET IMAGE

1905

1917

1927

1941

1953

1964

1984

1991

2005

FOREWORD

FOREWORD

BY PHILIP LONGWORTH

In the pages that follow, Peter Radetsky provides a compelling account in words and pictures of Russia over the last century—the most tumultuous and traumatic in its history. The Russians suffered three revolutions, a civil war, and two world wars, in which they lost more than any other belligerent. They were also afflicted by pogroms and massacres, Nazi death camps, Soviet labor camps, famines, and epidemics ranging from typhus to AIDS. Yet the period saw the construction of a superpower with a bigger empire and a more extensive zone of influence than Russia had ever had before, and remarkable flowerings of the creative arts.

The photographs in this book bring these aspects dramatically to life. But the photographic record starts in the early twentieth century; the story of the Russians, of course, begins much earlier, and the deeper causal factors of the events pictured here are embedded in that history, and indeed in geography. Russia is a hard country with a harsh climate, and much of its terrain is difficult. Its rivers flow in inconvenient directions—into the Arctic Ocean, or into landlocked seas—and the vagaries of its weather are a curse. These conditions helped mold the character of the people and the nature of their institutions. Coping with adversity, for example, seems to have bred a cooperative spirit and disposed Russians to self-sacrifice in a common cause.

The shortness of the summers made for poor crops. It also encouraged the use of coercion, without which a prince was unlikely to obtain the surplus he needed to organize and defend society. In the early 1600s, unusually bad weather for several years in succession precipitated a series of catastrophic harvests,

consequent migrations, social chaos, and political collapse. This period of national disaster embedded itself in the collective memory as the "Time of Troubles." It also triggered a sharp fall in population and hence a labor shortage that led to the establishment of serfdom, which was to plague Russia's development into modern times.

The origins of some traditional Russian enmities are also to be found in the past. Suspicion of the West derives from the Eastern Orthodox Church's hatred of the Catholic Church, which they associated with the Crusaders' rape of Constantinople in 1204. The Russian attitude toward Poland is founded, in part, on the memory of the Polish occupation of Moscow four centuries ago; and in more recent times, Russians' prejudices, like our own, have been shaped by cold war propaganda. Mutual distrust is now deeply embedded in Russian-Western relations. The photographs in this book, produced by the state news agency largely to further the aims and ideals of the Kremlin, reflect Soviet propaganda, but also the perspectives and ideals of the Russian people under Soviet rule, including a suspicion of the West. But those in the West have also been encouraged to view Russia with suspicion.

As Radetsky shows, the 1917 Revolution began spontaneously. The civilian population, and eventually part of the army too, could no longer bear the strains of fighting World War I. The Bolsheviks came to power through a coup d'etat, but they had been gaining popular support before that. Lenin was the only politician to promise peace, bread, and land for the peasants. But promises are one thing; delivery another. Russia was broke, much of industry in ruins, the countryside short of labor and livestock, and the population exhausted and demoralized. Chaos reigned in many districts. Then a vicious civil war broke out, marked by atrocities on both sides.

This was the setting for the events described in chapter 2, "Establishing Power." The peculiar brutality of Bolsheviks' methods can be explained, though not excused, by their desperation. The Bolsheviks were a small conspiratorial group who, though having seized power, lived like desperados, in constant fear of being wiped out. This preoccupation helped shape the character of the regime they built. The kill-or-be-killed mentality encouraged preemptive suppression, purges, and the elimination of real or supposed enemies.

Dire circumstances in the country as a whole help to explain the practices the Communists adopted (some of them derived from wartime military practice)—the ruthless imposition of order, the use of forced labor, the prison camps, requisitions and confiscations. Moreover, the repudiation of Russia's debts (which it was unable to repay) made it a pariah among the nations. Isolated, insolvent, and lacking investment capital, the country had, somehow, to lift itself up by its own bootstraps. Hence the suppression of dissent; the massive propaganda campaigns to mobilize the population for the huge task of reconstruction; and the programs of forced industrialization and collectivization, introduced in 1928.

Collectivization was intended as a means of reintroducing the efficiencies of large-scale farming that had disappeared when the great estates were divided to give land to the peasants. Millions of surplus peasants were now uprooted and forced to migrate

THE SOVIET IMAGE

1905

1917

1927

1941

1953

1964

1984

1991

2005

FOREWORD

to the cities, where they provided unskilled labor for building works and the new factories. These cruel prescriptions succeeded in creating productive industries and, eventually, even a viable agriculture, though the wastage in human lives was great.

Paradoxically, however, the prevalent mood of the Terrible Thirties was cheerful rather than fearful, and the young in particular tended to be optimistic. The great show trials were popular among the masses. They took comfort from the sight of formerly arrogant and powerful officials being publicly humiliated and, in most cases, executed. Functionaries and officers took heart from the sudden disappearance of their superiors and the chances of promotion that it brought.

Whether or not the Soviet Union would have prevailed against the might of Nazi Germany if Stalin had not ordered the construction of a huge industrial-military complex, the product of these transformations is still a moot point among historians. But the fact is that the Nazi onslaught was parried in 1941, and halted in 1942. The battle of Stalingrad made a German victory impossible; the battle of Kursk ensured Soviet victory. From that point on Germany fell farther and farther behind in the race to produce tanks and other materials of war. Soviet military technology, with its multiple flamethrowers, T-34 tanks, and Kalashnikov rifles, also proved superior, and became the basis of a successful arms-exporting business after the war. This was the background to the human story so vividly told in chapter 4.

The costs of war had been enormous for the Russians, and, taking care to exploit the moment, Stalin emerged as a heroic, fatherly, almost superhuman figure. But he had had to make concessions to obtain victory: he had eased off the repression, relaxed the censorship somewhat, and rehabilitated the Orthodox Church. Although the loving restoration of ravaged cities (notably St. Petersburg with all its palaces) was costly, the dividends of war were considerable. The Soviet Union emerged with the largest and most powerful empire Russia had ever possessed. And the Soviet star continued to rise in the aftermath. Production continued to increase, though quality did not improve much; parity in nuclear weaponry was reached with the United States, and the Soviets even came to lead the world in some fields. Russians took pride not only in their Nobel Prize winners and record-breaking athletes, but in sending the first man into space, developing the first long-range jet airliner, and becoming a model for Third World countries. Living standards rose from a very low base, and from the 1960s, washing machines, holidays in the sun, and even automobiles gradually ceased to be rarities.

This was also the era of Russians' love affair with their archrival, America. It had been seen in Stalin's efforts to build new Pittsburghs, and was exemplified by Khrushchev's admiration of the Midwest's agriculture and Brezhnev's infatuation with the Lincoln Continental.

The frenzied activity and the optimism of the 1930s, 1940s, and 1950s had tailed off some time before. Stagnation had set in—and, with it, disillusionment and cynicism. The Soviet army was mauled in Afghanistan (America subsequently took up the burden, to its cost). Then, with Gorbachev, as adept as any democratic politician, hopes rose again. His program of détente and modernization, restructuring and openness promised a new, happier age.

Gorbachev also engineered the fall of the hardline satellite regimes in Eastern Europe (which, in any case, were costing too much in subsidies). Unwittingly, however, the architect of this revolution was also its destroyer. His efforts to speed up energy output led to the Chernobyl disaster; his tendency to spend his way out of political trouble led to galloping inflation; and his efforts to persuade managers to make decisions for themselves rather than constantly referring to Moscow promoted administrative chaos. His abolition of the party's supremacy ensured the collapse of Communism. Shorn of empire and even self-respect, Russia ceased to be a first-class power.

The new leader who emerged from the debacle was a former *apparatchik*. Boris Yeltsin came to power as the man who had rescued Russia's nascent democracy from the coup against Gorbachev, mounted by leaders of the old elite. Two years later, when he was faced with opposition from the parliament, he shut it down. There was resistance, an armed confrontation, chaos, and some casualties. Yeltsin ordered tanks to fire on the parliament building, and the conflict was ended.

Yeltsin dismantled the Soviet Union, forcing the constituent republics to go their own ways, some of them against their will. He appropriated Communist Party property, and introduced some radical economic reforms that, however necessary, destroyed much of what had made life tolerable for the vast majority of Soviet citizens.

Under Yeltsin, Russia suffered the introduction of capitalism in its harshest form. Public assets were sold off, often corruptly, for a fraction of their value, and the proceeds were spirited away to tax havens abroad. The living standards of all but a handful of Russians plummeted, and more than half the population was thrust into poverty. At the same time social services shrank, public health declined—and so did the population. Russia was plunged into demographic crisis from which it has not yet recovered. Institutions also suffered; even the educational system, which, aside from its ideological component, had been among the most effective in the world, deteriorated.

The scale of the disasters that marked Yeltsin's years in office makes Putin's immense popularity (a 70 percent approval rating according to most polls) less surprising. Russians have welcomed the return of stability after a decade of turbulence and slumping living standards. Democracy and a free press have lost their attractions for most of them. They have come to distrust Western prescriptions.

At the end of Mussorgsky's opera *Boris Godunov*, after three crowded hours of dramatic action and tragedy, a holy fool rings down the curtain with an infinitely sad, simple refrain bewailing the unhappy fate of the Russian people. The collapse of living standards, Chechen atrocities, and the *Kursk* disaster are reminders of that sad destiny.

But what of Russia's prospects now?

Its economy is growing fast once more, and its control of much of the world's energy gives it international clout again. But will the new Russia be characterized by democracy, open markets, and the rule of law—or by a return to the old authoritarianism? From here, it looks likely to be a mixture of the two. Putin spoke of "the dictatorship of the law," but what about those who follow him? The media are not entirely free, though freer than they once were; and however surprising we may find this, the American kind of democracy seems not to be to most Russians' taste. Business is booming, but the country's huge gas and oil reserves will not last forever. Russians used to say that the situation was serious but not hopeless. Now wits say it is hopeless, but not serious—by which they mean that Russia will not adopt the West's criteria, but will go its own way. Most Russians seem content with that.

But this is not the end of Russian history, and those who study the pages that follow will themselves be better equipped to weigh Russia's chances.

THE SOVIET IMAGE

1905

1917

1927

1941

1953

1964

1984

1991

2005

THE LIFE OF

A PEOPLE

INTRODUCTION

THE LIFE OF A PEOPLE

In the Moscow headquarters of the ITAR-TASS Photo Agency, wooden drawers line the walls, towering nearly to the ceiling of the agency's massive main archive. Vivid and faded, powerful and prosaic, in series and in fragments—the images in these drawers represent the life of a people. Country scenes, city scenes. Peasants and politicians, wandering holy men and desk-bound merchants, athletes, beggars, schoolchildren, cosmonauts, babushkas, storekeepers, soldiers, artists, musicians, and writers. The last tsar, Nicholas II, is here, with his family. President Vladimir Putin is here, in his judo uniform. Housewives with their shopping bags, dancers on the great Bolshoi stage, lovers snatching a private moment. Gagarin lionized, Solzhenitsyn exiled, the Russian White House besieged, the great queue to Lenin's Tomb snaking through Red Square. From tsars to commissars, from the 1917 Revolution to the fall of the Soviet Union in 1991, TASS has documented all of it. Its archives represent the single largest visual record of Russian history. *The Soviet Image* is the result of unprecedented access to this treasure trove.

The agency was founded in 1904 by decree of Nicholas II as the St. Petersburg Telegraphic Agency (SPTA). In 1918 the fledgling Bolshevik government moved the organization to Moscow, and in 1925 it became TASS, the Telegraphic Agency of the Soviet Union. In 1992, after the collapse of the Soviet Union, the news agency was renamed the Information Telegraph Agency of Russia—ITAR-TASS. It remains the central information hub of the country. Although state-subsidized in Soviet times, the photo agency is now an independent subsidiary of the larger news organization, which operates 130 bureaus in Russia and around the world, competing against international companies such as America's Associated Press (AP), the United

Kingdom's Reuters, and France's Agence France-Presse (AFP). Its photograph sales amount to some $2 million per year. The agency is investing heavily in modernizing its computer and Web-based capabilities so as to compete even more successfully.

During most of its existence, however, things were very different. The agency was rigidly controlled by the Kremlin, covering stories the Kremlin wanted covered, producing images the Kremlin wanted produced. Without Kremlin permits, photographing national events was forbidden. As a result, the reader will notice photos that seem almost too good to be true: strong, heroic citizens working happily for the good of Mother Russia; fit and handsome youths parading their commitment to the motherland; bright and attentive students soaking in the glories of their Communist way of life. This brand of photojournalistic propaganda began in Lenin's time, gained fierce momentum during Stalin's rule, and continued as a matter of course through the Soviet regimes that followed. If these pictures seem out of place on the same pages as photos and narratives illustrating the grim realities of Russian life, they certainly reflect the image the Soviets wanted to project to the world.

Extreme examples of such political image-making involve photos that have been visibly altered to reflect the reality the government preferred at the time. Here the reader will find pictures with figures crudely scratched or blotted out. This blatantly obvious excising of personages who had fallen out of political favor reached its grim apotheosis during Stalin's late 1930s purges and continued into the 1950s. Often the obliterated images were those of well-known founding figures of the Communist state, comrades of Stalin's who had fallen into his doghouse or had been sent to the Gulag. They were not only deleted from photographs but removed from the history books. It is only in the last two decades that Russians have had the full weight of their history restored to them.

Another example of the use of falsified imagery involves the movies. From Lenin on, Soviet leaders appreciated the propaganda power of film. Because the Revolution produced relatively few photographs, documentary-like feature films supplied images to fill the void. An example appears on page 42. This famous shot ostensibly depicts Bloody Sunday, the 1905 massacre of marching workers by the tsar's troops that begins chapter 1 of this book. Although its Russian source insists the picture is authentic, claiming a dated negative as proof, an authoritative Western researcher maintains it is a still photo lifted from a 1925 Russian movie about the event.

No matter the truth, the uncertainty reflects the underlying thread of this book: the dense and difficult nature of Russia and its turbulent last hundred years. From the most rigid of monarchies to seven decades of Soviet rule to a rambunctious, erratic, and fragile democracy, the changes boggle the mind—and are all fomented by a people capable of the most powerful artistic and creative achievement, the most appalling cruelty, the most astonishing endurance. The Soviet Image tells this story—from the uprisings of 1905, through the 1917 Revolution, through the Soviet years, to the collapse of the Soviet Union in 1991, to today's democratic Russian Federation. Many of these photographs have never been published, and many have never been seen outside Russia. They provide a window into the life of a people.

1905 – 19
– 1941 – 1
1964 – 19
– 2005

ROYALTY TO REVOLUTION

17 — 1927
953 —
84 — 1991

THE SOVIET IMAGE

1905 –

1917

1927

1941

1953

1964

1984

1991

2005

ROYALTY TO

REVOLUTION

BLOODY SUNDAY

The beginning of the end for the Russian Empire arrived on a cold, clear January 9, 1905. Snow blanketed the squares and avenues of St. Petersburg. The temperature hovered just below freezing. Led by a thirty-four-year-old priest named Georgi Gapon, some two hundred thousand workers left their homes on the outskirts of the city and slowly made their way along the great avenues leading to the Winter Palace. There they would present to the tsar a petition to address long-held grievances: "We, the workers of St. Petersburg, our wives, children, and helpless old folk, have come to you to seek justice and protection."

They held above their heads religious icons, church banners, and portraits of Nicholas II, emperor and autocrat of all the Russias. "Save us, O Lord, your people," they chanted. "How glorious is our Lord in Zion. . . . God save the tsar." Dressed in their finest clothes, wives and children in tow, the workers locked arms and shuffled toward Palace Square.

They could not know that Nicholas was nowhere near the palace. He was sequestered with his family at his estate at Tsarskoe Selo, the "Tsar's Village," some fifteen miles south of the city. And they could not know that some twelve thousand imperial troops lay in wait for them, massed behind barricades. The city was on edge. Russia had been at war with Japan for a year, and the war had become a disaster, draining the empire's resources and confidence. A strike at St. Petersburg's huge Putilov steelworks had spread across the city, sending an army of protesting workers onto the streets. More than one hundred thousand citizens had signed Father Gapon's petition, which, among other issues, called for a minimum wage and improved working conditions, an end to the Japanese war, freedom of speech and religion, universal education, and an elected government.

Although more and more people shared such sentiments in turn-of-the-century Russia, to pronounce them publicly was startling and inflammatory. And marches such as this were banned. Still, Gapon and his followers pressed on. After all, wasn't Nicholas their Little Father, protector of Russian workers and peasants? If his loyal subjects couldn't turn to their tsar, where could they turn?

At first all seemed well. Onlookers bowed and made the sign of the cross as the marchers and their holy icons passed by; police officers actually cleared a path for them. But as they made their way to Palace Square, they were blocked by troops ordering them to stop.

Suddenly a squadron of Cossacks rode into the crowd, trampling and slashing, and troops shot into their midst—but still the marchers kept on, believing if they could only reach the palace, and the tsar, their appeal would be heard. As they entered Palace Square, the tsar's personal guards opened fire, mowing down workers, women, and children alike. The official tally was somewhere between one hundred and two hundred killed, as many as eight hundred injured. The actual number was certainly much higher.

The massacre became known as Bloody Sunday. It forever afterward colored Nicholas's reign, exploding once and for all the fiction that the tsar and his people were one. "There is no Tsar," proclaimed a letter from Father Gapon, who had survived the massacre and gone into hiding. "Between him and the people lies the blood of our comrades. Long live then the beginning of the popular struggle for freedom!"

MOTHER RUSSIA

In the early twentieth century, the Russian Empire encompassed one-sixth of Earth's surface, some sixty ethnicities, and more than one hundred million people. Russia was making strides not to be left behind by the rapidly industrializing nations of Europe and America and Japan, but it was still primarily a nation of vast farmlands tended by a limitless supply of peasants, little more than a generation removed from serfdom, most of them impoverished, uneducated, superstitious, illiterate.

At the same time, art, literature, science, industry, craft, trade, banking, and society all flourished. St. Petersburg was one of the world's most

vibrant and energetic cities. Aviation design pioneer Igor Sikorsky, psychologist Ivan Pavlov, composers Sergei Rachmaninov and Sergei Prokofiev, painters Ilya Repin and Marc Chagall, dancers Vaslav Nijinsky and Anna Pavlova, impresario Sergei Diaghilev, and poet Anna Akhmatova are just a few of the early-twentieth-century Russian luminaries—the list goes on and on. Russia was experiencing a burst of creative energy incredible for any time and place.

If this varied and rambunctious assemblage answered to anyone, it answered to the church—the Russian Orthodox brand of Christianity—and to the tsar. Russia had been ruled by a tsar for almost four centuries (the word *tsar* derives from "Caesar"). The tsar had authority over every aspect of his subjects' lives. He was backed by the army, the secret police, the church—and ultimately by God. The tsar *was* Russia.

Nicholas II had inherited all this—and wanted none of it. In January 1905, he was thirty-six years old, a pleasant person, a devoted family man, and tsar for ten years. But he had never wanted to reign. Governance, statecraft, bureaucracy, politics—the nitty-gritty of running a nation—none of this appealed to Nicholas. He embraced only one aspect of his inheritance: his God-given right of traditional, unlimited power.

In 1895, soon after assuming the throne, the young ruler firmly stated his case. "I am informed that recently . . . voices have made themselves heard from people carried away by senseless dreams about the participation of . . . representatives in the affairs of internal government," he stated. "Let all know that I . . . will uphold the principle of autocracy as firmly and as unflinchingly as my late unforgettable father."

The unyielding speech encouraged Russia's growing cadre of Marxist revolutionaries to found the Social Democratic Labor Party, which later divided into Mensheviks and Bolsheviks. While the Mensheviks (derived from the Russian word for "minority"), led by Julius Martov, were working with like-minded allies to replace the autocracy with a bourgeois democracy, Vladimir Lenin's Bolsheviks ("majority") believed fiercely that workers should be the heart and soul of a new order in Russia. These groups became the driving force behind the revolution to come.

"THE YEAR OF NIGHTMARES"

For Nicholas and his country, the next two decades produced a litany of unfortunate events, downright blunders, and worsening conditions. At the tsar's coronation in May 1896, in their rush to enjoy free food and beer, more than one thousand peasants were trampled to death. Although in his diary the tsar described the calamity as "a grave sin," he failed to cancel the evening's festivities and danced at the coronation ball. The lapse of judgment earned him the sobriquet of Nicholas the Bloody.

By the turn of the century, with Russia suffering from recession and mass unemployment, cries for representative government were becoming increasingly bold and revolutionaries increasingly well-organized and violent. An epidemic of assassinations broke out. Within four years, beginning in 1901, a minister of education and two ministers of the interior were picked off. The world-famous writer Tolstoy, seventy-three years old and in his last decade of life, wrote a letter to the tsar warning him about "what great evil you will bring to yourself and to millions if you continue on your present course." He urged Nicholas to "give the masses the opportunity to express their desires and demands."

The tsar's response was Bloody Sunday.

Thus ensued the momentous year of 1905, which Nicholas's mother described in a letter as "the year of nightmares." Strikes broke out across the empire. By the end of January, almost half a million workers and students were demonstrating in the streets. A new wave of assassinations began with the killing of Grand Duke Sergei Alexandrovich, commander of the Moscow military region and Nicholas's uncle. In June, sailors aboard the battleship *Potemkin,* the pride of the Black Sea fleet, mutinied after one of their comrades was shot for refusing to eat maggot-infested meat. The conflict spread to the port city of Odessa, where two thousand people were killed by imperial troops.

In the fall, Russia negotiated an end to the war with Japan. It was a devastating defeat for the empire. Soon a new series of strikes broke out. By October Russia's railroads stopped running; industry ground to

THE SOVIET IMAGE

1905 -

1917

1927

1941

1953

1964

1984

1991

2005

ROYALTY TO

REVOLUTION

a standstill. St. Petersburg was paralyzed. Transportation, gas, water, electricity, shops, newspapers, factories—all shut down. Teachers, lawyers, doctors, postal workers, servants—all walked off the job. Even the corps de ballet at the Mariinsky Theatre joined the protestors. And these shutdowns did not spring from the agitation of professional revolutionaries—they were spontaneous and deeply felt.

With grave misgivings, and going against everything he believed and had ever proclaimed, Nicholas caved in and granted his people civil rights and a representative parliament, the Duma. "From all over Russia they cried for it, they begged for it," he wrote his mother. "There was no other way out than to cross oneself and give what everyone was asking for." In effect, he proclaimed himself a constitutional monarch in a document that became known as the October Manifesto.

The October strikes had spawned a homegrown governing council, the St. Petersburg Soviet of Workers' Deputies. The October Manifesto strengthened its resolve. Leon Trotsky, a brilliant revolutionary thinker and writer who had earlier championed the role of Soviets, hurried back from his hideout in Europe to assume a key role. But others considered the manifesto an assault on the heart of Russia—and they knew just who to blame. "It's the Jews," declared the editor of *Kievlianin,* a newspaper so reactionary it had refused to close during the October strike. "In Russia every revolution runs over the carcasses of Jews." Ultranationalist groups called Black Hundreds hunted down and attacked Jews, the poor and aged, women and children—anyone they suspected might oppose their policies. The violence spread to other regions. A pogrom erupted in Odessa.

Nicholas didn't censure such behavior. But he did dispatch his troops and secret police to clamp down on the very rights he had just signed into law. He closed down the St. Petersburg Soviet, arresting some three hundred of its members, including Trotsky. When Moscow workers reacted to the news by mounting their own strike and uprising, government troops shot anyone within range, including bystanders. More than one thousand were killed. (A year later, Nicholas disbanded the Duma.) As these tentative steps toward reform were squelched in a fury of police bullets, and the tsar's constitutional monarchy was exposed as a charade, the "year of nightmares" staggered to a close.

"The Revolution is dead," declared Trotsky from his prison cell at the Peter and Paul Fortress. "Long live the Revolution!"

THE TSAREVITCH

"Lord, how painful and sad this is," wrote Nicholas in his diary after Bloody Sunday. He was concerned enough to meet the very next day with a delegation of workers. But as they stood uncomfortably before him in the ornate palace at Tsarskoe Selo, what was supposed to be a sympathetic dialogue became a self-righteous scolding: "I believe in the honest feelings of the working people and in their unshakable loyalty to me," he declared. "Therefore, I forgive them their guilt."

The tsar saw no irony in condescending to forgive those he had massacred. Neither did his empress, Alexandra. "Petersburg is a rotten town, not one atom Russian. The Russian people are deeply and truly devoted to their Sovereign," she wrote her sister. They lived in Tsarskoe Selo as in a cocoon. In the words of Gleb Botkin, the son of the court physician, it was "a world apart, an enchanted fairyland to which only a small number of people had the right of entry."

It was Alexandra who pushed her husband into this cloistered retreat. Although she embraced the Russianness of her new land and people (she had been born a German princess), she detested the ponderous rituals and protocols of the tsar's court and resisted performing the social roles earmarked for her. Alexandra was fiercely devoted and loyal to her "Nicky," yet she was shy and uncomfortable among crowds. Although strongly attracted to her husband (they were one of the few royal couples who shared the same bed), she advised and cajoled him in the manner of a loving mother. He readily deferred to her, a tendency that would have unfortunate consequences, especially toward the end of his reign.

Above all, she was devoted to her family. Raising children in the relatively cozy Alexander Palace at Tsarskoe Selo ("only" one hundred rooms)—surrounded by an army of servants, eight hundred acres of secluded forest and lawns, a Turkish bath, a Chinese pagoda, and a private lake—was much preferable to the cold public immensity of the Winter Palace. But although the couple's family was growing, it wasn't turning out as hoped: the throne needed a male heir. As Alexandra's sisters busily birthed male child after male child (her sister-in-law, Xenia, had six boys), she produced one girl after another: Olga, in 1895; Tatiana, in 1897; Marie, in 1899; and Anastasia, in 1901.

She became even more reclusive, retreating into her mauve-colored boudoir, where she would recline on a low couch and receive her circle of attendants. Increasingly they included suspicious characters, like a French former butcher's assistant and self-proclaimed physician, "Dr. Philippe," who claimed he could change the future. In 1902 he announced that Alexandra was pregnant with the long-awaited heir; several months later, his proclamation obviously not true, he fled Russia. But before he did, he offered Alexandra another prophecy: "Someday you will have another friend like me who will speak to you of God." The idea was thus planted for the family's desperate acceptance years later of the "Holy Devil," Rasputin, who would drive the last nail into the coffin of the Russian Empire.

Finally, on July 30, 1904, Alexandra gave birth to an eight-pound baby boy. As the momentous event was celebrated by the cannons of the Peter and Paul Fortress in St. Petersburg thundering three hundred times, his ecstatic parents named him after the seventeenth-century tsar, Alexei, Nicholas's favorite.

But just six weeks later their joy was shattered. His parents noticed bleeding from the baby's navel that persisted on and off for two days. "Alix and I have been very much worried," Nicholas wrote in his diary. "The child was remarkably quiet and even merry but it was a dreadful thing to have to live through such anxiety."

As the months passed, and Alexei began to crawl and then to walk, the most innocuous stumbles and falls produced bruises on his arms and legs that soon grew into purple welts that persisted for days. The blood within the bruises was not coagulating. The couple's worst fears were confirmed: the little tsarevitch suffered from hemophilia.

Rare as it is, hemophilia was not unknown to Nicholas and Alexandra. It had recently appeared in the royal families of Britain, Spain, and Germany, a legacy of long-reigning, diminutive Queen Victoria of England, mother and grandmother of much of royal Europe. Two of Alexandra's nephews suffered the disorder, and her brother and uncle had died of it.

Already his family's pampered pride and joy, Alexei now grew up a virtual prisoner within the cloistered luxury of his life. He was assigned two sailors from the imperial navy as around-the-clock attendants. Between their attentions and those of his increasingly nerve-wracked and despondent mother, he was never alone. But the restrictions couldn't prevent every accident. When they came, the result could be horrifying. The little tsarevitch was bedridden for months at a time, an invalid because of the pain and swelling.

Alexandra was devastated by her son's affliction. Her health, never robust, began to weaken. She developed shortness of breath and had difficulty walking. During Alexei's tortured bouts of bleeding, she would sit by his bed day and night; when the danger passed, she would collapse for weeks. She became more fanatically religious, praying hours every day in her private chapel for the health of her son.

As the years passed, and the tsar and his family struggled in secret with Alexei's illness, they began to lose the sympathy and support of the Russian people. Visitors to court would return with rumors of unscheduled disappearances, unexplained illnesses, stonewalling silences. It became more and more clear: something was not right.

"THE LITTLE ONE WILL NOT DIE"

In his diary for November 1, 1905, Nicholas wrote, "We've gotten to know a man of God, Gregory, from Tobolsk province." In his early thirties, dark-haired, muscular, unkempt, and filthy, with grey, penetrating

THE SOVIET IMAGE

1905 -

1917

1927

1941

1953

1964

1984

1991

2005

ROYALTY TO

REVOLUTION

eyes, this Gregory (like many peasants, he had no family name) appeared to be a *starets,* a poor, wandering holy man. Russian history was full of such impoverished pilgrims walking the length and breadth of the great land, living on the kindness of strangers. Declaring that only through sin could one come to know God, he presented himself as a man who had sinned greatly and repented. He was known primarily by his nickname, Rasputin, which in Russian means "dissolute." His admirers considered the name an appealing example of humility.

From peasants to royalty, Russians treated a starets with respect. So it wasn't a shock that Rasputin should be introduced to the tsar and his family. He charmed them from the beginning, playing with the children and calling Nicholas and Alexandra *Batlushka* and *Matushka,* "Father" and "Mother," as a peasant would speak to his own family. "He is just a good, religious, simple-minded Russian," Nicholas told an officer of his guard. "When in trouble or assailed by doubts, I like to have a talk with him, and invariably feel at peace with myself afterward." For Alexandra, Rasputin was the godly friend that Dr. Philippe had promised.

Though it's unclear how, Rasputin seems to have been able to ease the tsarevitch's suffering, calming and distracting the boy from his pain and disability—he even seemed to hasten his recovery. Alexandra grew confirmed in her belief that Rasputin was a personal emissary from God, sent to her and Russia to save the empire.

Meanwhile, Rasputin set himself up in an apartment in St. Petersburg, where he proceeded to live to the hilt his credo that sin leads to salvation. He cut a drunken swath through the city's taverns and its upper-class women. Society soirees at his apartment became a mark of status, especially for those ladies who disappeared with Rasputin into his bedroom. Courageous advisors tried to make the royal couple understand the dangers and implications of their relationship with this wild man, but their warnings fell on deaf ears.

In the fall of 1912, while the royal family was vacationing at a hunting lodge near Warsaw, Alexei began screaming during a ride in a carriage. He began to bleed uncontrollably. By the time the party returned to the lodge, the tsarevitch was almost unconscious.

For eleven days, the bleeding persisted, swelling Alexei's leg grotesquely. His shrieks filled the lodge, causing servants to plug their ears with cotton. Alexandra sat unsleeping at his bedside throughout the entire ordeal. Her hair turned gray. Without disclosing its cause, the tsar released a statement informing the country of his son's immediate condition. Russia fell into a period of national prayer. A priest administered the last sacraments; a bulletin was prepared announcing the tsarevitch's death.

During this time, Rasputin was thousands of miles away in his Siberian hometown of Pokrovskoe. Alexandra cabled him, asking him to pray for her son. He wired back one of the most famous telegrams in history: "God has seen your tears and heard your prayers. Do not grieve. The Little One will not die. Do not allow the doctors to bother him too much."

The next morning, Alexandra left the sickroom, smiling. "The doctors notice no improvement yet, but I am not a bit anxious myself now," she announced. "During the night, I received a telegram from Father Gregory and he has reassured me completely."

Soon Alexei's bleeding stopped. The tsarevitch survived.

COMMANDER IN CHIEF

On June 28, 1914, in Sarajevo, Archduke Franz Ferdinand, heir to the throne of Austria-Hungary, and his wife, Sophie, were assassinated. One month later, Austria-Hungary declared war on Serbia, which it blamed for the killings. Other European nations quickly took up sides. World War I began.

For Russia the onset of war was a powerfully mixed blessing. On the one hand, Nicholas's declaration of war against Austria-Hungary and its ally, Germany, prompted an outpouring of patriotism. Workers, owners, revolutionaries, reactionaries, nobles, and peasants alike pledged their support to the tsar and his government. On July 19, 1914, a huge crowd gathered in the square of the Winter Palace—the very place where on Bloody Sunday in 1905 Nicholas's troops had killed so many—to cheer Russia's entry into the war. Once again they carried holy icons and banners

and portraits of the tsar, singing "God Save the Tsar." Nicholas and Alexandra appeared on a palace balcony to greet them.

But Russia was pitifully ill-equipped for war. The disastrous encounter with Japan had already exposed the weakness of the Russian navy. Now the Russian army, the pride of every tsar for the last two centuries, was a wreck. Its plentiful troops carried a million fewer rifles than there were soldiers; they were some six hundred million rounds short of ammunition and fielded only a single machine gun for every six hundred infantrymen. The Germans had more than 380 batteries of heavy artillery—Russia just 60. Food was scarce, for troops and horses.

By the beginning of 1915, Russia was losing three hundred thousand soldiers every month. By fall, with the army seeming on the brink of collapse, Nicholas, in perhaps his greatest blunder, fired the army's respected commander in chief—his cousin, Grand Duke Nicholas—and personally assumed command. In September, despite receiving an unprecedented letter from ten of his ministers stating that "the decision you have taken . . . threatens Russia, you, and your dynasty with the direst consequences," Nicholas left Petrograd (as German-sounding St. Petersburg had been renamed) for the army's general headquarters.

Not everyone thought Nicholas's decision misguided, however. Alexandra—acting on "our Friend's" (Rasputin's) advice—urged him to go. Only he, "Russia's Savior," could right the sinking ship. As a talisman, she gave Nicholas Rasputin's pocket comb, instructing him in a letter to run it through his hair before making any important decisions. "Our Friend's prayers arise night and day for you to heaven and God will hear them."

If the tsar's assuming command had little impact (his presence was primarily ceremonial—his generals still ran the war), it was at home that the change was felt. With Nicholas's approval, Alexandra took over, regaling him with letters of advice. On domestic matters: "Our Friend begs you not to too much worry over this question of *food supply*—says things will arrange themselves." On military matters: losses from German heavy artillery would be reduced if troops would "go quickly under their range as they are for great distances and cannot change quickly." On governmental appointments: "*Guchkov* ought to be got rid of. He hunts after anarchy and [is] against our dynasty, [which] our Friend and God would protect."

Nicholas was deeply grateful. "Oh, my precious Sunny," he wrote his wife, "now I shall naturally be calm, and at least need not worry over internal affairs."

As Russia's war efforts abroad collapsed, so did the last remnants of stability at home. Three million Russian soldiers had been killed or wounded in the war; six million more remained at the front, facing starvation as the harshest winter in years shut down nearly all transportation and supplies. The economy became paralyzed. Breadlines became a fact of life. Meanwhile, responding to Rasputin's whims and biases, Alexandra drove virtually every able person out of the government. The influence of the empress and her "Friend" had become a full-blown scandal. "The days of Tsarism are numbered," declared Russia's leading munitions maker, Alexei Putilov, to Maurice Paléologue, the French ambassador. "Revolution is now inevitable. It is only waiting for a favorable opportunity."

THE END OF RASPUTIN

The prelude to revolution was a dramatic last-ditch effort to avert it. On December 16, 1916, Rasputin arrived at the Yussupov Palace on the banks of Petrograd's Moika Canal for a late-night rendezvous. Prince Felix Yussupov, heir to Russia's richest family, had invited the starets for midnight wine and cakes. Rasputin would have no reason to suspect that Yussupov, a flamboyantly effeminate man who enjoyed dressing as a woman and was married to Nicholas's niece, was plotting to murder him. His coconspirators included Grand Duke Dmitry Pavlovich; Vladimir Purishkevich, a conservative politician; and a Dr. Lazovert, who busied himself with injecting cyanide into the rose-flavored cream petits fours and the Madeira and Marsala wines, Rasputin's favorites.

Upon Rasputin's arrival, he and Yussupov settled into a basement room, where, to the prince's dismay, Rasputin feasted on the cyanide-laced cakes

THE SOVIET IMAGE

1905 –

1917

1927

1941

1953

1964

1984

1991

2005

ROYALTY TO

REVOLUTION

and wine for the next two hours, showing no ill effects. Exasperated, Yussupov ran upstairs, where the other conspirators were hiding, and asked if they would object to his simply shooting his guest. Returning to the basement with a pistol, he aimed at Rasputin's heart and shot. Rasputin fell to the floor.

But, cyanide in his veins and a bullet in his chest, the wild man was not yet dead. He leaped to his feet, clambered up the stairs after Yussupov, then burst into the courtyard and ran for the street. Purishkevich fired at Rasputin and, as the starets crumpled, kicked him in the head. Yussupov pummeled him with a rubber club. Satisfied that the starets was finally dead, the conspirators wrapped him in a blue curtain, bound him with rope, drove him to the Neva River, and dropped him through a hole in the ice. Three days later, the body was found, with an arm raised above the shoulder and lungs filled with water. Rasputin had still been alive when dumped into the river. He died of drowning.

REVOLUTION

After Rasputin's murder, Nicholas returned from general headquarters to commiserate with his family at Tsarskoe Selo. Although he still believed wartime patriotism would keep Russia in line, to soothe unrest, he begrudgingly allowed the Duma to reassemble in February 1917. Soon, despite rumors of coups d'état and threats against Alexandra's life, he dutifully returned to the front.

In the early morning of Thursday, February 23, as Nicholas's train made its way back to general headquarters, breadlines began to form in Petrograd. The day dawned clear, forty degrees below freezing. It was International Women's Day; demonstrations had been planned. The demonstrators were joined by workers who had been locked out of the Putilov steelworks, the same huge factory that had seen a strike in the days leading to Bloody Sunday, twelve years earlier, and by women who had been turned away from the breadlines, shouting "Give us bread!" The crowds remained

in the workers' districts across the Neva River, on the outskirts of the city.

The next day a crowd of more than two hundred thousand people gathered. Shouts of "Give us bread!" mingled with "Down with the tsar!" and "Down with the war!" Blocked by police from crossing bridges, they walked across the iced-over river toward the city center, where they were met by Cossack cavalry. In contrast to the events of Bloody Sunday, the Cossacks did little to stop the crowds.

That night, while government officials ordered the release of flour reserves so as to shorten breadlines and erected posters warning that the army and police would not be so lenient again, Nicholas wrote his wife from the front, "My brain is resting here—no Ministers, no troublesome questions demanding thought," and went to bed.

On Saturday morning, February 25, the number of protestors rose to nearly three hundred thousand and increased throughout the day. Confrontations between workers and police became violent. At Znamenskaya Square, under the huge statue of Nicholas's father, Alexander III, a demonstrator began a speech to thousands. Mounted police rode in to break up the crowds, but the speaker and the crowd held their ground. As the troops' commander aimed his pistol at the man, a Cossack rode between them and cut down the commander with his saber.

That night Nicholas sent a telegram to the commander of the Petrograd District, General Khabalov.

I ORDER YOU TO BRING ALL OF THESE DISORDERS IN THE CAPITAL TO A HALT AS OF TOMORROW. THESE CANNOT BE PERMITTED IN THIS DIFFICULT TIME OF WAR WITH GERMANY AND AUSTRIA. NICHOLAS

All night the troops placed machine guns on the roofs surrounding Petrograd's main squares. Battalions of soldiers took up positions throughout the city. Secret police arrested known revolutionaries. Huge posters went up forbidding public assembly. But

General Khabalov was worried. The events at Znamenskaya Square had marked a turning point—there was no assurance that the troops would obey orders to use force against the workers.

Sunday, February 26, broke warm and clear. Church bells resounded through the city. Both Khabalov and Alexandra telegraphed Nicholas, commenting on the quiet in the city. But Duma president Mikhail Rodzianko was not reassured. As he was drafting a telegram to the tsar warning him that a new government must be formed immediately, protestors converged on Znamenskaya Square. Elite troops called the Volynsky Regiment were waiting for them. After repeatedly ordering the crowd to disperse, an officer ordered the troops to open fire. But they fired into the air instead. Another officer grabbed a machine gun and fired into the crowd, killing some forty and wounding forty others. But still most of the soldiers refrained.

Later in the day, a reserve company called the Pavlovsky Guards rushed into Petrograd to investigate reports of shootings involving their comrades. As they approached the heart of the city, a detachment of mounted police barred their way, and the two sides exchanged fire. Troops were now in open conflict with one another. Back in their barracks, the Volynsky Regiment decided that should they be confronted by unarmed demonstrators, they would refuse to shoot. When a regiment captain attempted to restore order, he was shot.

The Revolution had started. On Monday, February 27, the Volynsky marched out to join it. Other regiments followed, including the famous Preobrajensky Guard, founded two centuries earlier by Peter the Great. By the end of the day, the Arsenal Building, the Ministry of the Interior, the Law Courts Building, the Military Government Building, the Secret Police Building, and many police stations were in flames. The Peter and Paul Fortress had been taken. Freed from their cells, prisoners joined the demonstrators on the street. More than sixty-six thousand soldiers had gone over to the Revolution. In desperation, Rodzianko sent a telegram to Nicholas.

GARRISON TROOPS CAN NO LONGER BE RELIED UPON. RESERVE BATTALIONS OF GUARDS IN REVOLT. THEY ARE KILLING THEIR OFFICERS. SIRE, DO NOT DELAY. IF THE MOVEMENT REACHES THE ARMY, IT WILL MEAN THE RUIN OF RUSSIA. INEVITABLY THE DYNASTY WILL FALL WITH IT. TOMORROW MAY BE TOO LATE.

Nicholas declared martial law and authorized one of his commanders at the front, General Ivanov, to take a battalion of troops and march on Petrograd. Nicholas would leave the next morning for Tsarskoe Selo, to meet there with Ivanov and other loyal subjects to strategize how to retake the capital. But Ivanov's men mutinied on the way to Petrograd. The city was lost to the Revolution, and now revolutionaries were spreading out into the countryside.

When he awoke in his private train carriage at 10:00 a.m. on Tuesday, February 28, the tsar discovered that it was no longer safe for him to continue on to Tsarskoe Selo. He detoured to the city of Pskov, 175 miles to the southwest of Petrograd. In Pskov he was presented with telegrams from his generals at various fronts as well as a communiqué from Rodzianko in Petrograd, all agreeing that the only strategy to retain the empire, and the authority of the tsar, was that Nicholas abdicate. After a few moments of ashen-faced silence, he faced his attendants and announced simply, "I have decided that I shall give up my throne in favor of my son, Alexei." Only his diary revealed the tsar's emotions: "For the sake of Russia, and to keep the armies in the field, I decided to take this step. . . . All around me I see treason, cowardice, and deceit."

Nicholas signed the abdication document at 3:00 p.m. on March 2. In the end, he abdicated in favor of his brother, Mikhail, rather than Alexei. He would spare his fragile, twelve-year-old son this cross to bear. The document began, "In this great struggle with a foreign enemy, who for nearly three years has tried to enslave our country, the Lord God has been pleased to send down on Russia a new, heavy trial."

It ended, "May the Lord God help Russia!"

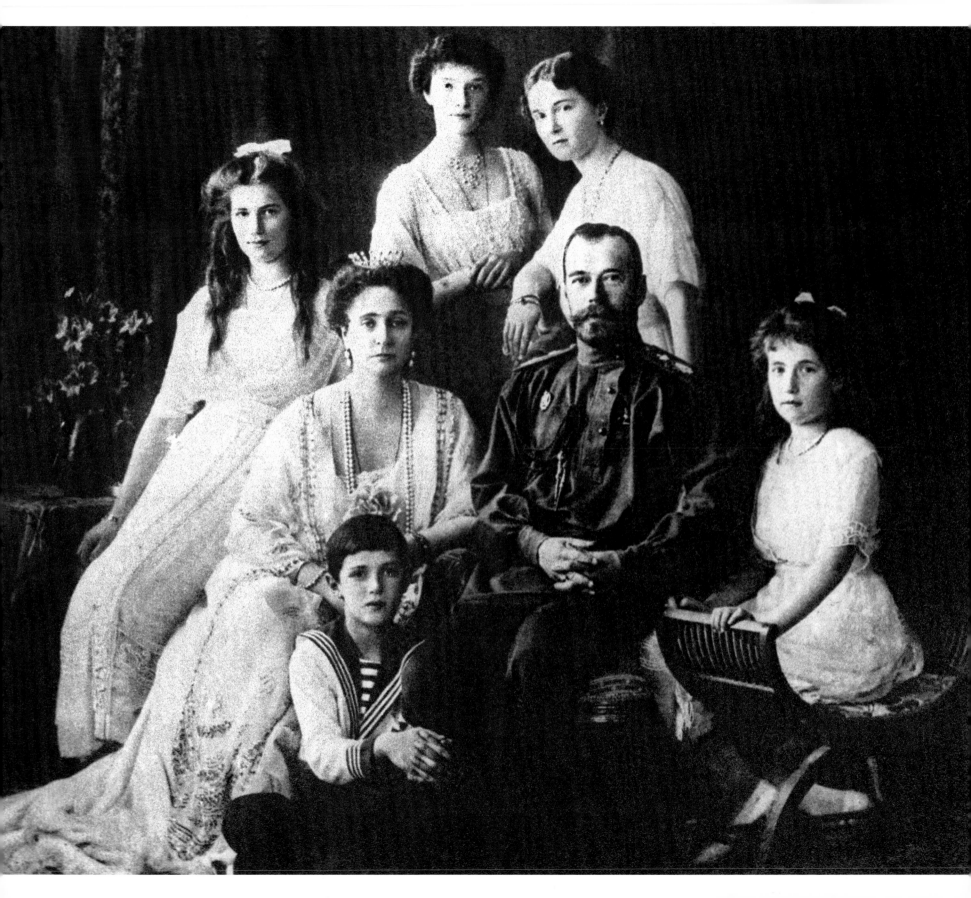

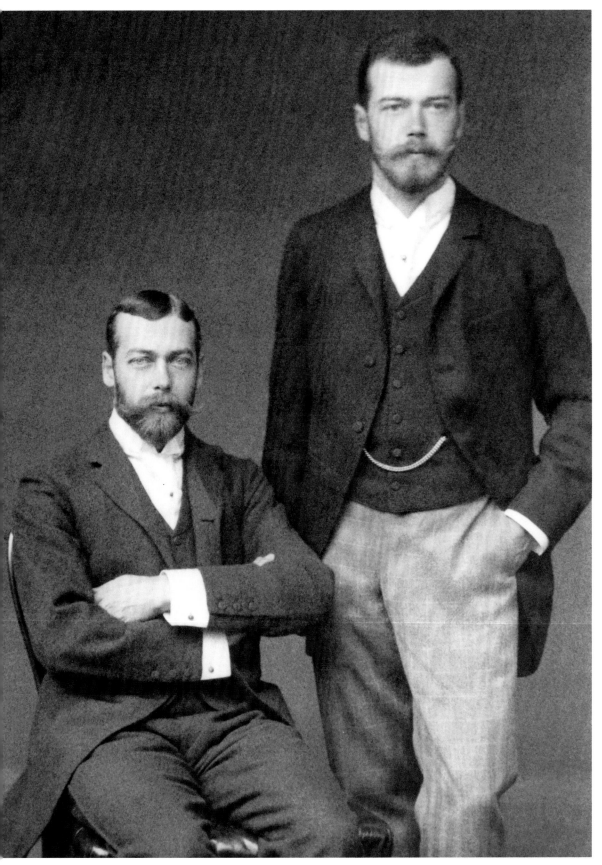

The Royal Family

The Romanovs sit for a formal portrait in 1913. Surrounding Nicholas and Alexandra are (clockwise from bottom) the tsarevitch Alexei, and daughters Marie, Tatiana, Olga, and Anastasia. Nicholas, a devoted husband and father who liked nothing better than to spend time with his family in the privacy of royal palaces and other privileged settings, was unfit by training and character to lead his country in the turbulent years of the early twentieth century. He was more suited to be a constitutional monarch, but neither he nor the times permitted it. Five years after this photo was taken, with his country in the throes of revolution, Nicholas and his family were murdered.

Cousins

Emperor-to-be Nicholas (right) and his cousin George, Duke of York, pose for the camera in Germany in 1890. Their resemblance was so striking that, legend has it, the two men were mistaken for each other at George's own wedding reception. Three decades after this photo was taken, as Russia convulsed around the ex-tsar and his family, the duke, now King George V, refused to grant "dear Nicky" and his family asylum in England, thus ensuring their deaths.

RIGHT, TOP

Royal High Jinks

Amusing themselves with a lighthearted *stsenka,* or informal performance, are (left to right) Grand Duke Kiril of Russia; Emperor Nicholas II; Empress Alexandra; Alexandra's brother Grand Duke Ernst of Hesse; Prince Nicholas of Greece and Denmark; Ernst's wife, the Duchess Victoria Melita; and Grand Dukes Andrei and Boris of Russia. This 1899 photo was taken near the palace in Darmstadt, Germany.

RIGHT, BOTTOM

Sailors

Nicholas II (right) welcomes King Edward VII (center) and the Duke of York (far left) aboard the imperial yacht *Standart* during the tsar's visit to England in 1909. The photo reveals a formal and complacent age that soon would be shattered by the upheavals of World War I and the Russian Revolution—the uniformed formality of the royal men, their proper and elegant women in the background, the luxury of the shining, wood-paneled yacht itself.

OPPOSITE

Loving Couple

Nicholas and Alexandra on holiday atop a mountain in the Crimea in 1909. The tsar's pleasure in this relatively private interlude is evident. The tsarina seems about as close as she ever came to smiling in public.

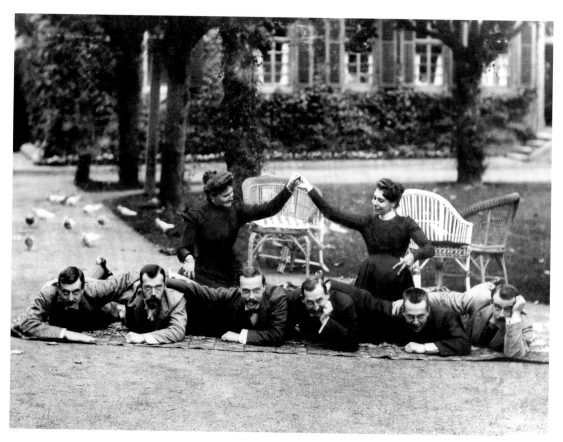

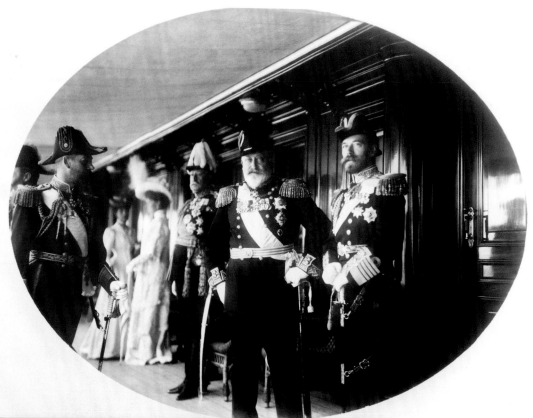

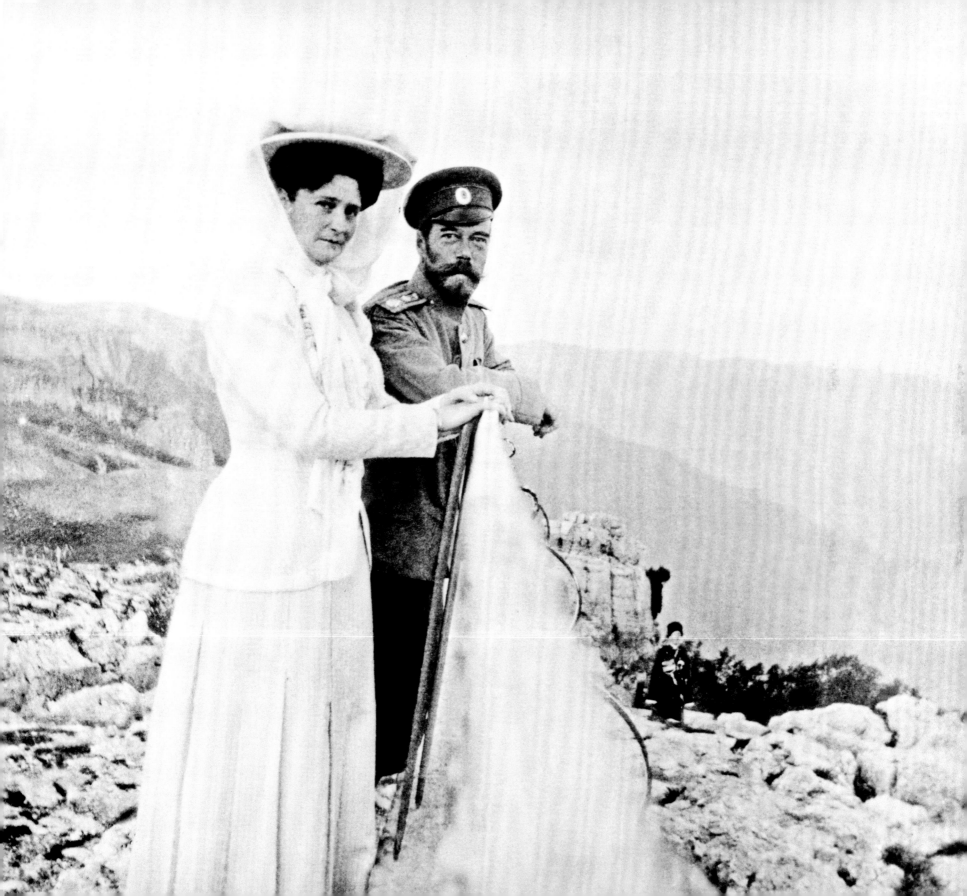

Workers in a Tavern
Moscow, circa 1900.

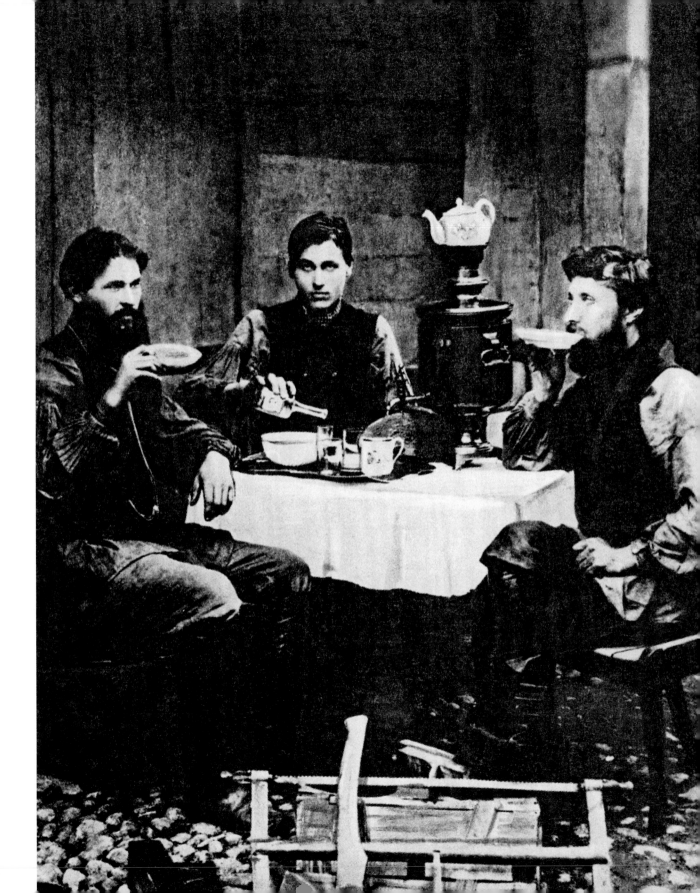

Rest Stop

Villagers in the Orenburg region of Russia just north of Kazakhstan, where Europe and Asia meet, enjoy the traditional drink kumis. Made from fermented mare's milk and mildly alcoholic, kumis is a cousin to kefir, which comes from the milk of cows.

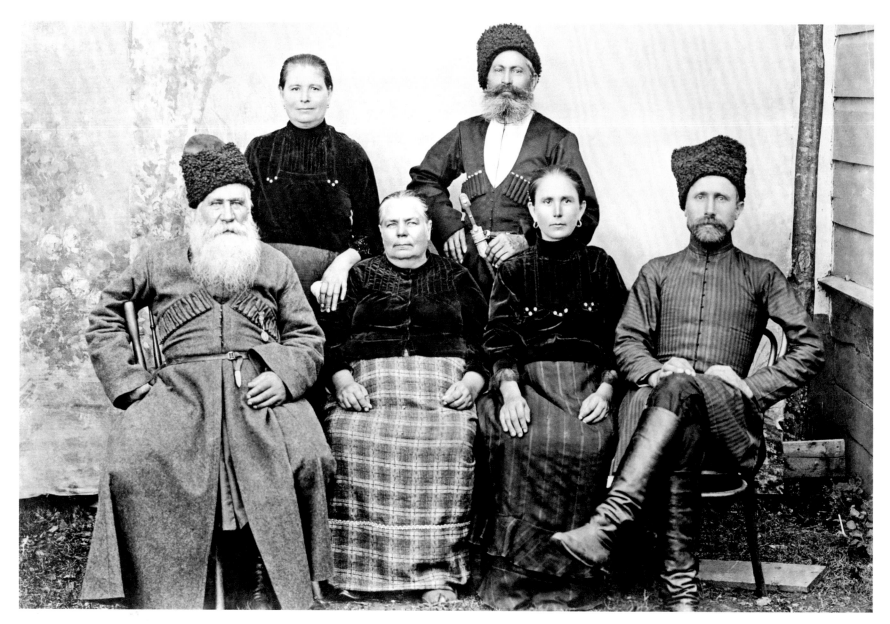

Cossacks

"Always on horseback, always ready to fight, always on the alert," wrote the Russian poet Alexander Pushkin about these fierce warriors. Russian tsars always did their best to gain the loyalty of these stubborn, independent people. Cossacks supported the tsar during the unrest of 1905, but in 1917, a number of Cossack regiments joined the Revolution, hastening the fall of the monarchy. Here a family of Cossacks from the Kuban region in the Caucasus Mountains pose for the camera, 1910.

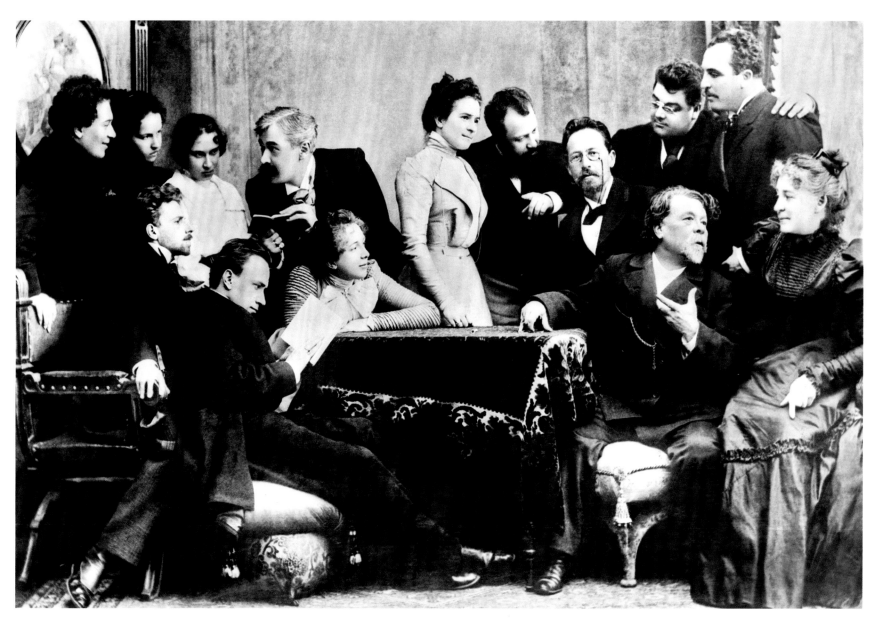

Moscow Art Theatre

The Moscow Art Theatre is generally considered the first modern theater. Cofounded in 1897 by the director Konstantin Stanislavsky, the theater moved away from the highly stylized, melodramatic approach of the nineteenth century toward a more realistic method of acting and production. Its first great success was its 1898 staging of Anton Chekhov's play *The Seagull*. In this 1899 photo, Chekhov looks directly into the camera, surrounded by the theater ensemble. Stanislavsky (fourth from the left in the back row) is busily chatting up the ladies.

Moscow Medici

Railroad magnate Savva Mamontov's Abramtsevo estate north of Moscow was a creative retreat for many of the finest Russian artists of the early twentieth century. His friends called Mamontov "Savva the Magnificent," likening him to Lorenzo de Medici, the leading patron of the arts in fifteenth-century Florence, Italy. Here Mamontov plays the piano surrounded by (left to right) painters Valeri Surikov, Ilya Repin, Konstantin Korovin, Valentin Serov, and sculptor Mark Antokolsky, circa 1900.

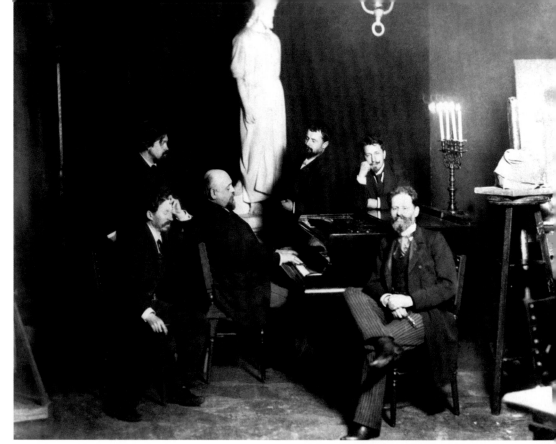

The Wanderers

Writer Maxim Gorky (left) and critic Vladimir Stasov (center) visit artist Ilya Repin at his retreat in Kuokkala, Finland, in 1904. Stasov was the domineering advocate and Repin one of the stars of a group of artists called the Wanderers. Instead of imitating European art, these artists turned to Russian themes: in Stasov's words, "scenes from the village and the city, remote corners of the provinces, the godforsaken life of the lonely clerk, the corner of a lonely cemetery, the confusion of a market place, every joy and sorrow that grows and lives in peasant huts and opulent mansions."

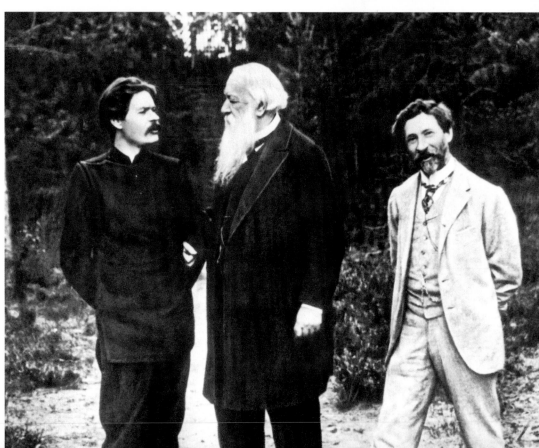

Writers

Author Maxim Gorky (right) visits Leo Tolstoy at Tolstoy's country estate, Yasnaya Polyana, in 1901. Gorky was thirty-three years old and had just begun his best-known play, *The Lower Depths*. He was decidedly the disciple to the increasingly otherworldly, seventy-three-year-old Tolstoy, the author of *War and Peace* and *Anna Karenina*. Wrote Gorky, "His interest in me is ethnological. In his eyes I belong to a species not familiar to him—only that."

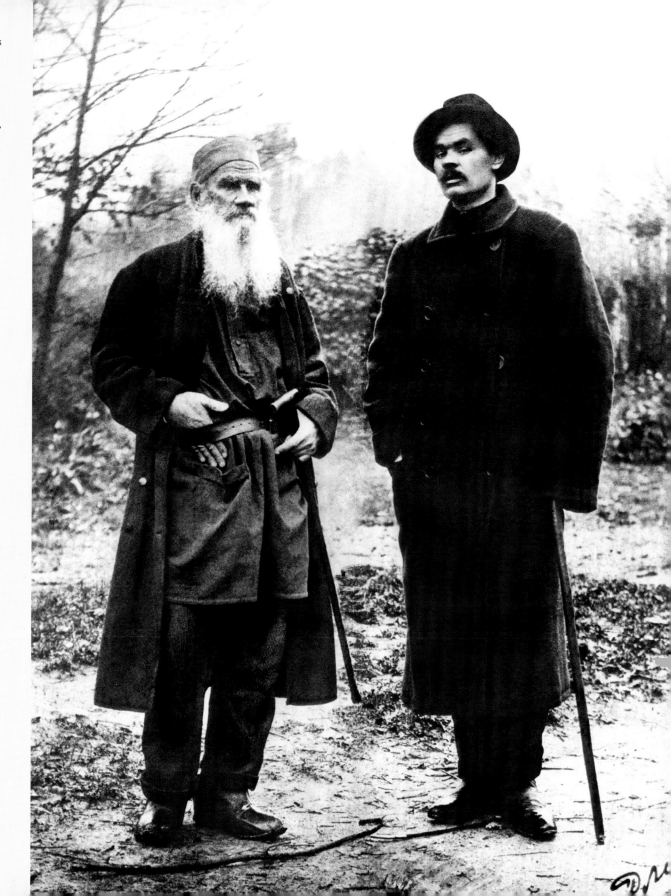

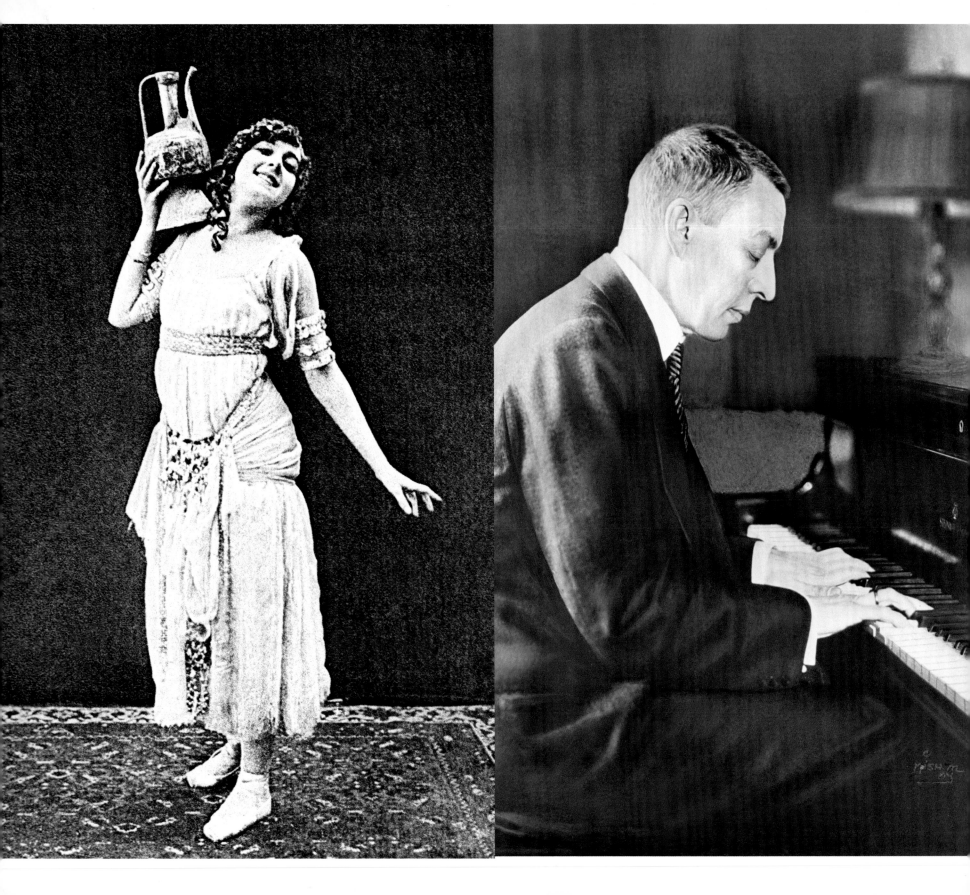

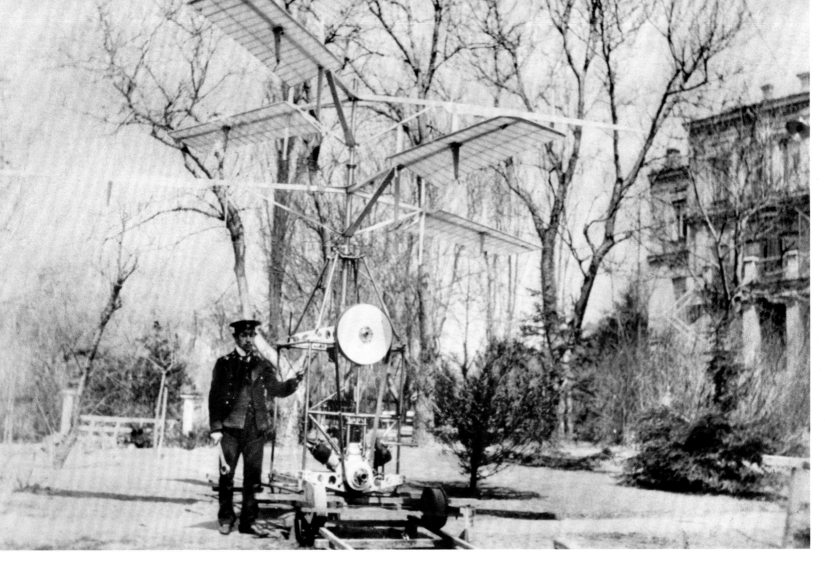

The Whirlybird
Twenty-one-year-old Igor Sikorsky stands next to his second helicopter, the S-2, in 1910. Like the first, a year earlier, the aircraft couldn't fly. It took the Father of the Helicopter another twenty-nine years to design one that actually worked. Yet he considered these early efforts successes. "This machine was a failure to the extent that it could not fly. In other respects it was a very important and necessary stepping stone."

OPPOSITE, LEFT
Bolshoi Ballerina
Vera Karalli danced with the Bolshoi as well as the Diaghilev Ballet. She was known more for her beauty, expressiveness, and dramatic presence than classical ballet technique, and so easily made the transition to film, becoming one of Russia's first movie stars. Moscow, 1915.

OPPOSITE, RIGHT
The Master
A renowned composer and perhaps the greatest pianist of his generation (his hands were so huge they covered the interval of a thirteenth on the keyboard, a span of some twelve inches), Sergei Rachmaninov left Russia during the Revolution, never to return. He continued to perform, but in leaving Russia, he left behind the source of his inspiration and virtually ceased composing. By 1917 he had written thirty-nine pieces; afterward, until his death in 1943, he managed only six.

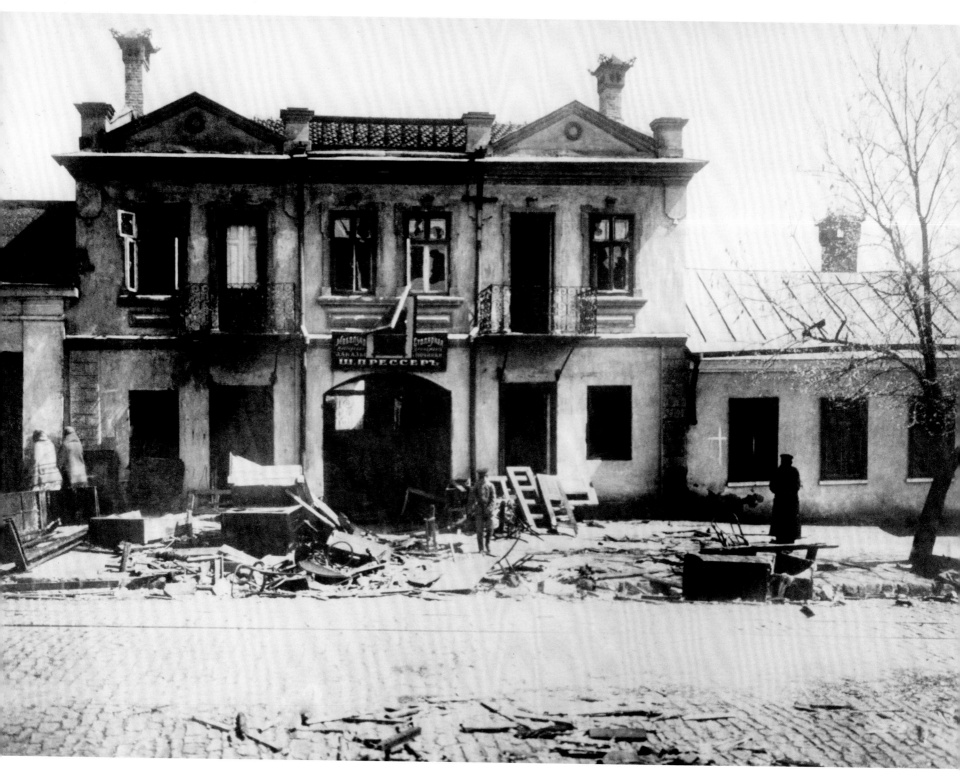

The Kishinev Pogrom

On Easter day, 1903, a riot broke out against Jews living in the town of Kishinev (in today's Moldova). It began when the editor of an anti-Semitic newspaper accused the Jews of murdering a Christian boy so as to use his blood in their religious ceremonies (a relative of the boy had actually done the killing). The resulting pogrom killed at least forty-seven people, injured some six hundred more, and looted and destroyed more than seven hundred homes.

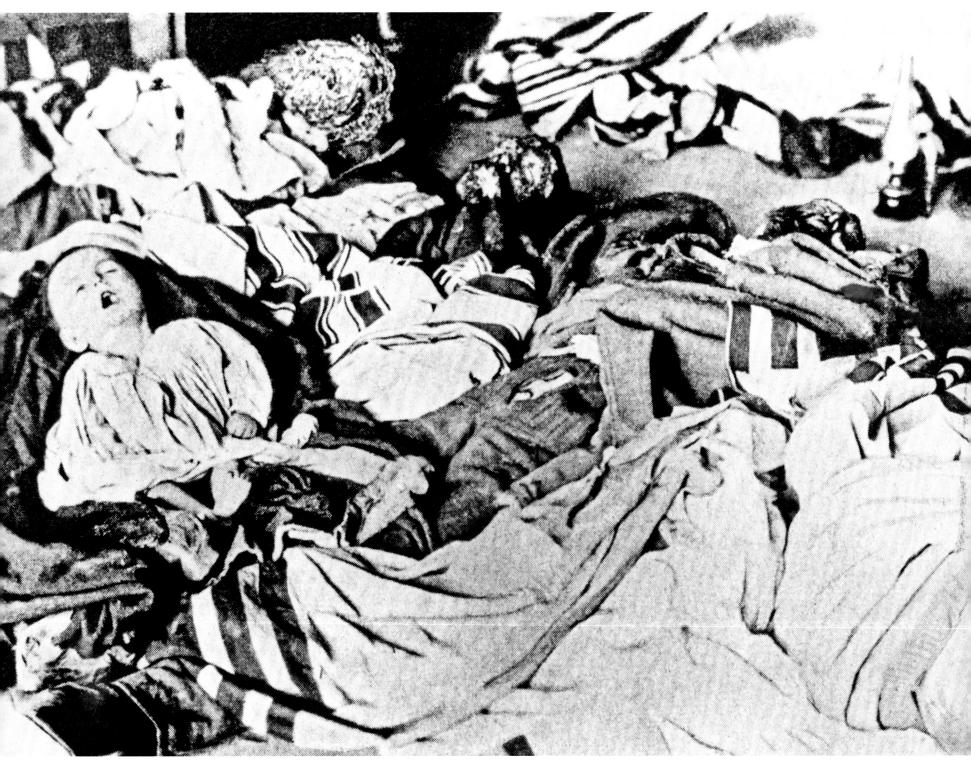

Victims of the Pogrom
The brutality of the massacre is graphically captured by this photo. When a Russian newspaper refused to publish novelist Maxim Gorky's article about the incident, he sent it to the Frankfurt *Kleine Presse,* which printed it on May 22, 1903. His words foreshadow the sentiments of the revolution to come. "Who bears the blame of this base crime, which will remain on us like a bloody blot for ages? . . . It would be unjust and too simple to condemn the mob. . . . For it is well known that the mob at Kishinev was led by men of cultivated society. . . . The cultivated classes are a crowd of cowardly slaves, without feeling of personal dignity, ready to accept every lie to save their ease and comfort. . . . Come, therefore, all who do not want themselves to be regarded as the lackeys of the lackeys, and who still retain their self-respect; come and help the Jews!"

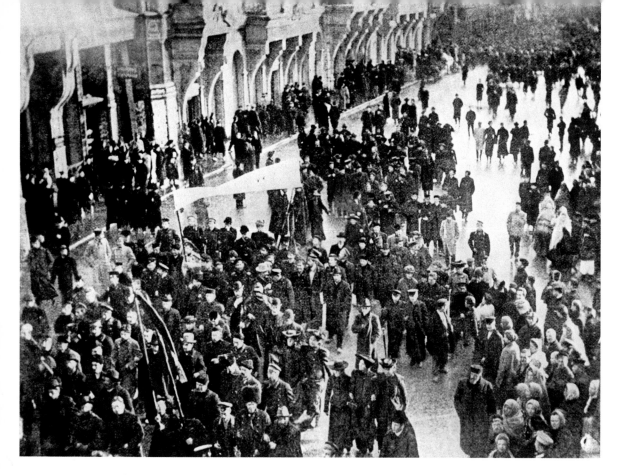

Prelude to Revolution

The year of 1905 began in violence, with tsarist troops gunning down demonstrators during Bloody Sunday, and ended in violence, with troops massacring striking protestors. In between, widespread strikes and demonstrations paralyzed the country, forcing the tsar to pay short-lived lip service to civil rights and a representative government. Pictured here, a demonstration in Moscow's Tverskaya Street in 1905.

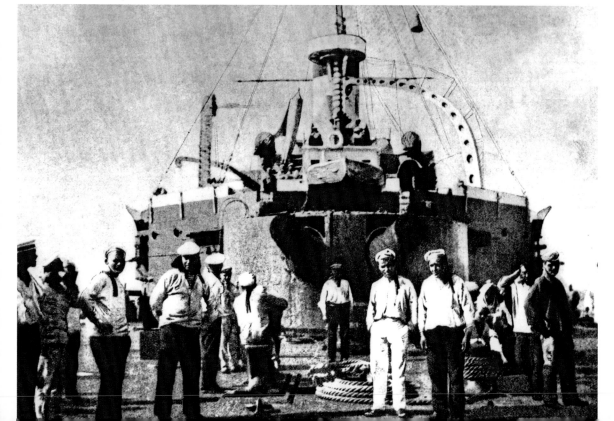

Battleship Potemkin

Sailors mill about on the deck of the *Potemkin*. The 1905 mutiny aboard the ship, while prompted by sailors' refusal to eat maggot-infested meat, soon became a rebellion for the sake of representative government. The striking sailors produced a manifesto that read, "Our slogan is: freedom for the whole Russian people or death! We demand an end to the war and the immediate convocation of a constituent assembly on the basis of universal suffrage. That is the aim for which we shall fight to the end: victory or death! All free men, all workers will be on our side in the struggle for liberty and peace. Down with the autocracy! Long live the constituent assembly!" Circa 1905.

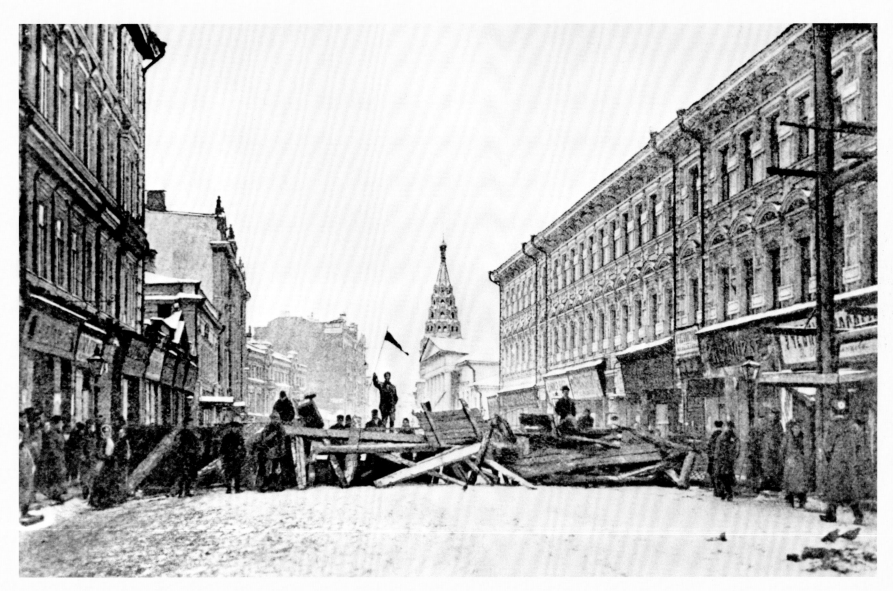

Barricades in the Streets
Arbat Street, Moscow, 1905.

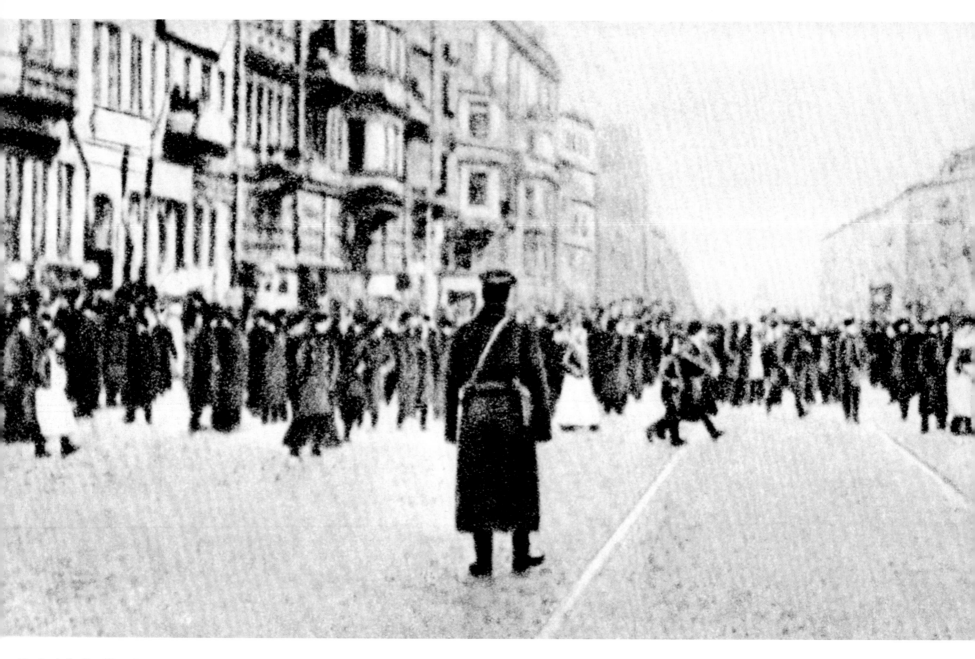

Protests in the Street
Under the watchful eye of tsarist cavalry, workers march in 1905 St. Petersburg.

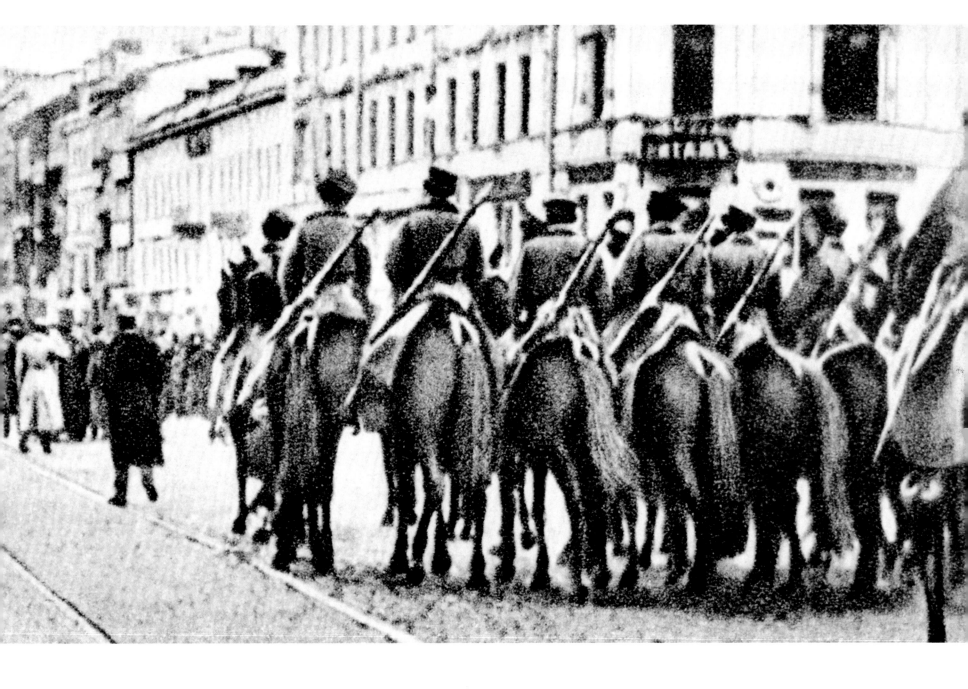

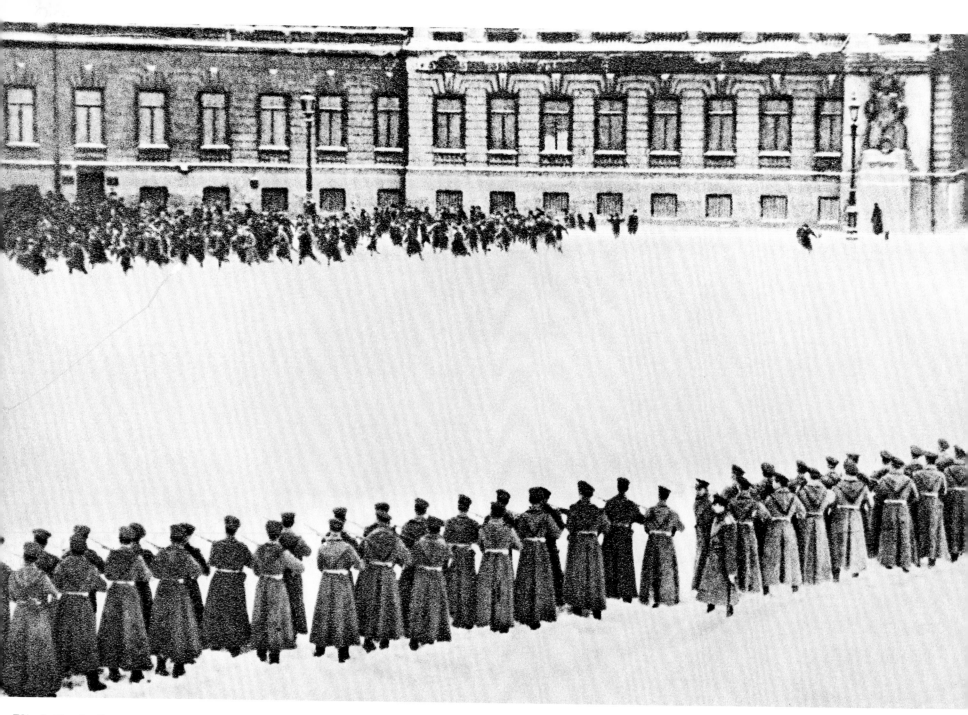

Bloody Sunday?
This controversial photo ostensibly captures the harrowing moment when tsarist troops opened fire on unarmed workers in front of the Winter Palace in St. Petersburg in 1905. The incident became known as Bloody Sunday. But is the photo authentic? It may be that it was lifted from a 1925 movie entitled *The Ninth of January*, by director and actor Vyacheslav Viskovsky. No matter its authenticity, the photo became famous inside and outside the Soviet Union as a record of an iconic moment that led to revolution.

Opening of the Duma
Nicholas II authorized a second Duma to convene in St. Petersburg in February 1907. It lasted three months—the tsar closed it down in June. This armed conflict with the police occurred on the Duma's opening day.

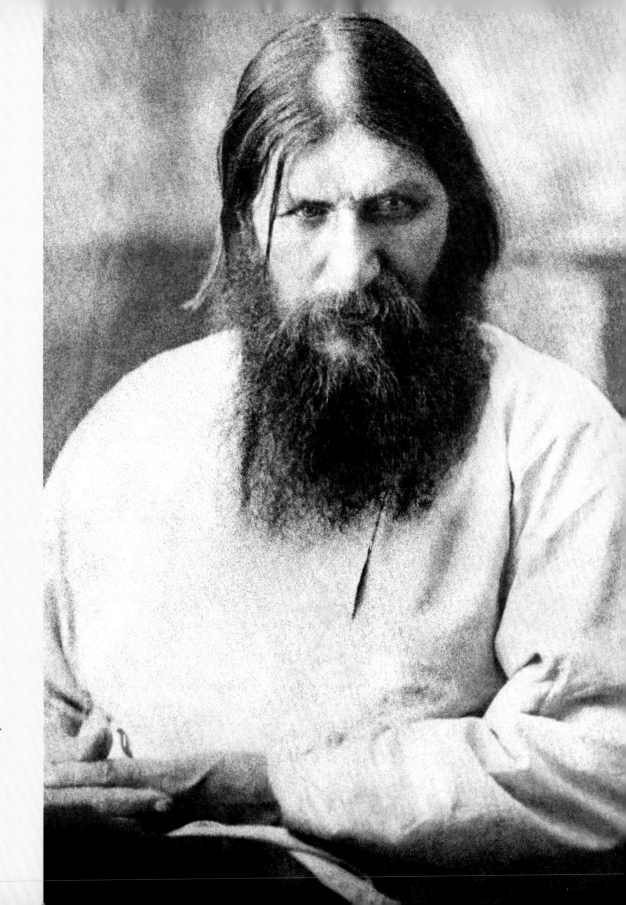

The Mad Monk

"Rasputin was dark, with long stiff hair, a thick black beard, a high forehead, a broad prominent nose, and sensuous mouth. The full expression of his personality, however, seemed concentrated in his eyes. They were pale blue, of exceptional brilliance, depth, and attraction. His gaze was at once piercing and caressing, naive and cunning, far-off and intent. When he was in earnest conversation, his pupils seemed to radiate magnetism. He carried with him a strong animal smell, like the smell of a goat."
—*Maurice Paléologue, French Ambassador*

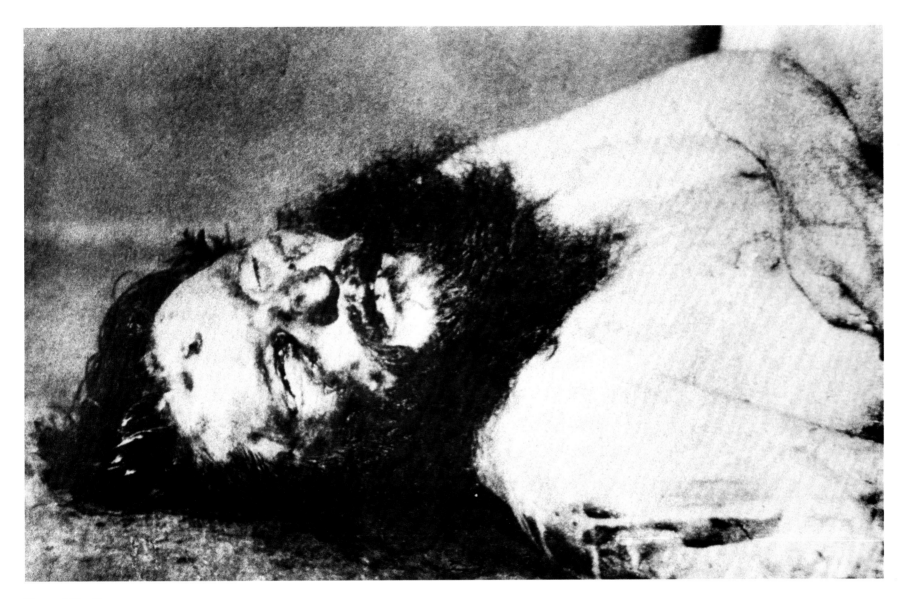

Face of Death
Fished out of the Neva River, Rasputin's body displays the beating he endured
before being dropped through a hole in the ice into the river. Examination of the
body suggested that, despite having been poisoned, shot, and beaten severely,
Rasputin died by drowning. St. Petersburg, 1916.

The First World War

It was supposed to be the war that ended all wars. Instead, it became a bloody and gruesome springboard to a century of wars—and for Russia, a catalyst to revolution. At the front, 1914.

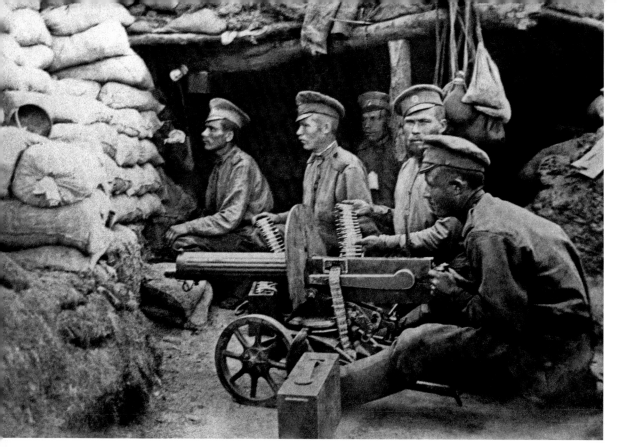

The First World War

At the front, 1915.

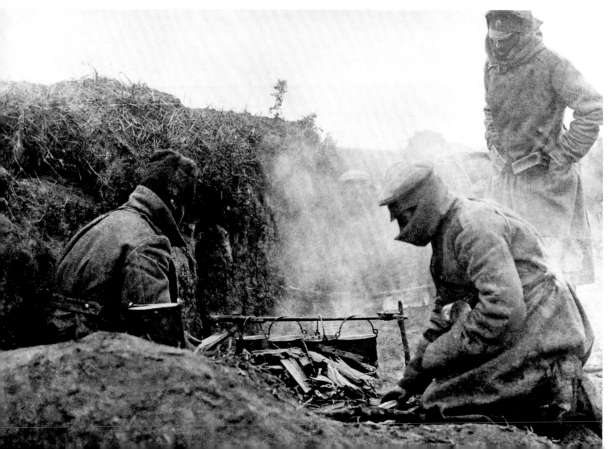

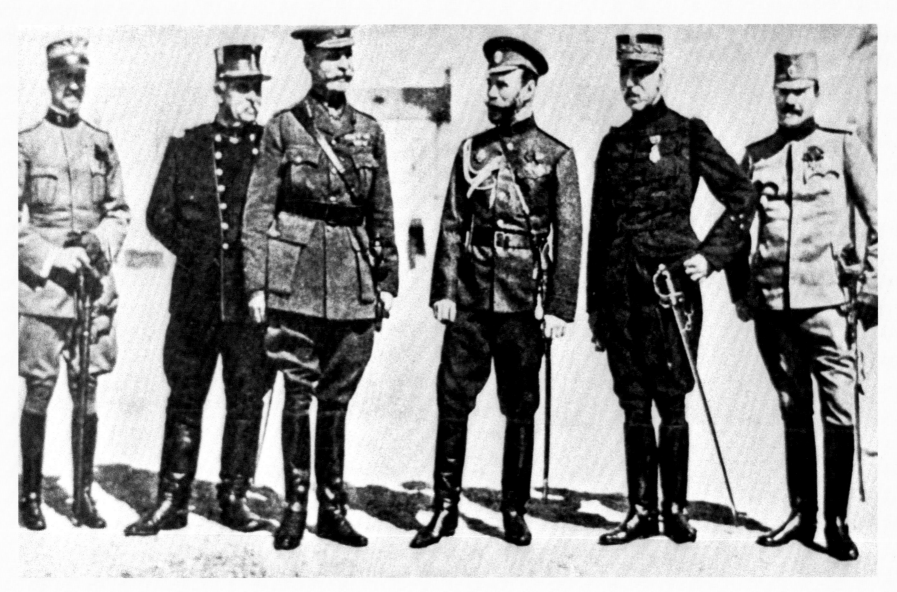

Architects of War
Nicholas II (third from right) poses with representatives of World War I allies in
Moscow in 1915.

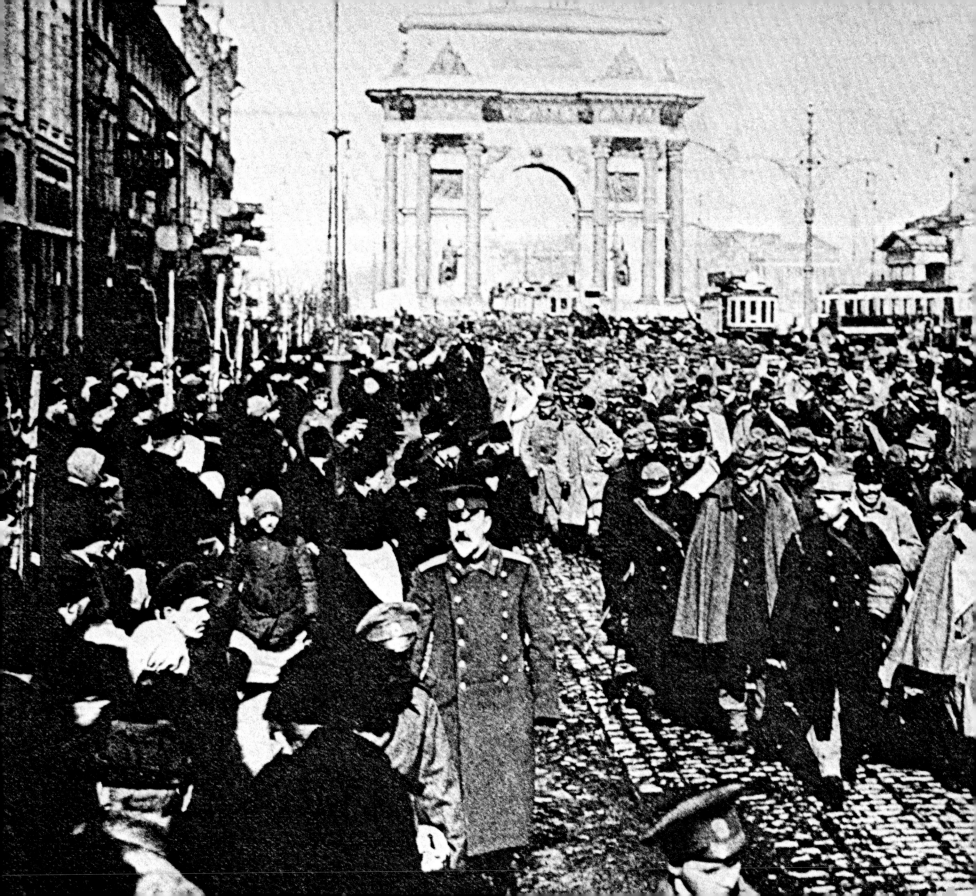

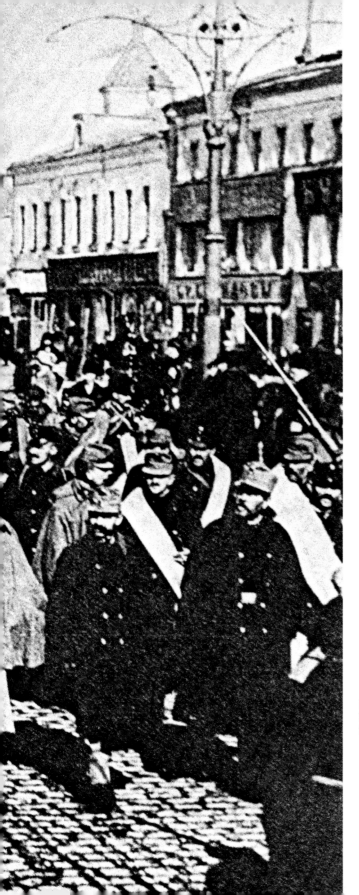

Prisoners of War
World War I prisoners of war march down Moscow's main
thoroughfare, Tverskaya-Yamskaya Street, in 1915.

1905 – 19
– 1941 – 1
1964 – 19
– 2005

ESTABLISHING POWER

17 – 1927
953 –
84 – 1991

THE SOVIET IMAGE

1905

1917 –

1927

1941

1953

1964

1984

1991

2005

ESTABLISHING

POWER

"PEACE, BREAD, AND LAND"

When Lenin, living in poverty in Zurich, heard about the Revolution, he couldn't believe it. Just two months earlier he had stated, "We older men may not live to see the decisive battles of the approaching revolution." And now, here was the event he had dreamed of, worked toward, and lived for, and he was nowhere near the action. Frustrated and angry, he busied himself by writing an article denouncing Russia's newly formed Provisional Government and calling for withdrawal from the war.

Born Vladimir Ilyich Ulyanov in the Volga city of Simbirsk in 1870, Lenin was mostly known as a troublemaker. Early on, his main claim to fame was that his older brother, Alexander, had been hanged in 1887 for attempting to assassinate Alexander III. Young Vladimir earned a law degree, but, like his brother, his chosen profession soon became that of revolutionary. He adopted the pseudonym Lenin (probably derived from the river Lena in Siberia) and became a single-minded, indefatigable, and remorseless Marxist. Eloquent and contentious, he violently denounced anyone who didn't agree with him. "Lenin is devoted to the revolutionary cause. But to him revolution is embodied in his person," was the assessment of fellow revolutionary Victor Chernov. In 1895 he was arrested and sentenced to three years of exile in Siberia. Upon his release, he, like so many other revolutionaries, left for Europe to talk and think and write—and plot the overthrow of the Russian monarchy. And now, isolated in Zurich, his revolution underway without him, he schemed of ways to get himself back to Petrograd.

Many in the city didn't want him back. The last thing the Provisional Government needed was a Bolshevik firebrand undermining its efforts. But nothing would suit Kaiser Wilhelm of Germany more. Lenin was preaching withdrawal, and with Russia and its millions of troops out of the picture, Germany could advance unopposed. So Germany came to Lenin's rescue. It transported him and a handful of other revolutionaries through the front lines in a sealed train car and provided funds for their activities once they got back to Petrograd. Wrote Winston Churchill, "They turned upon Russia the most grisly of all weapons.

They transported Lenin in a sealed truck [sic] like a plague bacillus into Russia."

Lenin arrived at Petrograd's Finland Station just after 11:00 p.m. on April 3, 1917. He feared being arrested on the spot. Rather, he was met by several thousand workers, an honor guard of sailors, and a brass band playing "La Marseillaise." Clambering to the top of an armored car, he electrified his greeters by declaring that not only had they liberated Russia but a global revolution was in the making, and the entire world was looking to them. Lenin then made his way to the second-floor balcony of Bolshevik headquarters, the commandeered palace of Mariinsky prima ballerina Mathilde Kshesinskaya, to exhort another waiting crowd.

Stalin was already there, released from Siberia, where he had been exiled since 1913 for a variety of revolutionary activities, including robbing banks to provide funds for the Bolsheviks. Born Josef Vissarionovich Dzhugashvili in a Georgian slum in 1878, he had adopted the name Stalin, meaning "steel." His streetwise, practical talents had made him valuable to the Bolshevik cause, but his personality never endeared him. Rude, vulgar, and abrasive, he had received a mixed welcome in Petrograd. But by the time Lenin pulled into Finland Station, Stalin was one of the leaders of the party and editor of the Bolshevik newspaper, *Pravda* ("truth" in Russian).

Trotsky was on his way. Born Lev Davidovich Bronstein in the south of the Russian Empire (Ukraine) in 1879, he had been known as Trotsky ever since using the name and passport of a former jailer to escape from exile in Siberia in 1902. He was flamboyant, eccentric, brilliant—the only man to rival Lenin in intellect and influence. He, too, was in Europe, until 1916, when France deported him to Spain for anti-war activities. Spain immediately sent him on to America. He heard about the Revolution while employed writing revolutionary articles in New York. He finally reached Petrograd in May.

The Bolsheviks' primary adversary was Alexander Kerensky, the prime minister of the Provisional Government. Kerensky was from Simbirsk, Lenin's hometown (he was born in 1881, eleven years after Lenin). His father was the principal of Lenin's school and

a close friend of Lenin's father. A compelling speaker, Kerensky was the one man who could bridge the animosity between the Provisional Government, which consisted primarily of former Duma members under the tsar, and the homegrown, worker- and soldier-dominated Soviet. Sustained by a steady diet of brandy, morphine, and cocaine, Kerensky hurtled from crisis to crisis, meeting to meeting, loosing his oratory on all.

Lenin and his colleagues wanted nothing to do with the Provisional Government, judging it far too timid, conciliatory, and genteel—useless for the kind of revolution Lenin had in mind. In a series of speeches that came to be known as his April Theses, Lenin outlined his vision: the army, police, and bureaucracy should be eliminated; banks socialized; workers put in control of the production and distribution of goods; and land divided up among the peasants. His slogan became a rallying cry: "Peace, bread, and land."

In the summer of 1917, Lenin and his Bolsheviks rose against the Provisional Government. Kerensky and the army quickly put down the attempted coup, destroying the office of *Pravda,* occupying the Kshesinskaya Mansion, and issuing warrants for Lenin, Trotsky, and other Bolshevik leaders. "They're getting ready to shoot us," Lenin declared, shaving his goatee, covering his bald head with a gray wig (amusing the wigmaker, as most buyers wanted dark wigs so as to look younger), and fleeing to Finland. Trotsky was arrested and thrown into Petrograd's gloomy Kresty Prison.

But soon things turned sour for Kerensky. While he assumed the most elegant trappings of power—moving into the Winter Palace, sleeping in Nicholas's bed, traveling in the imperial train—all around him the country was self-destructing. The war effort continued to deteriorate. Deserters drifted away by the thousands, overrunning stations and trains, killing indiscriminately. Peasants in the countryside began seizing land, murdering landlords, burning manor houses and crops, and slaughtering animals. As a result, food and other provisions became even scarcer. Supplies to the front dried up, products from the cities dropped away, factories ground to a halt, and crime was everywhere. Bloody pogroms were mounted against the Jews, the traditional scapegoats

for Russia's problems. Inflation skyrocketed so precipitously that the government printed and circulated whole sheets of money, not bothering to cut the devalued currency into single notes.

At the end of August, the army's commander in chief, General Lavr Kornilov, decided to take matters into his own hands. A brash soldier who was described by an associate as having the heart of a lion and the brains of a sheep, Kornilov declared that it was "high time to hang the German agents and spies headed by Lenin" and proceeded to march on the city.

With his own army spiraling out of control, Kerensky had to make a pact with the devil—the Bolsheviks—who sent their fledgling Red Army against Kornilov, cut the rail line to Petrograd, agitated with his troops to mutiny, and subverted the coup.

Kerensky's ploy saved the Provisional Government—but in the popular view, the Bolsheviks were now the real force in the land. And now they had a fresh supply of captured weapons and ammunition. Within two months, Bolsheviks comprised the majority in the Petrograd and Moscow Soviets. Trotsky was released from prison. The stage was set for Lenin to come back to Russia.

"LONG LIVE THE REVOLUTION OF WORKERS, SOLDIERS, AND PEASANTS!"

In early October, Lenin secretly returned to Petrograd. On the night of October 10, still beardless and bewigged and now sporting a pair of glasses, he attended a secret meeting of the Bolshevik Central Committee. Also attending, similarly disguised by wigs and spectacles and glued-on beards and moustaches, were the heart of the party: Trotsky; Stalin; Felix Dzerzhinsky, who would soon head Lenin's secret police; Yakov Sverdlov, soon to become the executioner of the tsar and his family; and a handful of others. Had Kerensky only known, he could have destroyed the Bolshevik Revolution in one sweep.

The meeting was stormy and contentious. Despite the Bolshevik gains, not everyone shared Lenin's conviction that the time was right for another

THE SOVIET IMAGE

1905

1917 –

1927

1941

1953

1964

1984

1991

2005

ESTABLISHING

POWER

stab at power. Finally, at three in the morning, he wrote a resolution "recognizing . . . that an armed uprising is inevitable and that its time has come." He was determined, relentless, and his comrades could only agree. "Lenin . . . seems to be made of one single piece of granite," commented Victor Chernov. "He is all round and polished like a billiard ball. You cannot get hold of him. He rolls with irrepressible speed." The Bolsheviks would again attempt to take over Russia.

Kerensky knew it was coming. On Tuesday, October 24, he reinforced the guard at the Winter Palace; sent troops to the telephone, post, and telegraph offices; and set up traffic controls in the streets. He closed three of the four main bridges over the Neva River to limit access to the city. He gave an impassioned speech to his government, declaring Lenin a state criminal and promising to fight to the death against a Bolshevik uprising. He then returned to army headquarters to issue urgent orders for troops to return from the front and defend the city. But they never arrived.

At 9:00 a.m. on Wednesday, October 25, Kerensky awoke in Nicholas's bed to discover that his telephone was dead and the Bolsheviks had taken over the Winter Palace Bridge, the one still-functioning span over the Neva. He resolved to head for the front and bring back loyal troops himself, only to find that the Bolsheviks had disabled all the palace vehicles. Finally he was able to borrow two cars, including one from the American Embassy. With the American car leading the way, Stars and Stripes flying, Kerensky raced through Petrograd in the open backseat of the other, standing and saluting the crowds as he passed by. Bolsheviks manning checkpoints simply waved the motorcade through without bothering to check his identity. Even when the American driver became lost and had to ask directions, no one stopped them. At the outskirts of the city, Kerensky recalled later, guards "came rushing toward our machine from all sides, but we had already passed them."

Lenin, meanwhile, had been up most of the night making sure this time the coup wouldn't fail. At about ten in the morning he produced a proclamation to be posted throughout Petrograd. "To the Citizens of Russia!" it began. "The Provisional Government has been deposed. . . . Long live the revolution of workers, soldiers, and peasants!" And at about two in the afternoon, Trotsky gave a thunderous speech declaring that because of a movement of "such enormous masses" hitherto unseen throughout history, the government had "ceased to exist."

This was hardly the case. Rather, Petrograd was trying to live as normally as possible in the midst of hard times. Kerensky might have fled, but his ministers continued to meet in the Winter Palace, people lined up outside shops, and Felix Yussupov, back in his palace after his brief exile for murdering Rasputin, had resumed throwing lavish parties. The city's culture and entertainment centers continued to function. The great bass Fyodor Chaliapin was singing in *Boris Godunov* at the Mariinsky Theater; Alexei Tolstoy's *The Death of Ivan the Terrible* was playing at the Alexandrinsky Theater. Restaurants, cinemas, bars, and clubs were open. The only indication that something monumental was brewing was an occasional armored car racing through the streets, siren blaring. Yet, for historians, Trotsky's heroic image struck a romantic chord. It was his rhetoric that invested a slipshod and chaotic revolution with mythic proportions, transforming it into the legendary Red October.

Soon the Bolshevik Military Revolutionary Committee came up with an ultimatum: if the ministers didn't surrender, the cruiser *Aurora*, whose crew supported the Bolsheviks, would open fire on the palace and the assault would begin. The go-ahead signal would be a red lantern hoisted onto the Peter and Paul Fortress, across the river. But the Bolsheviks couldn't find a red lantern. And the *Aurora*, fresh from repairs in dry-dock, had no live ammunition on board. No matter. At about 10:00 p.m. the crew opened fire—with blanks. Soon the fortress's guns began lobbing live rounds across the river, but most missed the palace. The ministers held fast.

At about 2:00 a.m., a few hundred Bolsheviks swarmed up the palace's broad staircases and made their way to the ministers' chamber. Finally acknowledging the inevitable, the ministers surrendered. The elated revolutionaries herded them down the stairs and to cells in the Peter and Paul Fortress. Just like that, it was over.

LEARNING TO RULE

Now what? Neither Lenin, nor Trotsky, nor Stalin, nor any other Bolshevik leader had any experience with government. They had extensive experience in organizing revolutionary groups, issuing proclamations, fomenting strikes and demonstrations, running from the secret police, and living in exile. They could expound on Marxist theory, produce rhetorical articles, and argue fiercely among themselves—but could they band together to run a country?

The Bolsheviks now held Petrograd, but keeping it was no sure thing. Kerensky, some thirty miles from the city and preparing to attack, found himself unexpectedly abandoned by the Cossack cavalry troops he thought loyal—the Cossacks preferring to return to their home region along the Don River to the south. He escaped disguised as a sailor. Elsewhere in the country, the larger, industrialized cities, themselves experiencing strikes and unrest, were coming over to the Revolution. After days of bloody fighting, Moscow knuckled under to Bolshevik control. But much of the countryside remained chaotic and unsettled.

Then came a turning point. Lenin had pledged to support nationwide elections for a new parliament called the Constituent Assembly. But when elections were held in November 1917, most votes went to more moderate socialists, many of whom had been part of the Provisional Government. The Bolsheviks garnered just 25 percent of the vote. For Lenin's still-shaky Revolution, it was a potentially fatal irony. Thanks to the Bolsheviks, Russia finally could express its political will, and it barely acknowledged the Bolsheviks. Had Red October come to this, a Bolshevik Revolution that had no room for Bolsheviks?

The answer was decisive, unambiguous, effective—at the Constituent Assembly's inaugural meeting, Lenin and his Bolsheviks made a brief appearance, then walked out. Soon a guard informed the assembly's chairman that it was time to adjourn. When delegates arrived the next day, they found the hall surrounded by guards, the doors locked. The assembly never met again. There was no official announcement; none was needed. Soon, in a blatant power play enforced by the Bolsheviks' growing military might, Lenin banned all political parties except the Bolsheviks. The new nation's course was suddenly clear: it would be governed at Lenin's pleasure—and by force. Russia was reverting back to the very kind of dictatorship it had rebelled against—with a new ruling class called Communists (as Lenin had renamed the Bolshevik Party) and a new "tsar"—in power, if not title—named Lenin.

"A SHAMEFUL PEACE"

But there was not much left of the country to rule. Russia was in shambles, especially its cities. People were starving, the social order disintegrating. In January 1918 alone, Petrograd suffered more than 25,000 burglaries and 135 murders. Lenin began to take ever more repressive measures. He set up his version of the tsarist secret police, the Cheka (Extraordinary Commission to Combat Counter-Revolution and Sabotage). Under the direction of the fearsome Polish Bolshevik Felix Dzerzhinsky, the Cheka began arresting political opponents. Dzerzhinsky sent soldiers into the countryside to seize grain from the peasants to feed the starving cities (Stalin headed one of these expeditions). He took hostages to discourage opponents from assassinating prominent Bolsheviks.

And Lenin turned his attention to the greatest problem of all: the war. The cost had become unbearable: more than half of some twelve million troops the country had mobilized had been killed or wounded. "The German position on the Baltic islands is so good that they could take . . . Petrograd with their bare hands," Lenin declared. "Of course, this peace we are going to conclude will be a shameful peace, but we need a respite . . . we need time."

In March 1918, Trotsky, now the foreign commissar, led a delegation to the town of Brest-Litovsk, near the Polish border, to negotiate a separate peace treaty with the German high command. It was a typically ad hoc business. For symbolic reasons, the group was to include representatives from Russia's soldiers, sailors, workers, and peasants. But as the delegates drove to the railway station in Petrograd, they discovered that no one had bothered to bring a

THE SOVIET IMAGE

1905

1917 –

1927

1941

1953

1964

1984

1991

2005

ESTABLISHING

POWER

peasant. Suddenly they spotted an old man trudging through the snow to catch a train to his village. They offered him a lift and asked about his political leanings. Finding him suitably supportive, they invited him (for a fee) to come to Brest-Litovsk as part of the Russian peace delegation. (When asked to choose between white and red wine during a meal at the conference, the peasant answered, "Whichever is stronger.")

The results of the negotiations were fully as shameful as Lenin predicted. The Bolsheviks got their peace, but at a huge cost: they agreed to renounce Russia's claims to Finland; the Baltic territories Estonia, Latvia, and Lithuania; Poland; and parts of Belarus and Ukraine. In one humiliating swoop, the nation lost one-third of its population and agricultural lands and three-quarters of its industry. Concerned that Petrograd was now too close to European adversaries, Lenin "temporarily" moved his capital to Moscow—where it remains to this day.

The capitulation outraged Russia's allies and European anti-Bolsheviks. It also outraged Lenin's opponents within Russia. These counterrevolutionary groups, led by former tsarist military commanders, became known as Whites. They began military strikes throughout the country. An army commanded by Admiral Alexander Kolchak, the self-styled "Supreme Ruler" of the White Army, emerged from Siberia to attack across the Ural Mountains in central Russia; another army, led by General Anton Denikin, advanced up the Volga to within 250 miles of Moscow; General Nicholas Yudenich's Northwest Army reached the outskirts of Petrograd. The French, American, Japanese, and British offered weapons and other supplies to the anti-Bolshevik cause.

These armies were bolstered by the Czech Legion, forty thousand ex-POWs marooned in Siberia, who took control of thousands of miles of the Trans-Siberian Railway. By the summer of 1918, they, too, were advancing into the Urals. These incursions threatened the very survival of Lenin's Communist Party. They also, however, hastened the solution to one of his nagging problems: what to do with the former tsar, Nicholas.

"THE DECISION WAS NOT ONLY EXPEDIENT BUT NECESSARY"

After his abdication in March 1917, Nicholas and his family had been imprisoned at Tsarskoe Selo. Kerensky's new Provisional Government had tried to persuade England to grant the family asylum, but King George V refused to take in his cousin, "dear Nicky," for fear of upsetting his own working class. Every other potential European haven followed suit. As conditions in Petrograd deteriorated in the late summer, Kerensky felt it necessary to move Nicholas and his family to a remote and safe location, Tobolsk, in western Siberia.

After the Bolshevik victory in October, the ex-tsar and his family were Lenin's responsibility. He handed off the "Romanov problem" to his close associate, Yakov Sverdlov, who moved the family to the Ural Mountains mining town of Ekaterinburg in the spring of 1918. They settled into the town's largest dwelling, the Ipatiev house, isolated by a tall wooden fence, watched over by a troop of Red Guards, and attended by an entourage of just four—a doctor, a cook, a valet, and a maid.

Unfailingly cooperative and polite, Nicholas impressed even the most hostile of his captors. The guardsman in charge, a Cheka officer named Yakov Yurovsky, wrote of him that he "appeared to be an ordinary gentleman, simple, and I would say very much like a peasant soldier." For months the family lived in hope of rescue, by friends in Russia or relatives in Europe, but in the first week of July, these prospects dimmed. Nicholas abandoned the diary he had faithfully kept for more than three decades. Typically, his last entry described an injury to Alexei's knee.

Meanwhile, the White Army and Czech Legion continued to advance. On July 14, the Communist military commander in the Urals sent Moscow a warning that he might not be able to hold Ekaterinburg longer than a few more days. On July 17, the Romanovs' guards wouldn't allow the family to take their daily walk about the courtyard. At about 2:00 a.m. on July 18, acting on telegraphed orders from Sverdlov, Yurovsky awakened his prisoners. He explained hurriedly that the Whites were advancing more quickly than expected,

and he was forced to move them to a safer place. The family must dress quickly and wait in a small basement room—cars would arrive soon. Obliging to the end, Nicholas's only request was for chairs for Alexandra, Alexei, and himself.

As the family waited patiently, Yurovsky and eleven guards armed with rifles and handguns burst into the room. "Nicholas Alexandrovich," he proclaimed, "by the order of the Regional Soviet of the Urals, you are to be shot, along with all your family." The explosion of gunfire didn't kill everyone—some bullets were deflected by jewels the women had sewn into their clothing. The guards finished them off with bayonets. By 3:15 a.m. it was over: the Romanovs and their attendants were dead.

Yurovsky and his men loaded the bodies onto a truck parked outside with its engine racing. As dawn broke they dumped the bodies into a mine shaft outside town. The next day, with the entire town whispering about horrible doings and a "secret" site, they went back, removed the remains, and went searching for a more secluded mine shaft. But their truck became stuck in mud, forcing them to dispose of the family on the spot. Hastily, they dug a pit six feet deep and eight feet square in a nearby meadow. "The bodies were put in the hole and the faces and all the bodies generally doused with sulfuric acid, both so they couldn't be recognized and to prevent any stink from them rotting," Yurovsky wrote. "We scattered it with branches and lime, put boards on top, and drove over it several times—no traces of the hole remained."

Three days later, the Bolsheviks issued a press release stating that "the ex-Tsar, Nicholas Romanov, guilty before the people of innumerable crimes," had been shot, but that his family had been moved to a secure location. The lie gave rise to rumors that have lasted to this day that some of the royal family survived—in particular, Nicholas's youngest daughter, Anastasia.

Eight days later, the White Army took Ekaterinburg. Officers rushed to the Ipatiev house to free the tsar, only to find it empty, the interior ransacked. They found only one living creature: a half-starved English spaniel, Alexei's pet, Joy.

Years later, from exile abroad, Trotsky wrote of the killings, "Actually the decision was not only expedient but necessary. . . . The execution of the Tsar's family was needed not only in order to frighten, horrify, and dishearten the enemy, but also in order to shake up our own ranks, to show them that there was no turning back, that ahead lay either complete victory or complete ruin."

"WE WANT TO SETTLE ACCOUNTS"

In late August 1918, Lenin gave a speech at a Moscow factory. As he was leaving, a woman fired three shots. One passed harmlessly through Lenin's coat, one hit him in the left shoulder, the other in the left lung. Fearing other assassins might be lurking, Lenin refused to go to a hospital and returned to the safety of the Kremlin, where doctors deemed it too dangerous to remove the bullets. That evening the Cheka interrogated the shooter. Her name was Fanya Kaplan. "I had resolved to kill Lenin long ago," she stated. "I consider him a traitor to the Revolution. . . . I favored the Constituent Assembly and am still for it." She was executed four days later. Lenin survived, but his health was broken.

The attempted assassination inflamed Communist Russia. "Each drop of Lenin's blood must be paid for by the bourgeoisie and the Whites in hundreds of deaths," declared a Petrograd newspaper. "An end to this clemency and slackness!" decreed the Bolshevik government. "From among the bourgeoisie and the officers, large numbers of hostages are to be seized. At the least sign of White Guard resistance or activity, mass shootings are to be the rule without further discussion."

The ensuing horror became known as the Red Terror. The Petrograd Cheka shot 512 hostages. Five hundred prisoners were executed at the Kronstadt Naval Base, near Petrograd. Sixty were shot in Moscow, including grand dukes and former tsarist ministers. The Cheka declared that guilt or innocence was beside the point—it was necessary only to look at prisoners' hands. Soft, white hands meant a member of the nobility or bourgeoisie. That was enough

THE SOVIET IMAGE

1905

1917 –

1927

1941

1953

1964

1984

1991

2005

ESTABLISHING

POWER

to ensure death, sometimes in the most gruesome fashion—some Cheka victims were rolled in barrels encrusted with nails. As the Cheka approached, the upper class soaked their hands in alcohol and rubbed dirt into the cracks in an attempt to escape a death sentence. (Prince Felix Yussupov narrowly avoided becoming a victim. Confronted by Reds at his Crimean estate, he identified himself as Rasputin's killer, whereupon he was congratulated and feted with his own liquor.) By the fall of 1918, killings from the Red Terror exceeded ten thousand. "We don't want justice," declared Cheka head Felix Dzerzhinsky. "We want to settle accounts."

For their part, the Whites were easily as ruthless, stealing food, killing peasants, and mounting bloody pogroms against the Jews (justifying their attacks by pointing to the large number of Jews in the Bolshevik command). The country had fallen into full-fledged civil war.

Appointed war minister by Lenin after the Treaty of Brest-Litovsk, Trotsky had tirelessly built the Red Army from a small core of Red Guards to a powerful force of five million soldiers. He hurtled from battle to battle in a heavily armored command train, logging some sixty-five thousand miles in three years. The train featured artillery and machine guns, a radio and printing press, horse carriers, a sleeping car and a dining car, ammunition and supply cars, a special flatbed for Trotsky's Rolls-Royce, and a brass band for boosting morale. In his high black boots, greatcoat and leather gauntlets, and peaked cloth hat with red star, Trotsky cut a dashing figure.

Dissent was unacceptable, and deserters were shot on the spot. Though Trotsky conscripted ordinary soldiers into his Red Army and allowed former tsarist officers positions of leadership, he didn't trust them, installing Communist commissars in the ranks to spy on everyone. Every order had to be countersigned by both officer and commissar. If commissars no more than suspected someone of treason, they could shoot him. Trotsky called this safeguard his "iron corset."

In October 1919, General Denikin's troops advanced on Moscow from the south, and General Yudenich's army approached Petrograd from the west. Lenin feared the worst and decided to abandon Petrograd so as to concentrate on saving Moscow. But Trotsky defied his wishes and attacked Yudenich in the suburbs of Petrograd. By early November, with Trotsky shouting, "This beautiful Red Petrograd remains what it has been, the torch of the Revolution!" the Red Army pushed Yudenich out of Russia into Estonia.

That left Denikin, who controlled the Volga only 130 miles south of Moscow. Trotsky's Red Army routed his troops in the town of Orel and forced them south to the Crimea. Denikin fled Russia, turning his forces over to General Peter Wrangel. In December, Wrangel wrote Denikin, "The Army is absolutely demoralized, and is fast becoming a collection of tradesmen and profiteers . . . there has been an outbreak of debauchery, gambling, and wild orgies." Soon it fell apart completely.

Trotsky's troops pushed the Whites of Admiral Kolchak deeper and deeper into Siberia. A famously disagreeable character, Kolchak had lost the support of the Czech Legion as well as the Americans, British, and Japanese. By November his army was a disorganized mess. Kolchak himself was arrested in Irkutsk in January. He was executed by firing squad and his body dumped into the local Ushakovka River.

By November 1920, the civil war was over. Russia was now officially Red.

"I'LL SHOOT YOU LIKE PHEASANTS"

It was also in ruins. Moscow's population had fallen by half, Petrograd's by four-fifths. Wages had dropped to less than one-tenth of prewar levels. In February 1921, factories went on strike, with workers heckling Lenin and demanding his ouster.

As the Communists continued to seize food and supplies, the peasants discovered they had only exchanged masters—and not, it seemed, for the better. They responded by refusing to till the land. By 1921 food output fell to less than half the level in 1913. Devastated by the loss of the Ukraine, Byelorussia, and other grain-growing regions because of the Treaty of Brest-Litovsk, and a disastrous drought, Russia suffered the worst famine in its history. Revolts swept the country. Trotsky brutally suppressed the uprisings, shooting prisoners en masse.

The most alarming—and last—of the major uprisings occurred in March at the Kronstadt Naval Base. The sailors at the base had not only been Bolshevik supporters but they were heroes of the Revolution, in Trotsky's words, "the pride and glory of the revolution . . . the reddest of the red." But now they felt betrayed. Declaring that "all of Soviet Russia has been turned into an all-Russian penal colony," they demanded what Lenin had promised in 1917: free elections and a constituent assembly. Trotsky ordered leaflets airdropped over the base, informing his former comrades that if they didn't surrender within twenty-four hours, "I'll shoot you like pheasants."

With the help of fifty thousand Red troops, Trotsky did just that. Perhaps as many as twenty thousand of them died in the effort. Rebel losses also ran into the thousands, with many more arrested and at least five hundred executed. Some eight thousand sailors escaped over the ice to Finland.

"WE VOW TO THEE, COMRADE LENIN"

Six months later, Lenin fell ill. Nothing serious, declared his doctors, probably the result of overwork. By the winter of 1922, he was excusing himself from meetings because of insomnia and terrible headaches. His doctors removed a bullet that had remained in his shoulder since the assassination attempt in 1918 and once again concluded there was nothing wrong with him that a little rest couldn't cure. In May he experienced slurred speech and paralysis on his right side, and his doctors acknowledged he had suffered a slight stroke. Lenin knew well its significance: "This is the first bell," he said.

His health improved over the summer and fall—so much so that he forcefully expressed his displeasure over Stalin's chauvinistic attitude toward the smaller Soviet nationalities.

But in December—after another disagreement with Stalin—Lenin suffered a second stroke. Warning that any controversy might provoke a fatal attack, his doctors insisted that he be kept from political affairs. They allowed him to dictate every day but for no more

than five or ten minutes. Now, with his right arm and leg paralyzed, confined to his bed at the Kremlin, cut off from government business, and knowing the end was near, Lenin frantically worked to set his affairs in order. He began to dictate to his wife and others his "last testament."

Foremost on his mind was the question of who should succeed him as leader of the Soviet Union, which had just officially been formed in December. Of the obvious candidates, Lenin judged Trotsky "perhaps the most capable man" in the party, but also too sure of himself and too preoccupied with administrative work to be the supreme leader. That left Stalin. Lenin had in April 1922 appointed Stalin general secretary of the Communist Party. Now he was having second thoughts. "Comrade Stalin, having become Secretary-General, has unlimited authority concentrated in his hands, and I am not sure whether he will always be capable of using that authority with sufficient caution," Lenin wrote. Stalin had rudely scolded Lenin's wife for helping him stay involved in party affairs; Lenin in turn tried to find a way to remove Stalin from his post.

It was not to be. In March 1923, Lenin suffered yet another stroke, massive enough to paralyze him completely and destroy his ability to speak. Wheelchair-bound, gazing mutely at a Russia he had created but now could no longer influence, he hung on for almost a year before dying on January 21, 1924.

An Immortalization Committee was formed to properly celebrate him. Inspired by King Tut, whose tomb had been discovered little more than a year earlier, Lenin's body was embalmed and put on public display in a red granite and porphyry mausoleum in front of the great Kremlin Wall in Red Square. Petrograd was renamed Leningrad in his honor. Earlier, as the body lay in state in Moscow's Hall of Columns, Stalin gave the eulogy. He had been a seminary student during his boyhood in Georgia; now his words evoked the ecclesiastical ritual he knew well: "We vow to thee, Comrade Lenin, that we will honorably fulfill this thy commandment."

Later dictators, such as Hitler and Mao, would make themselves gods. Stalin was content to be the disciple. It would be enough.

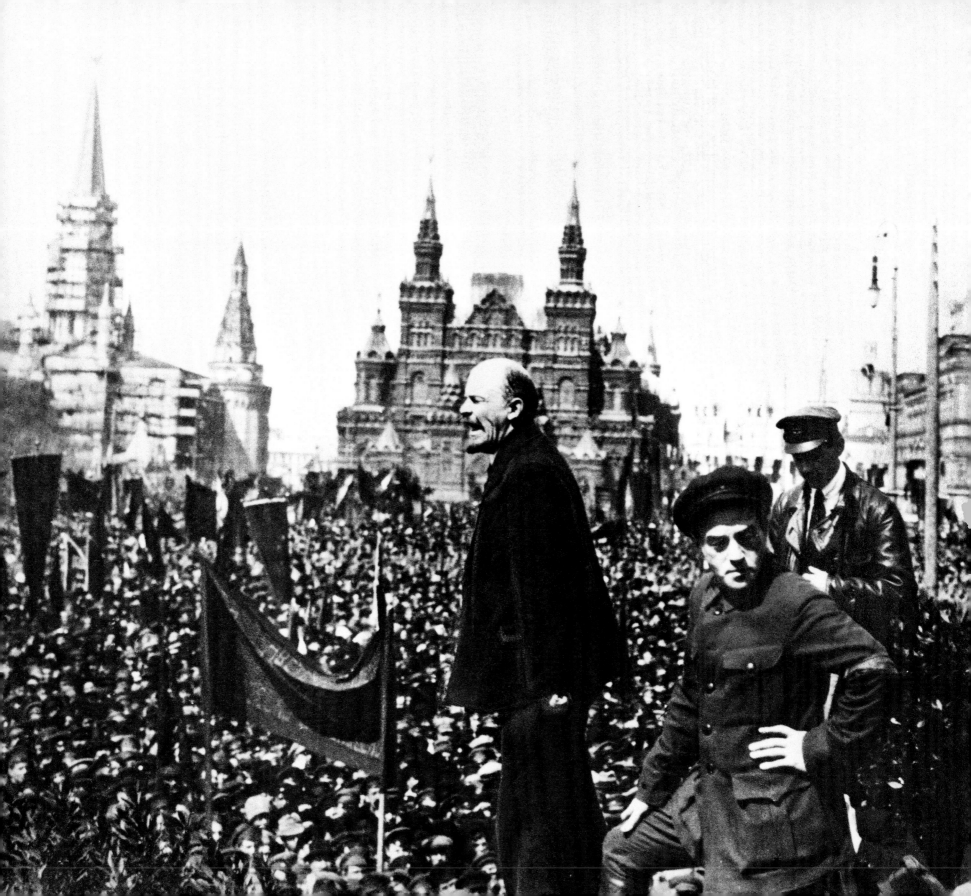

Lenin in Red Square
Lenin addresses the masses from a platform high above Red Square on May Day, 1919. This dramatic photo seems suspicious, as though Lenin and the other foreground figures have been superimposed against the enormous crowd, or the crowd embellished behind them. Manipulation of images became more and more common as the Bolsheviks came to appreciate the strong propaganda power of photographs.

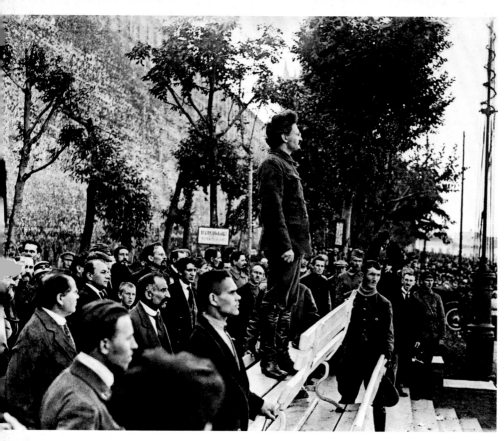

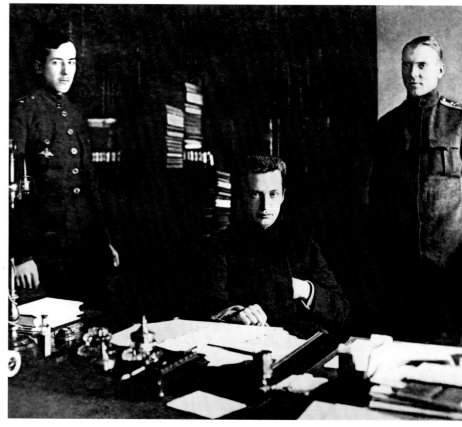

ABOVE, LEFT
Delivering the Message
Leon Trotsky, the strategist, writer, and mythologizer of the Revolution—and a powerful orator—addresses a crowd in Red Square from atop an impromptu bench podium.

ABOVE, RIGHT
Kerensky and Aides
Alexander Kerensky with his adjutants in Petrograd, 1917.

RIGHT
The Force behind the Revolution
Without Trotsky's Red Army, the Bolsheviks would not have survived the civil war. He was a fierce and merciless commander, inspiring loyalty, fear, and unquestioning obedience. Trotsky was perhaps *the* hero of the Revolution, but in just a few years after this photo was taken, he would be discredited and deported from the Soviet Union he did so much to make possible. Here he reviews his troops in Red Square, circa 1920.

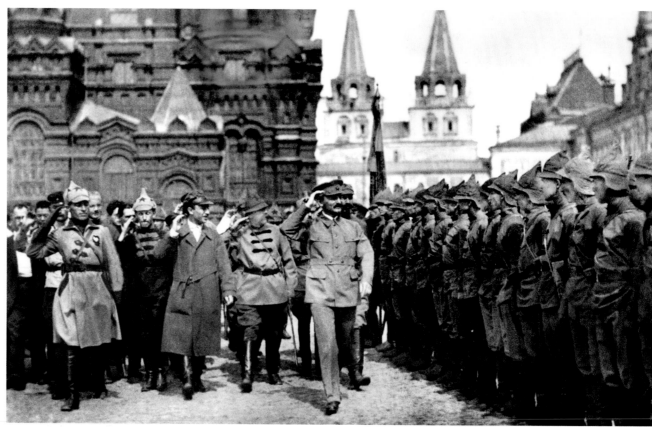

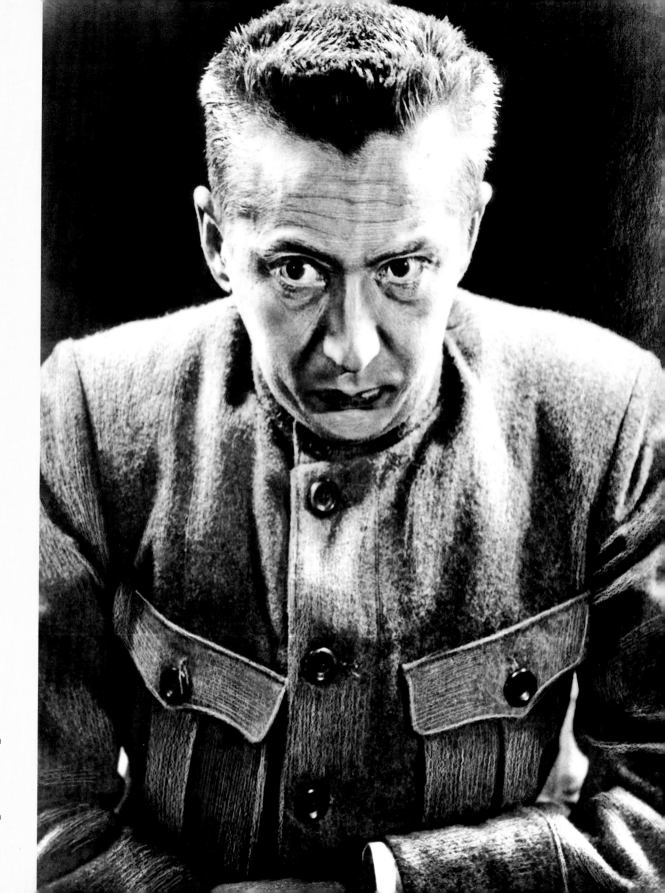

The Man Who Would Be President
This 1917 photo shows Alexander Kerensky looking
suitably concerned. By the end of the year, his Provisional
Government would be defunct, the Bolsheviks would begin
their takeover, and he would flee the country. He spent
the rest of his life in exile, mostly in Paris and New York,
with an eleven-year interlude teaching and researching at
Stanford University. To the end of his life he maintained
that for the few months between the tsar's abdication and
the Bolshevik Revolution—when he was in charge—Russia
was the freest country in the world. Petrograd, 1917.

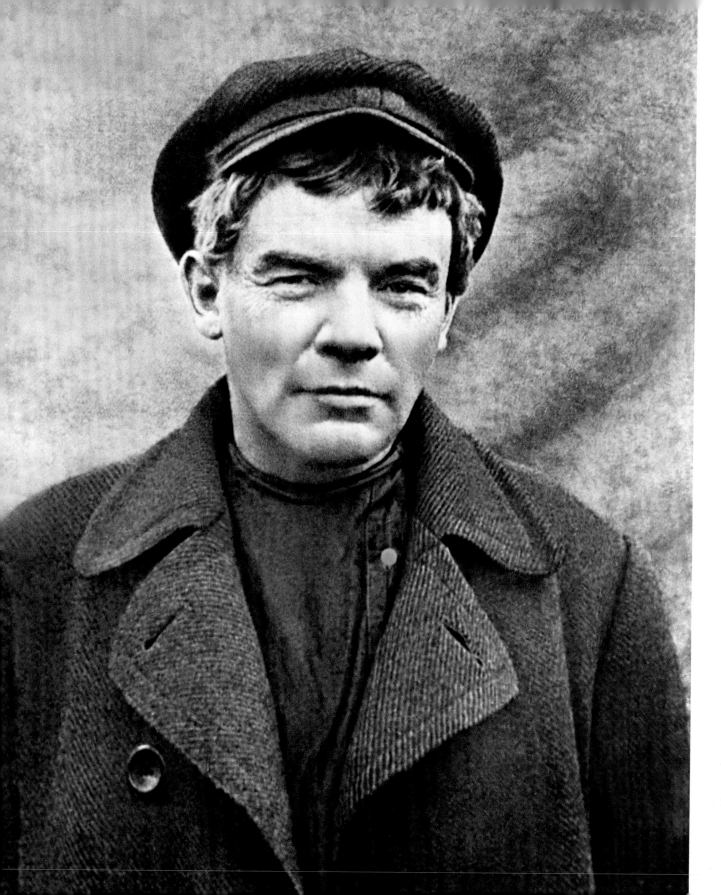

On the Run, in Disguise
After the failure of the Bolsheviks' attempted coup in 1917, Lenin shaved his goatee, donned a wig and makeup, pocketed a fake ID bearing the name "Ivanov," and fled to Finland. His choice of a gray wig amused the wigmaker (who worked at the Mariinsky Theatre)—most buyers wanted younger-looking, dark-haired wigs.

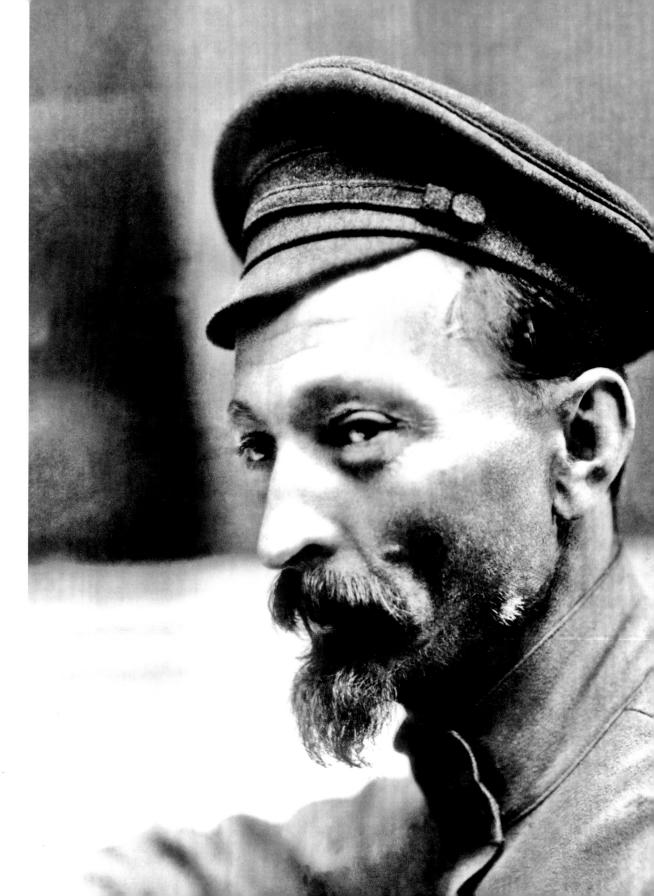

The Secret Policeman

American journalist Louise Bryant described Lenin's secret police (Cheka) chief Felix Dzerzhinsky (shown here in the 1920s) as "shy, aloof, and deeply puritanical. One feels he can neither understand nor forgive moral weaknesses in others, since he himself possesses that fanatical devotion. . . . He asks nothing of life but to serve the cause of Socialism." Dzerzhinsky ruthlessly pursued and disposed of anyone considered a threat to the Communist regime and instigated the brutal Red Terror following the attempt on Lenin's life. He died of a heart attack in 1926.

In Exile
In 1917, Nicholas and his family were moved from confinement in their palace at Tsarskoe Selo to the town of Tobolsk, in Western Siberia. A lover of exercise, Nicholas spent as much time as possible outdoors. Here, he and a kitchen aide saw firewood. The end was little more than a year away.

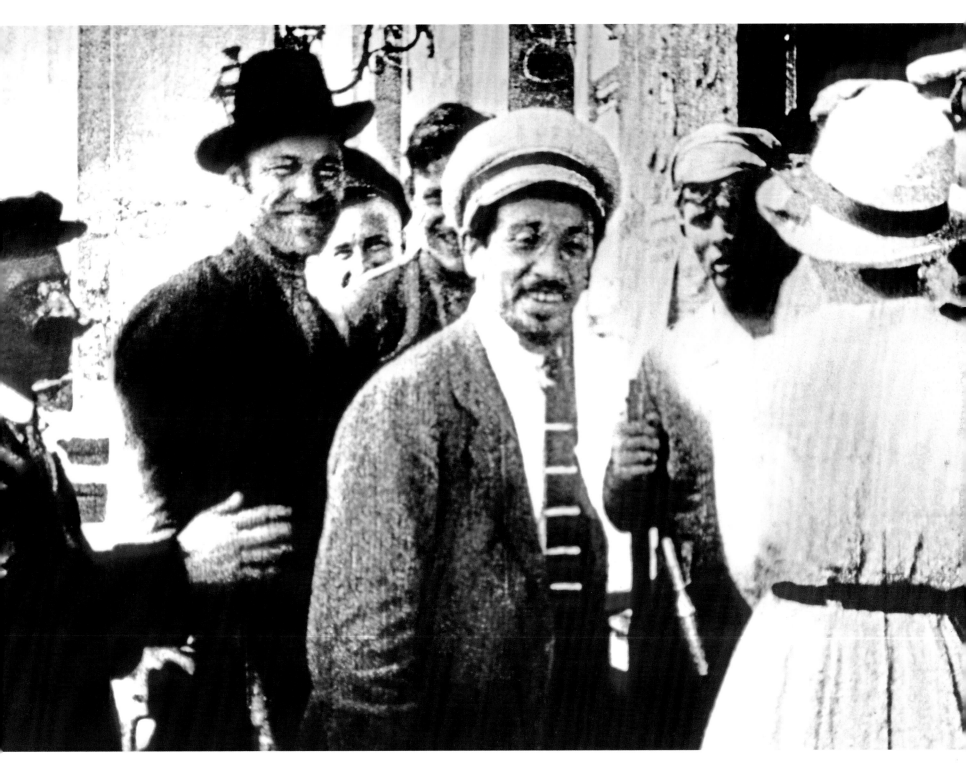

Bolshevik Organizer
Yakov Sverdlov smiles into the camera, circa 1917. A close friend of
Lenin's (it was said that Lenin provided the theories—Sverdlov made
sure they worked), and chairman of the Bolshevik Central Executive
Committee, Sverdlov gave the order to murder Nicholas II and his
family in 1918. He died at age thirty-four during the great influenza
pandemic of 1919.

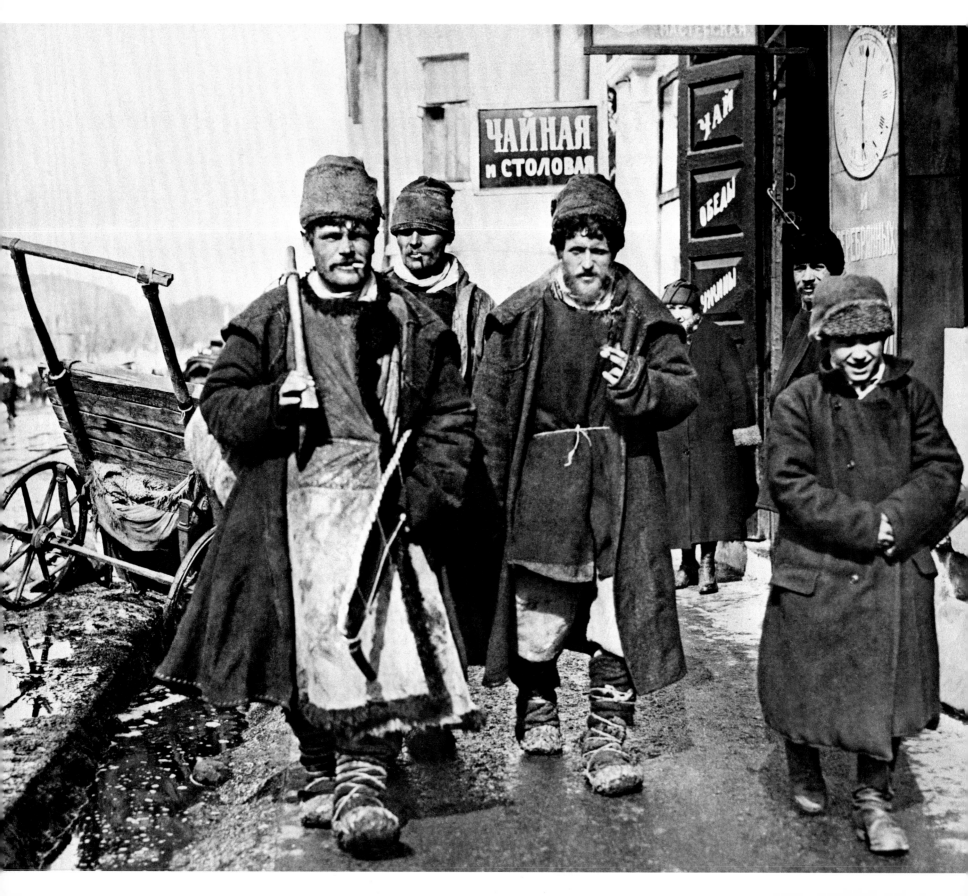

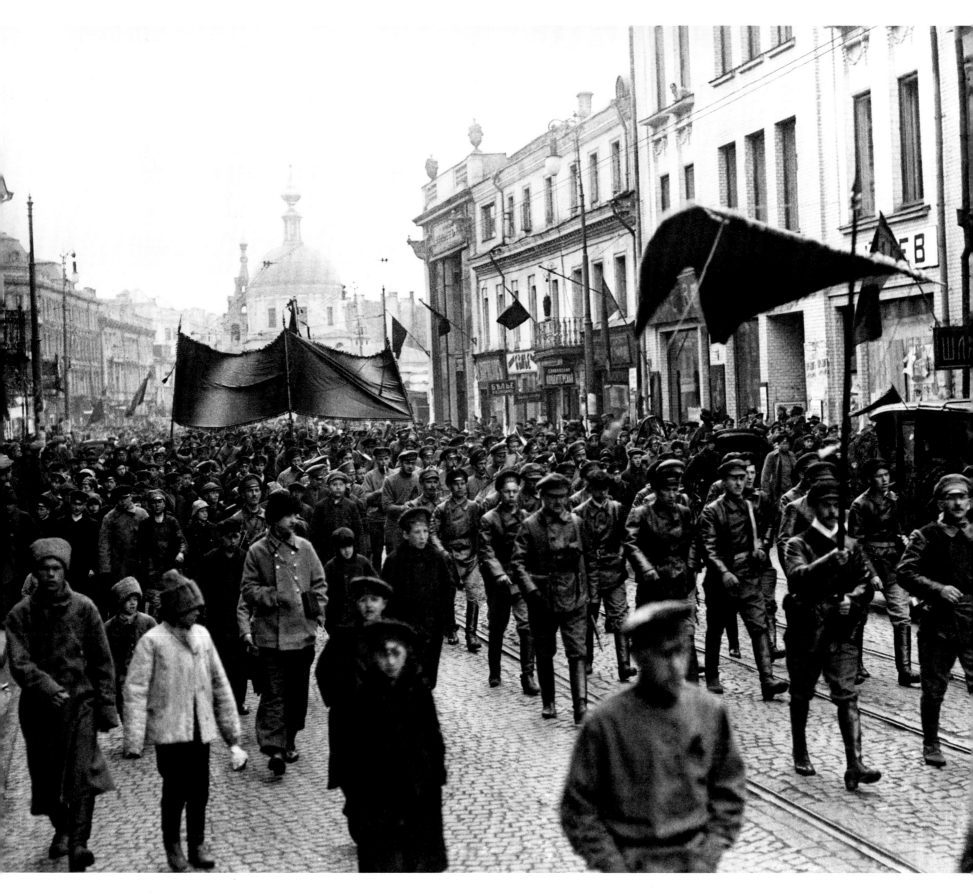

PAGE 68
Coming to the City

Carpenters from the countryside walk down a Moscow street in 1920. With the country devastated by civil war and famine, many people migrated to the cities looking for work.

PAGE 69
May Day

A traditional holiday honoring workers and celebrating the coming of spring, the first of May soon became an opportunity for the Soviet Union to demonstrate its military power with a massive parade through Red Square. Pictured here, a 1918 May Day parade along Moscow's Sretenka Street.

RIGHT, TOP
The First Tractors in Torzhok

Townspeople with the latest 1920s farming technology pose before a "State Warehouse Consumer Goods" sign in Torzhok, a town in the upper Volga region between Moscow and Petrograd. Such delight was often short-lived, as early tractors in the Soviet Union were prone to breakdowns, and trained mechanics were rare.

RIGHT, BOTTOM
Soup Kitchen

Poor workers line up for food in 1920s Moscow.

OPPOSITE
Peasants Examine a "Lenin Lightbulb"

"Communism is Soviet power plus the electrification of the entire country," wrote Lenin. He saw electricity as the key to modernizing Russia and raising the country's standard of living. Villages in remote areas might not have running water or toilets, but after the Communists took control, there was a good chance they had electricity. 1920s.

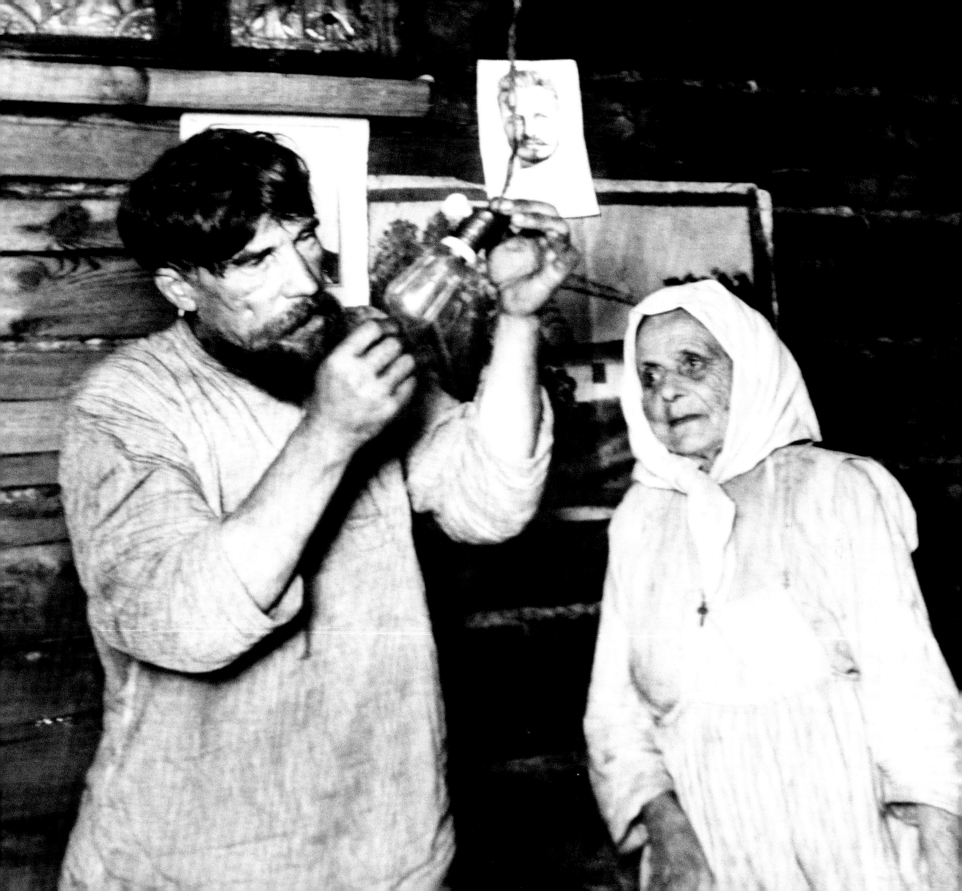

The Impresario and the Composer

Sergei Diaghilev (left) toured his Ballets Russes throughout Europe in the first and second decades of the twentieth century, collaborating with Russian dancers such as Nijinsky and Pavlova, choreographers such as Fokine and Balanchine, artists such as Bakst and Benois, and composers such as Prokofiev and Igor Stravinsky (right). The Ballets Russes premiered Stravinsky's great ballets *The Firebird, Petrushka,* and *The Rite of Spring.* Circa 1920.

Doomed Lovers

American dancer Isadora Duncan and Russian poet Sergei Yesenin's volatile marriage lasted a year, from 1922 to 1923. It was marked by drunken arguments, restaurant brawls, and destroyed hotel rooms. Yesenin hanged himself in 1925, leaving behind a verse written in his own blood: "In this life it is not new to die / but neither is it new to be alive." Duncan died in 1927, strangled when her long scarf became entangled in the rear wheel of her open car. Circa 1922.

"No Foreign Sky Protected Me"

In 1922, when this photo was taken, Anna Akhmatova was an acclaimed writer of five books of poetry. Yet her life was descending into a pattern of deprivation and loss that would distinguish her as a supreme example of an artist facing the terrors of the Soviet century. Her husband had already been executed for alleged antigovernment activities, her son would be exiled to Siberia; many of the people closest to her would be imprisoned or killed, and she was about to suffer a ban of her poetry that would last, on and off, for three decades, forcing her to survive by translating works of others, while she and her poetry were forgotten. Yet she never attempted to leave her homeland, preferring to remain and endure. In her poem "Requiem" she wrote, "No foreign sky protected me, / no stranger's wing shielded my face. / I stand as witness to the common lot / survivor of that time, that place."

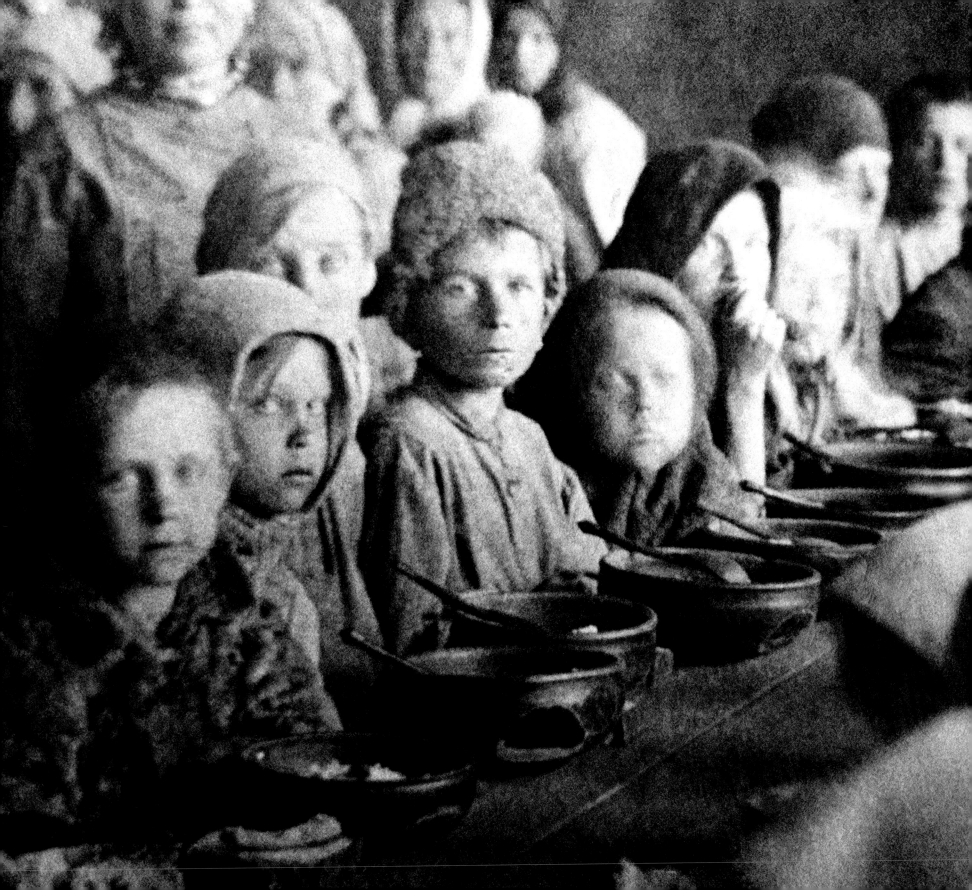

The Famine

The famine of the early 1920s was the worst in Russian history.
In the town of Pokrovsk in the Volga region southeast of Moscow,
hungry children in a public canteen warily look up from their bowls.

The Famine

These children were not so lucky. Their bodies show the distended bellies and wasted limbs of starvation.

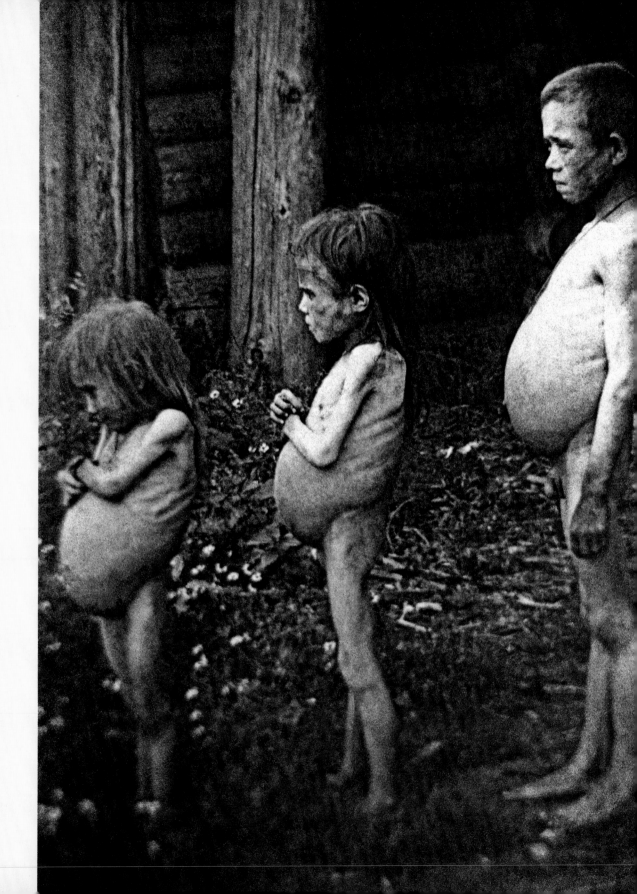

Troops Going to the Front

A grand send-off for Bolshevik troops on their way to fight in the civil war. The signs read (left to right), "Proletarians Unite! Long Live the Communist International"; "Death to [White Army general] Baron Wrangel!"; "All barons and generals must die!"; and "The Crimea must be captured no matter what!" Circa 1920.

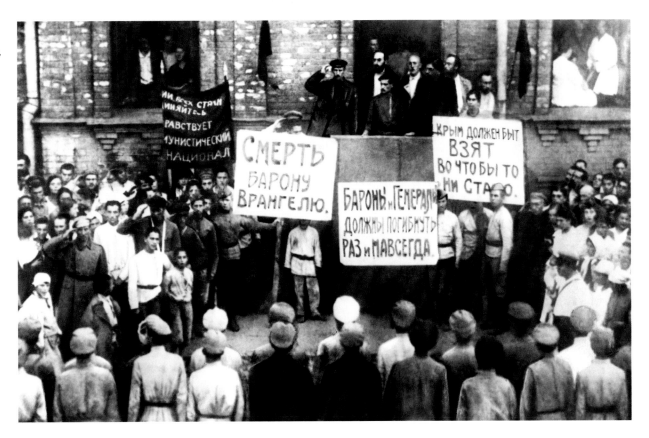

Chinese Troops

Chinese troops fighting with the Bolsheviks in the civil war pose before going to the front in 1918. The banner reads, "Long Live the Russian Communist Bolshevik Party."

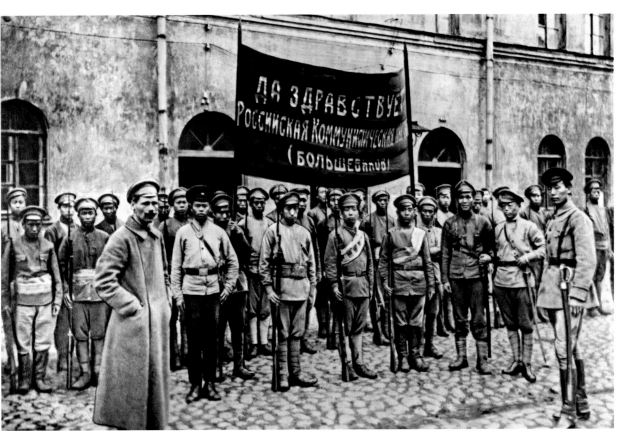

Commander in Chief

Before becoming commander in chief of the southern White Army during the civil war, General Anton Denikin witnessed the breakdown of the Russian army in World War I. "Not even in the darkest days of the Tsar did the secret police employ upon those whom they regarded as most criminal such tortures, such jeers, as are now inflicted upon faithful officers by the fury of drunken soldiers and revolutionary mobs."

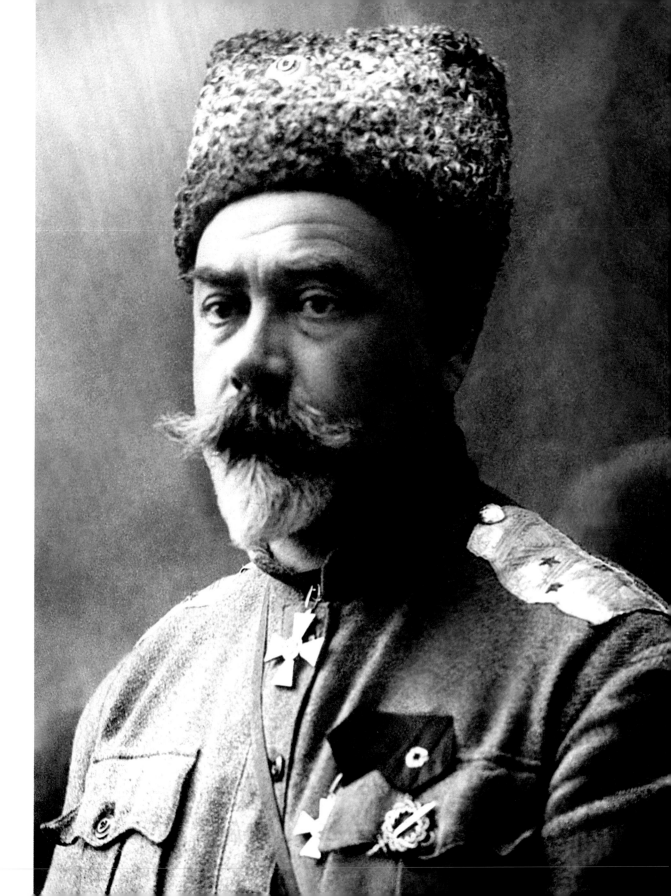

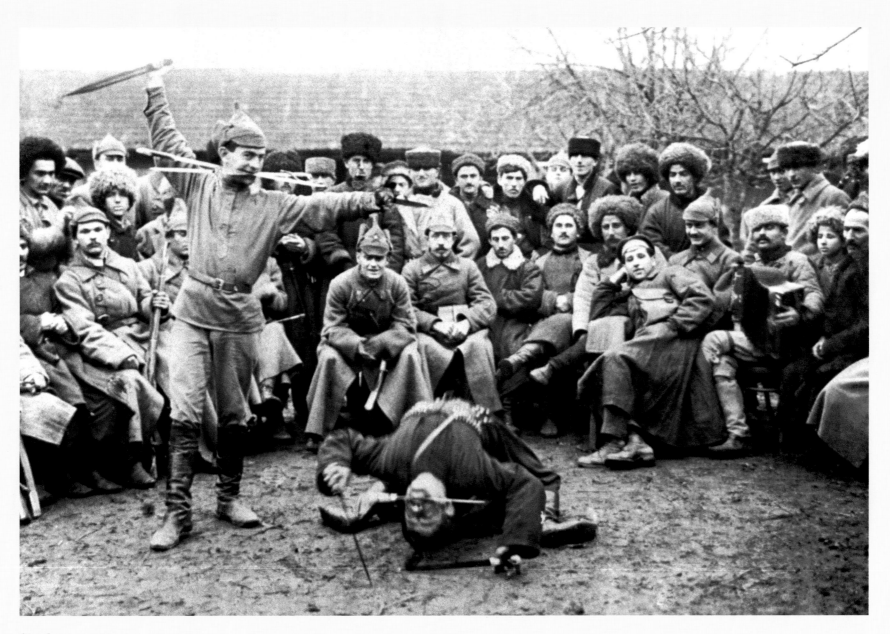

Chechnya

The Chechen Autonomous Region became part of the Soviet
Union in 1922. Celebrants with daggers in their mouths cavort
before delegates in the town of Urus-Martan in 1923.

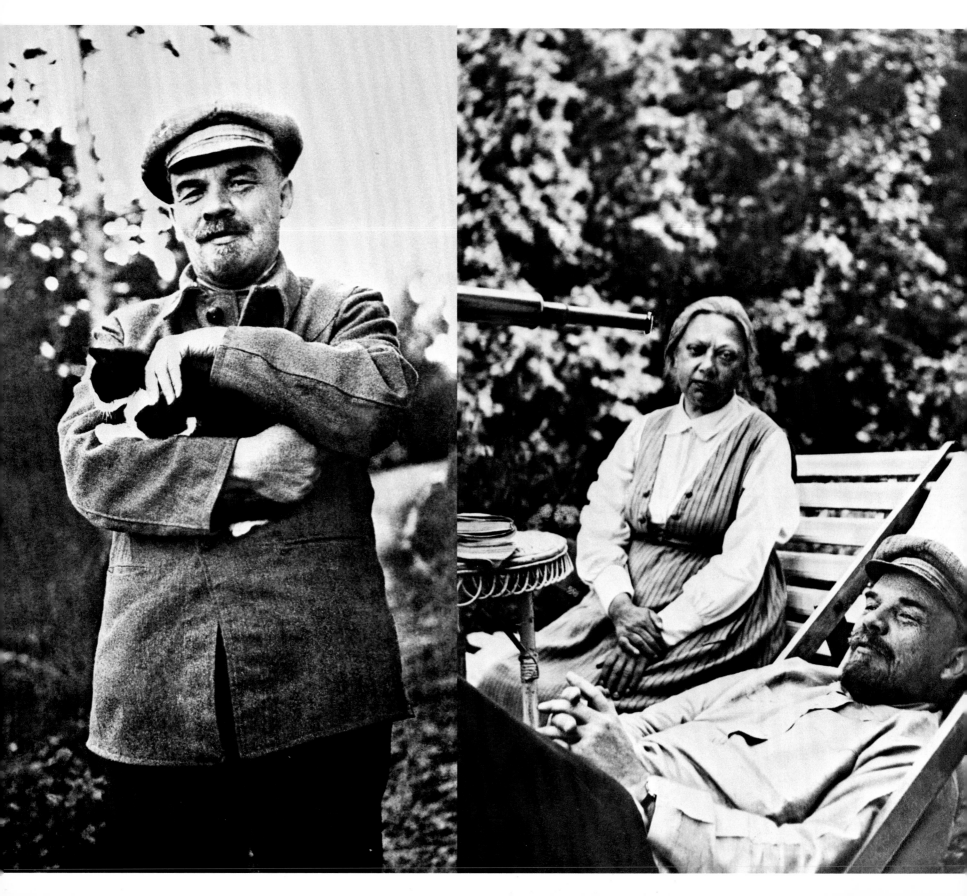

OPPOSITE, LEFT
On Borrowed Time
After his first stroke, in May 1922, Lenin recuperated in the village of Gorky, some twenty miles south of Moscow. Declaring "This is the first bell," he acknowledged he was living on borrowed time.

OPPOSITE, RIGHT
In the Country
Lenin dozes peacefully in the town of Gorky in late August 1922, under the gaze of his wife, Nadezhda Krupskaya. He had suffered a mild stroke just months earlier. The photo was taken by Lenin's sister, Maria. She failed to notice that the telescope to the left looks like a gun pointed at Krupskaya's head. Later publications of the photo edited the telescope out of the picture.

RIGHT
Last Days
Paralyzed and mute, Lenin looks out feebly from his wheelchair in Gorky in 1923. This is one of the last images of him alive—he died in January 1924. The fruits of his revolution, the Communist Party and Soviet state, were slipping from his grasp, soon to be taken over by the man he was too ill to stop: Stalin.

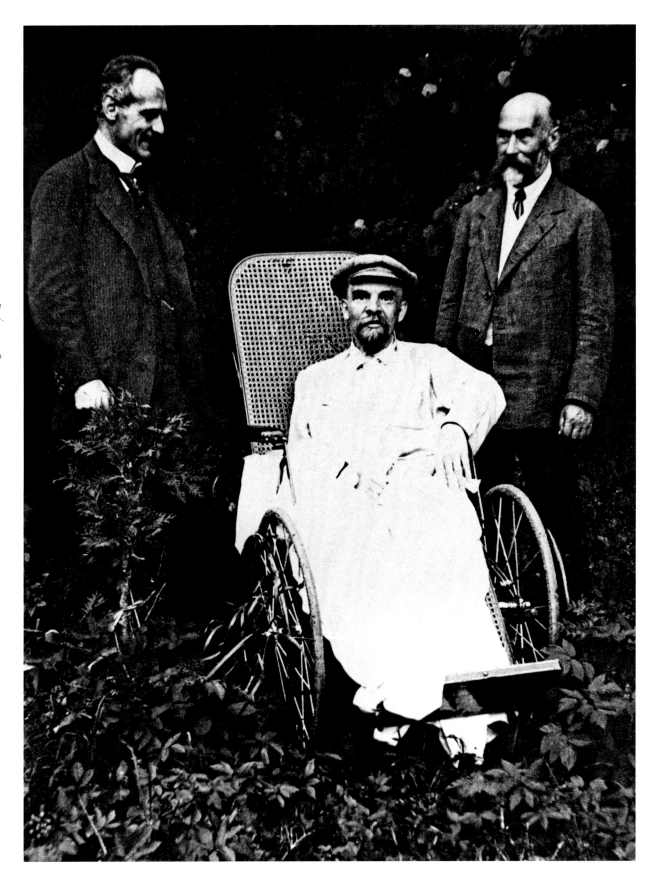

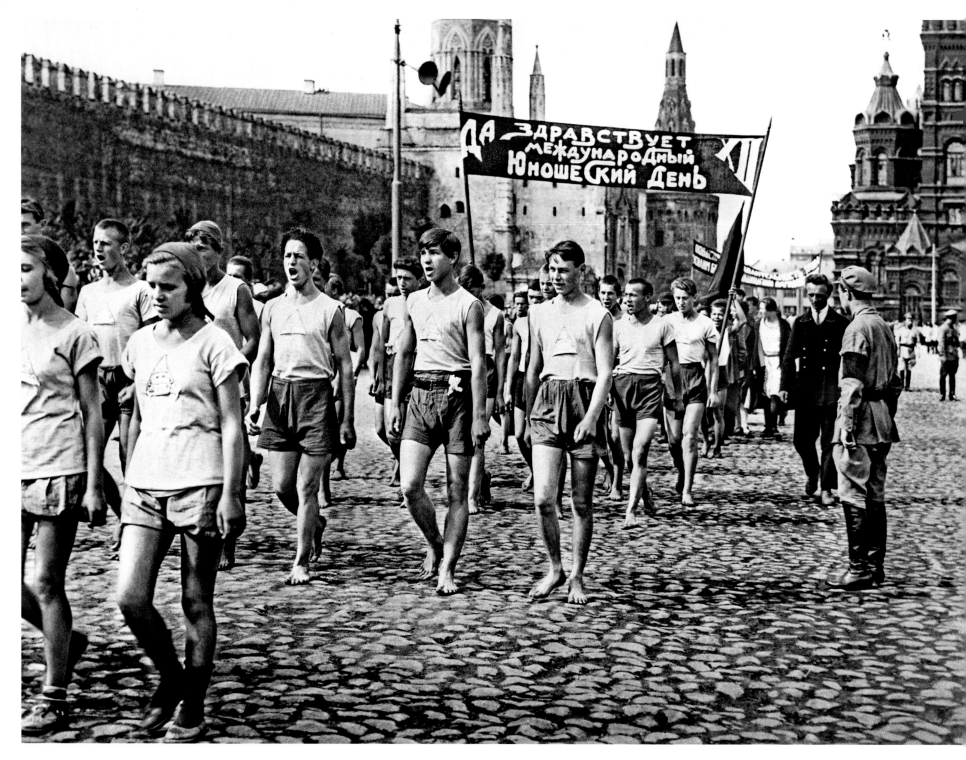

Communist Youth
Young Soviet athletes parade barefoot through Red Square in 1926.
The banner reads, "Long live the International Day of Youth."

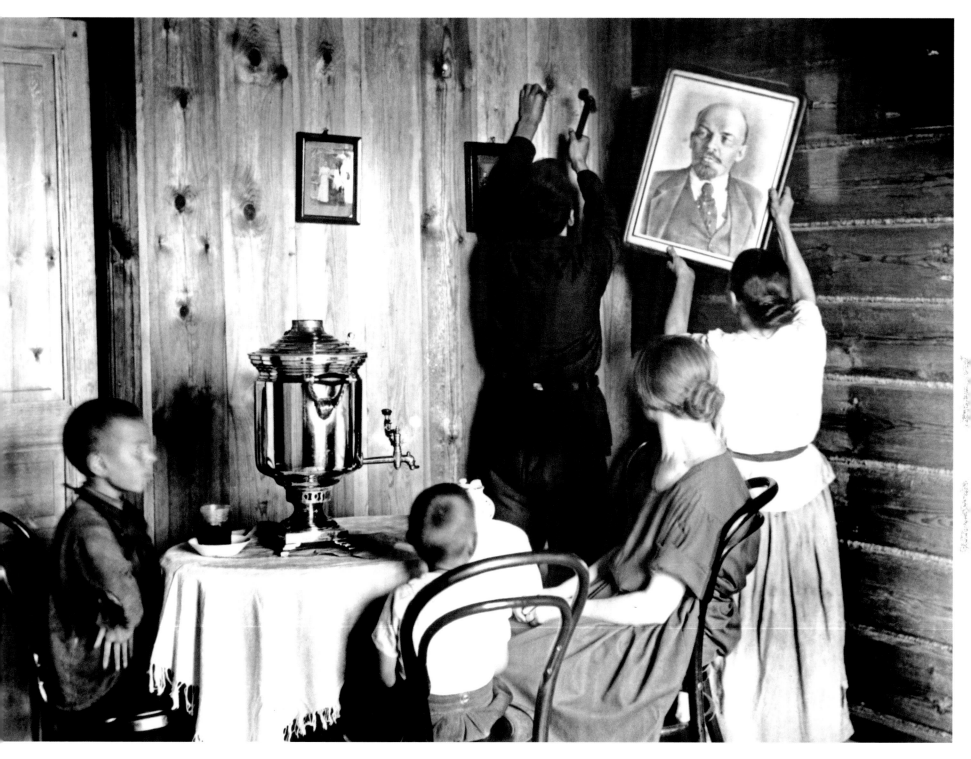

A New Home
A worker's family settles into a new flat in Moscow in 1927. Two familiar objects dominate the photo: the samovar in the middle of the table and the obligatory portrait of Lenin, about to assume its place of honor on the wall.

1905 – 19
– 1941 – 1
1964 – 19
– 2005

17 - 1927
953 -
84 - 1991

THE SOVIET IMAGE

1905

1917

1927 –

1941

1953

1964

1984

1991

2005

THE MAN OF

STEEL

TAKING CHARGE

By 1927, Josef Stalin was the undisputed leader of the Soviet Union.

His rival, Leon Trotsky, was a charismatic orator and accomplished writer and had been a hero of the Revolution. Stalin, on the other hand, had done most of his work behind the scenes. (American journalist John Reed's eyewitness account, *Ten Days That Shook the World,* mentions Stalin only twice, both times in passing. Later, for that very reason, Reed's book would be banned in Stalin's Soviet Union.) Nicknamed "Comrade Index Card," Stalin was a consummate manipulator and manager. He had seized an early advantage by organizing Lenin's funeral (ill and out of the country, Trotsky did not attend) and establishing himself as the sole custodian of Lenin's legacy. To combat Trotsky's popularity within the Communist Party, Stalin then organized a recruiting drive, which nearly doubled the party's membership, to one million. This effort further eroded Trotsky's power, as the new members were loyal to Stalin. Finally, in mid-1927, Stalin accused Trotsky and his followers of the crime of attempting to split the party and create their own political entity. He banished Trotsky into internal exile and finally deported him in 1929.

Now the Man of Steel was in charge. And he knew what he wanted. He would make the Soviet Union into a modern, self-sufficient state by instituting a massive, rushed, no-holds-barred program of industrialization. And he would transform agriculture, always a vexing problem, into a system able to feed the increase in factory workers required by industrialization. That meant relocating peasants onto collective farms. He didn't care about how he reached these goals, their difficulty or cost—he only knew they must be accomplished if the Soviet Union were to survive.

THE SECOND AMERICA

With the goal of emulating the rapid industrial growth of the United States and transforming his backward country into a "Second America," Stalin initiated a series of Five-Year Plans, the first of which began in 1928. Stalin's goals were ludicrously unattainable. Nationalizing all industry and services, he called for a 250 percent increase in overall industrial development and a 330 percent expansion in heavy industry alone. Central planners provided output quotas to on-site plant managers, who were obligated to fulfill them, no matter what. Often they simply couldn't and so fabricated acceptable results, which, to avoid Stalin's displeasure, their higher-ups passed on as accurate. These unrealistic demands instigated a vicious circle of deception and fear.

Thousands of massive factory towns were established throughout the country, utilizing foreign expertise and equipment (the majority from the United States and Germany) and Soviet peasantry—more than fifteen million peasants were relocated to work in these plants (with one guaranteed meal per day). Because they were suddenly thrust into jobs for which they had no training or aptitude, serious injury and death were commonplace. The workweek was divested of names, with days simply numbered one through five. With this emphasis on heavy industry, consumer goods suffered. As had become all too usual, Soviet people had to cope with daily shortages.

The effort to industrialize was accompanied by mammoth public-works projects—dams, railways, canals, irrigation systems—likewise built with foreign expertise and Soviet labor. The 141-mile White Sea–Baltic Sea Canal was built entirely by hand, dug through solid rock by convicts and enslaved peasants using hammers and chisels. The hard labor was officially trumpeted to "reforge" these "enemies of the people" into good Soviet citizens. As many as one hundred thousand of them died in the process. But the hard-won canal proved useless—too shallow for the naval vessels for which it had been built.

A more successful project was the far-flung and speedy Moscow subway system. Widely regarded as a marvel of engineering and a work of art for the ornate beauty of its stations, it was begun in the 1930s and expanded for decades afterward. Stalin's colleague Lazar Kaganovich (who was fond of saying that a factory should quake when the director walks through it)

oversaw the project, along with his protégé, an ambitious Ukrainian politician named Nikita Khrushchev.

"DIZZY WITH SUCCESS"

Stalin's agricultural strategy of moving Russia's peasant farmers into huge collective farms in the hope of increasing yield and efficiency was to prove one of the most devastating events in Soviet history.

Although the party glorified the working class, it had no fondness for the peasantry. They were considered backward and reactionary, as much a part of the old Russia, which needed to be remade, as the aristocracy. Lenin viewed them with contempt. In particular, he hated the group known as *kulaks* (the word means "fist"), peasants who were slightly better off and so could hire help, even if just a family member. Much of the grain produced in the Soviet Union came from kulak farms—the country badly needed them. However, to Lenin (and therefore the party), kulaks were seen as evil personified: vectors of venereal disease, bloodsuckers, enemies of the state.

Lenin had made clear his feelings for the kulaks in a letter to the Penza region, south of Moscow, setting a tone that Stalin would carry forward with a vengeance.

Comrades! The revolt by the [kulaks] must be suppressed without mercy. . . . We need to set an example.

1) You need to hang (hang without fail, so that the public sees) at least 100 notorious kulaks . . .
2) Publish their names.
3) Take away all of their grain.
4) Execute the hostages—in accordance with yesterday's telegram.

This needs to be accomplished in such a way, that people for hundreds of miles around will see, tremble, know and scream out: let's choke and strangle those bloodsucking kulaks.

Telegraph us acknowledging receipt and execution of this.

Yours, Lenin

P.S. Use your toughest people for this.

Stalin's collectivization efforts started in 1930 with the "liquidation of the kulaks as a class." Forbidden to join collective farms, their belongings were confiscated, and reduced to bitter poverty, they were sent off to forced labor camps—the Gulags—packed into railway cattle cars so tightly that children were crushed to death. Many starved, as food consisted of scraps of salted fish flung through the windows. The Gulags awaiting them were often no more than depressions dug into the frozen ground. Kulaks doing hard labor received a pint of soup and five ounces of bread a day in areas of Siberia so cold that entire camps died, including the much-better-fed, -housed, and -clothed guards and their dogs. (At a camp called Oymyakon, in the Siberian Arctic, temperatures fell to minus 97.8 degrees Fahrenheit.)

For the rest of the peasants, collectivization meant being transformed into an agricultural proletariat, the workers in the field modeled after workers in the factory. After enjoying seventy years of relative freedom since Tsar Alexander II liberated them in 1861, they were now herded back to serfdom. The Communists destroyed whole villages and issued the peasants internal passports that tied them to the collectives. Everything they owned—livestock, grain surplus, seeds, foodstuffs, even ears of corn—was confiscated by the state. Stealing a single ear of corn was now punishable by ten years of hard labor or quick death, gunned down by party members overseeing the fields from watchtowers.

In protest, peasants slaughtered their own livestock and gorged themselves on the meat. By 1933 the numbers of sheep, goats, horses, and cattle in the country had been reduced by as much as two-thirds. The result was unprecedented famine. Cannibalism became rampant. The peasants were left simply to starve into submission.

THE SOVIET IMAGE

1905

1917

1927 -

1941

1953

1964

1984

1991

2005

THE MAN OF

STEEL

Stalin's collectivization ensured that the world's largest country would not be able to feed itself for decades to come. Per-acre grain production in the Soviet Union didn't climb back up to pre-Revolution levels until the mid-1960s. The death toll probably came to fourteen million peasants, including some four million children. Because cremation was forbidden by the Orthodox Church, corpses lined the roads, stacked like wood.

Stalin's response was to undertake an extensive propaganda campaign praising his accomplishments. Reports of the number of deaths were covered up, and, in the kind of dark irony at which Stalin excelled, he arrested the census board for "treasonably exerting themselves to diminish the population of the USSR." Even to refer to the famine was a crime, with sentences ranging from three years in the Gulag to death. In 1930 the official Soviet newspaper, *Pravda,* published an essay by Stalin entitled "Dizzy with Success," announcing that the "very great" success of collectivization was because of its voluntary participation. "Collective farms cannot be set up by force. To do so would be stupid and reactionary. The collective farm movement must rely on the active support of the great bulk of the peasantry."

"LET'S DIE WITH DIGNITY"

In 1930, Stalin formed the Main Directorate for Corrective Labor Camps (in Russian, **Glavnoe Upravlenie Lagerei**)—the Gulag. A network of forced labor camps had existed since 1919, but now it was greatly enlarged, with camps in Siberia and other far northern regions. The flood of prisoners, called "white coal" by their guards, soon reached into the millions. (Under the tsars, the largest number of prisoners ever recorded was 189,949 in 1912. By 1938, thirty to forty times more convicts inhabited the Gulag.) They included murderers, thieves, and other common criminals—but the Gulag became famous for "rehabilitating" political and religious dissenters.

Stalin put these "enemies of the people" to work. Gulag convicts constructed canals, railroad lines,

hydroelectric stations, roads, and industrial facilities. They felled lumber and mined coal, copper, and gold. And Stalin (who himself had experienced life inside tsarist prisons) knew how to treat his "guests." Torture was the modus operandi. "Beat, beat, and beat again" was Stalin's advice to interrogators, and the Gulag guards energetically followed suit. "They use rubber truncheons, and they use wooden mallets and small sandbags. It is very, very painful when they hit a bone—for example, an interrogator's jackboot on the shin, where the bone lies just beneath the skin," wrote Gulag survivor and Nobel Prize winner Alexander Solzhenitsyn. "As everyone knows, a blow of the fist in the solar plexus, catching the victim in the middle of a breath, leaves no mark whatever. The Lefortovo Colonel Sidorov, in the postwar period, used to take a 'penalty kick' with his overshoes at the dangling genitals of male prisoners. Soccer players who at one time or another have been hit in the groin by a ball know what that kind of blow is like. There is no pain comparable to it, and ordinarily the recipient loses consciousness."

In 1934, fearing a conspiracy to remove him from power, Stalin began his Great Purge. First to go was Sergei Kirov, an old Bolshevik and the party chief in Leningrad, shot to death at party headquarters. It is widely thought that, wary of Kirov's popularity, Stalin himself ordered the assassination and then used it as a pretext to purge the party, and the country, of any opposition. (Characteristically, he then spread Kirov's name everywhere. Two cities, parks, roads, towns, and even a major ballet company soon bore his name.)

The purges quickly gathered momentum and swept through all levels of the party, government, army, and society. Anyone who at any time had opposed Stalin or his policies might be arrested, executed, sent to a Gulag, or ousted from the party and his position. Interrogators extracted confessions admitting to any number of offenses, no matter how implausible—plotting against the leadership, maintaining relations with Trotsky, committing treason for Germany or Japan, sabotaging industry and agriculture. An atmosphere of fear, mistrust, and suspicion reigned.

No one was safe, even—or especially—the highest-ranking party members. Lev Kamenev and

Gregory Zinoviev, two of the most famous, senior, and important Bolsheviks, were denounced and arrested. In 1936 they were brought to trial in the first of the infamous Moscow Show Trials. Accused of sabotage and state treachery (based on a fabricated charge of conspiring to bring down the Communist government and replace it with a capitalist administration), Kamenev and Zinoviev were found guilty and executed. The international conspiracy was supposedly backed by Germany and led by Trotsky in exile.

Kamenev's and Zinoviev's executions signified a marked change in the Soviet Union: no one was safe.

The purges continued with the show trials of four other leading Bolsheviks: Karl Radek and Georgy Pyatakov in 1937 and Nikolai Bukharin and Alexei Rykov in 1938. Rykov was a founding member of the Bolshevik Party and had even succeeded Lenin as president of the USSR. All were found guilty of treason and executed, except for Radek, who is thought to have died in prison.

Bukharin had joined the Bolshevik Party in 1906. He and Stalin were friends and would even wrestle playfully, but they had a falling-out when Bukharin opposed collectivization of the peasantry, which he called "a mass annihilation of completely defenseless men, together with their wives and children." When Stalin labeled Bukharin "a half-educated theoretician" with "hypertrophied pretentiousness," Bukharin publicly recanted. But to no avail. When he received his death sentence, Bukharin wrote Stalin the last of forty-three unanswered letters, beginning, "Koba, why do you need my life?" Stalin was unmoved. But he kept Bukharin's letter in his desk drawer for the rest of his life.

Stalin also purged the Red Army, beginning in 1937 with Mikhail Tukhachevsky, field marshal of the Red Army and hero of the civil war. Though never brought to trial, probably because he could not be made to "confess" (his interrogation reports are stained with blood), he was convicted of leading a "military-Trotskyist conspiracy" and committing espionage for Nazi Germany, and shot along with eight other high-ranking officers. Tukhachevsky's wife and brothers were executed, his three sisters sent to the Gulag, and his young daughter placed in a correctional home until her seventeenth birthday, when she too was sent to the Gulag.

In all, 13 out of 15 army commanders, 57 of 85 corps commanders, 110 of 195 divisional commanders, and 220 of 406 brigade commanders were executed. The Red Army's junior officer staff, from the rank of colonel on down, was also decimated. They would be sorely missed. In just a few years, led by officers with little if any combat experience, the Red Army would prove defenseless in the face of the Nazi war machine in the early days of the Great Patriotic War (as the Soviet Union referred to World War II).

"NOW THEY WILL COME FOR ME"

Artists fared no better. The great Soviet writer Maxim Gorky died in 1936 under circumstances still unexplained. A passionate leftist, he had been imprisoned during the uprisings of 1905, later met Lenin, and proved to be a steadfast supporter of the Revolution. After the civil war, however, he became disillusioned with the Bolsheviks and left Russia, stating that Lenin and Trotsky were "poisoned with the filthy venom of power." In 1928 he returned and, after being initially feted by Stalin, was placed under arrest. It is thought he was poisoned on Stalin's orders. (His funeral was held in Red Square, with French Nobel laureate André Gide giving his eulogy. Stalin himself was a pallbearer.)

In the early 1930s, the short-story writer Isaac Babel, avoiding publicity in the hope of escaping Stalin's attention, joked, "I have invented a new genre, that of silence." After Gorky's death, he had no more illusions, writing, "Now they will come for me." In 1939 he was arrested, tortured in Moscow's secret police headquarters (the Lubyanka) and shot in one of the basement cells. (Soviet officials informed Babel's widow that her husband died in 1941 in a Siberian Gulag.) Like Gorky, Babel had originally been a Bolshevik supporter; he had even worked for the secret police.

THE SOVIET IMAGE

1905

1917

1927 –

1941

1953

1964

1984

1991

2005

THE MAN OF

STEEL

Stalin's relationship with artists was complicated and bizarre. Mikhail Bulgakov, author of the novel *The Master and Margarita,* wrote a letter to him requesting permission to emigrate. He received a late-night personal phone call from Stalin himself, denying him. Yet Stalin went to see Bulgakov's play *The Days of the Turbins* fifteen times. Stalin removed *Dr. Zhivago* author and future Nobel laureate Boris Pasternak's name from the purge lists, saying, "Do not touch this cloud dweller." Others were not so lucky. After the poet Osip Mandelstam (called "camp dust" by Stalin) was arrested, Stalin, ever ready to terrorize, made a midnight call to Pasternak, asking why he hadn't interceded in Mandelstam's behalf. "If I were a poet and a friend of mine was in trouble, I'd do anything to help him," Stalin declared. "He's a genius, isn't he?" Mandelstam died in a Siberian Gulag a few months later.

The leading poet of the Revolution and early Soviet period, Vladimir Mayakovsky, escaped Stalin's purges—he committed suicide in 1930. Later in the decade, when the Soviet press attacked his work and reputation, his former lover Lilya Brik wrote to Stalin to complain. "Comrade Yezhov, please take charge of Brik's letter," Stalin wrote to a colleague. "Mayakovsky is still the best and the most talented poet of our Soviet epoch. Indifference to his cultural heritage is a crime. Brik's complaints are, in my opinion, justified." Of this Stalinist canonization, Boris Pasternak said, "It dealt him the second death."

All told, some 20 million of the USSR's population of approximately 170 million, almost one in eight people, lost their lives due to the Great Purge.

NO ONE LEFT

For Stalin's great rival, Leon Trotsky, living in exile in Mexico, the end came suddenly. On August 20, 1940, Ramón Mercader, a Spanish-born Soviet agent who had entered Mexico on a fabricated Canadian passport, split open his skull with an ice axe. Trotsky, the driving force behind the Revolution, hero of the civil war, and author of the myth of Red October, died the next day. He was sixty years old. (Mercader was captured and imprisoned in Mexico. When released, he made his way to Castro's Cuba and back to the Soviet Union, where he was awarded the Hero of the Soviet Union medal, one of only four non-Russians to receive the USSR's highest award.)

With Trotsky's murder, all opposition to Stalin was finally silenced. There was no one left to remember the pre-Revolution days, no one to remember the Revolution itself, no one to remember the young Georgian roughneck named Josef Dzhugashvili. The only voice left was now Stalin's. In his account of the past, Lenin was a hallowed saint, an omniscient wise man whose mantle had fallen, rightfully, on Stalin. Libraries were combed, and all works deemed "dangerous" or "subversive," especially the writings of Trotsky, Zinoviev, Kamenev, and Bukharin, were removed. Encyclopedias were edited and rewritten to conform to the official state line, photographs altered to remove people who had fallen from favor. The younger generation of Communists knew nothing else.

The country lived in terror. Late-night disappearances were so common that people kept packed suitcases by the door in anticipation of a midnight knock. As everyone was encouraged to denounce neighbors and friends, betrayal became an art form. Children denounced their parents; sisters, their brothers; husbands, their wives. A woman in Kiev known as Nikolaenko denounced some eight thousand people. Streets would empty when she set foot in them.

Stalin's own life fell apart. In 1932 his second wife, Nadezhda Alliluyeva, committed suicide by shooting herself after a public argument with Stalin at a dinner party. "Hey, you, have a drink!" he had shouted, flicking orange peels and cigarettes at her. Nadezhda, who was allergic to alcohol, screamed back, "Don't you dare talk to me like that!" and stormed out of the room. Later that night she shot herself (and rumors abounded that Stalin shot her himself).

After Alliluyeva's death, Stalin rarely saw their two children. Their son, Vasily, became a pilot and a general in the army, dying of alcoholism when he was forty-one years old. Their daughter, Svetlana, eventually defected to the United States. She would later describe her father as having "reached the point of

being pathological, of persecution mania." An older son by Stalin's first marriage, Yakov, would die in a German POW concentration camp during the Great Patriotic War, allegedly by running into an electrified fence. Stalin had refused to exchange a Soviet-held German general for him, explaining, "A lieutenant is not worth a general."

In 1937, Stalin's mother died. He had been beaten by both parents as a child. Years later, when he asked his mother about those beatings, she replied, "That's why you turned out so well." When she died, he refused to attend her funeral service.

WAR CLOUDS

The Great Purge slowed with the onset of Nazi aggression. Now Stalin had a new enemy. The USSR that faced the prospect of war was a much different country than the Russia of World War I. Misconceived, badly planned, harshly executed—and stained with the blood of millions—Stalin's brutal policies nonetheless had propelled the Soviet Union into the twentieth century: living standards, employment, and health care improved, and social conditions, especially for women, became more equitable. And, most striking in a country that had been largely illiterate, almost everyone born during Stalin's rule learned to read and write. Although Soviet life was punctuated by gnawing fear, deceit, and terror, the USSR was establishing itself in the world.

And now Adolf Hitler was drawing Stalin's focus west.

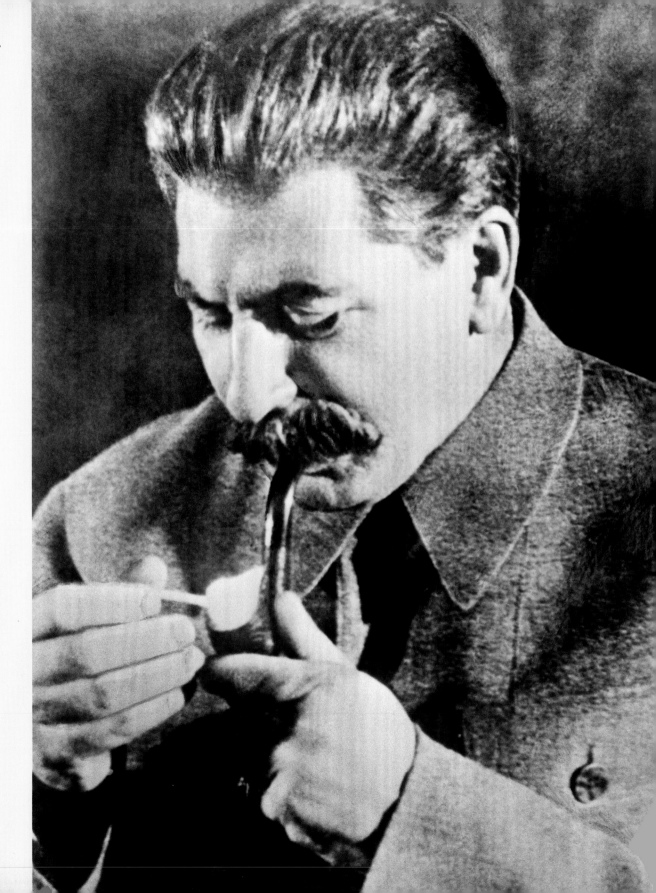

The Man of Steel
This—the ultimate propaganda image of the Great Leader, posed, composed, and airbrushed—presents a powerful and sensitive Stalin. Moscow, 1936.

Young Pioneers

Children march in a Young Pioneer column during a May Day demonstration in Moscow. The Communist Young Pioneer movement consisted of camps and activities for boys and girls, similar to the Scout movement in the United States. Moscow, 1927.

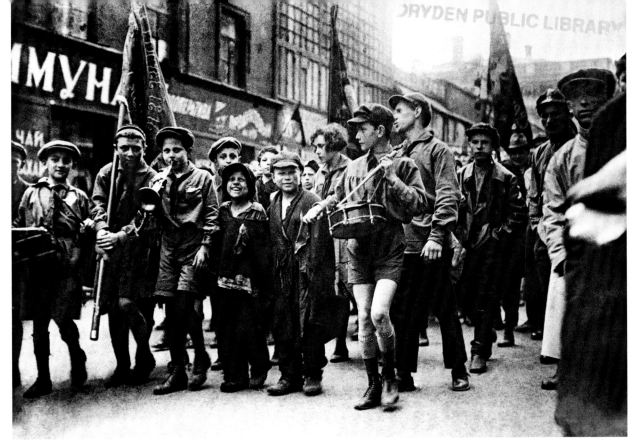

Anniversary

People of Orekhovo-Zuevo, an industrial city near Moscow, celebrate the twelfth anniversary of the Revolution, in 1929. Their banner reads, "By the growth of kolkhozes and sovkhozes [collective farms], let us fortify the union of the proletariat and the peasantry."

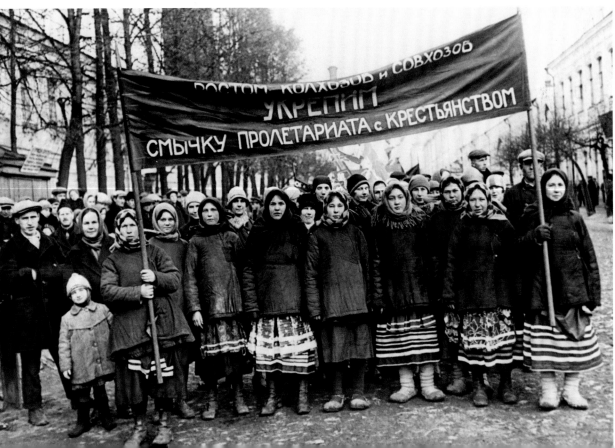

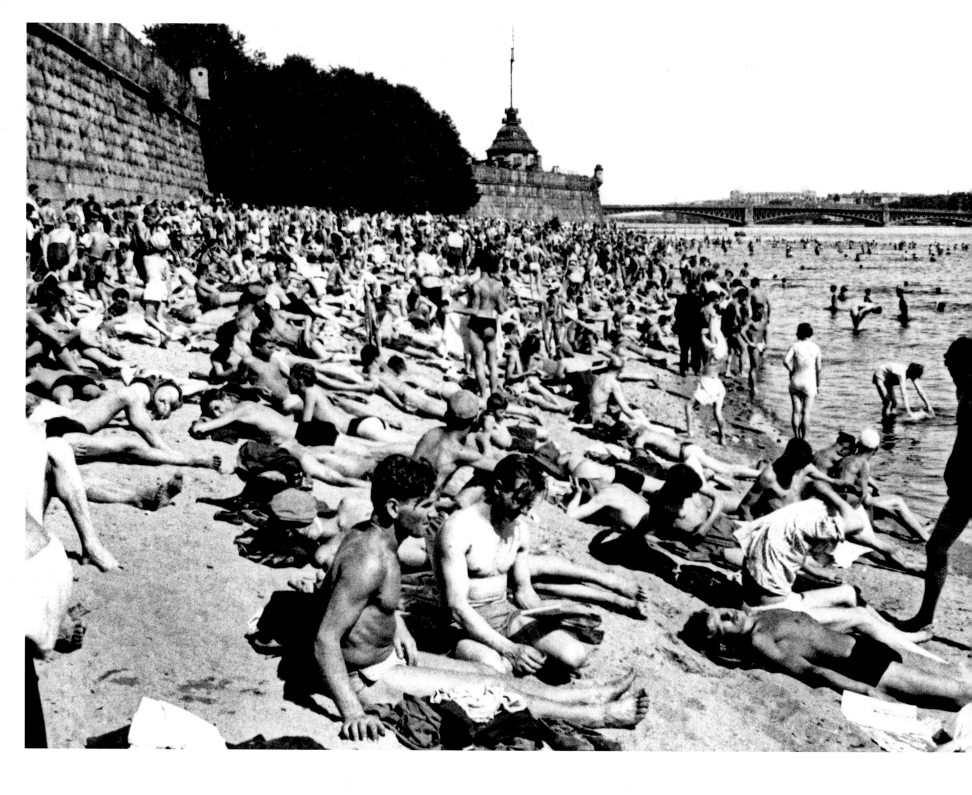

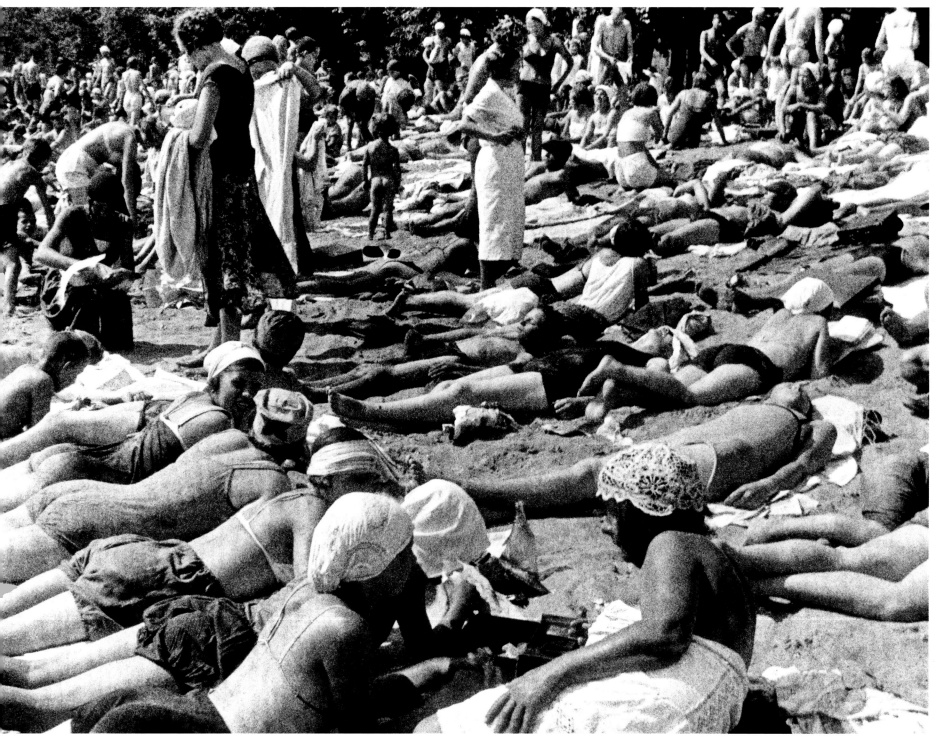

OPPOSITE AND ABOVE

Sunbathers
Leningraders hit the beach and take a dip in the Neva River
outside the Peter and Paul Fortress, still a favorite swimming
and sunbathing spot. Leningrad, 1920s.

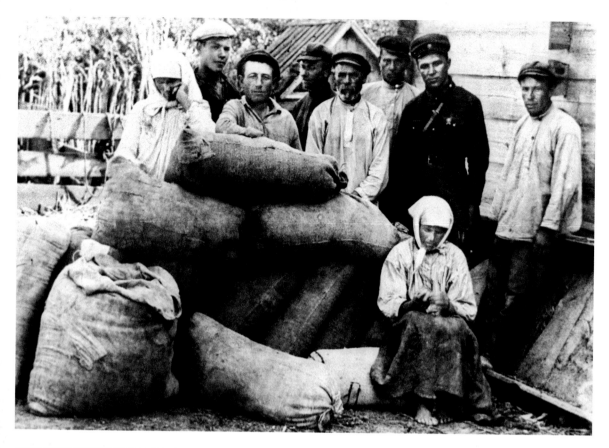

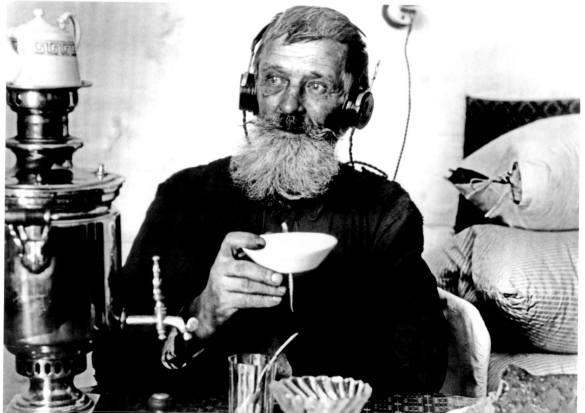

ABOVE, LEFT

Kulaks

Dispossessed kulak peasants huddle together in the village of Udachnoe in the Donetsk region of eastern Ukraine, circa 1930. Stalin's "liquidation of the kulaks as a class" in the 1930s was in its way as cruel and efficient as the Nazi Final Solution.

ABOVE, RIGHT

The Old Aristocracy

It wasn't easy being a former aristocrat in Stalin's Soviet Union. The glum expressions and tattered finery say it all. Moscow, 1932.

LEFT

Wired

Sipping tea from his samovar, a worker in the Siberian match factory Sibir listens to the radio. The photo implies that a good Soviet worker can enjoy modern pleasures, even in the depths of Siberia. Tomsk, southwestern Siberia, 1929.

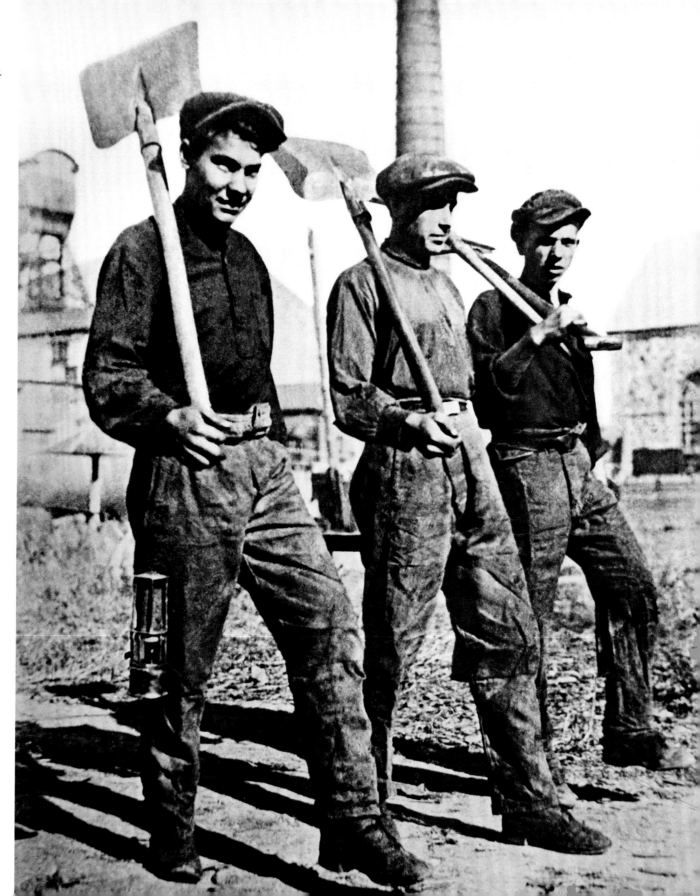

Young Communists
Komsomol members working at coal mines in the Donets Basin of eastern Ukraine in 1930. The Komsomol, the youth arm of the Communist Party, spanned ages fourteen to twenty-eight and was fed by the Young Pioneers. Komsomol members contributed hugely to the Soviet industrialization efforts of the late 1920s and 1930s.

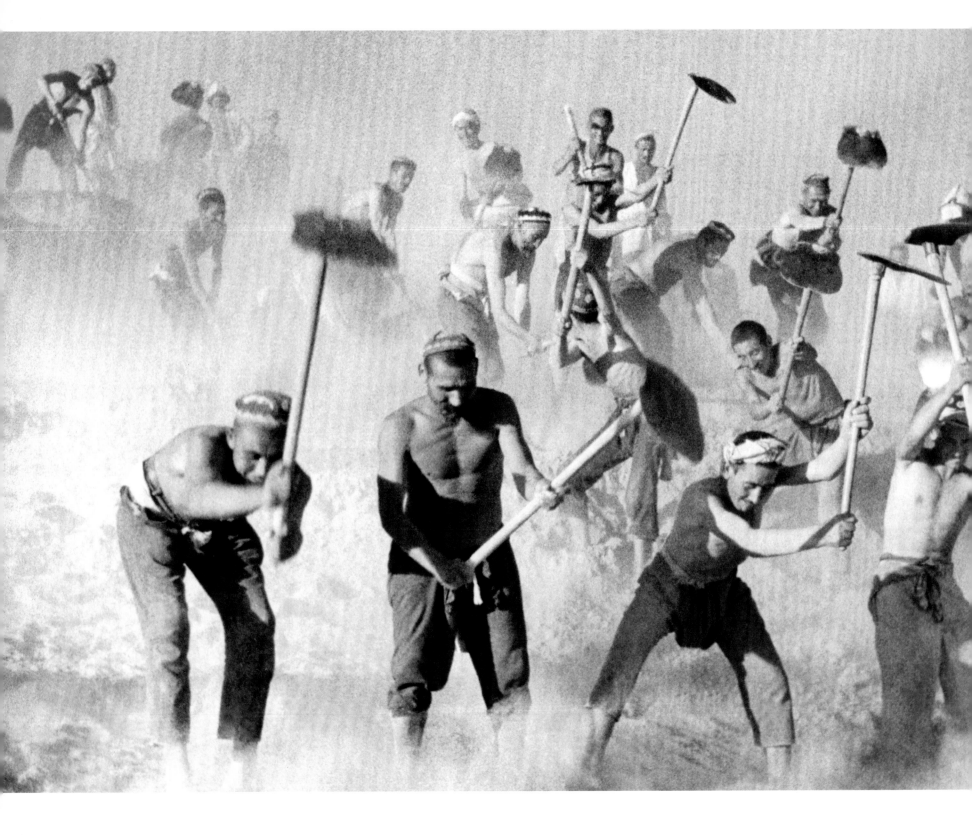

Pounding the Dust
Working in firm soil during the making of the Big Fergana Canal. Uzbek region, 1939.

КАМЕРА ШЛЮЗА. ПОСЛЕДНИЕ РАБОТЫ.

White Sea Canal
In 1932 the White Sea Canal neared completion with work on this, the last lock. Enslaved kulaks and convicts, enduring an astronomical death rate, hewed the canal by hand from stone and frozen ground.

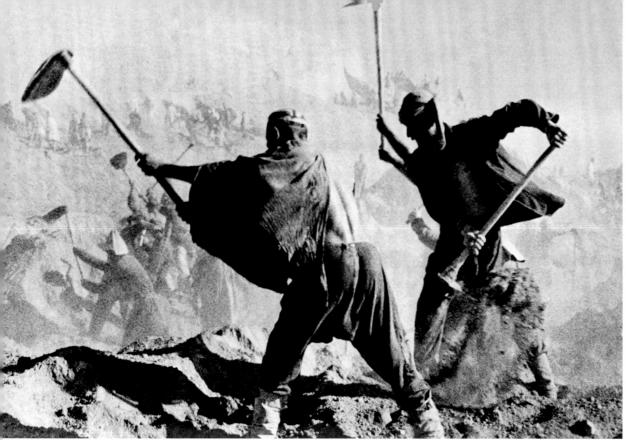

The Great Fergana Canal
A massive irrigation project designed to bring water to the high steppes in Central Asia, the Great Fergana Canal was built entirely by peasants armed with picks and shovels. The project took more than a decade to finish and was considered a great feat of Communist labor. 1930s.

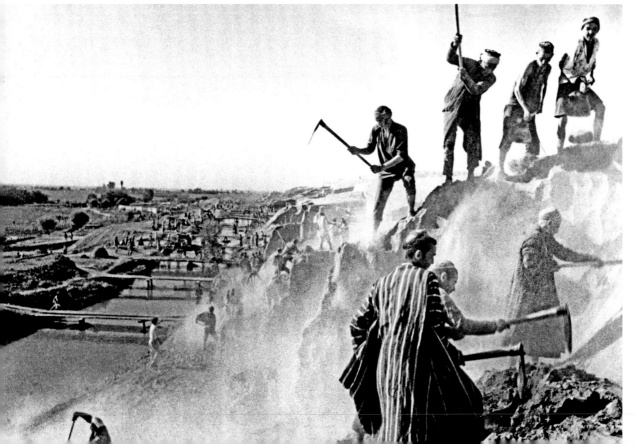

The Seventh Section
Laborers work at the seventh section of the Big Fergana Canal. Uzbek region, 1939.

Gymnasts on Parade
Female athletes march through Red Square. The Soviet government sponsored
physical fitness movements similar to the Nazis' "Strength through Joy."
Moscow, 1930s.

Tractors for the Homeland
Tractors roll off an assembly line in 1930. The tractors, part of
Stalin's first five-year plan, were based on American models.
Foreign experts set up the factories.

Seamstresses

Members of the sewing cooperative Udarnik pose for the camera in 1934.

Leisure Time

Leisure time in the newly literate Soviet Union in 1933. An "honored worker" named Nikiforova relaxes with a book.

FAR LEFT
The Master
Mikhail Bulgakov, author of *The Master and Margarita*, sits at the balcony of his flat in Moscow. 1935.

LEFT
The Cossack Writer
Mikhail Sholokhov prepares to go hunting in 1934, during the period when he was writing his famous work, *And Quiet Flows the Don*. It became the most read Russian novel in history and won Sholokhov the 1965 Nobel Prize. But some, including Alexander Solzhenitsyn, accused Sholokhov of plagiarism, contending that he stole the manuscript from the map case of a dead White Army officer during the civil war. The controversy has never been resolved.

The Literary Lion
Vladimir Mayakovsky, poet, painter, and playwright, on vacation in Yalta in 1926 with his mistress (and the wife of his publisher), Lilya Brik. At the time, Mayakovsky worked as a propagandist for the Soviet government. He soon grew disillusioned with the Communist Party and committed suicide in 1930. A suicide note was found in his pocket: "Love's boat has smashed against the daily grind."

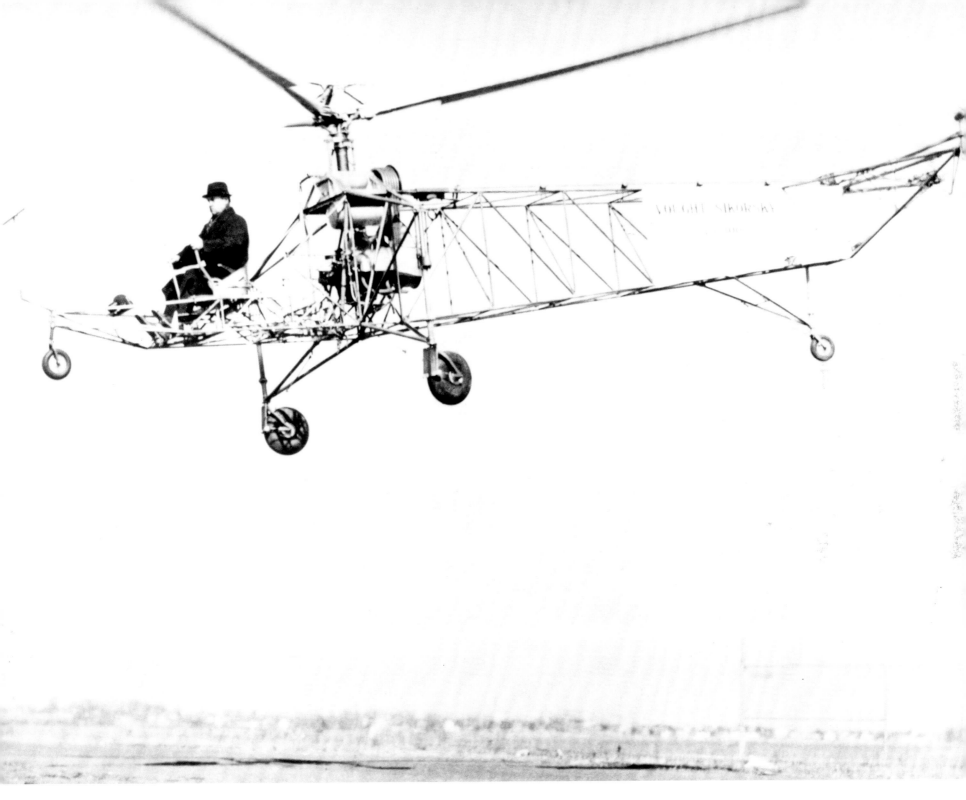

A Helicopter That Flies
Bundled up against the cold in topcoat and hat, Igor Sikorsky flies his VS-300, the world's first practical helicopter, in 1939. In 1941, the VS-300 stayed aloft for an hour and thirty-two minutes, a world endurance record. By then it had become the model for all modern single-rotor helicopters.

"Mankind Will Not Remain Tied to the Earth Forever!"

Such was the rallying cry of the great spaceflight pioneer Konstantin Tsiolkovsky. He developed rocket designs that are still influential today. Tsiolkovsky predicted how fast a rocket must go to escape Earth's gravity, multistage rockets, and liquid oxygen and liquid hydrogen fuel for propulsion. He also predicted spinning space stations, space suits, and even reclining seats for liftoff.

Pavlov

Ivan Pavlov developed the concept of conditioned reflexes from his classic experiment in which he trained a dog to salivate at the sound of a bell associated with food. For this and other work, he received the 1904 Nobel Prize in Physiology or Medicine. Here, in his eighties, he poses in front of his Institute for Physiology in the town of Koltushi. The sign behind him reads, "Experimental Genetics of Higher Nervous Activity." Circa 1930.

Polar Explorer

Explorer Ivan Papanin stands atop an ice floe with his colleagues at the polar drifting station "North Pole" in 1938. Drifting stations were scientific testing installations established on ice floes that drifted around the Arctic as the ice melted. Papanin and three others established the first drifting base near the North Pole in 1937–1938.

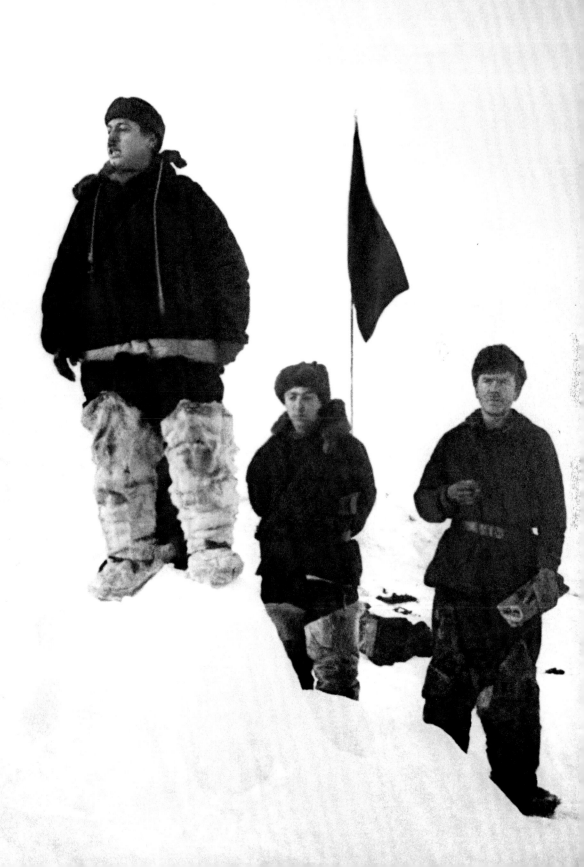

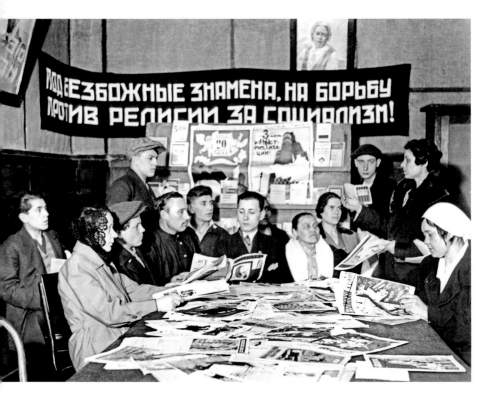

"Opium of the People"
Antireligious discussions in the Union Club of the Communes. The sign reads, "Under atheist flags, let's struggle against religion for Bolshevism!" Moscow, 1933.

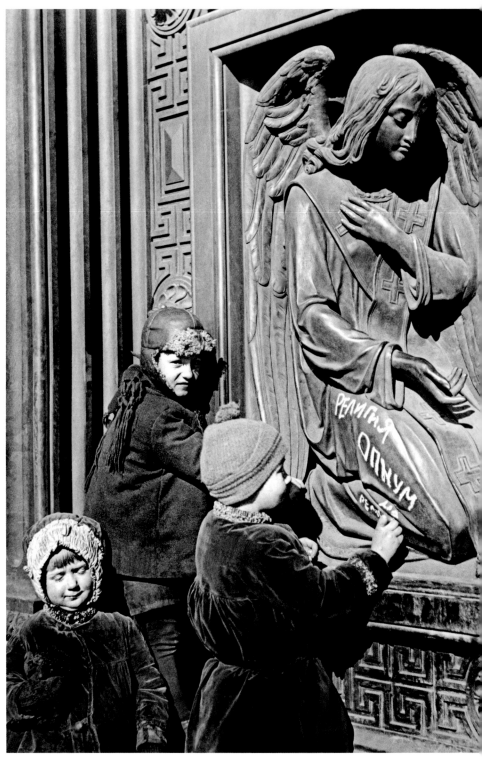

Children scrawl antireligious graffiti on a bas-relief at Leningrad's St. Isaac's Cathedral in 1930. Communist propaganda targeted the young especially, through schools as well as the Young Pioneer and Komsomol movements. The graffiti quotes Karl Marx: "Religion is the opium of the people."

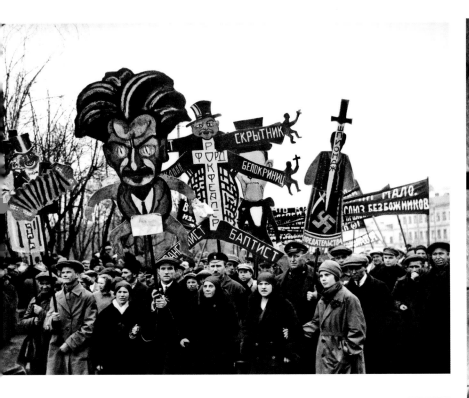

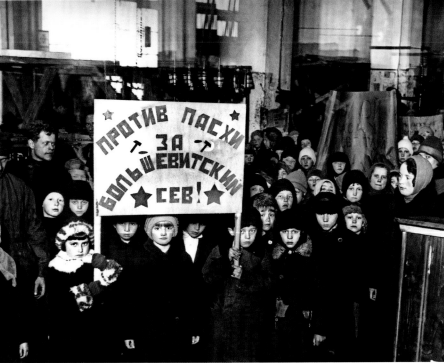

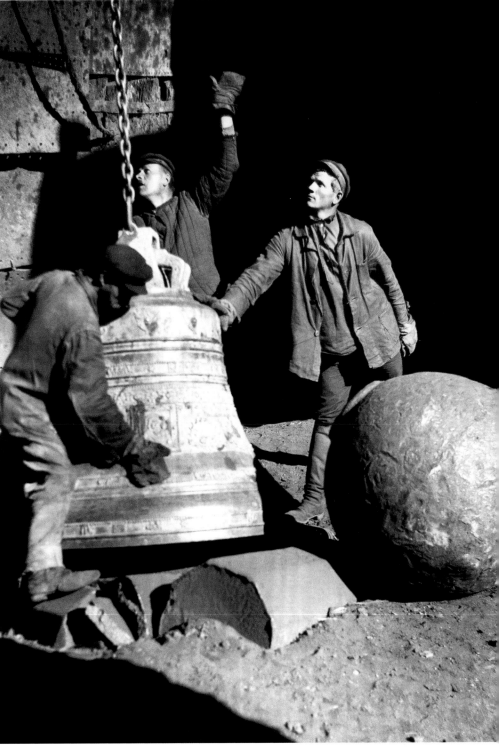

An antireligious demonstration in Moscow. 1928.

The sign reads, "Down with Easter! Long Live the Seeding of Bolshevism!"
Moscow, 1931.

During the early days of the Soviet Union, church bells were deemed more important for the metal they contained than for their call to worship. Here workers remove a large bell to be melted down. Moscow, 1925.

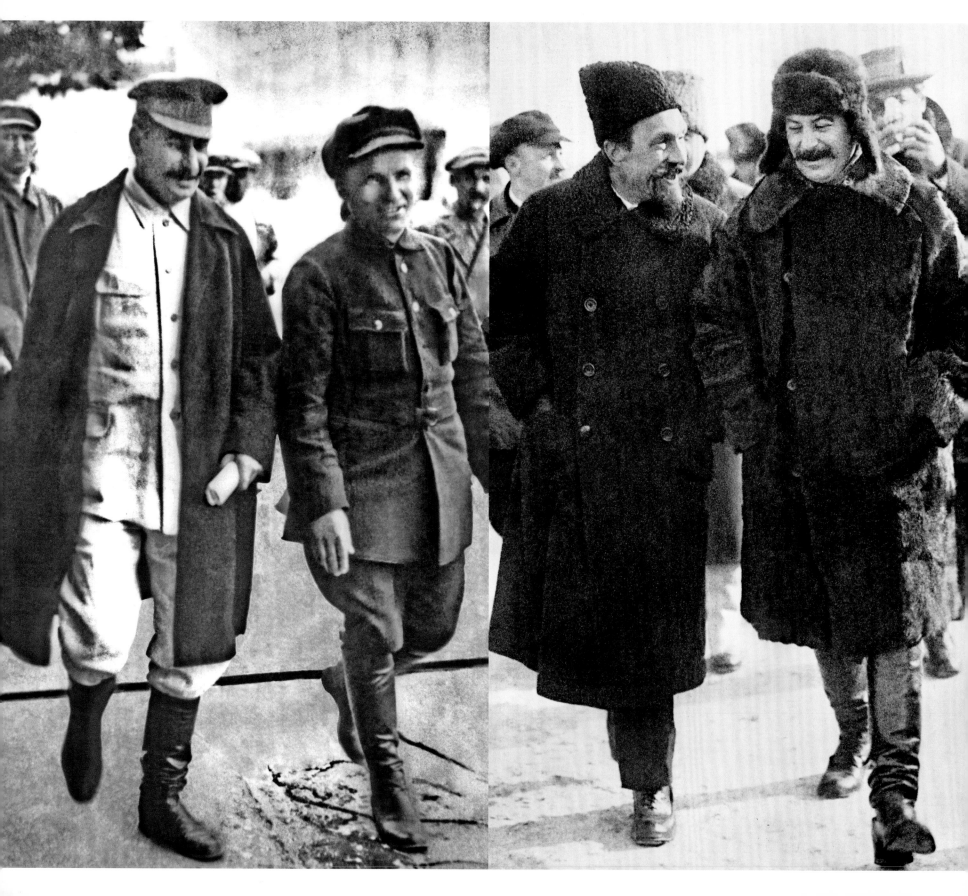

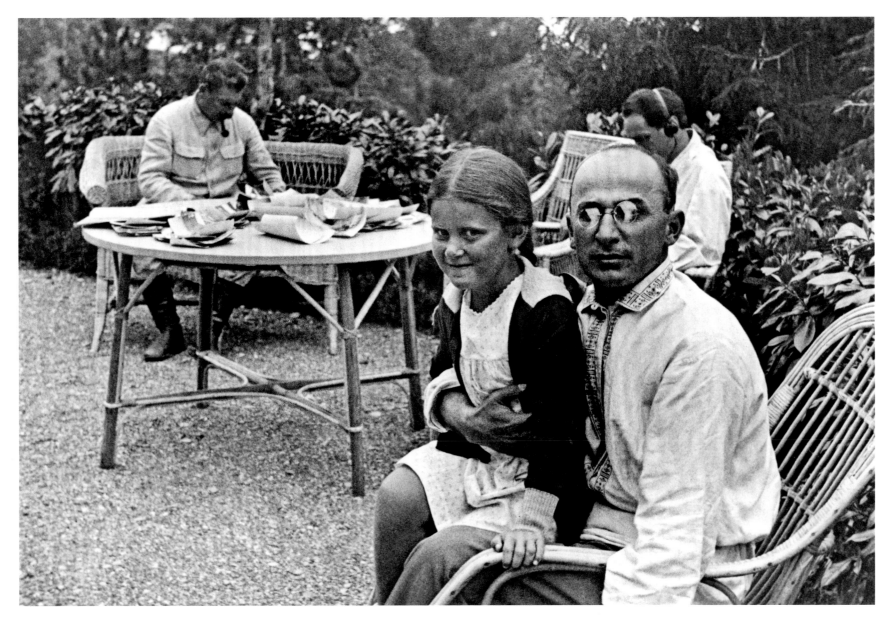

Old Bolsheviks
Josef Stalin and Leningrad Communist Party chief Sergei Kirov walk through Sverdlov Square in Moscow in 1930. Kirov joined the Bolsheviks in 1905 and rapidly rose to become virtually the second most powerful man in the Soviet Union. He was assassinated in 1934, under mysterious circumstances. Some say Stalin grew jealous of Kirov's popularity and ordered the murder himself.

Wolf and Sheep
Stalin and Alexei Rykov share a rare moment of mirth in the 1930s. A founding member of the Bolshevik Party, Rykov first fell afoul of Stalin in 1928 for being too moderate. The enmity lasted until 1938, when Rykov was accused of conspiring against Stalin with Trotsky (who had long since left the country), arrested, and executed.

A Tranquil Gathering in the Country
Commissar of the Ministry of Internal Affairs—and later secret police chief—Lavrenti Beria balances Stalin's daughter, Svetlana, on his knee while her father works in the background in this photo, circa 1935–36. Soon, with the sinister Beria's help, Stalin would mount the purges that killed millions. Svetlana defected to the United States in 1967. Her autobiography, *Twenty Letters to a Friend*, was published the same year.

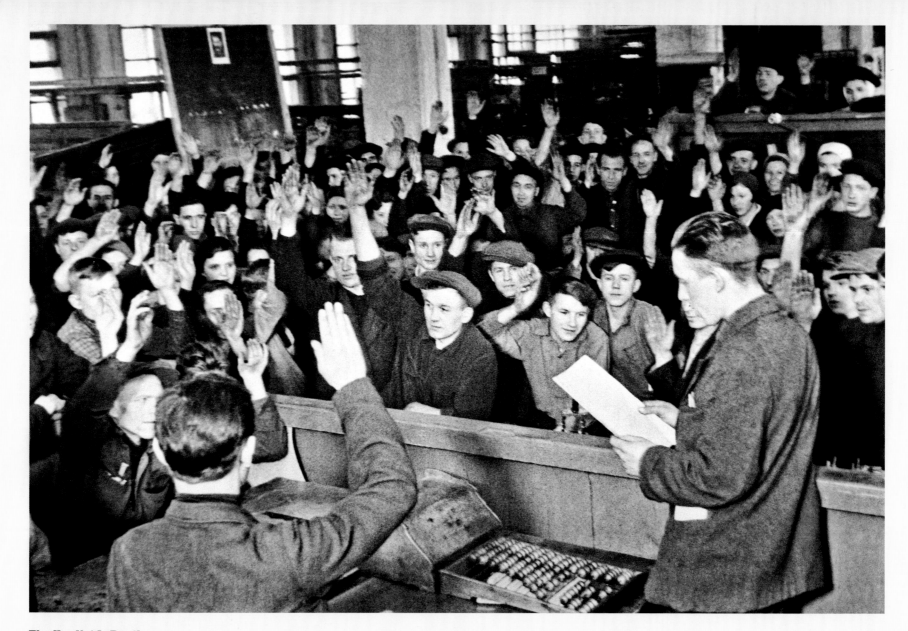

The Verdict Is Death
Workers at a factory vote for the execution of the "spies of Trotsky." Denunciation became an art during the purges of the 1930s, as all were encouraged to betray their neighbors and fellows. Children even denounced their parents. A woman in Kiev was said to have denounced some eight thousand people. Streets would empty when she passed by. Moscow, 1937.

RIGHT
"Poetry Is Respected Only in This Country"

In 1933, Warsaw-born poet Osip Mandelstam read to his friends a poem he wrote about Stalin. Among other scurrilous descriptions, it included the line, "The murderer and peasant-slayer." Although the reading was supposed to be secret, the news got out. Soon Mandelstam was arrested. He died in the Gulag in 1938, one of many artists who suffered and died under Stalin's hard yoke. "Poetry is respected only in this country," he said. "There's no place where more people are killed for it." Circa 1925.

FAR RIGHT
"Now They Will Come for Me"

Isaac Babel was the first major Russian Jewish author to write in Russian. His 1926 novel, *Red Cavalry,* which was translated into more than twenty languages, is his most famous work. In the 1930s, like so many other writers, artists, and musicians, Babel felt the weight of Stalin's persecution. After Maxim Gorky's suspicious death in 1936, he declared, "Now they will come for me." In 1939 they did. Babel was condemned as an "agent of French and Austrian intelligence" and shot to death. Moscow, 1927.

Erased from Existence

This photo of Stalin and other Soviet luminaries, originally taken in 1927, displays the kind of crude doctoring applied to erase from existence those eliminated during the purges.

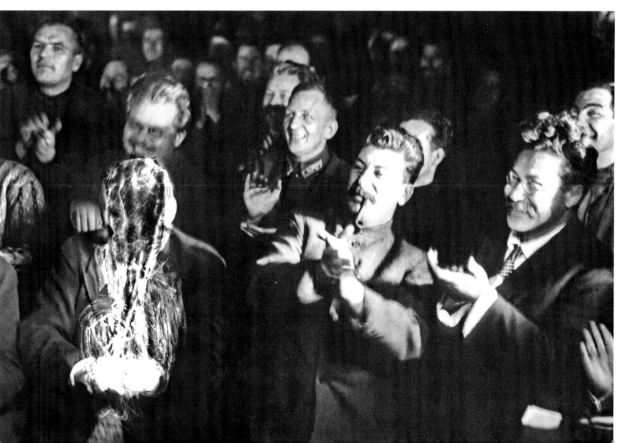

113

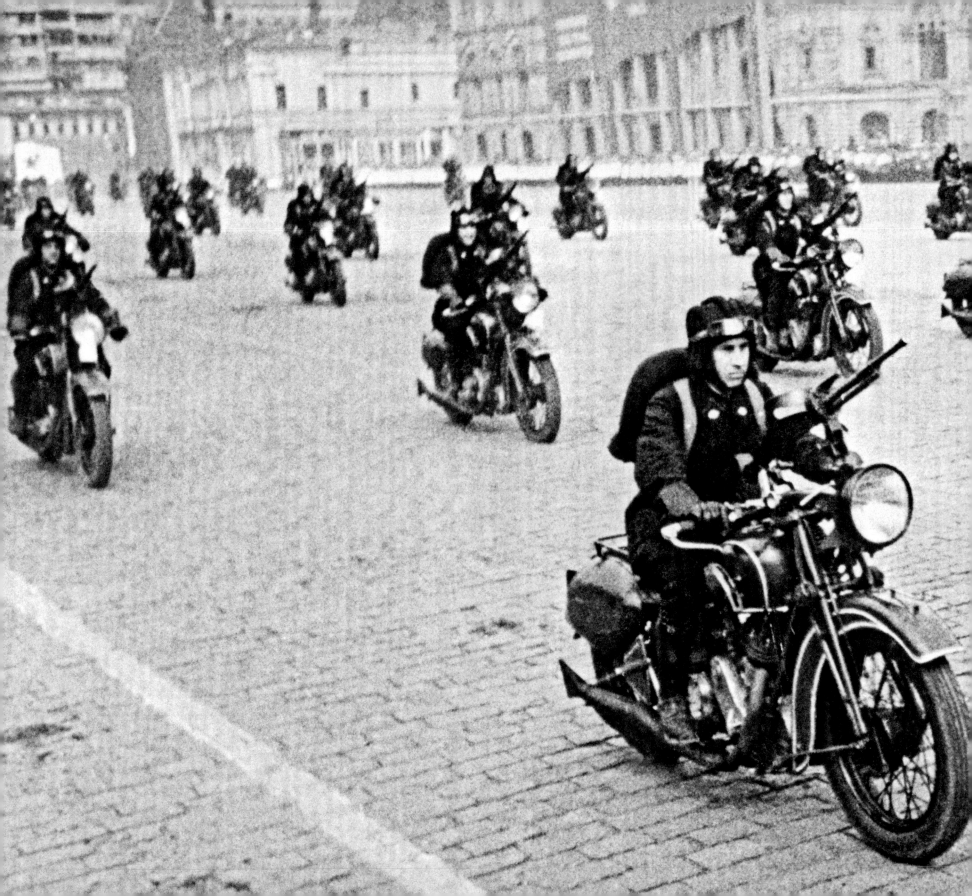

May Day
Combat motorcycles featuring handlebar-mounted machine guns parade through Red Square. Moscow, 1936.

Horse-drawn cannons roll through Red Square. Moscow, 1931.

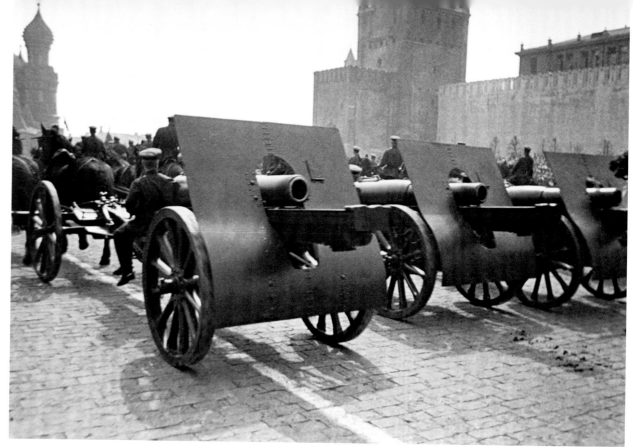

Funeral Speech
Standing atop the Lenin Mausoleum, Stalin eulogizes Bolshevik leader and civil war hero Mikhail Frunze in 1925. (He died, suspiciously, during ulcer surgery. Some believe Stalin arranged his death.) Stalin is surrounded by other leading Communists, including Mikhail Kalinin and Valerian Kuibyshev. Other faces, repressed during the purges of the 1930s, have been scratched out.

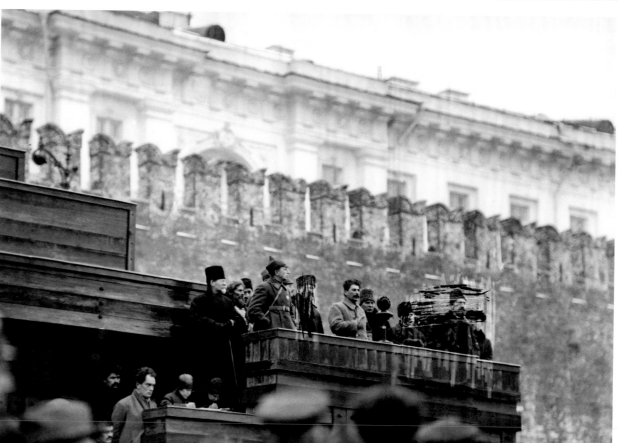

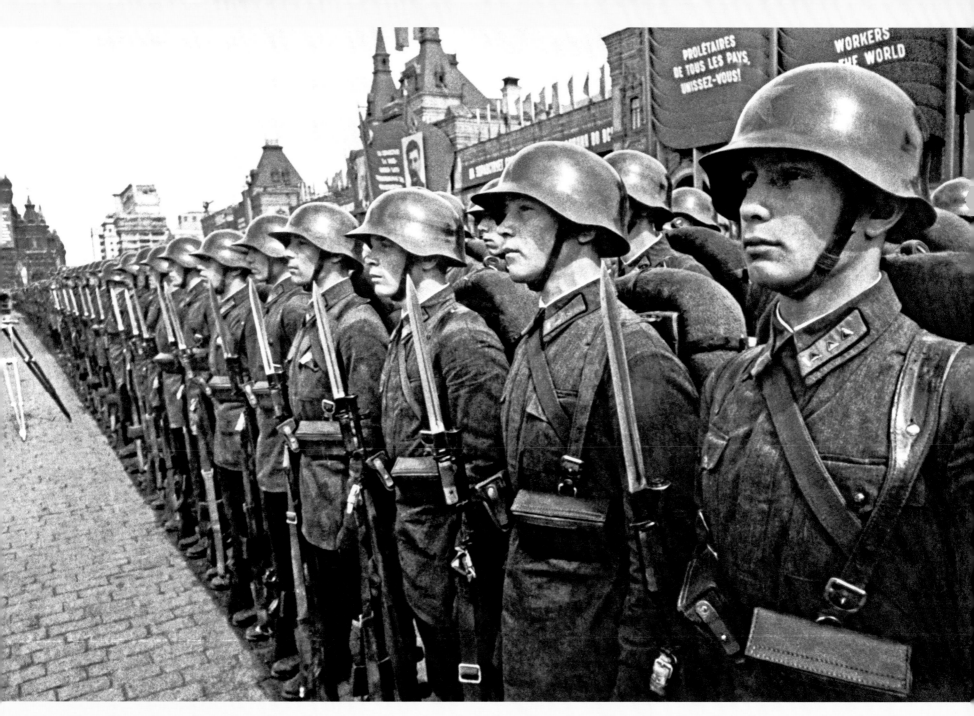

At Attention
Soldiers from the Moscow Proletarian Division line Red Square during the 1937 May Day celebrations. The banners in the background proclaim the ascent of the proletariat in several languages, including English and French.

1905 – 19
1941 – 1
1964 – 19
– 2005

THE GREAT PATRIOTIC WAR

17 – 1927
953 –
84 – 1991

THE SOVIET IMAGE

1905

1917

1927

1941 –

1953

1964

1984

1991

2005

THE GREAT

PATRIOTIC WAR

"I CAN GUARANTEE ON MY WORD OF HONOR"

On August 23, 1939, in Moscow, Soviet foreign minister Vyacheslav Molotov and German foreign minister Joachim von Ribbentrop signed a treaty ensuring that neither country would invade the other. This German-Soviet Non-Aggression Treaty stunned the world. "Without the Russian pact," *Time* magazine declared, "German generals would certainly have been loath to go into military action. With it, World War II began."

The pact was the offshoot of European politics. After the mutual catastrophe of World War I, Germany and the Soviet Union had established a curious rapport. Both nations were international pariahs in the 1920s and early 1930s—Germany for starting the war and subsequently losing it, the Soviet Union for being Communist. Although the Treaty of Versailles prohibited Germany from enlarging its army and developing military aircraft, the Soviets had provided Germany with research facilities and training bases deep in Soviet territory. In return, German technology had helped to build the nascent Soviet air force.

The rise of the Nazi Party shattered this cooperation. The Nazis despised Russia in general and Soviet Russia in particular. Adolf Hitler, in his 1926 manifesto, *Mein Kampf,* described Communism as a Jewish conspiracy designed to keep Germany from reaching its ordained greatness—which included enslaving the inferior Slavic race as workers. "The Slavs are a mass of born slaves who feel the need of a master," he wrote. The destruction of the Soviet Union would not only liberate the Russian people from their Jewish-Bolshevik masters but would also provide "living space" for the German master race. Hitler publicly stated, "If we had at our disposal the Urals, with its incalculable wealth of raw materials, and the forests of Siberia, and if the unending wheat fields of the Ukraine lay within Germany, our country would swim in plenty."

The Western powers adopted a policy of appeasement toward Hitler. When British prime minister Neville Chamberlain and Hitler signed the Munich Pact of 1938, forcing Czechoslovakia to give to Germany a disputed area called Sudetenland (a pact that, Chamberlain announced, would bring "peace in our time"), Stalin began to worry that the West would not back the Soviet Union in the event of a German invasion and opted for his own pact of appeasement: the German-Soviet Non-Aggression Treaty.

Publicly, the treaty seemed to promote peace; secretly, it included provisions for the Soviet annexation of the Baltic states, Finland, and Eastern Poland in exchange for Germany receiving Western Poland and Soviet war materials. As a result, less than a month later, in September, Poland was caught between the twin crucibles of a German army invading from the west and Soviet tanks crossing the eastern border. Along with the Red Army came the Soviet secret police, then called the NKVD (People's Commissariat for Internal Affairs). They executed some twenty thousand Poles, including the massacre of forty-five hundred Polish military officers. In all, nearly two million Poles and people from the newly acquired lands were sent to the Gulag.

In November 1939, the Soviets attacked Finland—but Finland proved to be a tougher morsel to swallow. Finally, beaten down by the sheer overwhelming numbers of Soviet troops, the Finns sued for peace in March 1940. But the Red Army's performance had been dismal. The massive purges conducted in the 1930s had gutted the army—and it showed. The Soviets lost nearly one thousand aircraft, compared to seventy Finnish planes. Nearly four hundred thousand Soviet troops were killed, wounded, or went missing in action. "We have conquered just enough Finnish territory to allow us to bury our dead," said a Soviet general. The German military intelligence saw very little that was impressive or intimidating.

In June 1940, the Nazis overran France. But Germany's blatant aggression didn't seem to faze Stalin. After all, he had his treaty. "The Soviet Government takes the Pact very seriously," he announced. "I can guarantee on my word of honor that the Soviet Union would not betray its partner." Flushed with victory, Hitler didn't quite feel the same way. Declaring that "you have only to kick in the door and the whole rotten structure will come crashing down," he secretly

began planning to invade the Soviet Union in what would become the largest land campaign in history—Operation Barbarossa.

OPERATION BARBAROSSA

In reality, Hitler's plan was anything but secret. Western intelligence agencies knew of it and warned Stalin, as did U.S. president Franklin Delano Roosevelt. British prime minister Winston Churchill sent an urgent warning to Stalin on June 13, barely a week before the invasion. Even Mao Zedong, in remote Yunan Province in China, warned him. The German ambassador in Moscow, who opposed the invasion, supplied a date, and a Nazi deserter supplied the very hour. The Germans were conducting a huge military buildup on the Soviet border and flying reconnaissance missions over Soviet territory. But Stalin refused to believe the warnings. He ordered the German deserter shot and gave orders not to fire on the Germans no matter what the provocation.

Thus, incredibly, the German attack on June 22, 1941, caught the Soviets completely by surprise. Stalin was stunned by Hitler's treachery. He suffered a nervous breakdown, leaving it to Molotov to announce the invasion to the Soviet people. "He had not guessed or foreseen that the Pact of 1939, which he had considered the outcome of his own great cunning, would be broken by an enemy even more cunning than himself," wrote his daughter Svetlana. "This was the real reason for his deep depression at the start of the war. It was his immense political miscalculation."

Stalin didn't speak in public until July 3. When he did, he spoke as never before—personally, movingly. "Comrades, citizens, brothers and sisters, fighting men of our Army and Navy. I am speaking to you, my friends." He made no mention of the Communist Party or the Soviet state (nor offered any apology for the disastrous Nazi-Soviet pact)—this was an attack on the motherland, an attack on Russia. This was a "people's war," a "patriotic war." Yet, for all his appeal to camaraderie and patriotism, he was still the brutal dictator. He shot the western front commander, General Pavlov, and all his staff and savagely imposed "discipline of the revolver," holding soldiers' families accountable for battlefield behavior.

More than three million Germans, 136 divisions, advanced along a four-thousand-mile front, the largest in history. One hundred seventy Red Army divisions opposed them. The German forces deployed in three groups. Army Group North advanced toward the Baltic states with the ultimate goal of taking Leningrad; Army Group Center advanced toward Moscow; Army Group South drove to Kiev and Odessa with the goal of taking the Caucasus.

International opinion held that the end for the Soviets would come soon. In America, Roosevelt's navy secretary, Frank Knox, advised that "it will take anywhere from six weeks to two months for Hitler to clean up on Russia." Hitler was so confident the war would be swift that he reduced the size of the invading force two months into the campaign and allowed arms, munitions, and aircraft manufacturing to drop off. "When you receive this letter the Russians will be defeated and we will be in Moscow parading in Red Square," wrote a German soldier during the first months of the invasion. "I never dreamed I'd see so many countries. I also hope to be on hand when our troops parade in England."

And the confidence seemed justified; the Germans gained victory after victory. Within weeks of the initial attack, one million Soviet soldiers were dead, and another half million were captured and marching west to German labor and concentration camps. The Nazis shot Jews, Communist Party members, and commissars on the spot. They destroyed thousands of Soviet airplanes while still on the ground. "We could not believe our eyes," said a Luftwaffe pilot. "Row after row of Soviet planes stood lined up as if on parade." The Nazis took the Baltic states and overran the Ukraine. The push to the great Russian oilfields further east began.

As terrible as the initial onslaught was, however, the Red Army somehow managed to keep from being completely destroyed. People, factories, treasures—all were evacuated, at first haphazardly, but then more systematically, east to the great Russian

THE SOVIET IMAGE

1905

1917

1927

1941 –

1953

1964

1984

1991

2005

THE GREAT

PATRIOTIC WAR

hinterland. Eighty percent of Soviet industry, including more than fifteen hundred factories, was moved east, transferred by railroad while under bombardment by Luftwaffe bombers. The newly relocated factories began producing even before they had walls or roofs.

The poorly armed Soviets fought like demons. A Soviet colonel, later turned historian, named Vladimir Karpov recounted an incident in the Western Ukraine in which a basement where women and children were hiding was defended from an oncoming tank by "a man in flaming clothes [who] dashed toward the armored monster. Tearing off his burning coat he threw it on the grille of the engine hatch and then flung himself like a blazing torch under the tank. An explosion followed."

"I remember we were trying to take a little hill that was to give us control over a locality," wrote Karpov. "Three times we attacked and each time we were thrown back. . . .That was when I witnessed the following incident. A Soviet soldier was walking erect toward the hill. He was wounded, alone, without weapons. The Germans watched him closely. When he was about 30 meters from them, the soldier took out a harmonica and started playing a lovely Russian melody on it. The Nazis started to clamber out of cover and soon they had practically surrounded the man. The last thing I saw was a grenade explosion and the Germans being thrown in different directions. The soldier had blown himself up together with the enemy."

Soon the fearsome Russian ally, winter, descended. At the end of 1941 and beginning of 1942, twenty-degrees-below-zero temperatures ground the German advance to a halt. With engine and gearbox oil frozen into glue, it took two hours to start a tank and another half-hour to warm up enough to move. Steel and boot soles snapped; food had to be cut with saws. The wounded were dead in minutes unless swathed in blankets. Frostbite began to ravage the German soldiers, who were clad in lightweight uniforms because Hitler didn't believe the invasion could possibly last into the winter. The soldiers stripped Soviet prisoners and dead citizens of anything wearable.

The German treatment of civilians and partisans was particularly brutal. At first the Nazis simply shot and hanged partisans. Later, they were found with their heads stuffed into their abdomens and other mutilations. Female partisans were tortured and raped. Karpov wrote of searching for a well after having pushed the Germans out of the village of Davydovo near Moscow. "The well was there, undamaged. But when we glanced inside our blood ran cold. The well was full of the corpses of children, from tiny infants to some about five years old." Such treatment fueled anger and renewed determination on the part of the Russians.

LENINGRAD

By September 1941, German troops had encircled Leningrad and its two-and-a-half million citizens and began to bombard the city. It was the beginning of a brutal siege that would last nine hundred days.

All public transport quickly shut down. By the onset of winter, the city had no heating, no water supply, almost no electricity, and very little food. In January 1942, in the depths of the brutally cold winter, food rations in the city fell to a quarter-pound of bread per day. In January and February, two hundred thousand people died of cold and starvation. General Georgi Zhukov, tough and uncompromising, was sent to organize defenses. He declared, "We are not giving up Leningrad. We are going to defend!" and he created militia units and artillery brigades. The city began to broadcast, day after day, the sound of a metronome, reminding all that the heart of Leningrad still beat. The besieged city simply would not surrender.

Leningrad's only connection to the mainland was a dangerous road over the iced-over Lake Ladoga to the northeast—the "Road of Life." Over the nearly three years the city was under siege, several hundred thousand Russians were evacuated over this road; meager food and provisions came in. In winter, under constant enemy bombardment, trucks carried people across the frozen lake. During warm months, people were ferried across in boats.

Treasures of the Hermitage Museum and other depositories were hidden away. The city turned into a vast garden, with people growing food anywhere a root

would take hold. In 1942, with musicians and audience bundled in overcoats, composer Dmitry Shostakovich's Seventh "Leningrad" Symphony was performed in the city's Mariinsky Theater as an act of defiance. The citizens ate roots, rats, wood, books, and each other. The city would not surrender.

In January 1944, a Soviet offensive shattered the stranglehold, driving the Germans away from the southern edge of the city. The siege was finally broken. The daily bombardment, starvation, disease, and cold had killed almost half of Leningrad's inhabitants. The city became acclaimed as "Hero City," and the siege (*blokada* in Russian) became a rallying cry.

MOSCOW

With Moscow, German confidence would finally be shaken. Hacking and pillaging through the countryside, the Nazis drove to within miles of the city—but there was precious little to sustain them along the way. Declaring that "the enemy must not be left a single engine . . . not a pound of bread or a pint of oil," Stalin ordered a scorched-earth policy in the face of the invaders. It was the same strategy employed by Tsars Peter the Great and Alexander I against Sweden's Charles XII and Napoléon's Grand Army. In both cases, the invading armies eventually retreated in disarray.

Many Muscovites fled or were evacuated, but a stubborn minority, including Stalin, stayed. Tens of thousands of barefoot women, including opera and ballet stars from the Bolshoi Theater, dug antitank ditches. Giant antitank "hedgehogs," resembling massive toy jacks, were strewn in front of the approaching German invaders. Women workers in a lemonade-bottling factory produced Molotov cocktails. Antiaircraft guns were deployed on rooftops to halt the German bombing raids. The city was camouflaged against the Luftwaffe: roads were painted to resemble rooftops, the Kremlin Wall was painted to resemble housefronts, and mock factories were erected in an effort to fool German bomber pilots. The ornate Moscow subway system was pressed into service as a bomb shelter. Although

Stalin assumed the title "Supreme Commander of Soviet Armed Forces," he gave the defense of Moscow into the hands of Zhukov. For his part, Zhukov tolerated no interference from anyone, including Stalin.

The cold was appalling, reaching minus forty degrees. The German army had never experienced cold so intense, so brutal. Their automatic weapons jammed after a single shot, and they simply threw them to the ground and retreated. Soviet soldiers, used to the cold, picked up the superior weapons and brought them back to life with lubricating oil. Cavalry from Siberia, accustomed to even worse winter conditions, were used by Zhukov as guerrilla troops. Their horses, agile steppe ponies capable of traveling more than sixty miles a night, could navigate snowdrifts that completely defied tanks and other mechanized transport. The Soviet counterattack began to steadily push the German Wehrmacht, the armed troops, back.

"My dear wife," began a German letter. "The Russians don't want to leave Moscow. They've launched an offensive. Every hour brings news of terrifying developments. It's so cold my very soul is freezing. It's death to venture out in the evening. I beg of you—stop writing about the silks and rubber boots I'm supposed to bring you from Moscow. Can't you understand I'm dying? I'll die for sure. I feel it."

By the end of January 1942, just seven months after the "invincible" German army had crossed into Russia, roughly one million German troops had died in the attempt to take Moscow. It was just a taste of what was to come.

STALINGRAD

After his failure in Moscow, Hitler decided to drive southeast to capture the oilfields and the mines of the Caucasus and Volga regions. The German war machine needed oil; here was a way to supply it. German armor, ground troops, and the Luftwaffe drove swiftly through the Crimea and deep into southern Russia. At a bend in the Volga River sat the city of Stalingrad, twenty miles long but only three miles wide. Formerly Tsaritsyn, the "Tsarina's city," Stalingrad had been named for Stalin

THE SOVIET IMAGE

1905

1917

1927

1941 –

1953

1964

1984

1991

2005

THE GREAT

PATRIOTIC WAR

after he defended it against White troops in the Russian civil war. Hitler was determined to take his rival's namesake city, and Stalin was just as determined to keep it.

The heavily industrialized city was dominated by three massive factory complexes situated in the northern end—the Red October, Barricades, and Tractor factories. The German assault began with a massive bombing campaign carried out by the Luftwaffe. Soon most of the city was rubble; oil wells shot gouts of fire into the air. Amid huge casualty rates, civilians began haphazard evacuations. The battle deteriorated into slithering trench and sewer warfare and infantry charges. The war diary of the Soviet Sixty-Second Army recorded a morning of fighting in which a contested station changed hands fifteen times. Fueled by vodka, schnapps, and Benzedrine, Soviet and German troops reached the limits of human exhaustion. The Luftwaffe flew as many as three thousand sorties per day. Finally, the Russian forces were contained in a small bridgehead. "The Russian is finished," crowed Hitler.

But the Russians weren't finished. Boats full of unarmed but fresh Russian troops floated across the Volga at night and swarmed into the front lines to collect rifles and submachine guns from their dead countrymen. The Germans, used to blitzkrieg (lightning-fast warfare) tactics, were not prepared for the kind of street fighting that dominated Stalingrad. Their vaunted Panzer tank units couldn't operate in streets choked with rubble eight feet high. German soldiers called this kind of warfare *rattenkrieg*, rat war. The nights were the hardest to bear. Sappers dug trenches, troops advanced through rubble and sewers, and, over all, the snipers watched and waited. Both sides sent their top snipers, many of them women, to Stalingrad. Led by Vasily Zaitsev, a Siberian hunter from the Urals who had 114 confirmed kills, including 11 German snipers, the Soviets set up sniper schools whose graduates terrorized the Germans and undermined morale.

"This is not a battle for a locality or a river, but for street crossings and houses," reported the BBC. "Poland was conquered in 28 days. In 28 days in Stalin-

grad the Germans took several houses. France was defeated in 38 days. In Stalingrad it took the Germans 38 days to advance from one side of the street to the other." It was a hand-to-hand battle of knives, grenades, and submachine guns.

With the onset of winter, the Soviets surrounded the German Sixth Army—at 250,000 men the largest in the German military—on the steppe outside of Stalingrad. The Nazis called the encirclement *der Kessel* ("the cauldron"). Forbidden by Hitler to retreat or surrender, the German soldiers began dying from starvation, malnutrition, and frostbite. A Panzer division, coming fast across the frozen steppe to reinforce the troops, was ordered back by Hitler. Forbidden to break out, ordered to take Stalingrad at all costs, the remnants of the army dug into the earth, their backs to the Volga, starving, nearly out of ammunition, completely out of hope. On January 31, 1943, Nazi field marshal Friedrich von Paulus surrendered. Including von Paulus, the Soviets captured 24 generals, 2,500 officers, and 90,000 troops. The prisoners were marched east into slavery—only 6,000 would live to see Germany again. In all, two million died on both sides during Stalingrad's seven months of horror. It was the bloodiest battle in history.

KURSK

In the spring of 1943, both sides began preparing for what was to become the greatest tank battle in history. After Stalingrad, the Soviets pushed the Germans back nearly one thousand miles, creating a large bulge in the German front line near the town of Kursk, some three hundred miles southwest of Moscow. The German high command wanted to pinch off this Soviet bulge. They advanced a massive collection of troops and armor—some nine hundred thousand men and more than three thousand tanks—eager to avenge the loss at Stalingrad. Opposing them was an even larger Soviet army, equal in tank numbers and with half again as many troops. This time the Russians were well supplied and experienced, bursting with confidence after Stalingrad. Both sides knew that this would be the

decisive battle. Declared Hitler, "The whole future of the war may depend on its outcome."

The Germans attacked from the north and the south, attempting to encircle the Soviet bulge. So close was the tank warfare at Kursk that German and Soviet tanks rammed each other. Aircraft circling overhead couldn't bomb the enemy without damaging their own tanks. Aerial dogfights hurtled burning planes into a battlefield livid with exploding mines, snipers, and machine gunners. "It was difficult to establish which side was attacking and which defending," wrote Karpov. Tanks on fire were used as incendiary rams.

The German assault failed, and the Russian victory electrified the Soviet Union. Soon Soviet troops recaptured German-held cities in the Ukraine. Three Soviet armies readied an offensive on the Baltic states. The nine-hundred-day Siege of Leningrad was lifted. Wrote a German general, "The advance of a Russian army is something that Westerners cannot imagine. Behind the tank spearheads rolls on a vast horde, largely mounted on horses. The soldier carries a sack on his back, with dry crusts of bread and raw vegetables collected on the march. . . . You can't stop them, like an ordinary army, by cutting their communications, for you rarely find any supply columns to strike."

Few villages remained. Cities lay in ruin. Kiev, the "mother of Russia," lost four-fifths of its population. One in four Byelorussians died, victims of war and concentration camps. As many as three million Russians, Ukrainians, and Byelorussians were forcibly deported and used as slave labor. But the tide had turned, and the push to Berlin had begun.

BERLIN

The Germans began a long, grinding retreat back toward their fatherland, burning and destroying as they went. On January 26, 1945, Soviet soldiers reached Auschwitz—abandoned by the Germans—finding only 2,819 people, mostly invalids, remaining in a concentration camp so huge that it once held more than 50,000 prisoners. In early February, Stalin met with Roosevelt and Churchill in the Crimean city of Yalta, on the Black

Sea coast, to map out the final days of the war and postwar partitioning.

Stalin was determined to reach Berlin before the Allies. In March, Allied Supreme Commander Dwight Eisenhower sent a telegram to Stalin, agreeing that the capture of Berlin would be a strictly Soviet affair. In April the final assault upon Berlin began. During the first day, Soviet forces used 42,000 artillery guns and mortars to fire 2,450 freight-car loads of shells into German lines. Two million Soviet soldiers had amassed to take the city. On April 30, Adolf Hitler committed suicide. Soon the Soviet victory banner—hammer, sickle, and star—was unfurled on the roof of Nazi headquarters, the Reichstag, while fighting still raged in its basement.

On May 9, 1945, Germany unconditionally surrendered. Stalin spoke to ecstatic crowds, "My dear fellow countrymen and -women. I am proud today to call you my comrades. Your courage has defeated the Nazis. The war is over. . . . Now we shall build a Russia fit for heroes and heroines."

The cost was some twenty-seven million Soviet dead.

By war's end, the Red Army was eleven million strong. World power was now divided between America and the Soviet Union. And now the world had to contend with a new kind of war—the cold war.

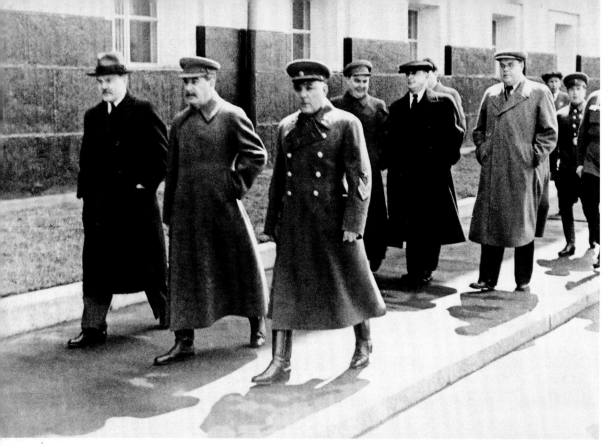

On the Eve of War

Josef Stalin, with, to his left, Kliment Voroshilov (the marshal of the Soviet Union, the country's highest military officer) and, to his right, the commissar for Foreign Affairs, Vyacheslav Molotov, walks to Red Square for May Day festivities in 1941. Little more than a month and a half later, on June 22, Hitler would invade the USSR. (Homemade hand grenades called "Molotov cocktails" are named after Molotov. The name was first coined by Finnish troops, who used the explosives against Soviet aggressors in the Winter War preceding the invasion of Poland.)

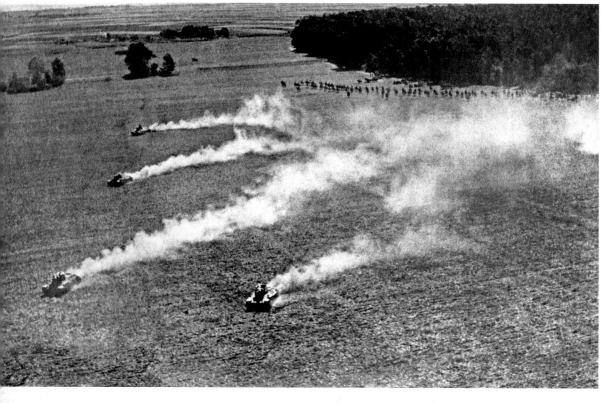

Attack

Soviet tanks on the offensive. The Red Army mainstay in World War II was the T-34 tank, the world's best at the time. A medium-weight tank, it was fast, versatile, and effective. 1940s.

More Tanks to the Front
Welders work under a sign reading "Let's give more tanks to the front!" The poster reads "Soldiers of the Red Army, save us!" 1940s.

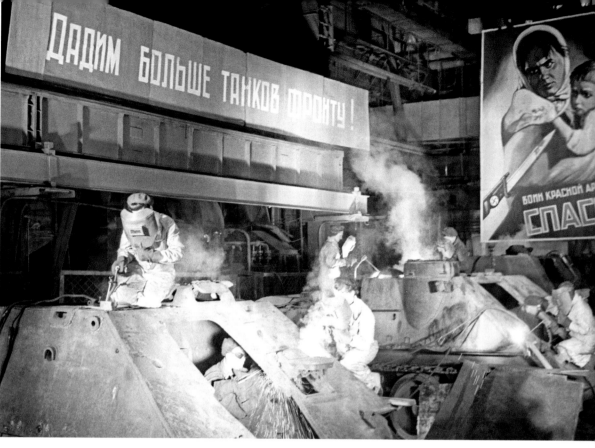

Northwest Front
Soviet soldiers wade through a river on the northwest front. 1940s.

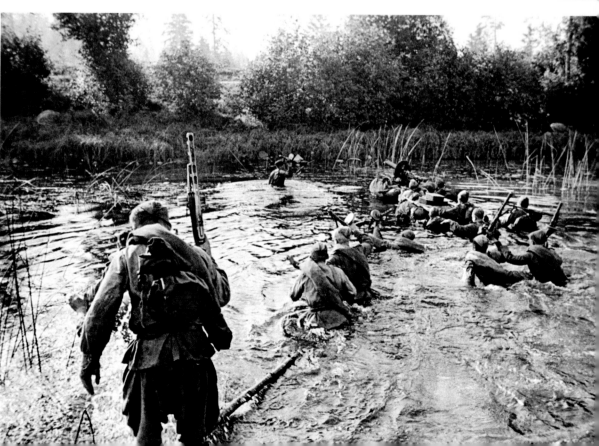

Slave Labor
In a scene repeated all along the eastern front, especially in the early years of the war, the Germans marched hundreds of thousands of Soviet POWs west to be used as slave labor. Circa 1941.

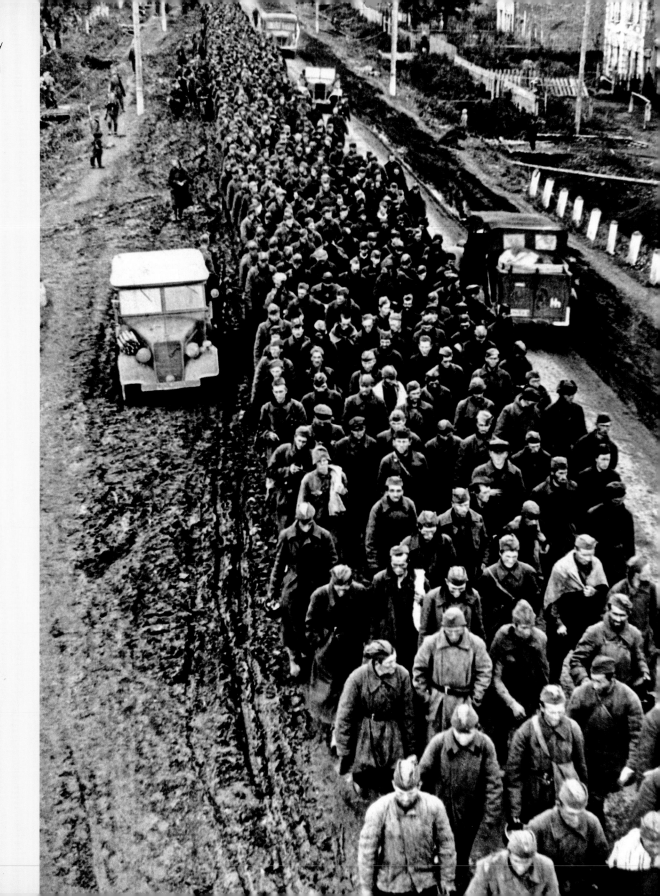

Walking Dead

Soviet POWs being marched to prison and forced labor camps in 1941 drink from a frozen stream. The SS camp guards treated Soviet POWs horribly, in some cases worse than Jewish prisoners. The poison gas Zyklon B, later used in the gas chambers at Auschwitz, was initially tested on Soviet POWs.

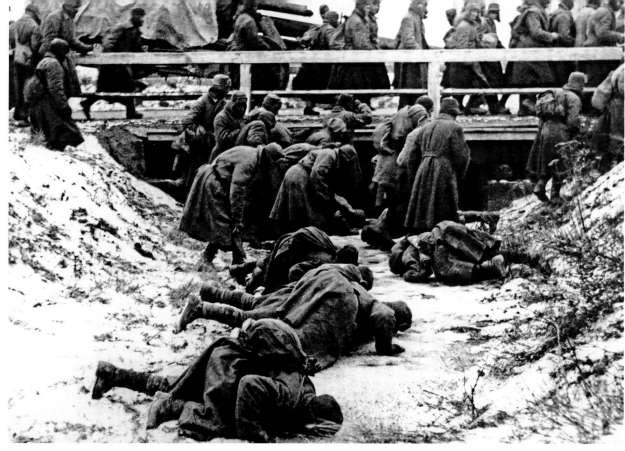

Homecoming

Women refugees haul their belongings home after the Nazis had retreated from the Tikhvin region near the northern front in 1941.

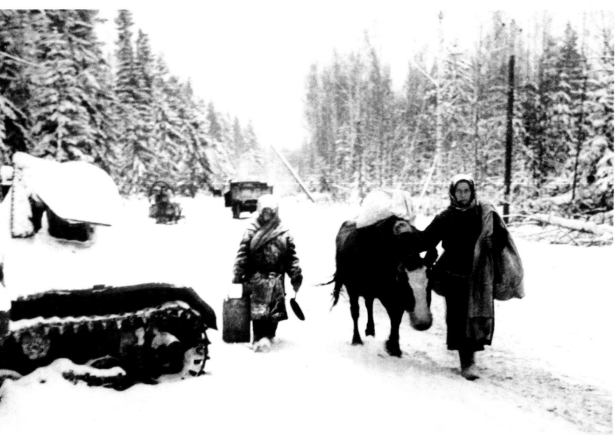

Entertaining the Troops

Folk singer Lydia Ruslanova performs for troops on the front line in 1941. A beloved entertainer, Ruslanova toured the front constantly during the war, including performing on the steps of the Reichstag in Berlin while parts of it still smoldered. Because of her popularity and friendship with Marshal Zhukov, Stalin began to regard her as a potential threat. She and her husband were sent to the Gulag in 1948. Upon Stalin's death, she was released and resumed performing until her death, in 1973.

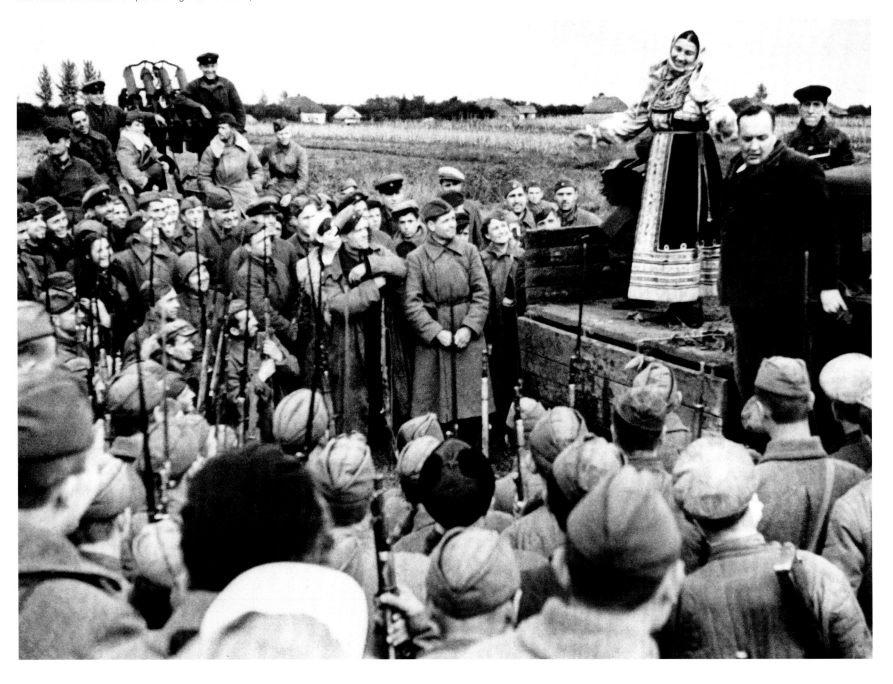

Writers at the Front
Soviet writers (left to right) Yevgeny Petrov *(The Twelve Chairs)*, Mikhail Sholokhov *(And Quiet Flows the Don)*, and Alexander Fadeyev *(The Young Guard)* inspect the remains of a downed Nazi plane in 1941.

The Siege of Leningrad
By the winter of 1941, Leningrad was isolated, without heat and water, and with little electricity and food. With deserted trolleys in the background, people haul water over the frozen ground from an open main on Zvenigorodskaya Street.

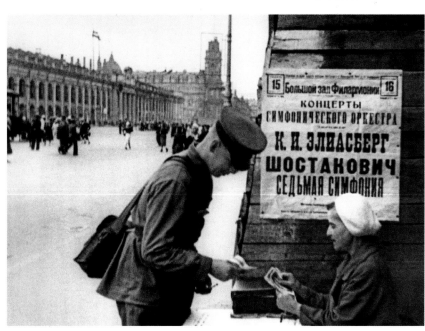

Seventh Symphony
In September 1941, as the Siege of Leningrad began, Dmitry Shostakovich spoke over Leningrad Radio: "An hour ago I finished the score of two movements of a large symphonic composition. . . . Why am I telling you this? So that the radio listeners . . . will know that life in our city is proceeding normally." In August 1942, during the darkest days of the siege, the finished work, his Seventh Symphony, was performed in Leningrad's Philharmonic Hall. Loudspeakers broadcast the concert throughout Leningrad and, as another act of defiance, to the German troops stationed outside the city.

A Red Army soldier buys a ticket to hear Shostakovich's Seventh Symphony. Leningrad, 1942.

131

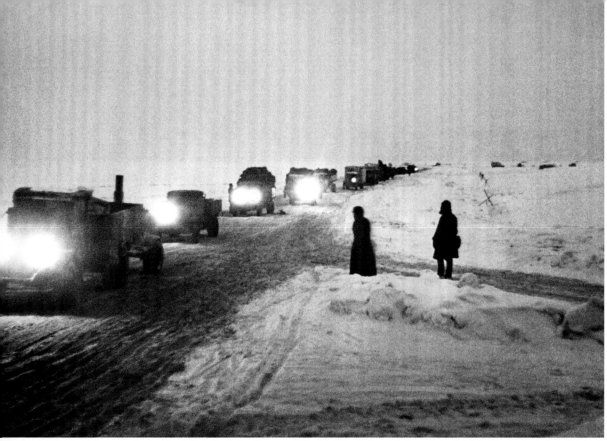

The Siege of Leningrad
Iced-over Lake Ladoga provided a dangerous and solitary lifeline for besieged Leningrad. Beset by enemy aircraft and artillery, the wounded and other evacuees were transported out of the city and supplies trucked in. An underwater oil pipeline was also built to supply fuel to the city. Lake Ladoga, Leningrad, 1942.

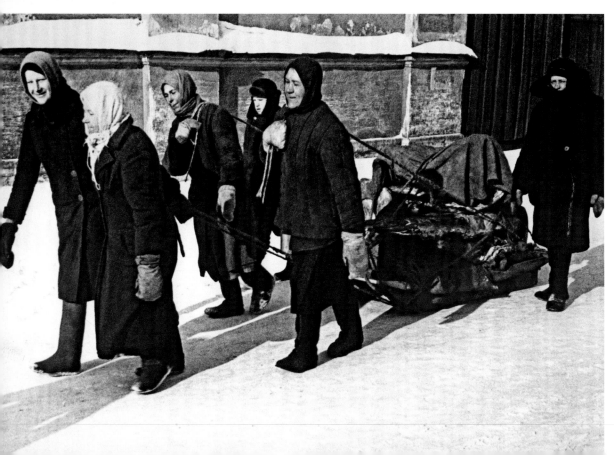

Supplies came in sporadically across Lake Ladoga, with trucks braving Nazi bombardment to cross the frozen lake. With almost no power in the city, people transported the provisions by sled. Leningrad, 1942.

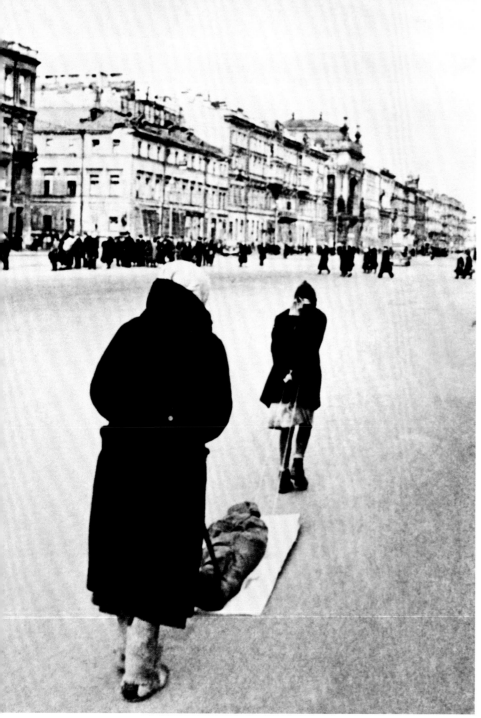

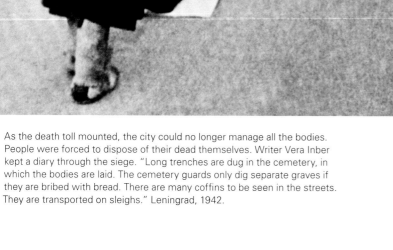

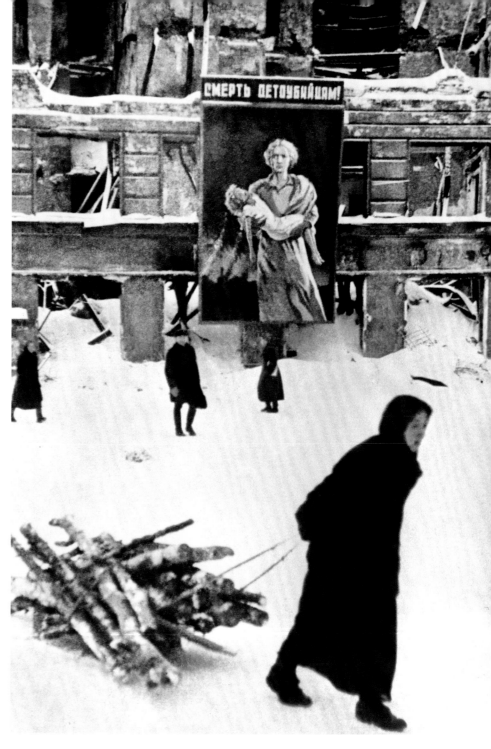

As the death toll mounted, the city could no longer manage all the bodies. People were forced to dispose of their dead themselves. Writer Vera Inber kept a diary through the siege. "Long trenches are dug in the cemetery, in which the bodies are laid. The cemetery guards only dig separate graves if they are bribed with bread. There are many coffins to be seen in the streets. They are transported on sleighs." Leningrad, 1942.

By the end of 1942, Leningrad had run out of oil and coal. People had to fend for themselves. "Our position is catastrophic," wrote Vera Inber. "Just now a crowd destroyed the wooden fence of the hospital grounds, and carried it away for firewood." The anti-Nazi sign reads, "Death to the Childkillers!" Leningrad, 1942.

The Siege of Leningrad
To combat starvation, people planted gardens on any available ground. Here two hospital staff members happily gather cabbage. The message is clear: "we shall survive." Leningrad, 1942.

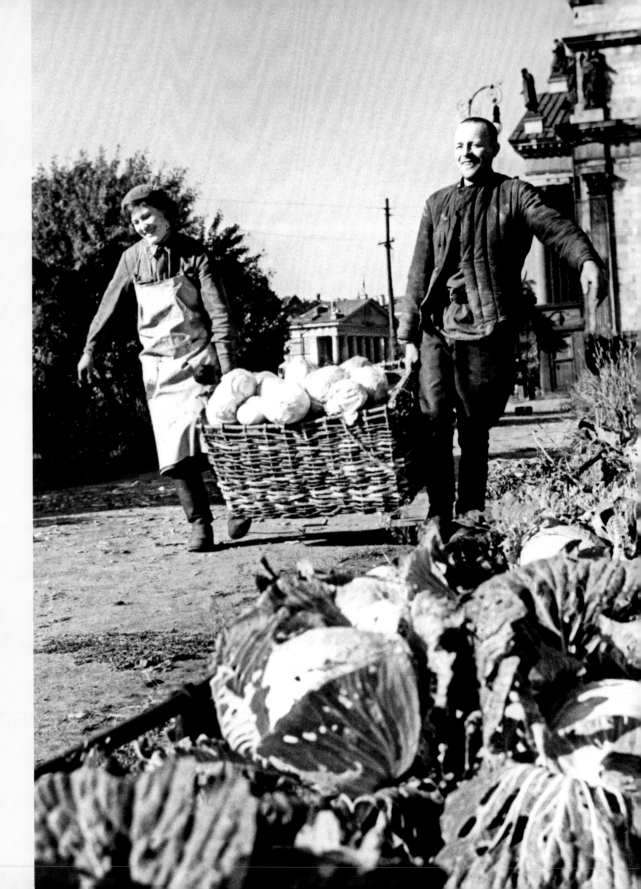

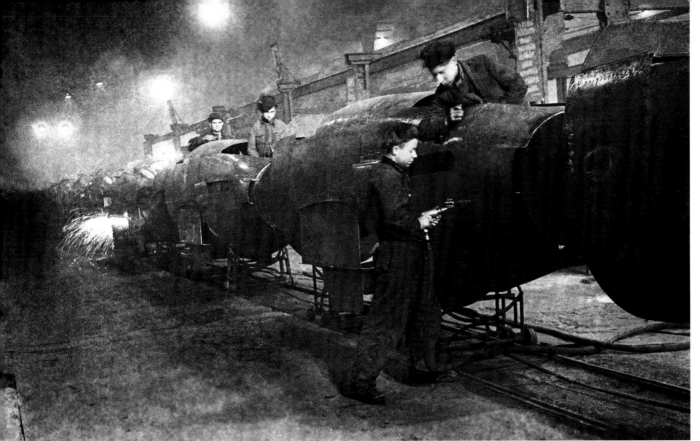

Industrial Warfare

The Germans were amazed at how quickly Soviet heavy industry mobilized to meet war demands. After the initial Nazi onslaught, the Soviets shipped some factories east into the vast Russian midlands. In some cases, they were again producing before walls were erected. Moscow, 1943.

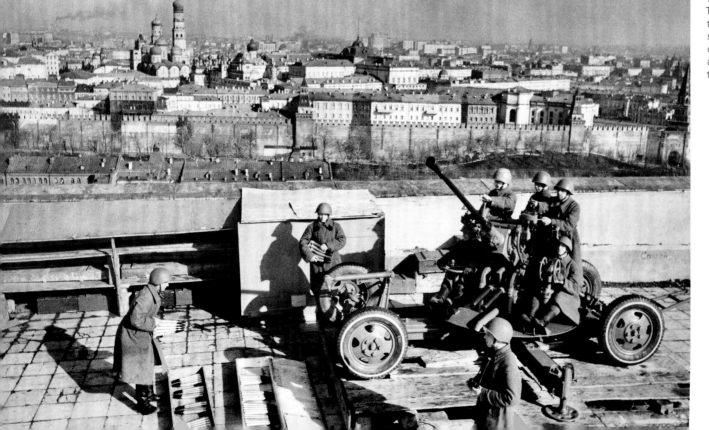

The Battle of Moscow

The failure to take Moscow was the first defeat of the war for the Nazis. It doomed them to march southeast to the Volga oilfields, which led to the defeat at Stalingrad and, ultimately, surrender. Here antiaircraft batteries scan the sky from the roof of the Lenin Library. Moscow, 1942.

The Battle of Moscow

A barrage balloon lies moored in Sverdlov Square during the Battle of Moscow in 1942. In the background is the Bolshoi Theater, home to the Bolshoi Ballet and Opera companies.

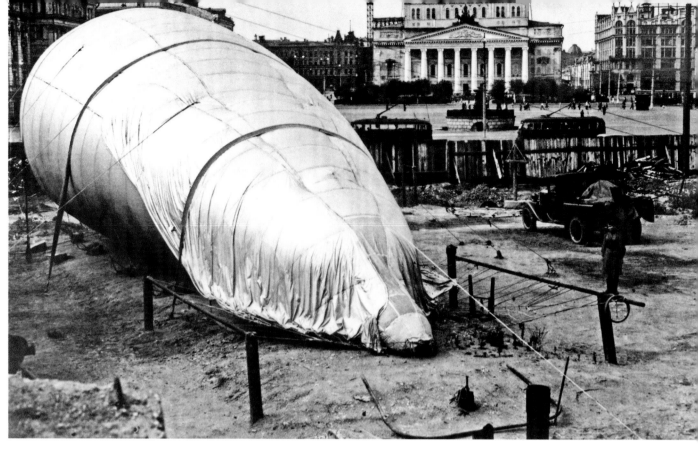

All civilians, men and women, left behind in Moscow contributed to their city's defense. Here Muscovites erect sandbag barricades in the city's suburbs. Moscow, 1941.

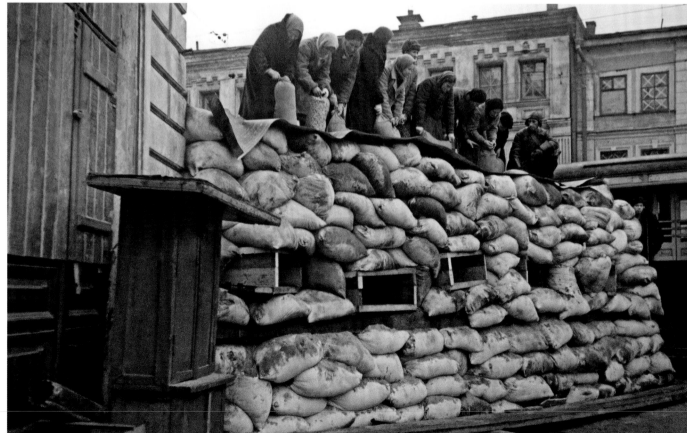

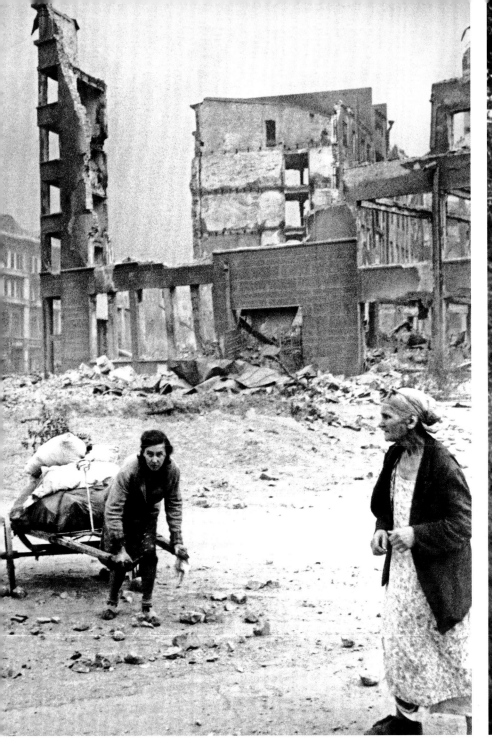

Stalingrad

Often considered the bloodiest battle in human history, the 1943 Soviet victory in Stalingrad was the turning point of World War II. Here two women pull their belongings through the ruined city in 1942.

To Berlin

"To Berlin. 1952 km." The Germans erected signposts like this along the roads to Moscow. 1941.

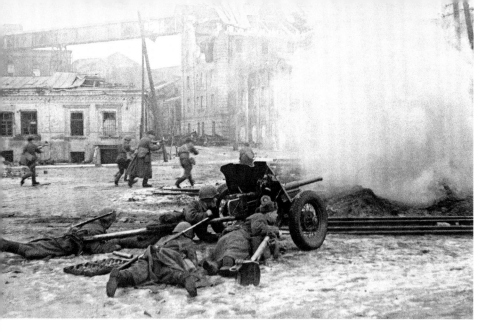

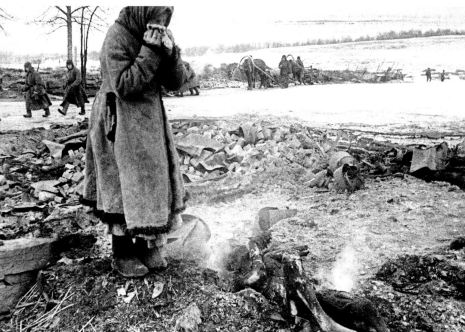

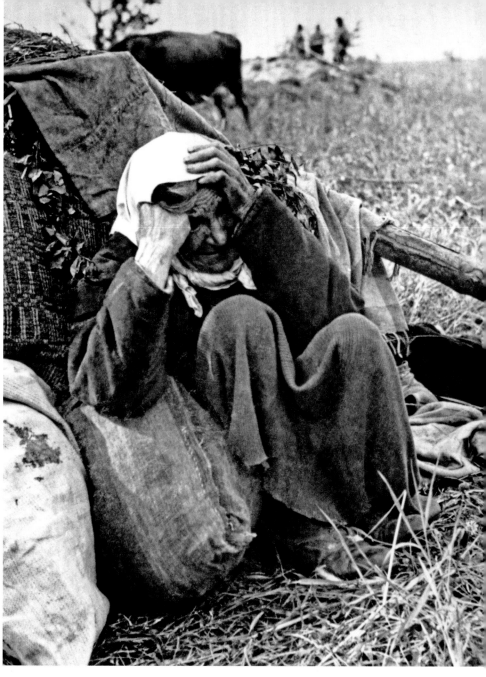

TOP
Gateway to the Caucasus
Soviet troops battle to dislodge Germans from the city of Rostov-on-Don in Southern Russia in 1943. The Nazis had occupied the city once before, in 1941, and were forced to retreat before retaking it a year later, in 1942. The back-and-forth fighting resulted in heavy destruction and casualties, with more than one hundred thousand Red Army soldiers killed. The Germans lost about fourteen thousand troops.

ABOVE
Massacre
A woman mourns over victims of the March 10, 1943, massacre in the village of Bolshevo in Smolensk. While retreating from the village, the Germans inflicted bloody reprisals on the locals.

ABOVE
Casualty of War
A peasant woman sits with her belongings at the front near the Dvina River in 1944. As usual in Russia, peasants—killed, starved, captured, evacuated, dispossessed—suffered terribly in the war.

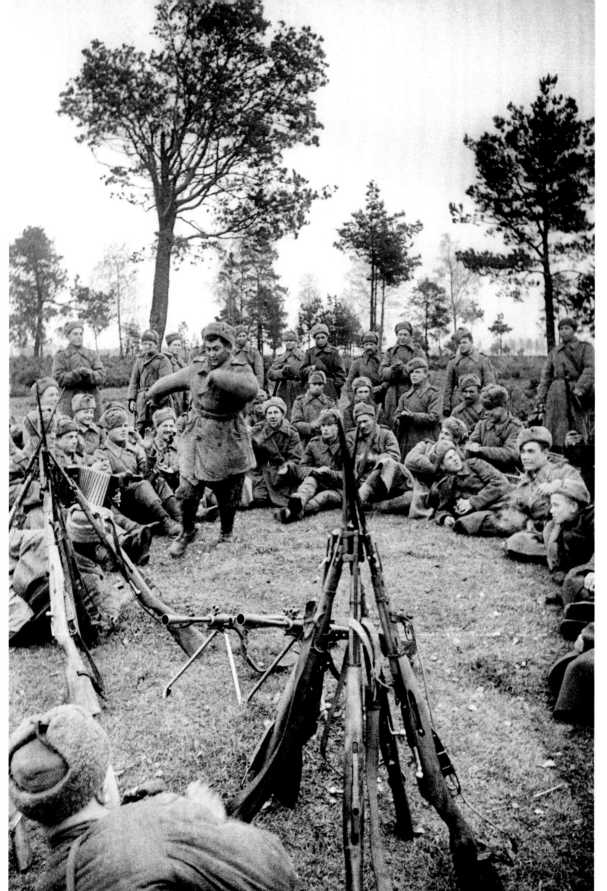

Impromptu Performance
A soldier performs a folk dance during a respite from fighting on the Byelorussian front in 1944. Soviet morale was high. The Red Army had won the battles of Stalingrad and Kursk, the Siege of Leningrad had been lifted, and the push to Berlin was underway.

Berlin Falls
This is one of a sequence of famous photos showing Soviet soldiers flying the Hammer and Sickle over the German Parliament Building, the Reichstag, the most recognizable building in Germany. The photos are as iconic as the image of U.S. Marines raising the American flag on Iwo Jima. Berlin, 1945.

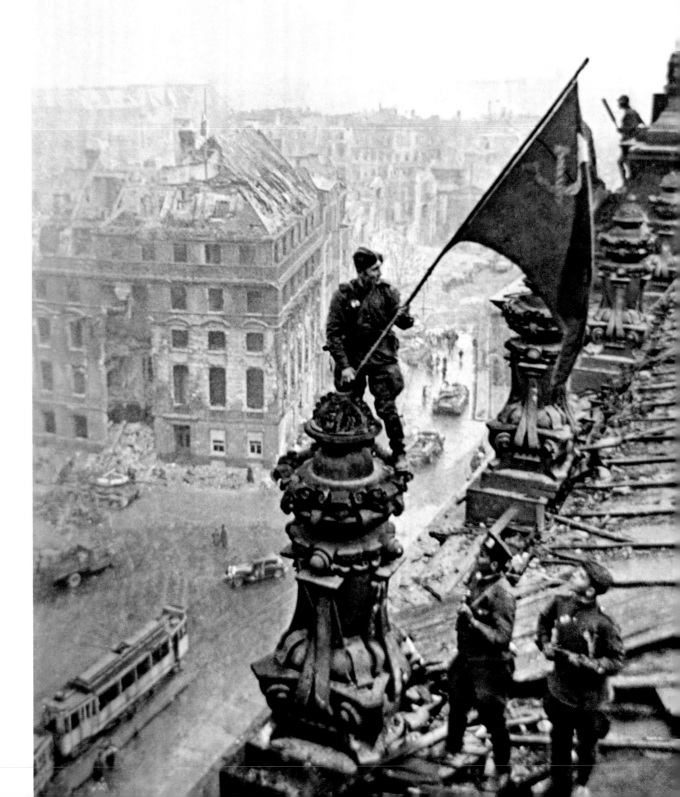

At the New Front
Soldiers from the 159th Rifle Division eat after a clash
with Japanese troops on the far eastern front in 1945.
The Red Army had periodic clashes with the Japanese
throughout the war, but war was not officially declared
until the summer of 1945, after Germany's surrender.

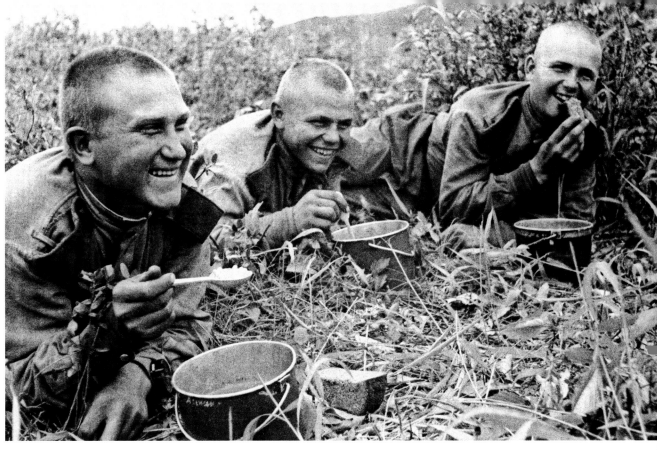

Conquering Heroes
Jubilant soldiers return from the front. The banner
reads, "We come from Berlin!" Byelorussia, 1945.

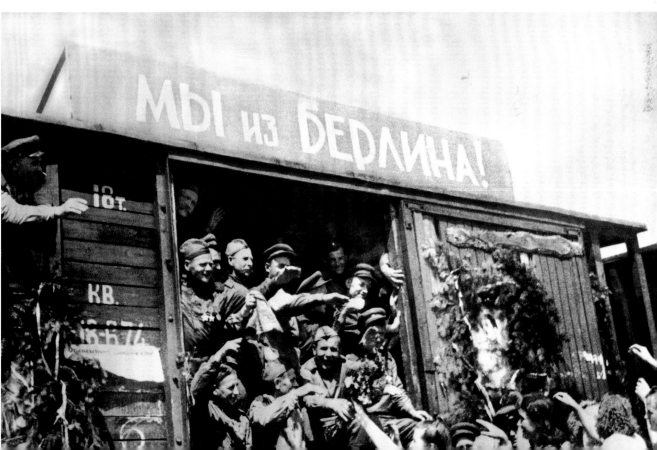

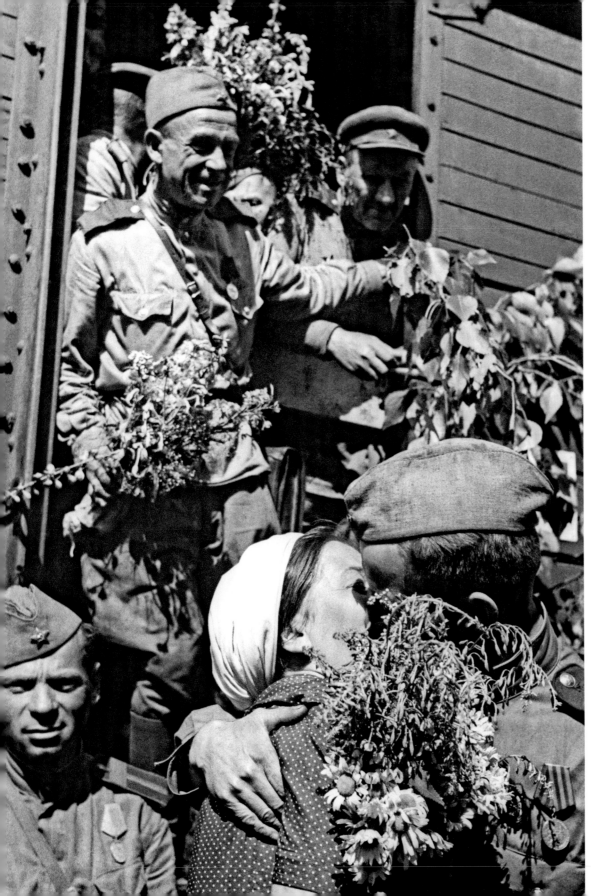

Homecoming
In a scene repeated throughout the Allied countries, returning soldiers are joyously welcomed home. In the Soviet Union, however, not all homecoming scenes were so happy. Stalin ordered many soldiers who had been POWs sent to the Gulag on charges of foreign contamination. Circa 1944.

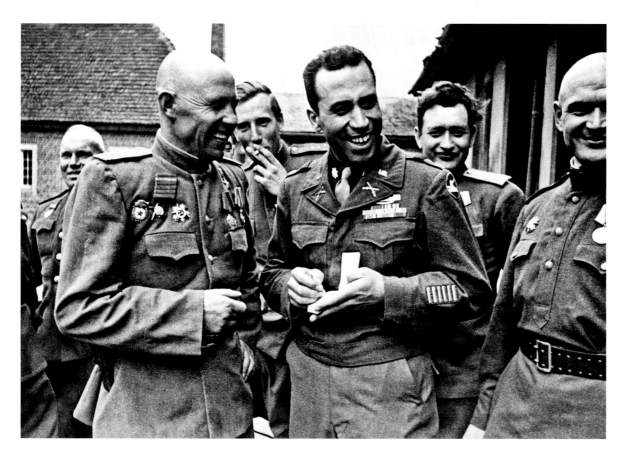

Allies

Soviet and American officers meet in early 1945. The camaraderie in this photo was soon replaced by wariness and mistrust, as the two countries jockeyed for position and power in postwar Europe. Germany, 1945.

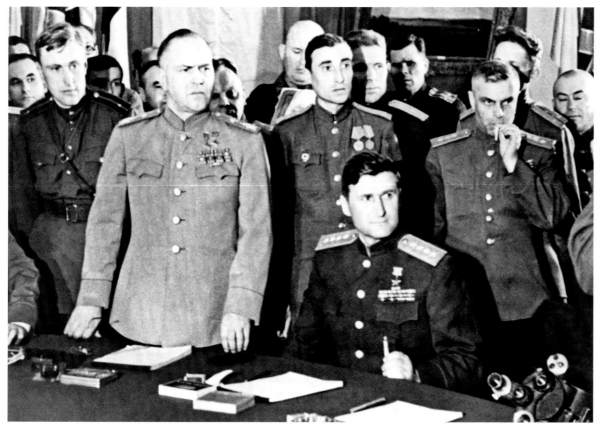

The Surrender

Marshal Zhukov (standing, both hands on the desk) glares at his German counterparts during the signing of the declaration of surrender of Nazi Germany in Berlin on May 8, 1945.

143

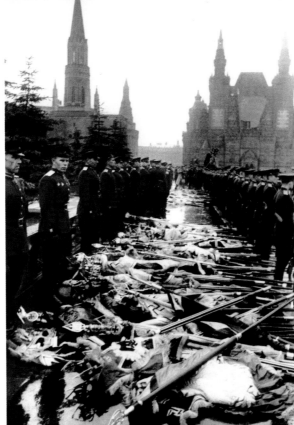

ABOVE, LEFT TO RIGHT
Leaving His Mark
Keeping alive a tradition stretching back thousands of years (Greeks left graffiti in Egypt, Romans in Greece), victorious soldier Sergei Platonov leaves his mark on a column of the German Parliament Building, the Reichstag. Berlin, 1945.

Spoils of War
Captured German military flags lie heaped on the stones of Red Square during the victory parade following Germany's surrender. Moscow, 1945.

Sappers on Parade
Combat engineers march across Red Square with their mine-sniffing dogs during the Victory Parade in 1945. The Battle of Stalingrad in particular featured trench and sewer warfare, with the two sides tunneling under each other in order to lay charges.

LEFT
Restoration
Workers labor to restore the Hermitage Museum in Leningrad, which had been damaged by enemy artillery during the siege. German troops were brutally callous toward Russian culture. They utilized the Catherine Palace in Tsarskoe Selo as a horse stable. Its Amber Room (adorned with 100,000 pieces of carved amber) as well as countless other treasures were hauled off and have simply disappeared. Leningrad, circa 1945.

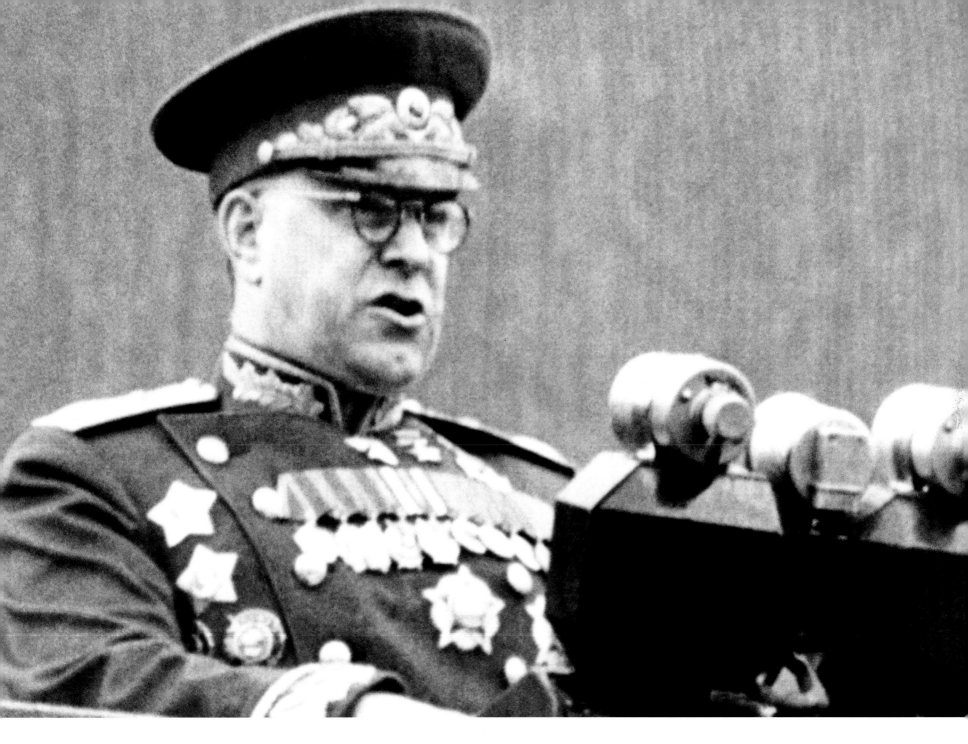

The Victor

Georgi Zhukov was the prime architect of the Soviet victory. He spearheaded the defense of Leningrad and Moscow and took Berlin. Here he speaks at the Victory Parade in Moscow following the Nazi surrender in 1945. Jealous of his popularity, Stalin later dismissed Zhukov. He became defense minister under Khrushchev, overseeing the invasion of Hungary in 1956.

The Big Three

With the fate of postwar Europe hanging in the balance, Winston Churchill, Franklin Roosevelt, and Josef Stalin (left to right) meet with their military counselors at Yalta in the Ukraine in February 1945. Stalin's primary goals were to establish the Eastern Europe Soviet bloc and annex eastern Poland as a buffer against any attack from the west. He accomplished both.

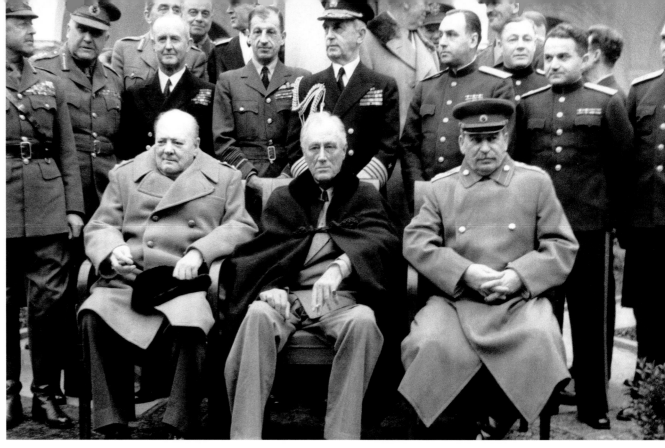

The Cold War Begins

Soviet artillery on the move in the Soviet sector of Berlin in 1945, after the fall of the city. The Soviet military presence in Berlin was soon concentrated in the eastern part of the city. With the division of the city—and the country—into east and west halves, the cold war began.

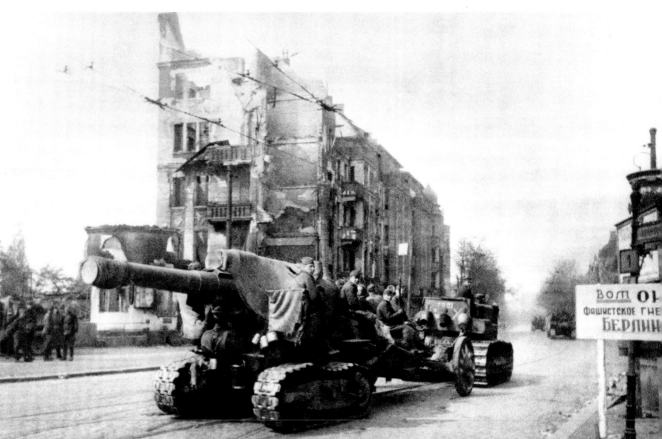

Potsdam

After the unconditional surrender of Nazi Germany, British prime minister Clement Attlee, U.S. president Harry Truman (who succeeded Franklin Delano Roosevelt after his death in April 1945), and Josef Stalin (front row, left to right) meet in Potsdam, outside Berlin, to partition Europe and administer war crimes trials. (Attlee replaced Winston Churchill, who had been voted out of office midway through the conference.) It was here that Truman made vague references to Stalin about America's newly developed atomic bomb, not knowing that the Soviet leader's spies had informed Stalin months before. July or August 1945.

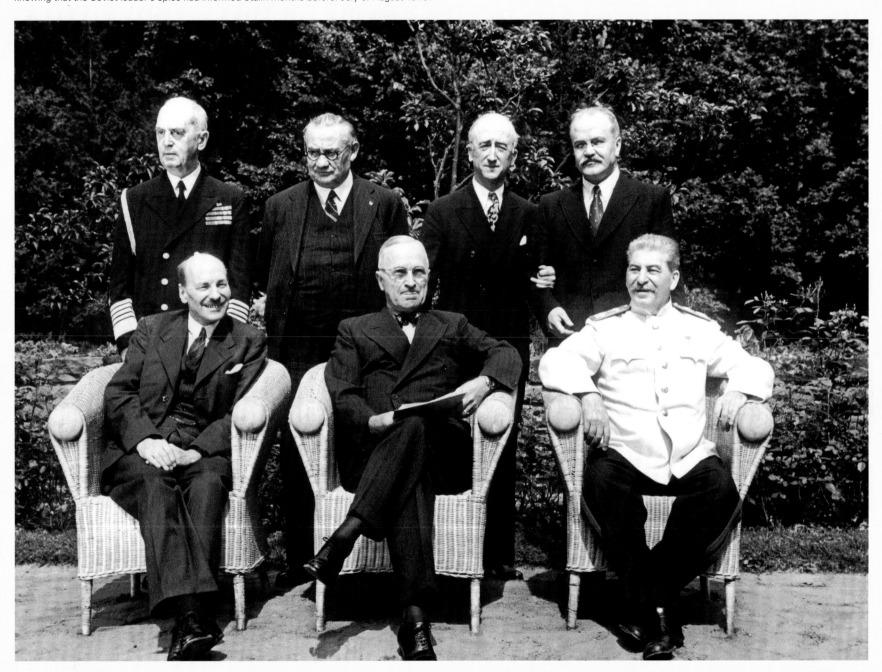

1905 - 19
- 1941 - 1
1964 - 19
- 2005

THE THAW

17 – 1927
953 –
84 – 1991

THE SOVIET IMAGE

1905

1917

1927

1941

1953 –

1964

1984

1991

2005

THE THAW

"THE SPIRIT WRENCHED ITSELF FREE OF THE FLESH"

At 4:00 a.m., March 6, 1953, the Soviet people received the news: Josef Stalin, "Man of Steel," "Father of the Peoples," "Supreme Commander," and the "Greatest Genius of All Times and Nations," was dead. The unquestioned "Great Leader" of the Soviet Union for nearly three decades, Stalin had suffered a cerebral hemorrhage at the age of seventy-three.

The Great Leader's intimate comrades had known he was dying for days. A handful of his inner circle—Deputy Premier Georgi Malenkov, secret police chief Lavrenti Beria, Armed Forces head Nikolai Bulganin, former minister of agriculture Nikita Khrushchev—had spent the night of February 28 with Stalin, watching a movie at the Kremlin, followed by a late dinner at his dacha just outside Moscow. "As usual dinner lasted until around five or six o'clock in the morning," Khrushchev recalled. "Stalin was pretty drunk after dinner and in very high spirits. He didn't show the slightest sign that anything was wrong with him physically. . . . So after this particular session we all went home happy because nothing had gone wrong at dinner. Dinners at Stalin's didn't always end on such a pleasant note."

The next day, Sunday, passed silently. That was unusual—Stalin usually arose before noon and rang for food. Guards noticed a light in his darkened room, but the call never came. They were forbidden to enter unless ordered to do so. Finally, shortly before midnight, Stalin's maid went in to check on him. She found him lying on the floor, unable to speak, his pants soaked with urine. His watch read 6:30 p.m. It appeared he had fallen, breaking the watch. He seemed to have suffered a stroke. The guards carried him to a sofa and alerted their superiors.

By the time Beria, Malenkov, and Khrushchev returned to the dacha, Stalin was asleep, snoring loudly. He wasn't seen by a doctor until morning.

This long delay in providing medical help has prompted the speculation that he may have been murdered. Certainly Stalin's son, Vasily, thought so. "You bastards, you murdered my father!" he screamed as Stalin lay dying. A few days later Beria himself

bragged to Molotov, "I did away with him. I saved all of you."

Murder was a familiar Kremlin strategy, and no one was better at it than Stalin. The instigator of some twenty million deaths during the 1930s, he was one of the most notorious mass murderers in history. His colleagues knew only too well his homicidal nature—they themselves had helped to facilitate the killings. And they had witnessed—or, at Stalin's orders, arranged—killings of a more personal nature, liquidations of his political opponents, even those who previously enjoyed the Great Leader's favor.

In his later years, Stalin had become more distrustful and suspicious than ever, to the point of paranoia. Declaring in a 1952 Politburo session, "Every Jew is a nationalist and potential agent of the American intelligence," he arrested thirty-seven of the most prominent doctors in the USSR—most of them Jews—accusing them of a plot to poison top political and military leaders. With a *Pravda* headline shouting, "Vicious Spies and Killers under the Mask of Academic Physicians," hundreds more were sent to the Gulag or executed. He was plotting to carry out a widespread pogrom, exiling thousands of Soviet Jews to newly constructed Gulags in the Far East. Beria, Malenkov, Khrushchev, and the others had to wonder whether Stalin's 1930s-style terror was back—and whether they were on the hit list.

It is no surprise, then, that when doctors finally did arrive at the dacha, they were terrified. The physician in charge approached Stalin with hands shaking, afraid even to touch him. A dentist removed Stalin's false teeth, only to drop them on the floor. The stricken leader's lungs were x-rayed, two electrocardiograms were performed, leeches were applied to his back and neck, but a nearby respirator was never used. Every procedure required approval from the hovering group of politicians, themselves terrified and incompetent to make medical decisions.

From time to time Stalin regained consciousness. While being spoon-fed soup and green tea, he smiled and pointed to a painting of a little girl feeding a lamb from a horn, as though acknowledging his own feeble predicament. Khrushchev recalled, "Then he began to shake hands with us one by one. I gave him

my hand, and he shook it with his left hand because his right wouldn't move. By these handshakes he conveyed his feelings."

Stalin's last day was a slow and painful decline into death. In her memoirs, his daughter, Svetlana, twenty-seven at the time, remembered: "His face altered and became dark. His lips turned black and the features grew unrecognizable. . . . At what seemed like the very last moment he suddenly opened his eyes and cast a glance over everyone in the room. It was a terrible glance, insane or perhaps angry and full of the fear of death. . . . Then something incomprehensible and awesome happened that to this day I can't forget and don't understand. He suddenly lifted his left hand as though he were pointing to something above and bringing down a curse on us all. . . . The next moment, after a final effort, the spirit wrenched itself free of the flesh."

"NO ONE'S AFRAID OF YOU NOW"

Stalin's death was a profound shock for the Soviet people. From March 6 to 9, while Beria's police sealed off the city with tanks and flamethrowers and restricted access to main thoroughfares, Stalin's body lay in state in Moscow's Hall of Columns, where Lenin himself had been mourned. Crowds by the thousands lined up in the snow to file past the open coffin. Among them was the great Bolshoi ballerina Maya Plisetskaya.

Plisetskaya was Jewish. Her father had been proclaimed a national hero for his work on behalf of the Soviet coal industry, but during the terror of the late 1930s, Stalin executed him and deported Plisetskaya's mother to a camp in Kazakhstan. At the age of eleven, dependent upon her extended family for survival, Plisetskaya was officially labeled a "daughter of an enemy of the people." But none of that prevented her from coming to see Stalin's body. Her experience illustrates the hold the Great Leader had on the Soviet people, the dread he inspired, and the long-suppressed emotions liberated by his death.

"The Hall of Columns . . . was draped with black crepe," she recalled in her memoirs. "There was a symphony orchestra on the stage behind a black muslin curtain, and a vague silhouette of the conductor. The sounds of slow classical music. It sounded like Beethoven. I approached the coffin. Duped out of my wits by the propaganda, I wiped a tear. How would we ever live now? We would perish, we should die. Behind me, a man suddenly said in a half-whisper, 'No one's afraid of you now.'"

Bonfires blazed throughout Moscow. Despite the cold, people sang and played balalaikas while the funeral procession made its journey from the Hall of Columns to Red Square. Nine pallbearers carried the coffin, led by Malenkov and Beria and including Bulganin, Molotov, Khrushchev, and Stalin's son, Vasily. As people surged toward the procession, thousands were trampled or crushed between buildings and security trucks. Hundreds died. For some, here was evidence that even in death, Stalin was to be feared.

Stalin's embalmed body was laid to rest inside Lenin's red granite mausoleum, next to that of the Bolshevik revolutionary himself. At precisely noon, a salute of bells, guns, factory whistles, and ships' sirens erupted all across the Soviet Union, just as at Lenin's last rites.

"A VERY PRIMITIVE MAN"

Stalin was followed by an unlikely successor. Nikita Khrushchev—volatile, roly-poly, the son of peasants and a man of exuberant emotions and colorful, earthy language—was considered by other party officials little more than a crude functionary. "Khrushchev wasn't stupid," declared Molotov, "but he was a man of meager culture. . . . Khrushchev reminded me of a fishmonger, a petty fishmonger, or a man who sold cattle. . . . He was a very primitive man."

Though uneducated, Khrushchev was energetic and ambitious. He had clawed his way up from his beginnings as a miner and factory worker to the head of Moscow's Communist Party and minister of agriculture. He doted on Stalin, and the leader seemed to enjoy his roughhewn commonness and seeming lack of guile. He was often the butt of jokes. Stalin liked to make him perform the traditional Ukrainian folk dance, *gopak,* with its deep squats and kicks. "I had to squat

THE SOVIET IMAGE

1905

1917

1927

1941

1953 –

1964

1984

1991

2005

THE THAW

down on my haunches and kick out my heels, which frankly wasn't very easy for me. But I did it and I tried to keep a pleasant expression on my face," he recalled in his memoirs. "When Stalin says 'dance,' a wise man dances." Once Beria scrawled *prick* on a piece of paper and pinned it to the back of Khrushchev's overcoat.

As Stalin had established no line of succession, Malenkov and Beria were the likely heirs-apparent. The two of them conducted a series of meetings among the top party officials to select the new leadership. Malenkov, intellectual, knowledgeable, reasonable—the anti-Stalin—and an efficient administrator, quickly inherited the top job as chairman of the Council of Ministers—in effect, prime minister of the Soviet Union. Beria became deputy chairman. He also was appointed head of the Ministry of Internal Affairs, which grew larger to include authority over the secret police. As such, he was the second-most-important person in the USSR. Molotov was named foreign minister. And Khrushchev soon became first secretary of the Communist Party—third in command.

The arrangement didn't last. Khrushchev, overlooked and underestimated, orchestrated a series of strikes that realigned the top leadership, removing rivals and installing himself in the prime position of power. First to go was Beria. Khrushchev promoted accusations that Beria was a British spy, leading to his arrest and execution. Soon afterward he demoted Beria's secret police from ministry status to that of a committee, with a new name, KGB (Committee for State Security). Next to go was Malenkov. Accusing him of being an ally of Beria and too liberal in his thinking, Khrushchev eased him out as chairman of the Council of Ministers, while allowing him to remain as a deputy in the party executive committee, the Presidium. Molotov lasted longer, but he consistently opposed Khrushchev's actions and finally had the bad judgment to become involved in an abortive coup attempt against the emerging leader. In 1957, Khrushchev fired him as foreign minister, expelled him from the Politburo and Central Committee, and banished him to the post of ambassador to Outer Mongolia.

Although neither his official titles nor public exposure advertised it, by early 1954, just a year after Stalin's death, Khrushchev was the most powerful man in the government. Operating behind the scenes, he quietly installed his supporters in key positions (including head of the KGB), and positioned himself so that all major decisions had to go through him. Power in hand, he began to establish a leadership style marked by bold, high-profile changes and reforms, including opening the Kremlin to the public. The medieval fortress had been a secure stronghold for the chosen few. (Stalin had lived within its walls, as did Molotov and other higher-ups.) Imposing and frightening, it was forbidden territory for common people; to photograph it was a crime. Khrushchev delighted in walking the grounds with the throngs of Russian tourists, and held a New Year's Eve Youth Ball within the walls. It was a highly symbolic opening-up.

In another bold stroke, he sought to solve the USSR's chronic crop shortages by developing thousands of acres of "Virgin Lands" in Kazakhstan and western Siberia—no matter that locals in these areas opposed this move or that knowledgeable advisors bold enough to speak the truth thought the plan worthless. By the spring of 1954, some three hundred thousand Komsomol (Young Communist) "volunteers" had answered Khrushchev's call to work the hinterlands, even though many had no experience with farming whatsoever. Thousands of tractors and other pieces of farm equipment were also diverted, further depleting production in existing farmlands. At first the effort produced excellent harvests, but soon, because of problems with climate in the newly cultivated areas, choice of crops, and lack of equipment and labor, it failed. For the moment, however, the Kremlin leadership praised Khrushchev for his decisive action. It was a taste of things to come.

"A GRAVE ABUSE OF POWER"

Khrushchev admired Stalin—"I'll say it straight: I valued him highly and strongly respected him"—but he had no illusions about the character of his mentor or the health of the Soviet Union he had left behind.

The Great Leader had accomplished much. He had transformed a backward peasant country into a modern industrial power. He had brought education

to a superstitious, illiterate people. For better or worse, he had created the Soviet system. But for all his industrial and military might, his methods—brute force and terror—had created a fearful and suspicious society, in which looking over one's shoulder was a way of life, and nearly two-and-a-half million people were imprisoned in labor camps. The intelligentsia were routinely squelched and persecuted, personal initiative was discouraged, and goods and housing were constantly in short supply, as was food. The cold war had poisoned relations with the West, anti-Soviet movements were boiling to the surface in Eastern European satellite countries, and newly Communist China, with the uncertain potential of its enormous population, and an enigmatic leader, Mao Zedong, who Stalin mocked as a "caveman Marxist," loomed worrisomely at the border. Deceit and corruption were endemic in government at all levels. Fear of Stalin's power had sustained such mind-deadening dysfunction. His successors knew things had to change.

In February 1956, more than fourteen hundred delegates from the USSR and Eastern European Communist countries descended on the Kremlin for the Twentieth Congress of the Soviet Communist Party. It was the first congress since Stalin's death. On the last day of the event, after ten days of meetings, delegates from the Soviet Union only (no Eastern Europeans or other foreigners were allowed) crowded into the Great Kremlin Palace for a closed session. Khrushchev stepped to the podium.

"Comrades!" he began. "It is impermissible and foreign to the spirit of Marxism-Leninism to elevate one person, to transform him into a superman possessing supernatural characteristics akin to those of a god. . . . Such a belief . . . about Stalin was cultivated among us for many years."

While the delegates listened with open-mouthed astonishment and increasing discomfort, Khrushchev proceeded to excoriate Stalin for four hours. Stalin was guilty of "a grave abuse of power," practicing "brutal violence." He had originated the concept "enemy of the people," which he used as a catch-all condemnation for "physically annihilating" individuals who disagreed with him. "Mass arrests and deportations of many thousands of people, exe-

cution without trial and without normal investigation, created conditions of insecurity, fear, and even desperation."

Khrushchev attacked Stalin for incompetent wartime leadership, for self-adulation, for the ruination of agriculture, and for never traveling outside Moscow, so that he "knew the country and agriculture only from films. And these films had dressed up and beautified the existing situation in agriculture." And was any of this the fault of Khrushchev or the rest of the Kremlin leadership? No. "Did we tell Stalin about this? Yes, we told him, but he did not support us.

"Stalin was a very distrustful man, sickly suspicious. . . . He could look at a man and say: 'Why are your eyes so shifty today?' . . . Everywhere and in everything he saw 'enemies,' 'two-facers,' and 'spies.'" And perhaps most damning of all, Stalin had betrayed Lenin. Lenin himself advised deposing Stalin—Khrushchev produced documents written by Lenin to prove so. "Comrades!" Khrushchev declared, "I will not comment on these documents. They speak eloquently for themselves."

Khrushchev's speech effectively declared independence from the suffocating Stalinist legacy. (And it didn't stay secret for long. With Khrushchev's blessing, it quickly was dispersed throughout the Soviet Union and beyond. By April even the American CIA had received a copy.) A few years later, at the Twenty-second Party Congress, in October 1961, Khrushchev finished the job. He ordered Stalin's body removed from Lenin's tomb, relocated to a nearby site alongside the Kremlin Wall, and buried under truckloads of cement—as though precautions had to be taken lest the Man of Steel escape.

The break was necessary, the boldest and most courageous move Khrushchev ever made, but it was also a huge risk. Khrushchev's efforts to scale back decades of repression and censorship, an opening-up that came to be known as "the Thaw," posed unpredictable and potentially dangerous results. "We were scared—really scared," Khrushchev later recalled in his memoirs. "We were afraid the thaw might unleash a flood, which we wouldn't be able to control and which would drown us."

THE SOVIET IMAGE

1905

1917

1927

1941

1953 -

1964

1984

1991

2005

THE THAW

"RUSSIANS GO HOME"

The Eastern European satellite countries had long resented Soviet domination. Now Khrushchev was discrediting their tormentor, Stalin—could the reforms be pushed further? The Poles were the first to react. In June 1956 a strike and antigovernment riots broke out in the Polish town of Poznan. The outburst lasted two days, with more than seventy killed and hundreds injured. The Soviets blamed the unrest on "enemy agents," but the Poles would have nothing to do with that familiar line of propaganda. They stated that the only way to calm things down was by "democratization." Khrushchev had used many strong words in his speech, but *democratization* was not one of them. In the following months, Soviet warships massed in the Baltic Sea off northern Poland, and Soviet tanks encircled Warsaw. But the Poles stood firm—and Khrushchev was hesitant to use force. In the end, an uneasy compromise was reached: the USSR would relax its demands on Poland (collective farms were no longer mandatory, for example) in exchange for stronger military ties between the two countries.

Next was Hungary. On October 23, 1956, in sympathy for the people of Poland, thousands of Hungarians rose up against their Russian-imposed Communist government. By dusk some two hundred thousand people (about one-sixth of the population of the city) had massed in Budapest's Parliament Square. When government authorities turned off the streetlights, people set fire to newspapers and government leaflets. When the state radio station refused to broadcast the demonstrators' views, a battle began outside the radio building, with Russian-trained security police firing into the crowd. Enraged, demonstrators hunted down security guards and lynched them from lampposts. Amid shouts of "Freedom" and "Russians Go Home," someone cut the Communist hammer and sickle out of a Hungarian flag. Suddenly the revolution had a flag: red, white, and green, with a hole in the middle.

All across Hungary, millions joined the uprising. The rebels' demands included the withdrawal of Soviet troops, free elections, and freedom of the press—none of which Moscow would even consider granting. A relatively civil stalemate over a relatively small Polish protest was one thing; this was a budding, full-fledged revolution. Khrushchev had decided against the use of force in Poland—but he couldn't afford to appear weak in the face of this more severe threat.

On November 4, 150,000 Soviet troops and 2,000 tanks advanced through Hungary. They found themselves facing barricades and Molotov cocktails; students armed with kitchen implements and gasoline, children barely into their teens; and antitank tactics that included loosening cobblestones, soaping roads, and blanketing streets with bales of silk soaked in oil. Children snuck up and smeared jam over tank drivers' windows. Yet every day tanks rumbled through Budapest, shelling buildings at point-blank range. At night, heavy artillery bombarded the city from the surrounding hills. By November 7—the anniversary of the Russian Revolution—the Hungarian Revolution was, to all intents and purposes, over. The French newspaper *Le Figaro* declared, "The Red Army now occupies Budapest. It is red with the blood of the workers."

In the end, some twenty thousand Hungarians (and fifteen hundred Soviet soldiers) died. Thousands more were imprisoned. Rueful and sardonic posters sprang up around Budapest. "Proletarians of the World Unite—but not in groups of three or more." And an ironic joke made the rounds: "Do you know where we went wrong in October? We interfered in our own internal affairs."

Khrushchev had demonstrated that although he was trying to distance himself and his country from Stalin, when it came to a serious challenge to Soviet influence and power, he wasn't above using Stalinist measures. The Thaw was proving to be difficult.

"HE SO DIFFERS FROM STALIN"

On the home front, at least, Khrushchev was enjoying the benefit of the doubt. ("I like him ever so much," declared no less an authority than Andrei Sakharov

to fellow physicist Igor Tamm. "After all, he so differs from Stalin.") In 1957, Moscow hosted the World Youth Festival, attracting young people from around the world, who came with their music, styles, attitudes, and energy. Muscovites could hardly believe their eyes.

New filmmakers began fresh explorations of the Great Patriotic War and everyday Soviet life. Jazz and rock 'n' roll were being heard. (Young people bid each other good-bye with "See ya later, alligator.") Soviet museums hosted exhibitions of French and American art. Painters once again began to experiment with nonrepresentational styles. "We learned about the terrible and tempting word 'abstractionism,'" stated a young artist.

Yet although Khrushchev sanctioned the blossoming, he didn't necessarily approve of it. As always, he found himself grappling with the gulf between his best intentions and ingrained biases. And in typical blunt, outspoken style, he didn't hesitate to express his views. In 1962 he attended an exhibition of modern art near the Kremlin. As he inspected the avant-garde works, he became enraged. "It's dog shit!" he bellowed. "A donkey could smear better than this with its tail. The people and the government have taken a lot of trouble with you," he told a young artist, "and you pay them back with this shit."

It was too much for sculptor Ernst Neizvestny. Neizvestny, a former soldier in the parachute troops who had been in tighter spots, interrupted Khrushchev's rant to inform him that he knew nothing about art. "You may be Premier, but not here in front of my works of art," he shouted. "Here I am Premier, so we shall have a discussion on an equal basis." Although he won Khrushchev's grudging respect this time, Neizvestny was eventually expelled from the Artists' Union and deprived of the legal right to work as an artist in the Soviet Union. He emigrated to the United States in 1976. As for the exhibition, it quickly closed.

Literature, too, the bedrock of Russian artistic expression, began to reflect the new openness—and suffered similar backlashes. Journals appeared with names like *Youth, Young Guard,* and *Our Contemporary*. Science fiction and detective stories enjoyed a resurgence in popularity. A young Siberian poet named Yevgeny Yevtushenko, in protest against plans to build a sports center on a site in Ukraine where the Nazis murdered more than one hundred thousand people (eighty thousand of them Jews), published a poem entitled "Babi Yar," in which he excoriated Nazi and Stalinist atrocities and proclaimed his solidarity with the Jews. Yevtushenko and other young poets became wildly popular, giving sold-out readings in which they were treated like rock stars.

In 1956, Boris Pasternak submitted for publication a novel he had been working on for a decade. Pasternak had been one of the most popular poets in the country, his audiences knowing his work so well that if he overlooked a line during a reading, they would supply it for him. But he had run afoul of Stalin's culture police and had published little for years; he was forced to make his living as a translator. Now he was trying again. "I am already old," he wrote to a cousin, Olga Freydenberg. "I may die quite soon and I cannot postpone the free expression of my real thoughts until God knows when." Set largely during the Bolshevik Revolution and the ensuing civil war, the novel follows the impact of the turbulent times on the life of a passionate and reflective poet-doctor. But *Dr. Zhivago* was considered too subversive to be published.

Pasternak wouldn't give up. Remarking to friends, "You are hereby invited to watch me face the firing squad!" he smuggled the book to an Italian Communist publisher, who immediately put it into print. *Dr. Zhivago* was a sensation. It was translated into two dozen languages, and in 1958, Pasternak was awarded the Nobel Prize for Literature.

But at home, he quickly became a pariah. The newspaper of the Soviet Writers' Union, the *Literaturnaya Gazeta,* denounced him as "a literary Judas who betrayed his people for thirty pieces of silver—the Nobel Prize." *Pravda* labeled Pasternak a "lampooner who had blackened the socialist revolution." And Vladimir Semichnasty, the head of the young adult wing of the Communist Party, the Komsomol, called Pasternak "a pig who has fouled his own sty."

In retrospect it may be hard to understand why the novel caused such an uproar. Although it

THE SOVIET IMAGE

1905
1917
1927
1941
**1953 –
1964**
1984
1991
2005

THE THAW

refers to Lenin as "vengeance incarnate" and Stalin as a "pockmarked Caligula" (Khrushchev had said worse in his secret speech), the novel is at heart apolitical, a sustained, melancholy manifesto of love, of life, and of country.

Pasternak was soon expelled from the Writers' Union and forced to decline his Nobel Prize. Ill and broken, he died two years later, in 1960, at the age of seventy. At his death, the KGB seized all his papers and arrested his lover—and inspiration for the character Lara in *Dr. Zhivago*—Olga Ivinskaya. She was banished to a labor camp in Mordovia, some two hundred miles southeast of Moscow, and the papers to the Soviet Archives in Moscow.

Dr. Zhivago was made into an acclaimed Holly-wood movie in 1965 and a television miniseries in 2002. In 1987 the novel was finally published in the USSR. Pasternak was posthumously reinstated to the Writer's Union, and Ivinskaya was rehabilitated back into Soviet society. She died in 1995, having made a personal plea to then-president Boris Yeltsin for the return of Pasternak's papers and letters. They were not returned.

"WE MUST TELL THE TRUTH"

In 1961 a forty-two-year-old mathematics teacher named Alexander Solzhenitsyn in the town of Ryazan submitted to the Moscow literary magazine *Novy Mir (New World)* a novella he had been composing in secret. "During all the years until 1961, not only was I convinced that I should never see a single line of mine in print in my lifetime, but, also, I scarcely dared allow any of my close acquaintances to read anything I had written because I feared that this would become known. Finally . . . this secret authorship began to wear me down. . . . I decided to emerge and to offer *One Day in the Life of Ivan Denisovich*."

The novella is the simple story of a day in a Soviet forced-labor prison camp—that is (to use the term that, thanks to Solzhenitsyn, became familiar worldwide), a Gulag. The central character, Ivan Den-isovich Shukov, is a peasant and former World War II soldier whose "crime" was to escape the Germans

and return to his own lines. But because any contact with the enemy was considered compromising, he was sentenced to the Gulag as a spy.

Once there, Ivan simply tries to stay alive. Everyone cheats. Everyone steals. He can trust no one. The only law is "the law of the taiga"—the law of the jungle. "Apart from sleep, the only time a prisoner lives for himself is ten minutes in the morning at breakfast, five minutes over dinner, and five at supper." When he survives from morning until night, he counts that day "almost a happy day. . . . They hadn't put him in the cells; they hadn't sent his squad to the settlement; he'd swiped a bowl of kasha at dinner; the squad leader had fixed the rates well; he'd built a wall and enjoyed doing it; he'd smuggled that bit of hacksaw blade through; he'd earned a favor from Tsezar that evening; he'd bought that tobacco. And he hadn't fallen ill."

Years after the *Dr. Zhivago* affair, when his son, Sergei, gave him a samizdat copy of the book, Khrushchev expressed regret: "We shouldn't have banned it. I should have read it myself. There's noth-ing anti-Soviet in it." When *Ivan Denisovich* was sent to him, he read the book. In contrast to Pasternak's Yuri Zhivago, an aristocrat whose privileged life was turned upside down by the Revolution, Solzhenitsyn's hero was a peasant trying to cope with an unjust and brutal imprisonment. As he shared similarly humble origins, Khrushchev might have identified with Ivan's plight. He was taken with the book. "It made the reader react with revulsion to the conditions in which Ivan Denisovich and his friend lived while they served their terms," he stated. Surprising almost everyone, perhaps even himself, he authorized publication. "We must tell the truth about that period," he explained. "Future generations will judge us, so let them know what conditions we had to work under, what sort of legacy we inherited."

One Day in the Life of Ivan Denisovich was published in *Novy Mir* in November 1961. It was an immediate best-seller. Until then no Soviet writer had tackled this terrible trademark of the Stalin era. Had Solzhenitsyn attempted to do so a decade ear-lier, he would have found himself dispatched back to the Gulag for the rest of his life—or worse. Now he found himself acclaimed as the moral conscience of

his country, his era's Pushkin or Dostoyevsky. As long as Khrushchev remained in power, he was safe. When only a few years later the tide changed, so changed his fortunes. As he personified the apex of openness during the Thaw, he would come to personify the nadir of repression in the stagnation to follow.

"IT'S GOING TO BE A COLD WINTER"

"We will bury you." — Nikita Khrushchev

Although some have suggested that Khrushchev's famous statement, "We will bury you," delivered in 1956 to a Moscow reception of Western ambassadors, was not as belligerent as it seemed, and was no more than a typically blustery boast that history was on the side of Communism, it wasn't received calmly in the West. The Soviet Union was in the process of crushing the Hungarian uprising. It possessed a huge and menacing army—and nuclear weapons. Relying on top-secret information stolen from America's Los Alamos nuclear laboratory, the USSR had exploded its first atomic bomb in 1949, just four years after American A-bombs destroyed Hiroshima and Nagasaki. It detonated its first true hydrogen bomb in 1955, only three years later than the Americans. It was developing intercontinental ballistic missiles. The cold war was at its chilliest. Nevertheless, Khrushchev turned to the West in his ongoing attempt to reverse the USSR's chronic food shortages.

He had assured the Soviet people that they would catch up with America in the production of meat, milk, and butter per head within years, but the pledge was not being fulfilled. His Virgin Lands project was underway but was not returning the kind of yields he had promised. (Although in some cases it was hard to know for sure, as officials tended to report what Khrushchev wanted to hear. Alexei Larionov, the party boss in Solzhenitsyn's home area of Ryazan, promised Khrushchev that he would triple Ryazan's meat production in a year. His reports seemed to back him up—until it was discovered that he had slaughtered every single livestock animal he could find, including dairy cows

and breeding animals; commandeered and killed cows and pigs from private herds; and purchased animals for slaughter from as far away as the Urals. He even made taxes payable in meat. When found out, Larionov shot himself to death.)

Khrushchev decided that adopting a bit of American know-how would turn the tide. In particular, he focused on a crop that not only could be a staple of the human diet but was perfect for feeding livestock: corn. After hearing about a Khrushchev speech calling for an Iowa-style corn belt in Russia, the *Des Moines Register* invited him to come see for himself. Khrushchev sent his deputy minister of agriculture, who returned to Moscow to announce, "That which the Americans have taken decades to achieve, we can manage to do in just a few years."

Thus began an unlikely partnership between the cantankerous Soviet boss and an equally cantankerous Iowa corn farmer named Roswell Garst. When Garst visited Khrushchev at his dacha in the fall of 1955, the two got on famously. Garst asked Khrushchev how a country that could steal information about how to build an atomic bomb could know so little about American agriculture. "You locked up the atomic bomb, so we had to steal it," Khrushchev replied. "When you offered us information about agriculture for nothing, we thought that might be what it was worth." Khrushchev bought five thousand tons of hybrid corn seeds from Garst. Soon Khrushchev became known as *kukuruznik*, the "corn freak."

Although the climate, soil, and other considerations made farmland in the USSR unsuitable for raising corn, Khrushchev ordered some eighty-five million acres planted with the crop. Only sixteen million could be harvested. And because millions of acres of hay fields had to be plowed under so as to be converted to corn, the availability of that reliable source of animal feed plummeted. Soon meat and dairy prices shot up. Shouting "Cut up Khrushchev for sausages," people in the town of Novocherkassk rioted and had to be put down by troops and tanks. The plan was not working. In the end, Khrushchev was forced to import Canadian wheat.

His contradictions played themselves out in other ways as well. He authorized a crackdown on

THE SOVIET IMAGE

1905

1917

1927

1941

1953 –

1964

1984

1991

2005

THE THAW

religion—which was seen as undermining the power of the state—demolishing churches and cutting in half the number of Orthodox parishes in the country to less than eight thousand in just ten years. Muslims, Jews, and Buddhists were also harassed. At the same time, he rehabilitated between eight and nine million Gulag victims. Even though most pardons were posthumous, a flood of ex-prisoners brought their stories back to cities and towns across the USSR.

He improved living conditions for Soviet citizens. Refrigerators, washing machines, and televisions became available; rent and fuel were inexpensive. He built massive apartment complexes, with floor plans that afforded families more privacy than the shared facilities of Stalin's collective apartments. (They became known, irreverently, as *khrushcheby,* a pun on his name and the word for "slums.") Yet for most, life continued to be hard. The Kremlin continued to control and censor the media. Stalin's dense system of informers remained. And travel was almost impossible. The few Soviets fortunate enough to go abroad were required to write reports on foreigners they met and leave behind a close family member to ensure their return.

Khrushchev himself traveled—throughout the Soviet bloc, abroad for a summit meeting with President Dwight D. Eisenhower in Geneva, and to America for memorable visits in which he toured his beloved Iowa corn belt and visited Hollywood. ("I could tell Khrushchev liked me," gushed Marilyn Monroe. "He smiled more when he was introduced to me than for anyone else.") But, to his disappointment, he couldn't go to Disneyland, as the Los Angeles Police Department refused to guarantee his safety without vacating the entire park. During another visit, he attended a United Nations meeting, in which he protested a speech accusing the USSR of oppressing Eastern Europe by banging the table with his shoe.

He authorized a Moscow presentation of U.S. customs and culture entitled the American National Exhibition, which was officially opened by then vice-president Richard Nixon. The two men did not get along. Their meeting culminated in an encounter in a model American "Miracle Kitchen," in which Khrushchev, considering the exhibit a rebuke, insisted that his country had fancy appliances like those, too. A long argument ensued, the two leaders sticking their fingers in each other's faces in full view of television cameras.

It was a kind of preview of Khrushchev's 1961 summit meeting in Vienna with newly elected U.S. president John F. Kennedy. Two years earlier, Fidel Castro had overthrown the Cuban government, establishing a Communist beachhead less than one hundred miles from America's border. Elated, Khrushchev began referring to Castro affectionately as "the bearded one." Kennedy's response was the botched Bay of Pigs invasion, in which he refused to offer air support and other reinforcements to thirteen hundred CIA-trained Cuban exiles storming the beach on the Cuban north shore. The result was a rout—ninety of the invaders were killed, the rest imprisoned.

For Khrushchev, the fiasco was an indication that Kennedy was weak. "What's wrong with him?" he wondered aloud to his son, Sergei. "Can he really be this indecisive?" He decided the Vienna meeting would be an opportunity to take the measure of this tentative neophyte of a president.

Hanging over the proceedings like a dark cloud was the U-2 affair. On May Day, 1960, one of the most important Soviet holidays, an occasion for parades and demonstrations in Red Square, the Soviets had shot down a high-flying American spy plane, the U-2. It had been an open secret on both sides that the United States was conducting such surveillance—and a source of humiliation for the Soviets, as the planes flew far beyond the range of Soviet anti-aircraft weapons. But now they had the technology to bring the planes down—and they did. U-2 pilot Francis Gary Powers was convicted of espionage in a Moscow show trial and sentenced to three years of imprisonment and seven years of hard labor. (He served a year and nine months of his sentence before quietly being exchanged for the Soviet spy Rudolf Abel on a bridge over the Havel River in Berlin.) Kennedy had inherited this baggage.

The meeting went badly from the beginning. Khrushchev pressured Kennedy on Berlin. He was planning to isolate and incorporate West Berlin into the Communist camp and implied as much. Kennedy warned him against such a miscalculation. "Khrushchev went berserk," Kennedy later told an aide. "He started yelling, 'Miscalculation! Miscalculation! Miscalculation! All I ever hear from your people . . . is that damned word, miscalculation! . . . I'm sick of it!'" If America wanted to start a war over Berlin, he said, "Let it begin now."

"If that's true," Kennedy replied, "it's going to be a cold winter."

Afterward, when asked how the meeting had gone, the young president admitted, "Worst thing in my life. He savaged me." Two months later, in August, construction began on the Berlin Wall.

"HE SAW AND KNOWS EVERYTHING"

Also hanging over the proceedings was an event that had taken place less than two months earlier. On April 12, 1961, Soviet cosmonaut Yuri Gagarin became the first man in space, orbiting Earth in his spaceship, *Vostok (The East).* Three weeks later, NASA responded by launching astronaut Alan Shepard on a fifteen-minute nonorbital flight. Just a week before the Vienna summit meeting, President Kennedy challenged the Soviets to the ultimate space race: landing a man on the moon by the end of the decade.

Like Kennedy in Vienna, the U.S. space effort had been overwhelmed by the Soviets. The first blow was *Sputnik.* For such a seminal event, the first announcement was oddly quiet. *Pravda* didn't even bother to refer to the satellite in its headline, "Tass Report": "As a result of very intensive work by scientific research institutes and design bureaus the first artificial satellite in the world has been created. On October 4, 1957, this first satellite was successfully launched in the USSR."

The rest of the world was not so reticent. In capital letters running across the entire front page, the *New York Times* announced,

SOVIET FIRES EARTH SATELLITE INTO SPACE;
IT IS CIRCLING THE GLOBE AT 18,000 M.P.H.;
SPHERE TRACKED IN 4 CROSSINGS OVER U.S.

It was true. *Sputnik (Fellow Traveler)* was hardly larger than a basketball, weighed only 183 pounds, and took ninety-eight minutes to orbit Earth on its elliptical path. It announced its presence to shortwave radio operators around the world with a simple and unmistakable series of beeps. In Moscow, Russians triumphantly went up to Americans, crying, "Beep, beep."

A month later the Soviets launched a dog into space. In 1959 a series of *Lunik* spacecrafts flew by and crash-landed on the moon and photographed the never-before-seen far side of the moon. In 1960, *Sputnik 5,* with two dogs aboard, orbited Earth and returned safely. And then Gagarin in 1961. The United States had been trumped at every turn. (When Americans finally landed a man on the moon, went the Soviet joke, he would be met by a short, fat man talking about how to grow corn there.) If a Soviet rocket could travel all the way to the moon, what would prevent one from transporting a nuclear payload to the United States? And if the Soviets controlled the heavens, what would prevent them from attacking from overhead? U.S. vice-president Lyndon Johnson lamented, "I felt uneasy and apprehensive. In the open West, you learn to live with the sky. It is a part of your life. But now, somehow, in some new way, the sky seemed almost alien." When Gagarin landed safely, Khrushchev immediately promoted him from senior lieutenant to major, named him a Hero of the Soviet Union (the country's highest award), declared a national holiday in his honor, and ordered a huge Red Square rally and Kremlin banquet in celebration. Khrushchev met Gagarin at the airport on his return to Moscow and rode with him in his open limousine past cheering crowds to Red Square. Their country used to be "barefoot and without clothes," he declared, but now "once-illiterate Russia" was blazing a trail into space. "That's what you've done, Yurka," he told Gagarin. "Let everyone who's sharpening their claws against us know, let them know that Yurka was in space, that he saw and knows everything."

THE SOVIET IMAGE

1905
1917
1927
1941
1953 –
1964
1984
1991
2005

THE THAW

"AS GRAVE A CRISIS AS MANKIND HAS BEEN IN"

A U-2 may have been downed in the Soviet Union, but the spy planes were still flying high over Cuba, Fidel Castro's new Communist state—and Soviet ally—less than one hundred miles from U.S. shores. On October 14, 1962, a U-2 took photographs revealing that an alarming construction project was going on in Cuba. The Soviets were building launch sites for nuclear missiles.

It took the White House a week to confirm the spy photos. An unusually high number of Soviet ships were sailing to and from Cuba. CIA aerial photographs had spotted Soviet freighters with enormous crates on their decks but riding too high in the water to be carrying steel or lumber or other ordinary supplies. A Cuban refugee had described seeing a truck convoy carrying tall, rounded objects masked by tarpaulins. This was definitely not business as usual.

On October 22, President Kennedy gave a speech that shocked the world. "Within the past week, unmistakable evidence has established the fact that a series of offensive missile sites is now in preparation on [Cuba]. The purpose of these bases can be none other than to provide a nuclear strike capability against the Western Hemisphere." He went on to report that some of the missiles had a range of more than a thousand miles; others could fly twice that far. Neither Washington, D.C., nor the Panama Canal, nor Mexico City were safe; neither was any other city in the Western Hemisphere, from as far north as Hudson Bay to as far south as Peru.

The United States would not stand for any of it, he declared. A strict quarantine was being imposed upon Cuba. "All ships of any kind bound for Cuba from whatever nation or port will, if found to contain cargoes of offensive weapons, be turned back." And then, his most chilling warning: "It shall be the policy of this nation to regard any nuclear missile launched from Cuba against any nation in the Western Hemisphere as an attack by the Soviet Union on the United States, requiring a full retaliatory response upon the Soviet Union." Within two days, the U.S. Strategic Air Command, for the first time in its history, adopted Defense

Condition 3, the last step before war. All American bombers and missiles went on full alert; planes loaded with nuclear bombs patrolled the world nonstop, refueling in midair, awaiting orders to attack. Ground troops amassed in the southeastern United States, the shoreline of nearby Cuba in their sights.

It was not quite what Khrushchev had in mind. Only six months had passed since Yuri Gagarin's flight into space, four months since Khrushchev's bullying of Kennedy in Vienna, two months since the construction of the Berlin Wall. Khrushchev was riding high. He had taken the measure of his White House counterpart and found him hesitant and inexperienced. Emboldened by these events, Kremlin hard-liners and other powers, such as China, were pressuring him to assume a tougher stance toward the United States. And then there was Turkey. The United States had installed missile sites in Turkey, which the Soviets considered as close to their doorstep as Cuba was to America's. That angered Khrushchev. With North Atlantic Treaty Organization (NATO) forces armed and ready in Europe, he was feeling surrounded and threatened—all this from an adversary he didn't respect. As the Soviets had to live with the threat of annihilation emanating from their own backyard, so could America. In a typical earthy anecdote, he explained his thinking to the Polish Communist leader Władysław Gomułka: A Russian peasant brought his goat into his hut for the winter. The goat smelled terrible, but the peasant got used to the smell. Kennedy would just have to "learn to accept the smell of the missiles."

It turned out to be, in the word Khrushchev hated most, a miscalculation.

Over the next few tense days, as the two sides jockeyed back and forth, Khrushchev's moods—never stable in the best of times—ranged from ebullience to bluster to thoughtfulness to black despair, often in the space of a few hours. The logistics of carrying on such a long-distance confrontation—from Moscow to Washington spanned more than forty-five hundred miles and a time difference of eight hours—meant that world-altering decisions on both sides were taking place in the dead of night or at the crack of dawn. Khrushchev flatly refused Kennedy's ultimatum. He wrote Kennedy, "The Soviet government considers

the violation of the freedom of navigation in international waters and air space to constitute an act of aggression propelling humankind into the abyss of a world nuclear-missile war." For his part, Castro wondered what Khrushchev was waiting for and urged him to attack.

Despite his military advisers' pushing for war, Kennedy and his team stayed the course, but not without agonizing uncertainty. His secretary of state, Dean Rusk, told a group of foreign ambassadors, "I would not be candid and I would not be fair with you if I did not say that we are in as grave a crisis as mankind has been in."

Two events sealed the outcome. The first involved an intelligence report that landed on Khrushchev's desk on October 26, four days after Kennedy's speech. It disclosed that Kennedy had decided once and for all to invade Cuba and destroy the Soviet installations. The plans were complete, U.S. hospitals were gearing up to treat casualties, and the attack could take place at any moment. Khrushchev was stunned. Then and there he began seriously to consider accepting Kennedy's demands. (It was discovered later that the report was false, the result of remarks imprecisely overheard by a Russian émigré bartender at the National Press Club in Washington. But no one in the Kremlin knew that at the time.)

The second event involved an occurrence that was all too real. On October 27, a Soviet-supplied ground-to-air missile shot down a U-2 over Cuba, killing the pilot. The incident profoundly affected both sides. For Khrushchev it was proof that the situation had gotten out of hand. He hadn't authorized the use of missiles—someone on the ground in Cuba had made that decision by himself. When he then received a letter from Castro urging a nuclear attack on the United States, he had had enough.

On the American side, the downing of the U-2 unleashed similar fears. The military was demanding that surveillance flights continue. If they were attacked again, the United States would have to respond. But how? And where would it all end? With the United States bombing the Cuban missile installations? With the Soviets attacking American missile sites in Turkey? With nuclear war?

That night in Washington, the president's brother, Attorney General Robert Kennedy, met with Soviet Ambassador Anatoly Dobrynin. It had come to this, Kennedy told Dobrynin: the United States would go to war if the Soviet missiles weren't removed from Cuba. If they were, President Kennedy would dismantle the U.S. missile sites in Turkey—but secretly. Khrushchev had to make a decision immediately.

On October 28, Khrushchev sent President Kennedy a letter. "Dear Mr. President: I have received your message of October 27. I express my satisfaction and thank you for the sense of proportion you have displayed. . . . The Soviet government . . . has given a new order to dismantle the arms which you described as offensive, and to crate and return them to the Soviet Union."

The showdown was over.

Khrushchev possessed the courage to back down. Given the possible consequences, it may have been his finest hour. The Kremlin hailed his actions, declaring that his "calm and wisdom" saved the world from nuclear war. Khrushchev's memoirs are a bit more measured: "Both sides showed that if the desire to avoid war is strong enough, even the most pressing dispute can be solved by compromise. . . . The episode ended in a triumph of common sense."

But behind the scenes, he and his Kremlin colleagues felt humiliated. He couldn't claim victory in Kennedy's Turkish missile concession, as that had to remain secret. He couldn't point too strongly to his success in defending Cuba, as Kennedy refused to put in writing a pledge never to invade the island. Castro called Khrushchev a traitor. The Chinese accused him of betraying the Communist cause. And the Americans, although being careful not to boast too loudly in public, were swaggering behind closed doors. Said Kennedy, "I cut his balls off."

"GRANDFATHER CRIES"

On the evening of October 12, 1964, while he was vacationing on the Black Sea, Khrushchev's hotline telephone rang. It was his number-two man in the Kremlin, Leonid Brezhnev. The Presidium was

THE SOVIET IMAGE

1905
1917
1927
1941
**1953 –
1964**
1984
1991
2005

THE THAW

convening a special meeting; Khrushchev had to be there. The next morning, sitting at the head of the long table in the senate meeting room, surrounded by his handpicked protégés, he grumpily demanded to know what was so important as to make him abort his vacation and fly back to Moscow on such short notice. It was his last moment of being in charge.

Led by Brezhnev, the group began to attack. Khrushchev's reforms contradicted Lenin's teaching. His agricultural policies were a disaster. He was a changed man, his behavior rude, erratic, incomprehensible, out of control. He was impossible to talk to, coarse, and overbearing. He had become isolated, unreachable. He was self-aggrandizing and glory-seeking. He had replaced the cult of Stalin with the cult of Khrushchev. And on it went, for two days.

Even then, Brezhnev and the others feared a last-ditch retaliation—but Khrushchev no longer had it in him. He offered only the weariest of responses. "I've been thinking for a long time that it's time for me to go," he admitted. "But it's hard to let go. . . . I'm upset, but I'm also glad that the party has gotten to the point that it can rein in even its first secretary." The comment was absolutely, ironically true. This was something new in Kremlin politics: a bloodless coup.

In the end, so deeply did Brezhnev and his new power brokers fear Khrushchev's volatile power, and so determined were they to tighten down the screws against his unpredictable Thaw, that they stripped their former boss of his positions, his homes, his vehicles, much of his furniture, even his self-respect and identity. He became a forgotten man. He lived seven more years, under virtual house arrest in the village of Petrovo-Dalneye outside Moscow, in deep depression early on (when asked by his school headmaster what his grandpa did with his time, Khrushchev's grandson answered, "Grandfather cries"), and later on dedicated to dictating some 250 hours of memoirs. In 1967 the KGB summoned him to demand he stop working on his memoirs. Faced with the kind of bullying he himself had so often dispensed, Khrushchev became defiant. "I consider your demand to be an act of force against a Soviet citizen, and as such a violation of the constitution, and therefore I refuse to obey you," he shouted. "You can put me in prison, or you can seize this mate-

rial from me by force. You can do all this today if you wish, but I categorically protest." Eventually, in an act that must have made him ruefully remember Boris Pasternak, he smuggled the manuscript abroad. An edited version appeared in the United States in 1970. The complete memoirs, some 1.5 million words, were published in Russia in 1999.

When he died, on November 11, 1971, a few lines at the bottom of the first page of *Pravda* "regretfully" announced the death of "former First Secretary of the Central Committee of the CPSU [Communist Party of the Soviet Union] and Chairman of the Council of Ministers of the USSR, personal pensioner Nikita Sergeyevich Khrushchev, age 78."

"THE FEAR IS GONE"

There would be no national day of mourning, no state funeral in Red Square, no burial near Lenin and Stalin outside the Kremlin Wall. After a small wake, Khrushchev was buried in the cemetery of the sixteenth-century monastery Novodevichy, the resting place of many prominent Russians. It took four years for his family to be granted permission to build a monument at his grave. For that they turned to the very sculptor Khrushchev had berated so strenuously at the modern art exhibition back in 1962, Ernst Neizvestny. His design, a bust of Khrushchev against interlocking slabs of white marble and black granite, seems to symbolize the man—the contrasts, the paradoxes, so much darkness fomented, so much light inspired.

In his last years, he said of himself, "The fear is gone. . . . That's my contribution." He also said, "In this country the doors are closed and locked. What kind of socialism is this? . . . Some curse me for the times I opened the doors. If God had given me the chance to continue, I would have thrown the doors and windows wide open." The final irony is, through his legacy, he did just that: from the Thaw to the end of the cold war to the end of the USSR itself.

Death of the Man of Steel

Stalin lies in state in Moscow's Hall of Columns in 1953. His death was a profound trauma for the Soviet Union, provoking conflicting feelings of grief and joy, fear and relief, dismay and hope. Above all, people felt amazement—Stalin had ruled for so long, it seemed inconceivable that he could be dead. And they felt cast adrift. What would happen to them now?

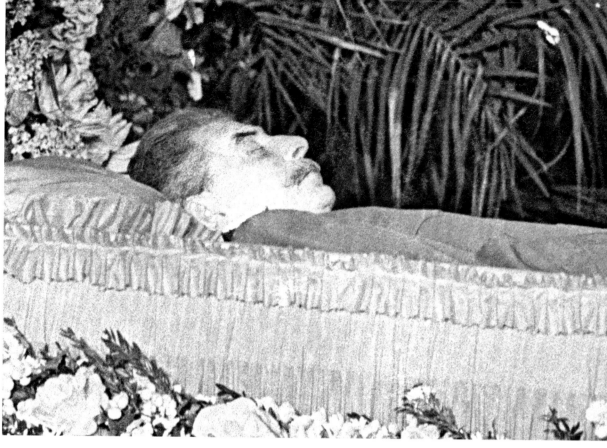

The Honor Guard

Politburo members (right to left) Anastas Mikoyan, Lazar Kaganovich, Nikita Khrushchev, and Nikolai Bulganin form a somber honor guard in front of Stalin's body. They and other top Kremlin leaders were already maneuvering to succeed Stalin. The least highly regarded, Khrushchev, would outsmart them all.

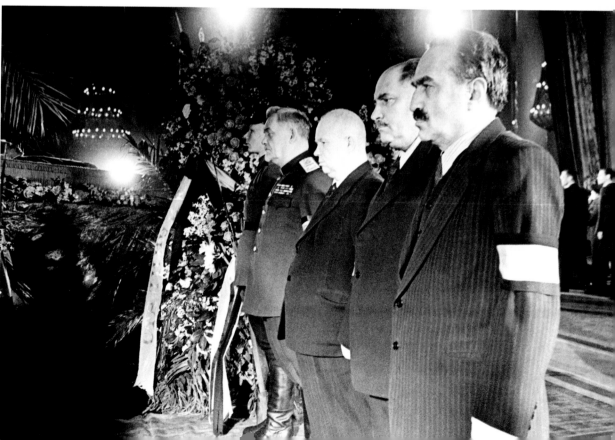

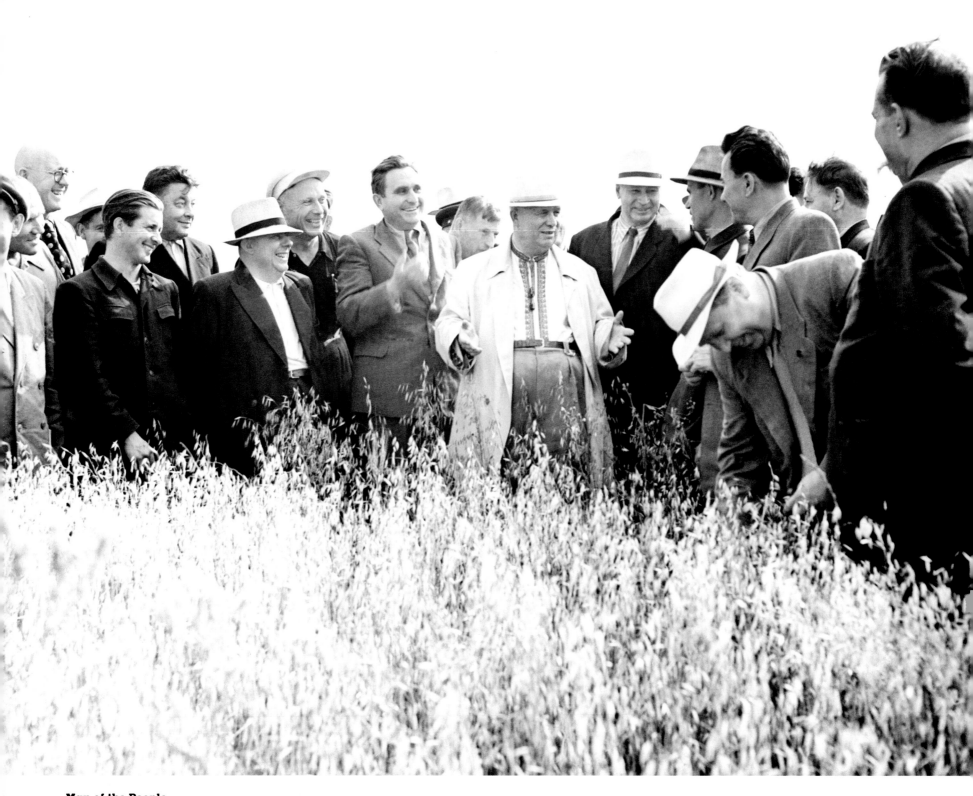

Man of the People
Khrushchev loved to mingle, invoke his humble roots, and tell earthy stories and jokes, all
the while making his points and advancing his agendas. Here he is in his element, examining
crops at a Virgin Lands grain farm in the Kustanay region of Kazakhstan.

Hungary, 1956: A Revolution Crushed

TOP
The charred wreck of a Soviet tank, burned in the streets of Budapest.

BOTTOM
Protesters fly a Hungarian flag from a Soviet tank near the Parliament Building in Budapest.

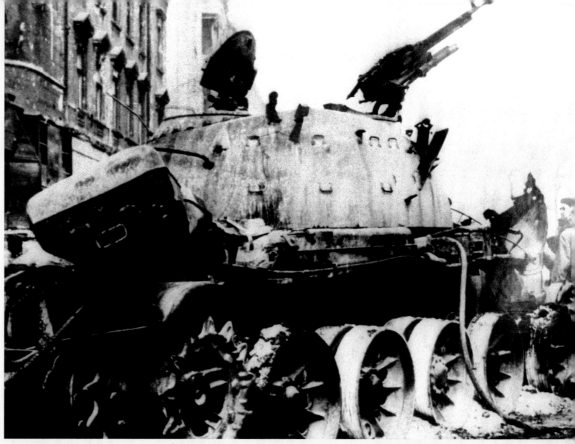

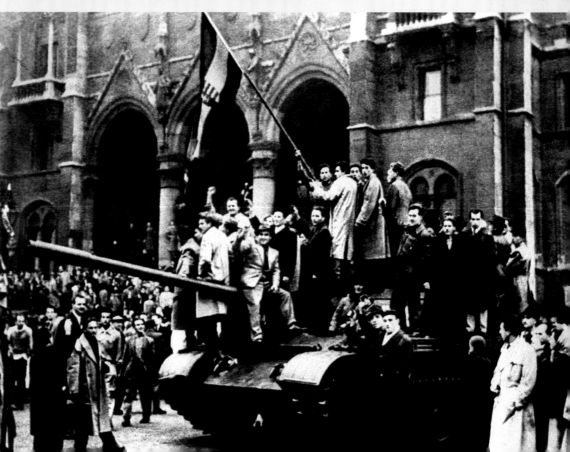

Hungary, 1956: A Revolution Crushed
The cost of revolution: dead bodies in the streets of Budapest.

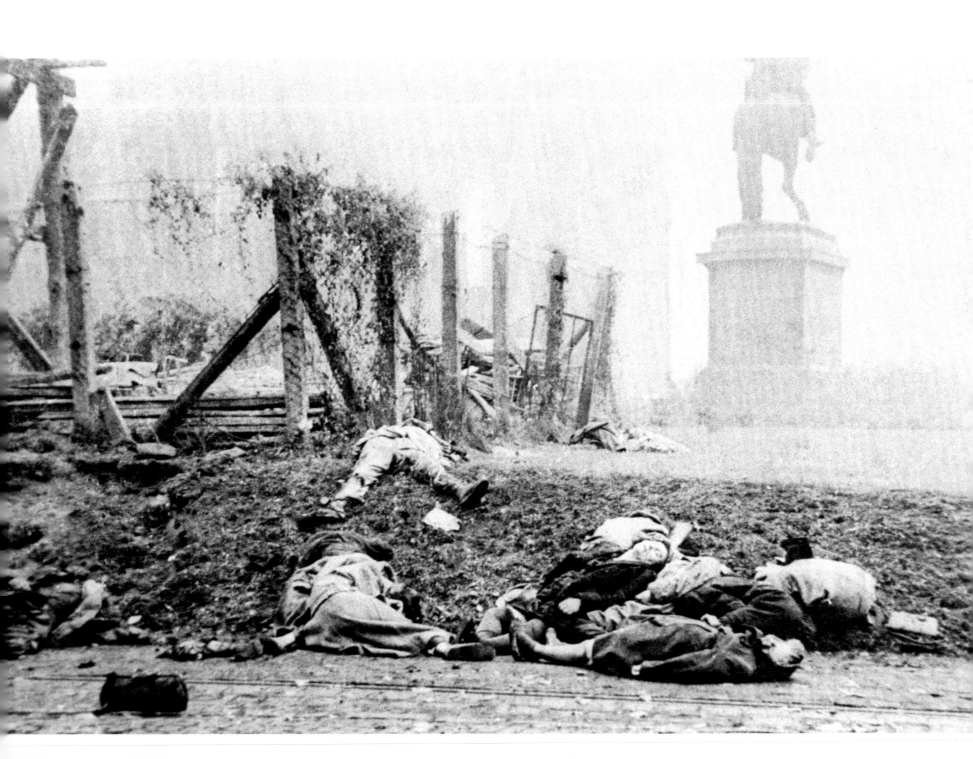

Pride of the Republic
Bare-chested athletes parade through a stadium in Frunze,
the Republic of Kyrgyzstan, in 1956.

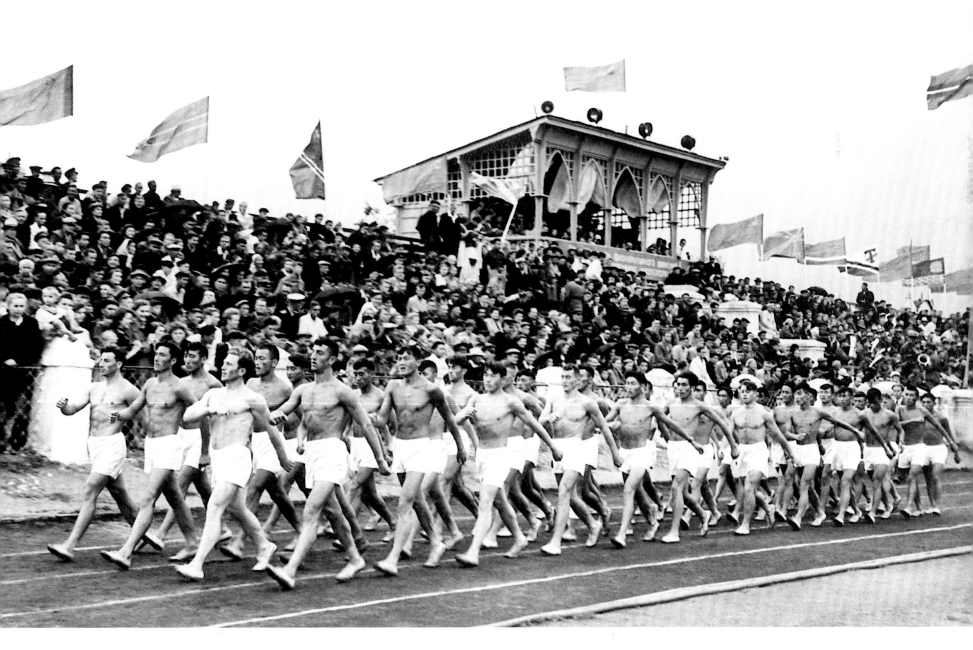

Soviet Scenes

ABOVE, LEFT

The sisters Khudovskov—Alexandra, Maria, Nadezhda, and Anna—and a friend work at the steel plant in Magnitogorsk in 1958. Built from scratch at the beginning of Stalin's first Five-Year Plan in the early 1930s, Magnitogorsk's steel- and ironworks constructed half of all Soviet tanks and many other weapons during the Great Patriotic War.

ABOVE, RIGHT

A photogenic Moscow student. 1958.

LEFT

Seven Sisters

Students walk in front of Moscow State University in 1954. This enormous building, one of a series of grandiose, neoclassic towers that became known as Stalin's "Seven Sisters," was constructed, largely by German prisoners, after the Great Patriotic War. Each "Sister" was designed according to Stalin's specifications in a wedding-cake style that lifted the eye toward a central tower. At thirty-six stories, the university building is the largest of them all.

OPPOSITE

A heroic image of blast-furnace supervisor Nikolai Revtov at the Zaporozhstal steelworks in Ukraine. 1959.

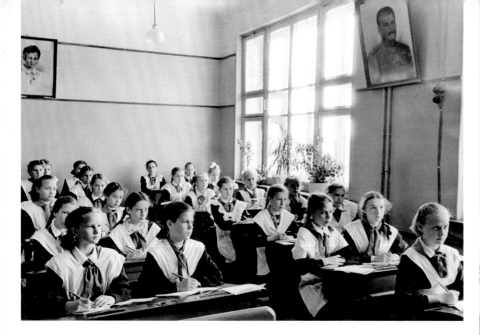

Soviet Scenes

TOP

Sixth-grade girls sit at attention under the gaze of Stalin at the Kosmodemyanskaya school for girls in Moscow. 1950.

ABOVE

Workers constructing Moscow metro lines catch some television in a hostel in Moscow. 1954.

ABOVE

Moscow Metro

Begun in the 1930s, fast, cheap, clean, efficient, and memorably ornate, the Moscow metro system was its city's pride. Opulent chandeliers illuminate the Komsomolskaya Station. The ceiling features mosaic panels depicting the country's military greats, from the thirteenth-century hero Alexander Nevsky on.

OPPOSITE

Icebreaker

The icebreaker *Lenin* was the world's first nuclear-powered surface ship. Nuclear-powered ships proved a great boon in the Russian Arctic, both for supplying enough power to break through ice up to ten feet thick and to eliminate the need for frequent refueling, a difficult task in these extreme conditions. Here *Lenin* plies its trade in 1961.

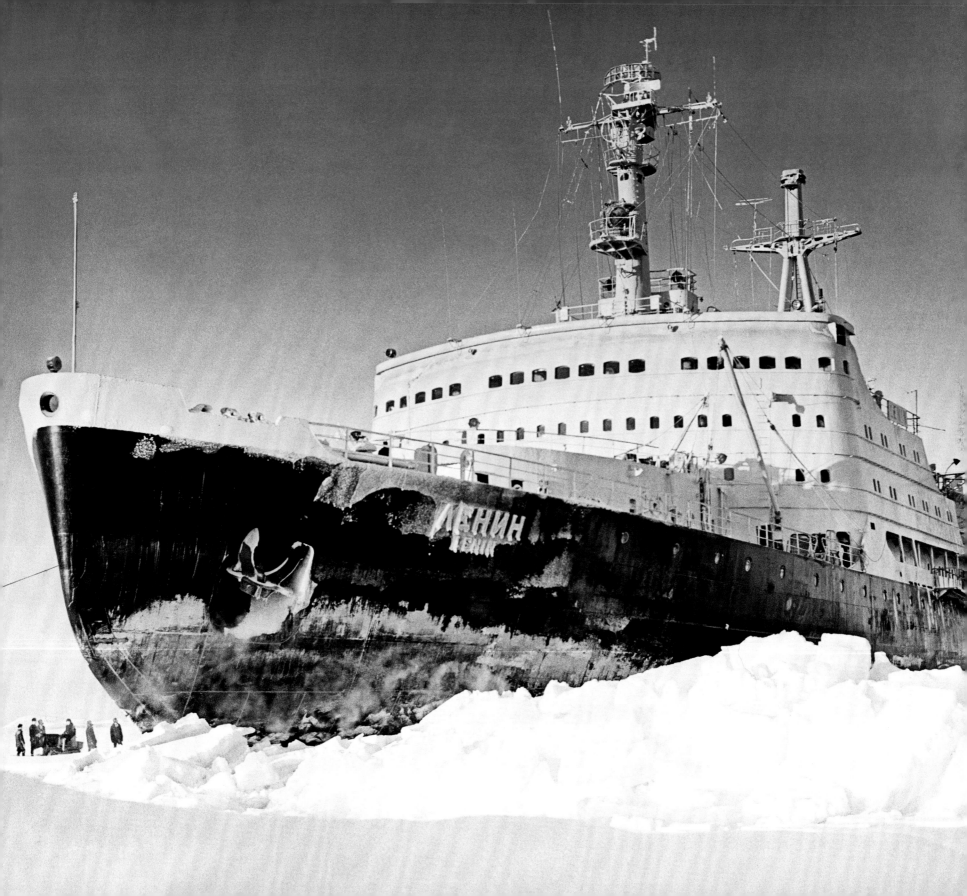

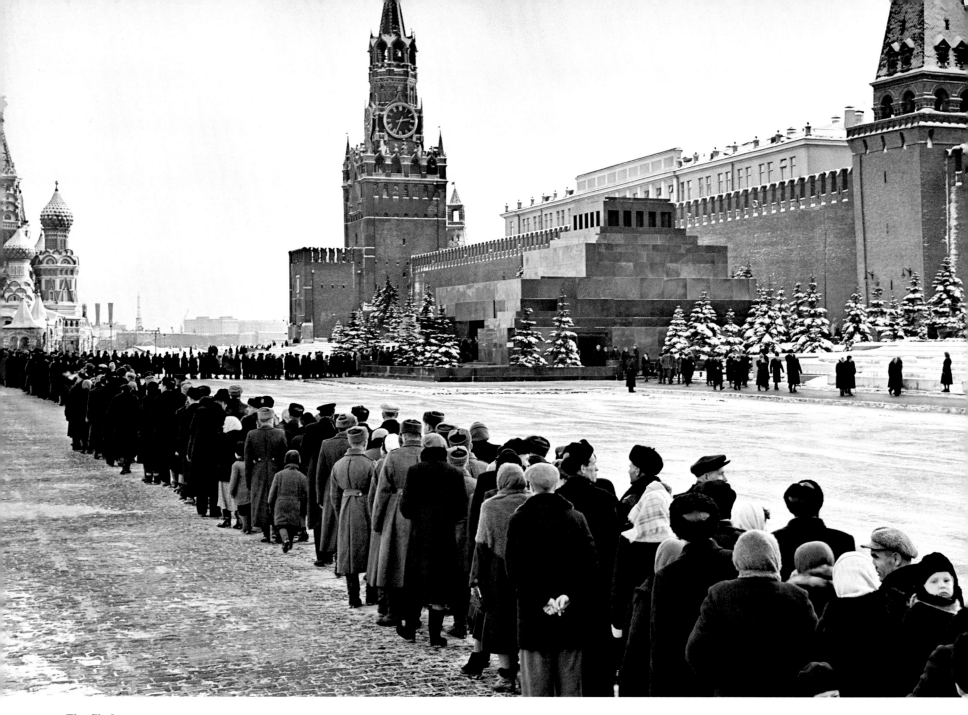

The Shrine
The line to view the remains of Lenin in his granite mausoleum snakes through
Red Square. The wait could take hours. Once inside, armed guards moved
things along briskly, forbidding any talking or stopping to linger. 1950s.

Harvest
Picking machines rumble along endless lines of tea on the plantations of the
Kirov State Farm in the Republic of Georgia. 1957.

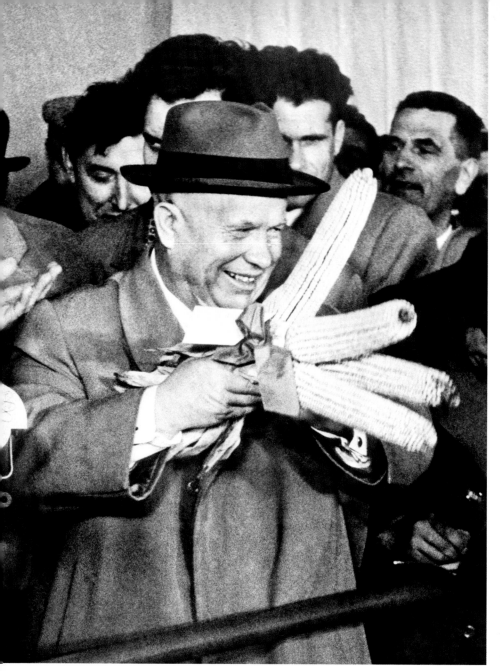

ABOVE
The Corn Freak
During a 1960 visit to France, a beaming Khrushchev touts his agricultural cure-all: corn. But the crop failed in the USSR's cold climate. "The poor girls and boys had to warm up the fields, day and night, so that the corn would grow," recalled a schoolteacher. "They burnt fires all through the night, especially if a frost was forecast. Sometimes they fell asleep too close to the fire and burnt their hands and faces. So the corn, for us, was not the queen of the fields, but an evil stepmother."

TOP
Boris Pasternak
Boris Pasternak talks with actors of Moscow's Vakhtangov Theater in 1956, the year he submitted *Dr. Zhivago* for publication. His great, sad adventure was about to begin: Nobel Prize recipient in 1958, a pariah in his own country, expulsion from the Soviet Writers' Union, death in 1960.

ABOVE
Poets
Anna Akhmatova and Boris Pasternak were not only two of the preeminent Russian writers of the twentieth century, they were especially close. (Akhmatova claimed that, although he was already married, Pasternak proposed to her three times.) Writer Lydia Chukovskaya described their power: "In the presence of both of them I looked at the world as if I were on a new planet." Moscow, 1946.

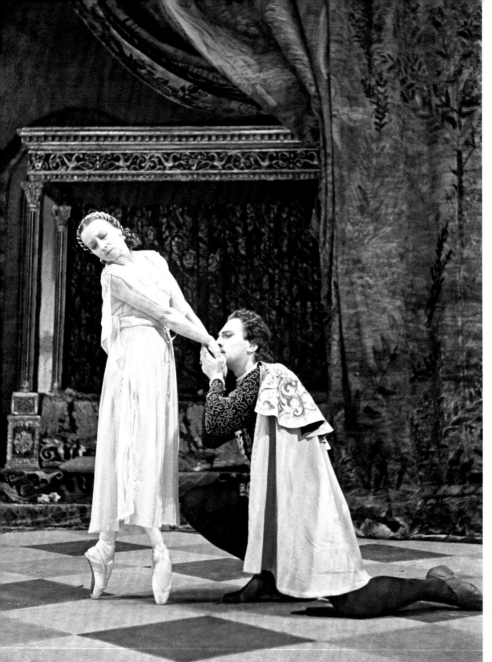

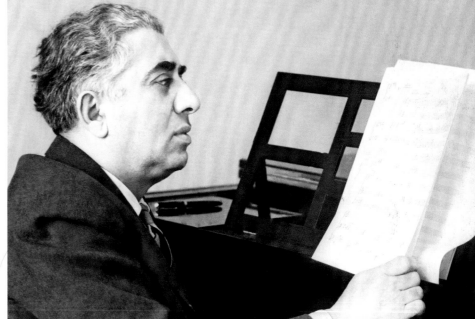

Ballerina of the Morning

Today, more than forty years since she last danced, Galina Ulanova occupies a central place in Russian consciousness. She was the Bolshoi's prima ballerina; its greatest international star; and the epitome, in style and approach, onstage and offstage, of the Soviet ideal. One writer called her "the ballerina of the morning"—the morning, which dawns full of promise and hope, endures steadfastly through the day, but ends, inexorably, in death. Ulanova could make audiences feel the poignancy of these transitions. Here she dances *Romeo and Juliet* in the 1950s.

Sergei Prokofiev

An expatriate for much of the 1920s and 1930s, the great composer was persuaded to move back to Russia by Stalin's promise of safe haven. He was deceived. He was attacked and disparaged, and his wife was sent to the Gulag. In a bitter irony, Prokofiev died within minutes of his tormentor, Stalin, on March 5, 1953. Stalin's death dominated the news; the composer's death was not reported until days later—and the wrong date was given.

Aram Khachaturian

With Prokofiev and Shostakovich, Aram Khachaturian was a titan of Soviet music in the twentieth century. Born in Georgia to Armenian parents, Khachaturian studied in Moscow and later taught at the Moscow Conservatory. He may be best known for his score for the ballet *Spartacus*.

175

Performance Art
In Moscow in 1962, poet Yevgeny Yevtushenko reads a poem about the revolution in Cuba. Dynamic, passionate, and an exciting performer, Yevtushenko led a surge in poetry readings during Khrushchev's Thaw.

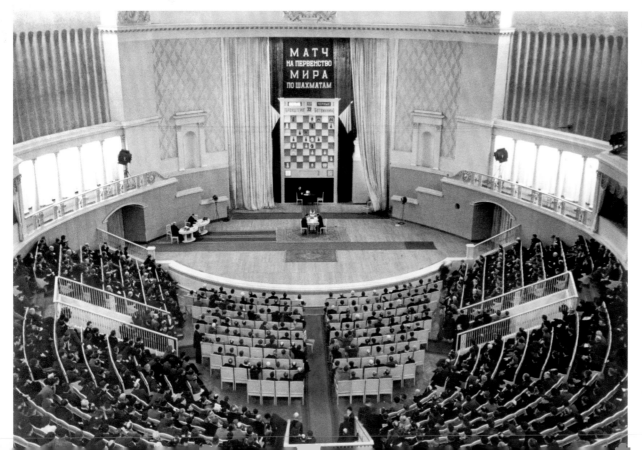

Chess Mania
Two Soviets, champion Mikhail Botvinnik and challenger Grandmaster David Bronstein, play for the world chess championship in Moscow's Tchaikovsky Concert Hall in 1951. Chess was extremely popular in the Soviet Union. The USSR dominated the world chess scene from the late 1940s on.

Chronicler of the Gulag

In 1945, Alexander Solzhenitsyn was sentenced to eight years in prison for the crime of criticizing Stalin in a letter to a friend. He spent the last three years of his sentence in a "special camp" for political prisoners in the town of Ekibastuz in Kazakhstan. The experience led to his novella *One Day in the Life of Ivan Denisovich,* his monumental *Gulag Archipelago,* a Nobel Prize, exile from his country, and worldwide awareness of an insidious institution: the Gulag. Here he is in his prison uniform in Ekibastuz in 1953.

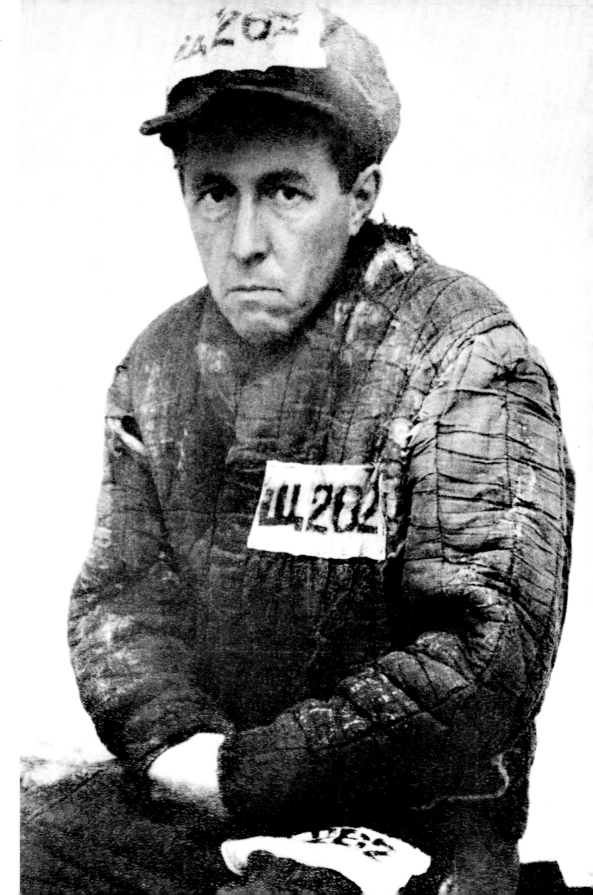

"American *Sputnik*"

U.S. pianist Van Cliburn accepts flowers during the First International Tchaikovsky Contest in Moscow, in 1958. The little-known Cliburn's victory over fifty contestants from more than nineteen countries caused a sensation. Cliburn received an eight-and-a-half-minute ovation from the music-loving Soviet audience and became an instant celebrity. Declared a Radio Moscow commentator: "He is the American *Sputnik*—developed in secret."

The Art Critic

Not bothering to mask his skepticism, Khrushchev attends an exhibition of modern art in Moscow in 1962. Soon he would erupt in disdain, declaring that "a donkey could smear better than this with its tail."

The U-2 Affair

The 1960 downing of the U-2 was a triumph for Khrushchev and his military. They had known about the American spy flights but had been unable to do anything about them. Now the world could see that the Soviets could defend themselves against advanced military technology. The trial of the pilot, Francis Gary Powers, was highly publicized. Here Powers listens to the verdict: three years' imprisonment and seven years' hard labor.

LEFT, BOTTOM

A portion of the evidence used against Powers, culled from the wreckage of his flight.

BELOW

Sputnik

When the Soviets launched _Sputnik_ on October 4, 1957, life changed. No longer were the heavens remote and inviolable. Lamented U.S. space enthusiast Lyndon Johnson, "I felt uneasy and apprehensive. In the open West, you learn to live with the sky. It is a part of your life. But now, somehow, in some new way, the sky seemed almost alien."

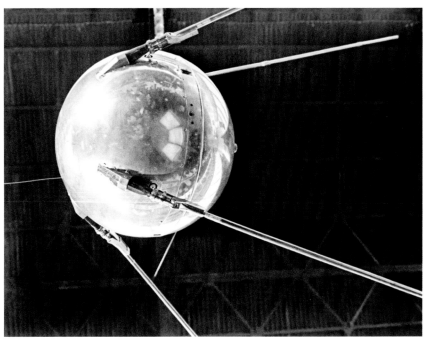

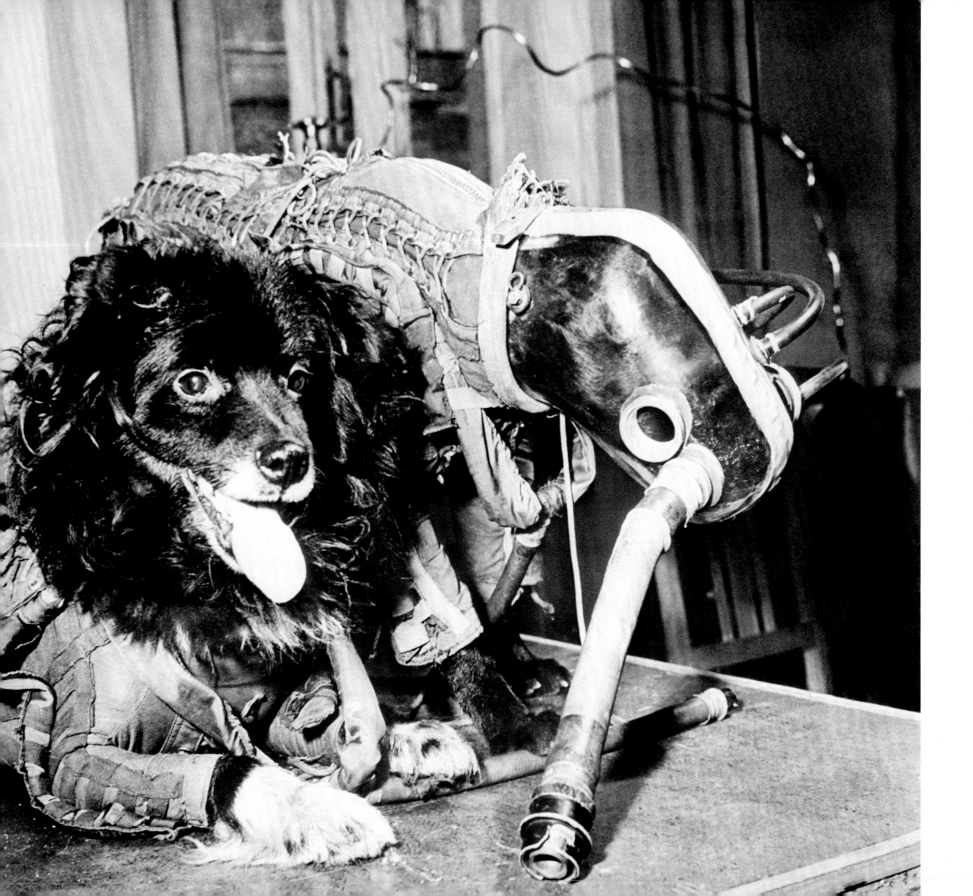

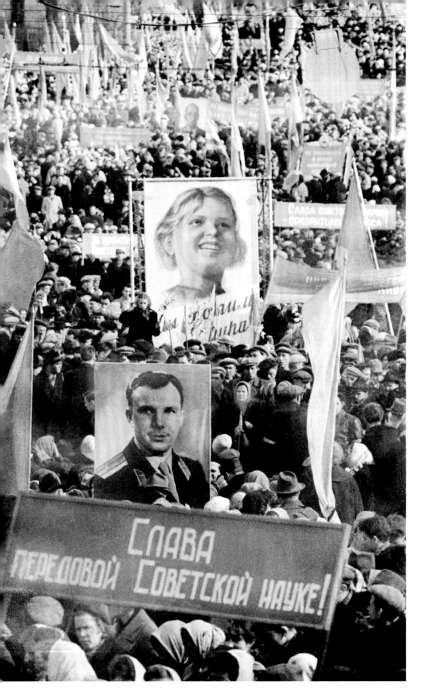

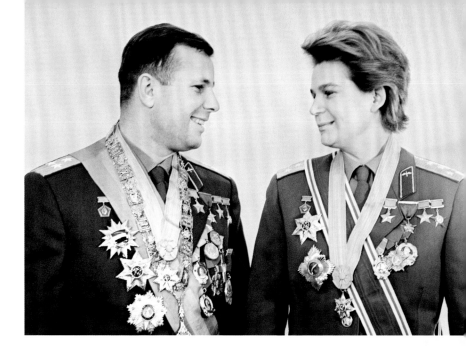

ABOVE
First Human in Space
On April 12, 1961, Soviet cosmonaut Yuri Gagarin orbited Earth. Here, two days later, with Gagarin instantly a hero, Moscow celebrates his return to Earth. The large banner reads, "Progressive science forever!"

OPPOSITE
Space Training
A dog named Mishka waits for its turn inside a pressure suit as its comrade Tsygarika undergoes training in 1959. Soviet spacecraft were unpressurized. At least thirteen dogs were launched into space between November 1957 and March 1961 to pave the way for human spaceflight.

TOP
First Woman in Space
On June 16, 1963, cosmonaut Valentina Tereshkova became the first woman in space, orbiting Earth forty-eight times over three days. Upon her return, she posed with Soviet space hero Yuri Gagarin, both suitably bedecked with medals and honors.

ABOVE
Strelka and Belka
Strelka (Little Arrow), left, and Belka (Squirrel), right, blasted off aboard *Sputnik 5* on August 19, 1960 (along with forty mice, two rats, and numerous plants). They returned to Earth the next day, the first animals to survive orbital flight. Strelka later gave birth to six puppies. Khrushchev gave one of them to Caroline Kennedy, the daughter of U.S. president John F. Kennedy.

Khrushchev and Kennedy

Khrushchev saw the two leaders' 1961 summit meeting in Vienna as an opportunity to take the measure of the young president. He came away convinced that Kennedy was weak and could be bullied, an impression that led to the Cuban missile crisis. Kennedy regarded the meeting as "the worst thing in my life."

Comrades

Khrushchev entertains Fidel Castro in Georgia in 1963. Determined to restore good relations in the aftermath of the missile crisis, Khrushchev was unusually candid with the Cuban leader. "You'd think I, as first secretary, could change anything in this country. Like hell I can! No matter what changes I propose and carry out, everything stays the same. Russia's like a tub full of dough: you put your hand in it, down to the bottom, and think you're the master of the situation. When you first pull out your hand, a little hole remains, but then, before your very eyes, the dough expands into a spongy, puffy mass. That's what Russia is like!"

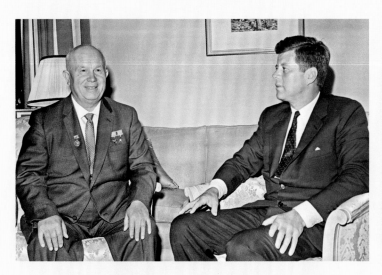

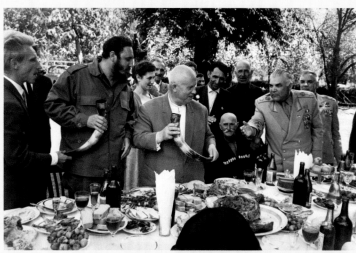

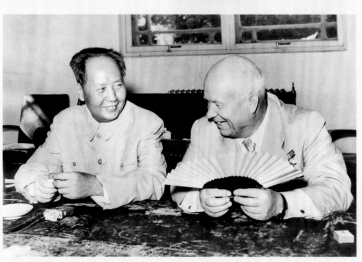

Keeping Up Appearances

Khrushchev and Chairman Mao Zedong observe the celebration of the fortieth anniversary of the 1917 Revolution atop the Lenin Mausoleum in Red Square. Relations between the Soviet Union and China were worsening dramatically, but the two leaders kept up the outward charade of Communist comrades.

Cats and Mice

"Russians look down upon the Chinese people," Mao declared. There existed no brotherly relationship between China and the USSR—rather, it was like "father and son, or between cats and mice." In 1958, Khrushchev hurried to Beijing in an attempt to calm the waters. It was a disastrous trip, with Mao treating Khrushchev like a barbarian come to pay tribute while he affected the role of the wise, august emperor. The resulting split between the two countries would last until the breakup of the Soviet Union in 1991. Here the two leaders put on happy faces at the airport.

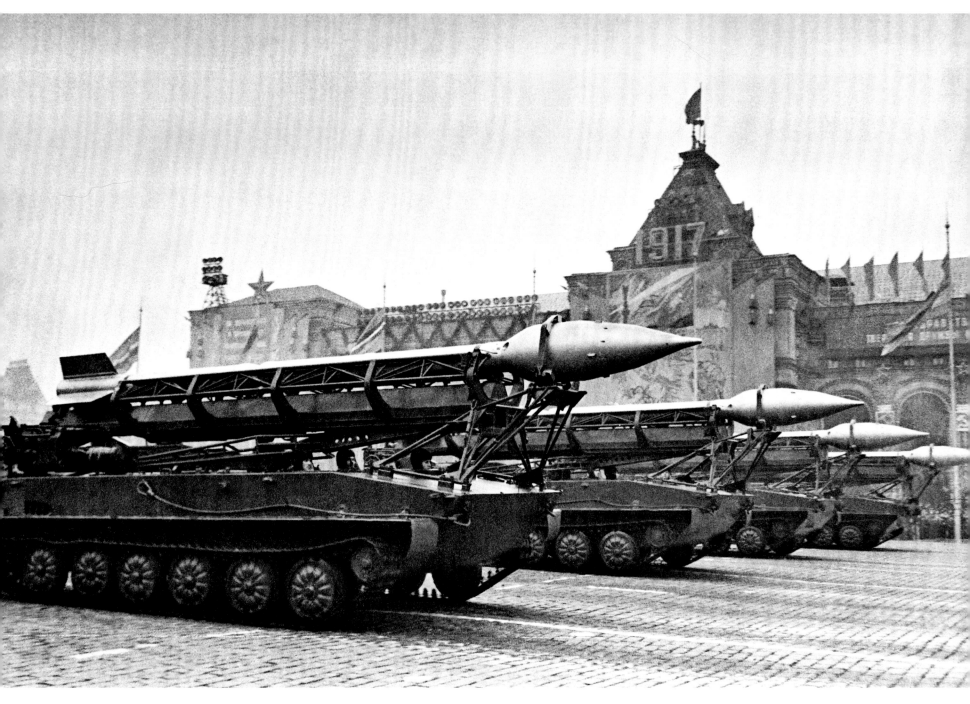

May Day in Red Square
Celebration of the fortieth anniversary of the Revolution, in 1957. The GUM
department store, opposite the Kremlin Wall, celebrates the historical date.

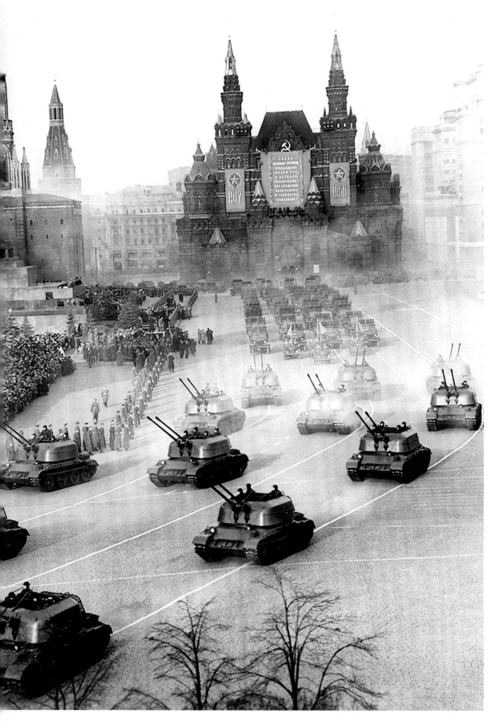

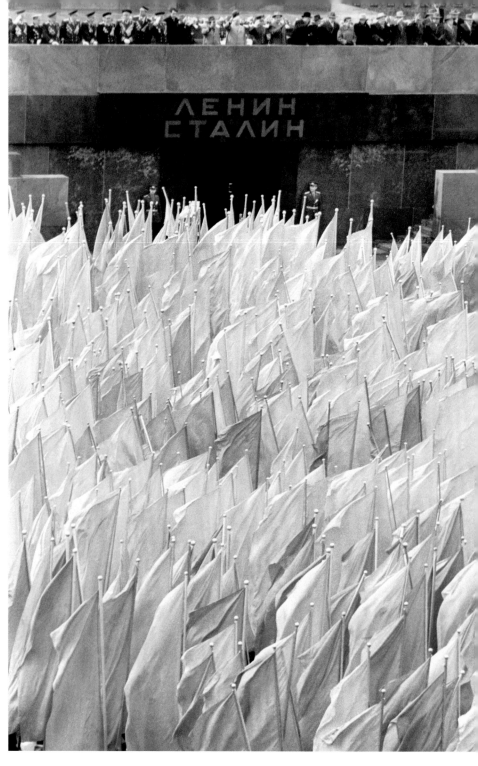

May Day in Red Square

The traditional holiday celebration was an opportunity for the Soviets to parade their military might. To the left, Lenin's Mausoleum stands massively before the Kremlin Wall. Dignitaries crowd atop its viewing platform to view the parade.

A sea of flags passes below Khrushchev and other dignitaries atop the viewing stand of the mausoleum in 1961. The lettering on the facade announces that both Lenin and Stalin are within. Six months later, in the dead of night, Khrushchev had Stalin's body removed and buried below the Kremlin Wall.

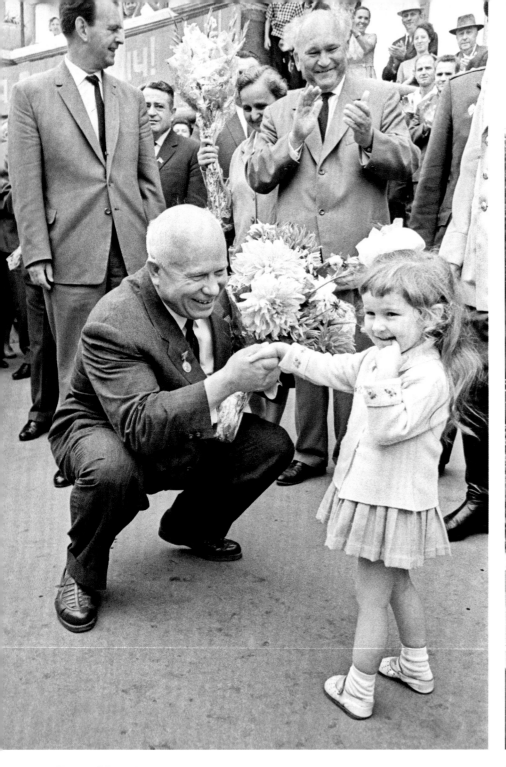

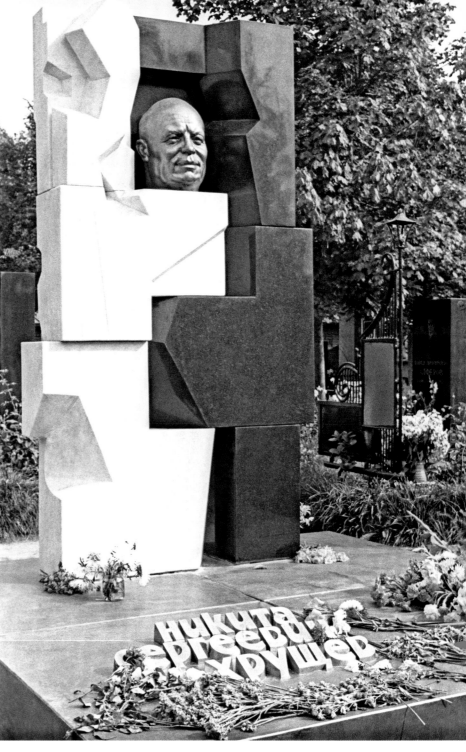

Happy Diversion

Little realizing that the end of his reign was approaching, Khrushchev delights in the welcome of a shy young girl in Ordzhonikidze, North Ossetia, in 1964.

Resting in Peace

Moscow's Novodevichy Cemetery was the resting place of many notable Russians but no former heads of state—except Khrushchev. He rests near the back of the cemetery, watched over by sculptor Ernst Neizvestny's monument of white marble and black granite that seems to symbolize Khrushchev's contrasts. A self-styled man of the people, he lies here among the people, the only deceased Soviet supreme leader not buried by the Kremlin Wall. (In 2007, former Russian president Boris Yeltsin was buried in Novodevichy Cemetary, joining Khrushchev.)

185

1905 – 19
– 1941 – 1
1964 – 19
– 2005

17 - 1927
953 -
84 - 1991

Soviet leadership. Unlike Stalin and Khrushchev, neither Brezhnev nor his colleagues had experienced the Revolution and the power struggles that followed. Rather than being shapers of the Soviet system, they were products of it. They had made their mark in the 1930s, taking advantage of the opportunities created by Stalin's purges of Soviet leaders. They had not only survived the fear and terror of the times, they had benefited from it.

Now, having also survived the tempestuous unpredictability of the Khrushchev years (Khrushchev, his fellow Ukrainian, considered the younger Brezhnev a protégé), Brezhnev wanted stability above all. He wasn't about to rock the boat. In a memoir, then–U.S. secretary of state Henry Kissinger compared Brezhnev to a huge, canny, wild boar. "One could see easily why it had attained such a size. It was not greedy; it set about to investigate the bait. It examined the ground before every step. It looked carefully behind every tree. It advanced in a measured pace. It had clearly survived and thrived by taking no unnecessary chances."

Under Brezhnev's two decades of leadership, the Soviet Union undertook a massive military buildup to become a powerful player on the world stage, fostered a sometimes strained policy of détente (a relaxation of tensions) with the West, and successfully provided a secure, steady environment at home. For the first time, many Soviet citizens reasonably could anticipate that if they behaved as expected, making no waves, they had a good chance of living a steady, uneventful life. That represented tremendous progress.

The cost, however, was high. Brezhnev plundered the nation's oil reserves to pay for his military

nepotism that saw leaders routinely appointing their own favorites to key positions. These *nomenklatura,* the elite, enjoyed special privileges: the best apartments, vacation dachas, access to the finest schools for their children, entrée to closed shops with Western goods, the right to travel abroad. Half a century after the Revolution was supposed to have put an end to all that, a vast new nobility lorded over the land.

Brezhnev thrived in such an atmosphere. Although bureaucratic to the core, he was lively and high-spirited, smoked heavily, loved drink and dirty jokes, and liberally dispensed bear hugs and kisses. He often entertained foreign visitors at his dacha outside Moscow, where he could hunt and make vodka toasts to his heart's content.

He was vain, draping his uniforms with self-awarded medals and his résumé with self-awarded honors, including the heroic military rank of "Marshal of the Soviet Union"—although his wartime experience had been limited to advising and propagandizing. (Some even joked—out of Brezhnev's earshot—that he had doubled Stalin's achievement in the mustache department, alluding to the two bushy eyebrows that dominated his face.)

"He likes beautiful women," President Richard Nixon once remarked, "and he likes beautiful cars." Nixon vividly recalled an incident during a Camp David visit in 1973, when Nixon added to Brezhnev's stable of a Rolls-Royce Silver Cloud, a Citroën-Maserati, and a Mercedes-Benz 450 with the gift of a Lincoln Continental. Brezhnev immediately slipped behind the wheel, waved Nixon into the front seat, and roared off. As Secret Service agents watched in horror, Brezhnev, a notoriously poor driver, careened down the twisting mountain road leading away from the retreat, ran a

Yet Brezhnev's sociability did not prevent him from toeing the hardest of lines. In April 1968, Czech leader Alexander Dubček introduced "socialism with a human face," declaring that the Communist Party was not the be-all and end-all of Czech society and that each citizen should be guaranteed the right of free speech, free press, and the right to travel abroad. This heady period became known as "Prague Spring." Jazz, rock 'n' roll, miniskirts, and other Western cultural staples appeared. Literature and film thrived. It was a time of euphoria for the Czech people.

It didn't last. On August 20, late at night, thousands of Soviet tanks rumbled into Czechoslovakia, accompanied by hundreds of thousands of troops. A column of tanks amassed outside Dubček's office. Soldiers cut his phone lines, arrested him and several of his colleagues, and whisked them off to Moscow. In the streets and countryside, people resisted with placards and slogans, changing the names of villages to Dubčekovo ("belonging to Dubček") as a gesture of support. But to no avail. Imprisoned and intimidated, Dubček acceded to Moscow's demands to restore the status quo and authorize an indefinite Soviet occupation. Released back to Prague on August 27, broken and demoralized, he broke into tears as he announced to his people that all was lost.

Afterward, in a speech to the Fifth Congress of the Polish United Workers' Party, Brezhnev justified his actions. "Each Communist Party is responsible not only to its own people, but also to all the socialist countries, to the entire Communist movement," he declared. "Whoever forgets this, in stressing only the independence of the Communist Party, becomes one-sided. He deviates from his international duty."

In other words, independent thought and action would not be tolerated. The policy came to be known as the Brezhnev Doctrine.

On January 28, 1980, while strolling along a Moscow street, physicist Andrei Sakharov was arrested by the KGB. He and his wife, Elena Bonner, were given two hours to pack their belongings, then were hustled onto a special flight to Gorky, an industrial city some 250 miles east of Moscow and off-limits to foreigners. Although he was never charged with a crime, never tried before a court of law, never convicted of anything, Sakharov was stripped of his official honors, including Hero of Socialist Labor, and forced into internal exile in Gorky for the next seven years.

"The Deputy Procurator of Gorky explained the terms of the regimen decreed for me," Sakharov later recalled. "Overt surveillance, prohibition against leaving the city limits, prohibition against meeting with foreigners and 'criminal elements,' prohibition against correspondence and telephone conversations with foreigners, including scientific and purely personal communications, even with my children and grandchildren. I was instructed to report three times a month to the police, and threatened that I would be taken there by force if I failed to obey."

Sakharov had been a thorn in the side of the Kremlin for years, the leading light of a small but forceful group of students, writers, artists, and scientists who actively protested the repressive Soviet regime. They became known as the dissidents. Open dissent had arisen gradually during the Thaw of the Khrushchev years, sparked by Khrushchev's "secret" speech criticizing Stalin, fueled by the Soviet clampdowns in Poland and Hungary, and inspired by the writings of Pasternak and Solzhenitsyn. But this was something different—more widespread, better organized, more articulate.

Prohibited from publishing their ideas, the dissidents went underground, circulating home-typed manuscripts with multiple carbon copies, a form of communication called *samizdat,* or self-publishing, that reached thousands. But their ace in the hole was the West. As soon as samizdat information leaked out, it was quickly published by Western media

THE SOVIET IMAGE

1905

1917

1927

1941

1953

1964 –

1984

1991

2005

STAGNATION

and broadcast back to the USSR, in Russian, by the American Radio Liberty, the BBC, and shortwave radio stations. The Soviets not only had to contend with the dissidents themselves but with pressure from the West and an increasingly informed citizenship. Unlike in former times, they couldn't effectively muzzle the spread of information.

"What alternative do the authorities have?" asked dissident Anatoly Sharansky. "To take more direct measures against us would be to return to the days of Stalin, and that they don't want. They are interested in Western opinion and in detente and in good economic relations, and most of the present leaders are the very men who survived Stalin. World opinion is what keeps us going, what keeps us alive."

The Thaw had exposed rips in the Soviet foundation, and now all sorts of new voices were working to further dismantle the structure. No matter how much Brezhnev desired the status quo, he could never bury them again; nevertheless, he tried. Some dissidents, like Sharansky, were sent to prison or labor camps. Others were pronounced mentally ill and locked up in asylums. (It was an ingenious ploy, as it precluded the need to wrestle with legalities and sent the message that only lunatics would oppose the Soviet system.) Writer Alexander Solzhenitsyn, a Nobel Prize winner in literature with an international following of millions, was in 1974 summarily deported, ending up living uneasily in small-town Vermont. And some, like Sakharov, were exiled internally.

At first Sakharov seemed an unlikely convert to the dissident cause. The USSR's most decorated physicist, he had spearheaded development of the most powerful device ever exploded, a hydrogen bomb called the "Tsar Bomb," detonated in 1961. But when another test was scheduled for the next year, Sakharov balked. Believing it unnecessary, wary about further ratcheting up the arms race with America, and fearful that radioactive fallout could kill hundreds of thousands, he implored Nikita Khrushchev to cancel the test. Khrushchev assured Sakharov he'd look into the matter—but the very next day it went off as planned.

Sakharov was devastated. "A terrible crime was about to be committed, and I could do noth-

ing to prevent it," he recalled in his memoirs. "I was overcome by my impotence, unbearable bitterness, shame, and humiliation. I put my face down on my desk and wept."

In that moment, his life changed. He had considered himself a soldier for the motherland. Now he realized he couldn't trust his country's leaders to shepherd the great power he had provided them. He began to lobby ever more fiercely for an end to nuclear testing—an effort that culminated in the 1963 U.S.-Soviet Partial Test Ban Treaty prohibiting nuclear explosions in space, the atmosphere, and under water—and in 1968 he wrote an essay entitled "Reflections on Progress, Peaceful Coexistence, and Intellectual Freedom."

"I wanted to alert my readers to the grave perils threatening the human race," Sakharov explained. "I went into some detail on the threat posed by thermonuclear missiles—their enormous destructive power, their relatively low cost, the difficulty of defending against them. I wrote about the crimes of Stalinism and the need to expose them fully (unlike the Soviet press, I pulled no punches)."

Within the Soviet Union, the essay circulated via samizdat. Once smuggled outside the country, it was published by a Dutch newspaper and the *New York Times* under the headline "Text of Essay by Russian Nuclear Physicist Urging Soviet-American Cooperation." That was too much for the Kremlin. Brezhnev revoked Sakharov's security privileges, ending his career as a nuclear physicist.

Banished from his military duties, Sakharov threw himself into politics. In 1970 he cofounded the Moscow Human Rights Committee. In 1971 he wrote Brezhnev, "Our society is infected. . . . The Party apparatus of the government and the highest, most successful levels of the intelligentsia . . . are profoundly indifferent to violations of human rights, the interests of progress, the security and future of mankind."

As Sakharov's stature grew around the world, the Kremlin tried harder to silence him. Soviet Academy of Sciences members published open letters denouncing him. Bogus letters from "simple people" attacked him. In 1973 a slanderous newspaper campaign targeted him along with fellow dissident

Solzhenitsyn. But it was to no avail. In 1975, citing his "fearless personal commitment in upholding the fundamental principles for peace," the Swedish Nobel Committee awarded Sakharov the Nobel Peace Prize. He was the first Russian ever to receive the Peace Prize. Churlishly, the Soviets didn't allow Sakharov to leave the country to receive his award. His wife, Elena Bonner, already abroad for medical treatment, accepted for her husband.

When the Soviet Union invaded Afghanistan in 1979, Sakharov led the outcry, personally expressing his displeasure to Brezhnev. It was the last straw. Soon afterward Sakharov was sent into exile. Even then, however, isolated, under around-the-clock guard, he refused to be silent. In 1983, Bonner smuggled out of Gorky a defiant statement. It included these words: "I shall continue to live in the hope that goodness will finally triumph."

FROM RUSSIA TO THE WEST

Perhaps nowhere was the repressive conservatism of the Brezhnev era more dispiriting than in its treatment of artists—those people for whom the essential nature of their work made compromise difficult. Whereas the dissidents, whose purpose was to effect change, were silenced because of their criticism, artists were targeted primarily for the crime of being themselves.

Joseph Brodsky, a free spirit who bounced from job to job (milling machine operator, ship's boiler-room stoker, geologist-prospector) while teaching himself to be a translator and poet, was in 1964 convicted as a "social parasite" and sentenced to five years of hard labor. As revealed in the court transcript, the gulf between his sensibility and that of the Soviet state was the unspoken message of his trial.

"Who designated you as a poet? Who put you in the ranks of poets?" the judge asked Brodsky.

"No one," he answered. "Who put me in the ranks of humanity?"

"Did you study to become a poet? Did you ever try to finish college?

"I didn't think it was a matter of education."

"Of what, then?"

"I think that . . . it came from God."

In 1972, Brodsky was exiled from the Soviet Union. He never returned to Russia, never saw his parents again, nor his wife, nor his four-year-old son.

The "crime" of cellist Mstislav Rostropovich and his wife, soprano Galina Vishnevskaya, was supporting Alexander Solzhenitsyn by allowing him to live in their dacha outside Moscow. Rostropovich added insult to injury by writing an open letter attacking the regime's repression of free speech and its oppression of artists, musicians, and writers. In response, the government cancelled Rostropovich and Vishnevskaya's concerts and foreign tours, prohibited any mention of them in the media, and blocked all recording projects. In 1974, after years of applying, they were finally granted exit visas. Four years later, having settled in the United States, they were stripped of their Soviet citizenship.

The most publicized of such incidents, at least in the West, involved dancers. Russian ballet was thought by many to be the finest in the world (certainly the Soviets believed it to be so). Leningrad's Kirov and Moscow's Bolshoi ballet companies were beloved cultural institutions at home and, during their infrequent tours, were sensations in the West. They interpreted the great nineteenth-century classic ballets more powerfully than anyone.

But rigid tradition, the Soviet ballet's strength, was, for its star dancers, its drawback. They yearned to explore new roles and new challenges. They yearned for access to modern works and choreographers flourishing in the West. And they yearned for the freedom to perform with companies outside the Soviet Union. "The Kirov or the Bolshoi is akin to a huge bottle, stopped up with artists, and everybody is a cork to the other," explained Vishnevskaya. "All of them are tied to the same stale repertory and the same stage, and there is no exit, as in the hell of Sartre's famous play."

The first to rebel was the Kirov's iconoclastic star, Rudolf Nureyev, who defected from the USSR in 1961 while the Kirov was on tour in Paris. As two KGB

THE SOVIET IMAGE

1905

1917

1927

1941

1953

1964 –

1984

1991

2005

STAGNATION

plainclothes agents waited to escort him onto the plane back to Moscow, he put himself under the protection of the French police and requested asylum.

The Kirov's ballerina Natalia Makarova was next; in 1970 she defected while on tour in London. This was the second such transgression by a Kirov star, and the repercussions back home were severe. The director of the company was summarily fired, and his wife, a teacher at the Kirov school, was dismissed from her classes. Involved KGB agents were demoted or removed altogether.

The most sensational defections were still to come. In 1974, with the Kirov on tour in Toronto, the company's young star, Mikhail Baryshnikov, plunged through a crowd of autograph seekers waiting at the stage door and literally dashed to freedom, hurtling away from his Soviet watchdogs, narrowly missing being run over, until a friend bundled him into a taxi and safety. Within days, he was performing with Western companies, generating rave reviews and sold-out theaters—and insisting that his flight was not a political act, rather an artistic one. "We had to come to America, because the standards of dancing are the highest and the choreography beyond anywhere else," he explained in a magazine interview after his defection. "If only the Kirov had permitted me to perform with other companies in the West. If only they had asked foreign choreographers to compose works for us."

And in 1979, while on tour in New York with the Bolshoi, dancer Alexander Godunov, with seventy-five cents in his pocket, requested asylum. After discovering his absence, the KGB hustled Godunov's wife, ballerina Ludmila Vlasova, onto a flight to Moscow. Before it could take off, however, the plane was grounded. For three days, it sat on the tarmac at Kennedy airport, with Vlasova aboard, while the U.S. State Department sparred with the KGB over her intentions—did she really want to leave or was the KGB making up her mind for her? Leonid Brezhnev and U.S. president Jimmy Carter even became involved.

Godunov was given permission to speak to his wife, but only in person aboard the plane. Not anxious to board a fully fueled, Moscow-bound airplane filled with KGB agents, he declined. After seventy-three hours, the State Department determined that it was Vlasova's choice to go after all and allowed the plane to take off. Godunov spent the next year futilely trying to arrange her return. The couple became known as the "Romeo and Juliet of the Cold War." They divorced in 1982.

BREZHNEV'S VIETNAM

On Wednesday evening, November 10, 1982, Soviet television viewers watched in surprise as a scheduled pop concert was scrapped and documentaries about the Revolution and the Great Patriotic War filled the screen. Then the nightly news came on, with announcers dressed in black. Explanation didn't come until the next day: Leonid Brezhnev had passed away from a heart attack at the age of seventy-five. He was the first Soviet leader to die in office since Stalin, three decades earlier.

Whereas Stalin's passing had set off unruly mob scenes punctuated by a potent mixture of fear, apprehension, and relief, Brezhnev's death evoked quieter emotions. "We used to complain some, bitch about this and that, and tell jokes about the old man," said an engineer upon exiting the funeral hall. "But now that Brezhnev is dead I feel sad because he conveyed a sense of security and stability."

Brezhnev's greatest legacy was just that: security and stability for a land that had known little of it, along with international superpower status conferred by his military buildup. His Achilles' heel was the flagging Soviet economy. And in 1979, just three years before his death, he made perhaps his greatest blunder, sending eighty thousand Soviet troops to fight in a civil war in Afghanistan that was threatening to displace that country's Communist government. Moving into a satellite state like Czechoslovakia was one thing—this was quite another. Western response was more than Brezhnev bargained for. Jimmy Carter declared, "My opinion of the Russians has changed most drastically," and he imposed trade sanctions, postponed further strategic-arms negotiations,

authorized aid to the Soviets' opponents in Afghanistan, and, along with more than thirty other countries, boycotted the 1980 Moscow Olympics. Brezhnev's final legacy, then, was the undercutting of détente and a quagmire of a war that lasted more than eight debilitating years, prompting many to characterize it as Brezhnev's Vietnam.

STAGGERING TOWARD THE FUTURE

For Soviet politicians, Brezhnev had been a godsend. He reigned so long, and so firmly, that he left in his wake a bureaucracy of the elderly—people just like him. (At Brezhnev's death, the average age of the Politburo was seventy-one.) True to form, his successor turned out to be a sixty-eight-year-old dying of kidney disease, Yuri Andropov. What was not business as usual was Andropov's background— head of the KGB. He was the first top Soviet leader with an extensive police background.

Despite speculation concerning his repressive inclinations (as KGB chief, he had, after all, presided over the squelching of the dissidents), Andropov's tenure was ineffectual and brief—he died after only fifteen months in office, much of it spent in a Kremlin clinic. His most noteworthy project was a crackdown against drinking and slacking off. When that campaign generated only anger and disdain, he attempted to regain favor by slashing the price of vodka (which led to a new nickname for the drink, "Andropovka"). He died in February 1984.

The reign of his successor, Konstantin Chernenko, instantly degenerated into farce. Seventy-three years old, weak and wheezing with emphysema, he could hardly move, much less lead. His main claim to power was his role as Brezhnev's friend and lackey. His elevation to general secretary was the last hurrah of the Kremlin's aging leadership. In the wings was fifty-three-year-old Mikhail Sergeyevich Gorbachev. As Chernenko was usually ill, Gorbachev often chaired Politburo meetings and traveled abroad in his stead. He made a strong impression. Confident and relaxed, a natural on TV, and accompanied by his smart, stylish, and outspoken wife, Raisa (this was a major departure— his predecessors' dowdy wives had stayed well in the background), he seemed a new breed of Soviet leader. When, after Gorbachev made a visit to England, prime minister Margaret Thatcher declared, "Gorbachev is a man with whom we can do business," a brighter future seemed likely for the Soviet Union.

In March 1985, after just thirteen months in office, Chernenko died. Gorbachev took the reins the very next day, hurtling his country, and the world, toward a future no one could have predicted.

Generous Host

This 1973 photo of Brezhnev toasting smiling Yugoslav leader Josip Broz Tito says much about the Soviet leader and his times: his love of entertaining, the outdoors, food, and drink; his vanity and high spirits (note the eye-catching sweater and the fancy revolver at his side). The heft, and age, of the Soviet leadership is apparent.

Proud Grandpa

Brezhnev holds his great-granddaughter, Galya, in Moscow in 1973.

Bonfire

Brezhnev and Tito cooking up a traditional treat at a bonfire in the Ukrainian countryside in 1973. The two leaders are enjoying wedges of *salo*—salted or smoked pork fat—with brown bread. A popular food throughout the Slavic countries of central and eastern Europe, salo goes well with vodka, especially in winter.

195

Mighty Hunter
Brezhnev poses with his kill in the countryside outside of Moscow. 1977.

TOP
Diplomatic Sport
A knife-toting Brezhnev stands in front of bemused U.S. Secretary of
State Henry Kissinger during a hunting excursion in 1975.

ABOVE
Soviet Fashions
New collections for the autumn-winter fashion season. Moscow, 1972.

ABOVE
Merry-Go-Round
A young couple swings against a background of birch trees
in Zelenogorsk, outside of Leningrad, in 1970.

Building Moscow
Two young plasterers, Misses Kudryavtseva and Makhreva, on the job in Moscow in 1974, soon after finishing trade school.

BELOW
A Day in the Life
Bolshoi ballerina Natalia Bessmertnova at work in her kitchen. Moscow, 1975.

ABOVE
The Big Theater
Bolshoi means "big." The name is appropriate, for Moscow's Bolshoi Theatre consists of three orchestras, the largest opera company in the world, and the largest ballet company in the world. Moscow, 1974.

ABOVE
High Tech
During the Brezhnev years, consumer goods began to appear on Soviet store shelves. Svetlana Kozlova demonstrates the latest in stereo systems, the "Melody 106," in Riga, the capital of the Baltic Sea Republic of Latvia, in 1978.

BELOW
Factory Superstar
Svetlana Klementieva beams at being honored for producing 487 tons of thread in four years and three months, exceeding the timetable of the Five-Year Plan, at her cloth factory in the town of Chita, Siberia. 1975.

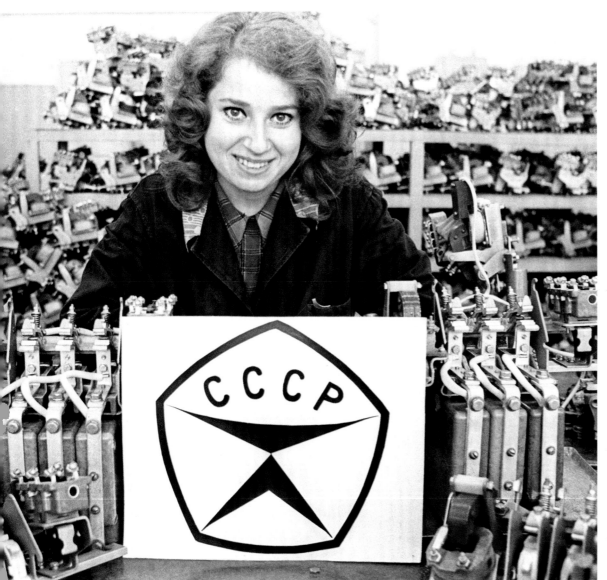

ABOVE
Best Worker
Svetlana Titukhina, after being proclaimed the best worker in her electrical supplies factory, poses with the fruits of her labor. The Republic of Northern Ossetia, 1976.

ABOVE
BAM
In 1974 the Soviets began work on a second trans-Siberian railroad, the Baikal-Amur Mainline (BAM). Dubbed "the construction project of the century," it spanned seven mountain ranges and covered more than 1,988 miles, from eastern Siberia to Lake Baikal and the city of Ust-Kut (where Trotsky was exiled in 1900). Here a young couple from Leningrad, come to Siberia to build the railroad, ties the knot. 1976, outside the town of Severobaikalsk.

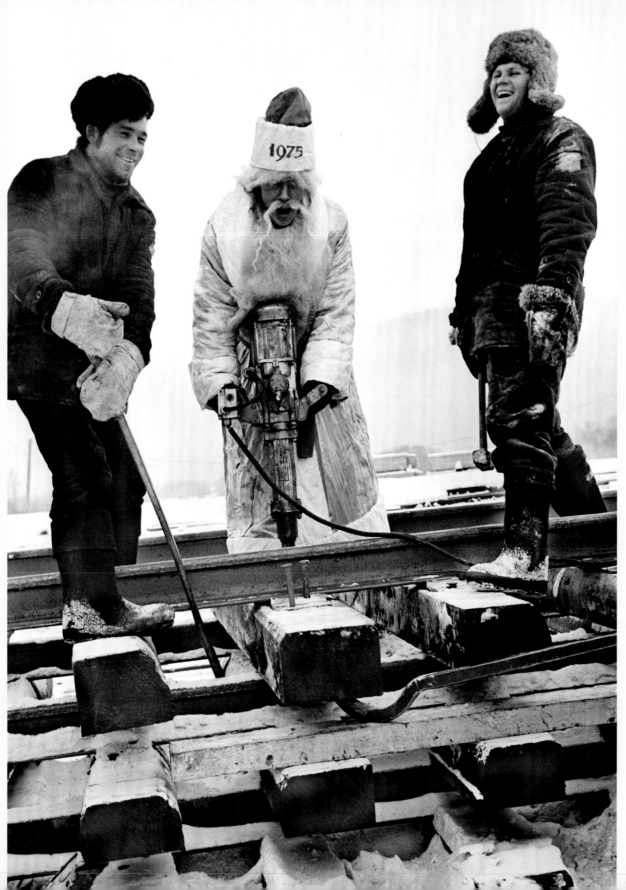

LEFT
Father Frost
A Baikal-Amur Mainline worker dressed as the traditional Slavic character Ded Moroz (Father Frost) helps bring in the new year. Irkutsk, near Lake Baikal. December, 1974.

OPPOSITE
Melon Farmers
Ismail Mirzoev examines his crop with his granddaughter. Tajikistan, 1974.

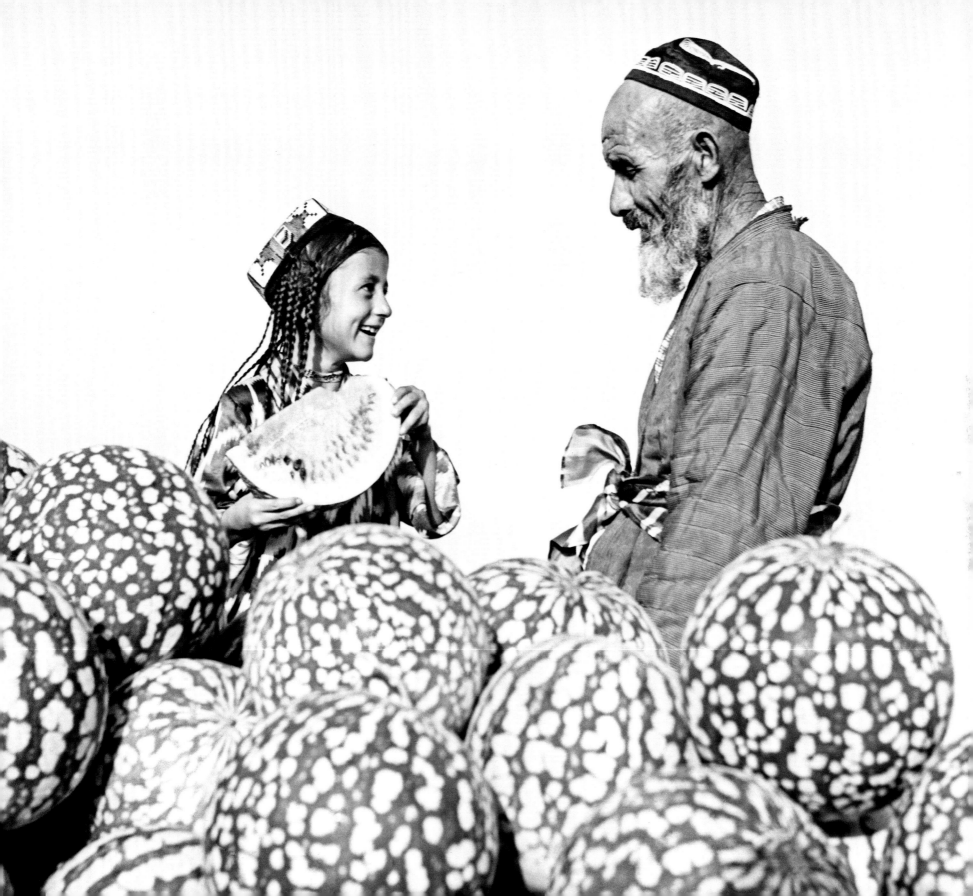

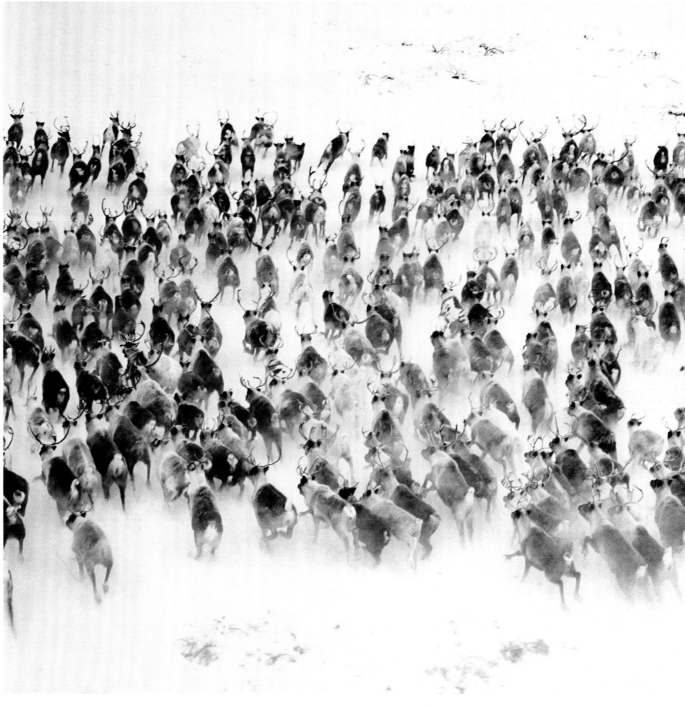

LEFT, TOP
Lifeline
A helicopter delivers supplies to a village in the Khabarovsk region of Siberia
in 1972. So vast is the area (more than three hundred thousand square miles)
that villages depended on aircraft for news and essentials.

LEFT, BOTTOM AND ABOVE
Reindeer Herders
Reindeer herders and their animals in the cold, rugged Koryak region of the
Kamchatka Peninsula. 1970.

Footballer
Star goalie Lev Yashin in 1969. From 1949 until 1970, he played for Moscow's favorite team, Dynamo, and was the goalkeeper for the Soviet National Team. Twice he won the "Golden Ball" award for the best player in Europe.

Budding Gymnasts
A gymnastics class in Frunze, the Republic of Kyrgyzstan, in 1979.

Young Archer
Natalia Bolotova from the city of Ribinsk. 1978.

Dmitry Shostakovich
Seen here in 1968, seven years before his death, the great composer stares out at the world with characteristic unease. Much of his life was a game of cat and mouse with the Kremlin, as his powerful, unconventional music drifted in and out of official favor. "It seems like everyone is looking at me. It seems as if they are whispering among themselves, following me with their gaze. And the main thing is that it seems they are waiting for me to fall, or at least to stumble. And so I feel that at any minute I will stumble. When the lights go out before a performance, I am almost happy. . . . But, as soon as the lights are back on, I am once again unhappy."

Nobel Laureate

Physicist Lev Landau was awarded the 1962 Nobel Prize for Physics for his investigations into liquid helium, work that for the first time allowed scientists to thoroughly explain properties of liquids. However, a devastating automobile accident prevented him from traveling to Sweden to accept the honor. Although Landau was unconscious for six weeks and several times declared clinically dead, he survived—although he never again was able to do creative work. He is pictured here in Moscow in 1968, the year he died.

Emotional Return

In 1973, when he was eighty-six years old, Marc Chagall returned to Russia to attend an exhibition of his work at Moscow's Tretyakov Gallery. It was the first time the great artist had set foot in the country since he left in 1922. Chagall's departure had been prompted by the Communists' disapproval of a series of huge, colorful murals he painted for the State Jewish Chamber Theater. The authorities had declared them to be self-indulgent and irrelevant to society. In Moscow, more than fifty years later, he was asked to sign the works, which courageous curators had safeguarded since he left. Here Chagall (center) and Minister of Culture Ekaterina Furtseva (right) attend the opening of the exhibition.

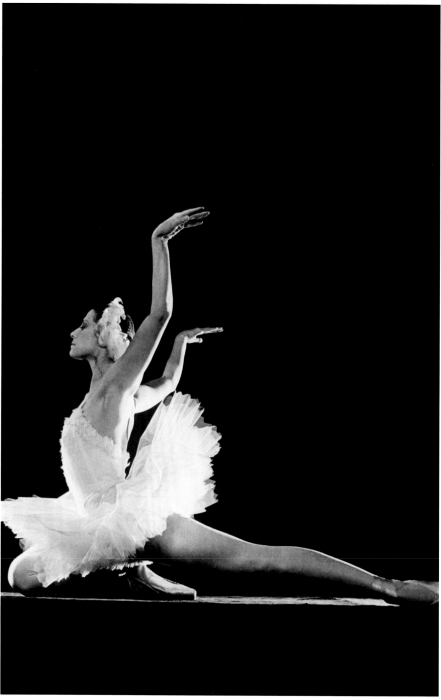

His Future Remained in the Past

After defecting to the United States in 1979, Alexander Godunov's life mixed accomplishment and disappointment. He danced with the American Ballet Theatre until a 1982 falling-out with his friend, company director Mikhail Baryshnikov. He toured with his own troupe for a time, acted in a handful of Hollywood movies, and carried on a high-profile romance with actress Jacqueline Bisset. In 1995 he was found dead in his apartment; the death certificate blamed chronic alcoholism. His epitaph reads, "His future remained in the past." Pictured here, a high-flying Godunov, twenty-three years old, soon after joining the Bolshoi. Moscow, 1972.

Dying Swan

Bolshoi ballerina Maya Plisetskaya dancing one of her signature roles, "The Dying Swan," to the music of Saint-Saëns. Dynamic and fiery, Ulanova's successor as the Bolshoi's greatest star, Plisetskaya was frequently at odds with both the Bolshoi management and the Kremlin itself. Her father was killed and mother imprisoned in Stalin's Gulag. Suspected of wanting to defect, she was for years forbidden to travel abroad, and she was held back professionally by not being permitted to dance modern works. She endured and outlasted all of it to become an international celebrity.

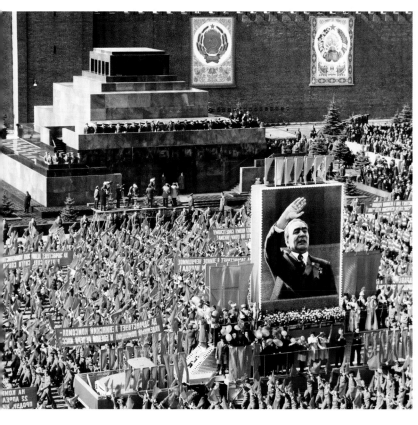

ABOVE
May Day, 1978

A Brezhnev-era May Day celebration. He and other Soviet dignitaries view the festivities from the observation platform atop the Lenin Mausoleum.

RIGHT, TOP
Andropov

After succeeding Brezhnev, Yuri Andropov stands in the midst of his aged Kremlin colleagues. Intelligent, sly, efficient, Andropov remains an enigma, a leader whose ill health and short tenure (only fifteen months) prevented him from forging a legacy. Ironically, this formidable former KGB chief was best known outside the USSR for his correspondence with an American fifth-grader, Samantha Smith. In response to her letter asking if he was spoiling for war, Andropov invited young Samantha to come to Russia to see his peaceful and friendly country for herself. "It seems to me," he wrote her, "that you are a courageous and honest girl, resembling Becky, the friend of Tom Sawyer in the famous book of your compatriot Mark Twain. This book is well known and loved in our country by all boys and girls." Moscow, 1983.

RIGHT, BOTTOM
Chernenko

Konstantin Chernenko was seventy-three years old and ill with emphysema when he succeeded Andropov. His reign was only thirteen months. This 1984 photo shows him enjoying the sun and sea of the Crimea.

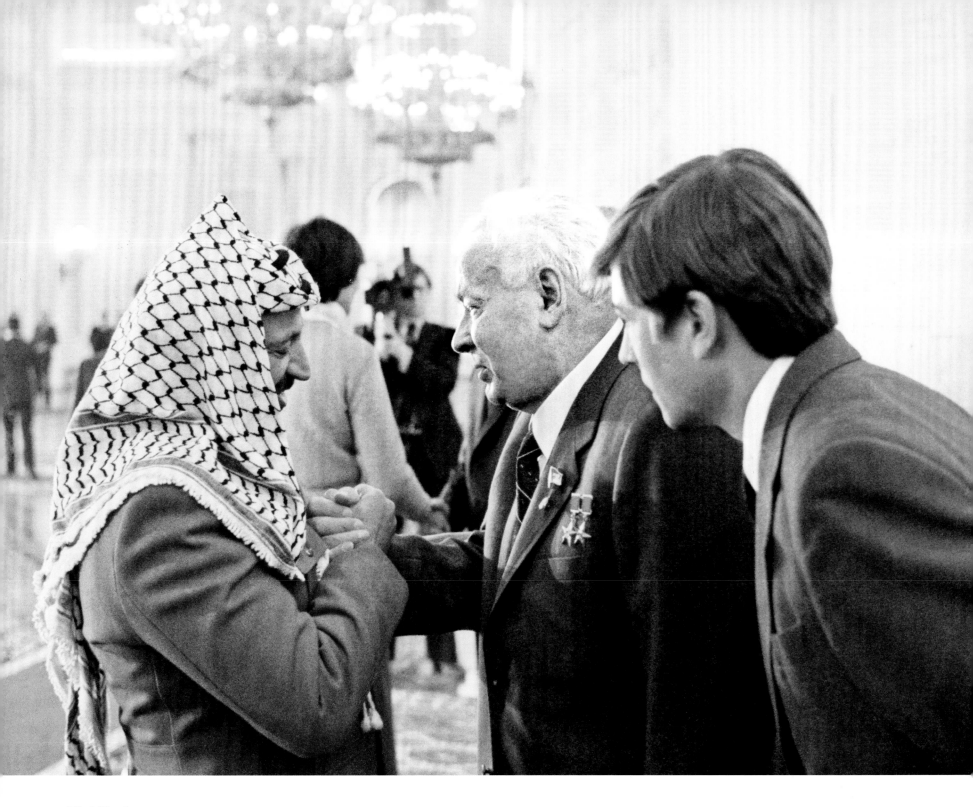

Kind Words
Palestinian leader Yasser Arafat offers condolences to Chernenko
at Andropov's funeral. Moscow, 1984.

The Hovering Presence
In 1992, soon after the Soviet Union collapsed, and ten years after Brezhnev's death, this photo of the bemedaled Soviet leader giving a speech in front of a menacing mural of Lenin was an entry in a Moscow photo exhibition.

1905 – 19
– 1941 – 1
1964 – 19
– 2005

THE LAST DAYS

17 – 1927
953 –
84 – 1991

THE SOVIET IMAGE

1905

1917

1927

1941

1953

1964

1984 –

1991

2005

THE LAST DAYS

MINERAL WATER SECRETARY

Mikhail Gorbachev inherited a Soviet system that was as tired, sick, and outmoded as its leadership. After assuming command in March 1985, he cut to the quick of the challenge facing him: "Our rockets can find Halley's Comet and reach Venus," he said, "but our fridges don't work."

Brezhnev's massive military buildup had starved the Soviet economy. For all its might and menace abroad, at home the Soviet Union still suffered the conditions of a developing nation. Housing was crowded and decrepit, and food, goods, and services were poor and scarce. Long queues were a mind-numbing daily routine. In the West, the era of personal computers was blossoming; in Russia "high tech" was a mirage. "The Soviet Union makes the finest micro-computers!" went the quip. "They are the biggest in the whole world!" Russians drank away their frustrations, as they had for centuries. But, compounding Andropov's mistake, Gorbachev decided that alcohol was a root of the country's problems and made it the target of one of his initial reforms.

Gorbachev inundated the public with temperance propaganda. In defiance of tradition, he banned alcohol from official receptions, pushed up the price of vodka, reduced the number of stores selling it, and curtailed their open hours. Already-long queues of customers now stretched out of sight. He also went after wine, plowing under thousands of acres of prime vineyards. The crusade was hugely unpopular—and futile. Home brew took off, with some four million gallons of moonshine produced per year. That explosion caused a run on sugar, which then had to be rationed. Perfume shops began to sell out as desperate people searched for anything containing alcohol. Hospitalizations—and deaths—from alcohol-containing poisons increased dramatically.

The campaign was equally devastating to government finances. Vodka and other alcohol sales were an important part of state income; when they plummeted, revenues plummeted. Right off the bat, Gorbachev, the promising, newly installed general secretary became known as the mineral water secretary. A joke began to make the rounds. A man waits in line for vodka. After many hours, he says, "I've had enough of this. I'm going to the Kremlin to kill Gorbachev." A few hours later, he comes back and resumes his place in line. "So? Did you kill him?" ask the others. "No. The line to do that was even longer."

"AN ACCIDENT HAS TAKEN PLACE"

On Monday morning, April 28, 1986, technicians at a Swedish nuclear plant north of Stockholm detected abnormally high levels of radiation. They suspected a leak in their reactors but found nothing. Yet when they monitored plant employees, they again found high levels. Geiger-counter readings of the soil and foliage surrounding the plant also disclosed excess radiation, up to five times the usual amount. Soon monitoring stations in Norway and Denmark reported similarly high levels. Something was wrong, but what?

The Swedish technicians turned to weather maps. For several days, winds had been blowing from the southwest, welling up over the Black Sea, and passing across the Ukraine and northward over the western Soviet states into Scandinavia. Could the Soviet Union be the source of the contamination? The Swedes contacted Moscow. Denials and silence.

It wasn't until 9:00 p.m. that night, almost twelve hours after Sweden's initial alarm, that a Moscow TV newscaster read a terse statement from the Soviet Council of Ministers: "An accident has taken place at the Chernobyl power station, and one of the reactors was damaged. Measures are being taken to eliminate the consequences of the accident. Those affected by it are being given assistance. A government commission has been set up."

In the days to come, the world learned the truth. It wasn't simply an accident—it was a catastrophe. An explosion had destroyed the number-four reactor at the Chernobyl nuclear power plant some eighty miles north of Kiev. Flames roaring two hundred feet into the air had caused a nuclear meltdown, spewing enormous quantities of radiation into the air. Tens of thousands were being evacuated from

the area. A vast plume of radioactive fallout was drifting over the western Soviet Union, Europe, Scandinavia, the United Kingdom, and toward North America. Estimates were that the amount of radiation was equal to ten Hiroshimas. It eventually came to be regarded as the worst disaster in the history of nuclear power.

But you wouldn't have known any of that by listening to Soviet reports. It wasn't until the weekend following the Monday explosion that Moscow offered a straightforward accounting, and it came from the little-known Moscow party chief, Boris Yeltsin. "The cause lies apparently in the subjective realm, in human error," he admitted to West German television. "We are undertaking measures to make sure that this doesn't happen again." And it wasn't until a full eighteen days after the explosion that Mikhail Gorbachev appeared on TV to discuss the event. Although he devoted much of his statement to a denunciation of the Western press's coverage of the disaster, he declared, "For the first time ever, we have confronted in reality the sinister power of uncontrolled nuclear energy."

Although true, the statement was self-serving. He failed to mention that were it not for blunders on the part of plant engineers, lack of modern safeguards inherent in the plant's design (for example, a radiation-containment building had never been built), an unwillingness to face the gravity of the situation, and a stonewalling cover-up, the destruction at Chernobyl and its horrific aftermath could have been averted or, at least, alleviated. When the engineers in the control room first reported the disaster, their supervisors didn't believe them. The most they would admit to Moscow is that a "mishap" had taken place. Control-room engineers informed Chernobyl's director, Victor Bryuchanov, that the radiation at the plant was millions of times higher than normal; he responded by insisting their meter was defective. Declaring that "panic is worse than radiation," a deputy minister named Boris Shcherbina refused to order a large-scale evacuation.

"Meanwhile," wrote Gregory Medvedev, a former engineer at Chernobyl, "the reactor was burning away. The graphite was burning, belching into the sky millions of curies of radioactivity." Children in the nearby town played soccer in contaminated dirt, weddings were conducted under a contaminated cloud, men fished in a contaminated river and ate their contaminated catch, people splashed in a contaminated open-air swimming pool. And Moscow did nothing.

The rest of the world was outraged. Italy banned imports of meat, livestock, and vegetables from most of Eastern Europe. West Germany urged children to stay out of sandboxes, keep out of the rain, and touch the ground only with shoed feet. Japan detected contamination in rainwater and fresh milk; sales of powdered milk skyrocketed. Radiation blanketed the United States from upstate New York all the way to the Pacific Northwest. Washington residents rushed to buy iodine-rich kelp tablets for protection.

While Soviet officials remained tight-lipped, in June, a month and a half after the explosion, the official Soviet newspaper, Pravda—usually the font of glowing reports on all things Soviet—ran a scathing article about the explosion's aftermath. Among the disclosures were that six officials had deserted their posts during the disaster and the plant's director and chief engineer had been dismissed for lack of leadership.

The reverberations of the disaster ran deep, at once encapsulating and condemning the condition of the USSR itself—its arrogance, its self-deception, its deep-seated and endemic decay.

GLASNOST AND PERESTROIKA

Chernobyl underlined what Mikhail Gorbachev knew only too well: his country was in dire straits. He quickly came to understand that no campaign against alcohol, or tinkering with the economy, or any other halfway measures would be enough to make a difference. The Soviet Union desperately needed true, far-reaching reform.

What Gorbachev came up with soon became the bywords of his era: glasnost and perestroika. Glasnost means "openness." (The Pravda article was an example of this new direction.) Perestroika means "restructuring." They weren't, however, an invitation to Western-style free speech or democracy. Gorbachev

THE SOVIET IMAGE

1905

1917

1927

1941

1953

1964

1984 –

1991

2005

THE LAST DAYS

was clear that both strategies must be understood within the existing Soviet system. Glasnost offered the opportunity to express the truth, yes, but in the context of Communist principles. Perestroika meant a streamlining of the bloated, corrupt Communist hierarchy. Gorbachev was searching for a workable middle ground that would allow market-generated free enterprise to invigorate a moribund state-owned economy. In everything, the party would retain the role of guide and bottom line.

That was the plan. But events soon spiraled out of Gorbachev's control. People emphatically and joyously embraced the easing of restrictions. They began to speak out against the repressive regime. When one formerly forbidden sentiment went unpunished, another more provocative one would follow. And now, for the first time since Khrushchev partially lifted the veil three decades earlier, Soviet citizens gained access to their past. History, so long suppressed, came alive—a history that included atrocities such as Stalin's purges and the horrors of the Gulag. Russian people now encountered the heavy weight of their heritage.

For the first time, Russians could openly read Vladimir Nabokov, Boris Pasternak, Joseph Brodsky. Anti-Stalinist works such as Anatoly Rybakov's novel *Children of the Arbat* became available. *Repentance,* a film made in 1984 by Georgian Tengiz Abuladze, was finally released. It not only denounced the nation's history of terror but condemned the generation that covered up the crimes. Gorbachev allowed all this and more.

The grand symbolic gesture of glasnost was Gorbachev's freeing of Andrei Sakharov. Sakharov had been languishing in internal exile in the closed town of Gorky since 1980. One winter's night in 1986, the KGB installed a telephone in his room, declaring, "You will get a call around ten tomorrow morning." The next day the phone rang—it was Gorbachev telling Sakharov he could come home to Moscow. "You have an apartment there," he said. "Go back to your patriotic work!"

As before, Sakharov's Moscow apartment became the moral center of the dissident movement—but this time there was less cause for dissent, more basis for optimism. In February of 1989 Gorbachev pulled Soviet troops out of Afghanistan, ending the decade-long war, and in March he authorized elections for a new assembly, the Congress of People's Deputies. It would be the Soviet Union's first democratically elected body. Communists, usually running unopposed, won the vast majority of seats, but there was at least one notable breakthrough: Andrei Sakharov himself was elected to the assembly. During the first session, it was Sakharov who made the first speech. His presence proclaimed a new era.

The proceedings were televised, two weeks' worth of political drama of a sort never before glimpsed by the Soviet people. In the past, Kremlin leaders had been mysterious figures doing shadowy things behind closed doors. Now the workings of government were exposed for all to see. And things didn't go as Gorbachev anticipated. It was as though he had let seventy years' worth of frustrations and anger and repression out of the bottle. Glasnost and perestroika weren't unfolding in a neat, orderly fashion.

A former Olympic weightlifter named Yuri Vlasov took the podium to criticize the KGB, condemning it for operating an "underground empire." Yuri Karyakin, a Dostoevsky scholar, called for Lenin's remains to be removed from his mausoleum in Red Square and given a decent burial. A Leningrad law professor, Anatoly Sobchak, lambasted the military for squelching a peaceful demonstration in Tbilisi, Georgia, and killing at least nineteen people in the process. (He was shortly after to become the first elected mayor of St. Petersburg.) And Gorbachev himself was not immune. One delegate called him to task for his expensive dacha on the Crimean coast. Another accused him of being led by the nose by his fancy wife. And when Gorbachev was nominated to run unopposed for president of the new assembly, a delegate named Alexander Obolensky took the podium to nominate himself, declaring, "It's not a question of winning; it's a matter of creating a tradition of political opposition and competition." Nothing close to this kind of political free-for-all had taken place since the early days of the 1917 Revolution—and this time, the melodrama was being beamed out to all corners of the land on national television.

THE VELVET REVOLUTION

Moscow wasn't the only place gulping down the intoxicating air of possibility. "Any nation has the right to decide its fate by itself," Gorbachev declared (on the American television program *Good Morning America;* Soviet foreign ministry spokesman Gennadi Gerasimov dubbed the stance the Sinatra Doctrine, an allusion to the singer's anthem, "My Way"). Gorbachev anticipated that Soviet bloc countries would freely express their desire to help reform the union, but he was wrong. It was a crucial misreading of the health of the satellite regimes and the hold Moscow had on them. With the Kremlin preaching restructuring and openness, and no longer cracking down on dissent, one country after another felt secure enough to spread its wings.

The first to fly was Poland. After being rocked by protests and strikes, and deeply in debt, the country's beleaguered government turned for help to the huge labor union, Solidarity, which it had previously banned, and to its head, Nobel Peace Prize laureate Lech Walesa. In 1989, Solidarity candidates committed to dismantling the Communist system and replacing it with a Western-style democracy and free-market economy won overwhelming victories in the most open elections in Poland in decades. And in 1990, Walesa became the first freely elected president of Poland in fifty years.

Hungary soon followed. In 1989 its Communist Party convened its last congress, transformed itself into the Hungarian Socialist Party, and repudiated four decades of Soviet rule, including the brutal suppression of the 1956 uprising. The country's legislature adopted a "democracy package" that included guaranteed civil rights, freedom of the press, multiparty elections, and a Western-like separation among the judicial, executive, and legislative branches of government.

Also in 1989, Prague Spring, so brutally squelched in 1968, belatedly bloomed. On the stage of Prague's Magic Lantern Theatre, poet and playwright Václav Havel, his country's version of Walesa and Sakharov, only recently released from a prison term for dissent, announced that the Czech Politburo

had resigned. He and a vindicated Alexander Dubček, who had been so publicly humiliated in 1968, raised a champagne toast to a free and democratic Czechoslovakia. Soon, proclaiming a "velvet revolution," Havel was elected president.

In Bulgaria, crowds gathered in the capital city of Sofia to demand reform. In early 1990, the Communist Party gave up its claim on power, and in mid-year, the nation held its first free elections since 1931.

And at the stroke of midnight on November 9, 1989, after East Germany's Communist government had announced that travel restrictions to the West would be lifted, the Berlin Wall came tumbling down. Thousands surged through, onto, and over the wall, whacking off chunks of concrete with hammers and chisels, singing and dancing, flooding into the streets of West Berlin for a celebration that continued for days. "Berlin Is Berlin Again," trumpeted the newspaper *B.Z.*

Communist East Germany's entire cabinet and politburo resigned, and the country threw open its borders. President and party leader Egon Krenz promised "free, general, democratic, and secret elections." And although Moscow warned that this sudden access between East and West should *not* be considered a step toward German reunification, reunification took place anyway. On October 3, 1990, East and West coalesced into the democratic Federal Republic of Germany.

In Moscow, Andrei Sakharov watched the metamorphosis of the Soviet Union with amazement. But he was too busy to dwell on it—working on a constitution for a new democratic Russia, struggling to complete his memoirs, attempting to persuade Gorbachev to repeal the decades-old political monopoly enjoyed by the Communist Party. At age sixty-eight, he had become frail, easily winded, with slurred speech, but he continued to greet all manner of visitors in his apartment and continued to push reform as a delegate of the Congress of People's Deputies. On the evening of December 14, 1989, he returned home exhausted from a meeting at the Kremlin, ate a quick dinner, and told his wife, Elena Bonner, that he was going to his study to take a nap, and to wake him at nine. "There

THE SOVIET IMAGE

1905
1917
1927
1941
1953
1964
1984 –
1991
2005

THE LAST DAYS

will be a battle tomorrow," he said. When she came to wake him, he was dead.

Earlier in the year, during the Congress sessions, Sakharov had met with Gorbachev. "Mikhail Sergeyevich!" he had said. "There is a crisis of trust in the country toward the leadership and the Party. Your personal authority and popularity are down to zero. . . . The country and you are at a crossroads."

It was a prophetic statement. Sakharov's death was at once an exclamation point to the astonishing transformations rocking the countries surrounding Russia, changes he and his fellow dissidents had helped set in motion, and a harbinger of even more profound changes to come at home.

A "MORTAL DANGER" TO THE MOTHERLAND

On August 18, 1991, Mikhail Gorbachev was relaxing at the traditional vacation spot for tsars and Soviet leaders, the Black Sea coast of the Crimean peninsula, hundreds of miles south of Moscow. He had built himself a palatial compound there, complete with indoor swimming pool, movie theater, and a guest house for thirty people. He spent his time taking long walks with Raisa, swimming, watching movies, reading, and working on an article and speech. On August 20, he was to sign a treaty for a new Soviet Union that would make the Soviet Republics truly independent in a federation with a common foreign policy and military—and Gorbachev as president.

In retrospect, he might have reconsidered his decision to go on vacation just now. The Kremlin was deeply divided over the direction he was taking the country in. For right-wing hard-liners, Gorbachev's glasnost and perestroika campaign had been hard to swallow from the beginning. Now they could point to the revolutions in the Soviet bloc nations and this new, relaxed union as the inevitable result of such a foolhardy loosening of restrictions. The Soviet economy was continuing to worsen, with goods growing scarcer and queues growing longer, and in the new atmosphere of openness, people were loudly voic-

ing their displeasure. The hard-liners were aware of the pressure on Gorbachev to rescind the country's one-party, Communist monopoly. During the previous year's annual May Day celebration, traditionally an opportunity for the Soviets to parade their military might and tout their achievements in space, marchers in Red Square had lingered in front of the leaders' reviewing platform atop the Lenin Mausoleum to unfurl red Soviet flags with the hammer and sickle ripped out and chant "Down with the party!" "Down with Gorbachev!" What might be next? A full-fledged revolution at home?

Ironically, among Gorbachev's reading at his vacation retreat were tomes on Soviet history. He certainly was aware, then, that the last Soviet leader to be deposed, Nikita Khrushchev, had been vacationing in the Crimea while his enemies and so-called friends plotted against him. And in the article Gorbachev was writing, he even discussed the possibility of a right-wing coup. So it shouldn't have come as a surprise when, late in the afternoon, a security officer announced unscheduled visitors, including a KGB chief—but it was. Gorbachev picked up the phone to find out what was going on. It was dead. All the phones in the compound were dead. Now he knew: at the very least, his position was in jeopardy; at the very worst, his life was.

"Who sent you?" Gorbachev asked.

The State Committee for the State of Emergency, one of the men answered.

"Who appointed such a committee? I didn't appoint such a committee, and neither did the Supreme Soviet," Gorbachev argued.

His protests were useless. The committee, they told him, included Vice-President Gennady Yanayev, KGB Chairman Vladimir Kryuchkov, Interior Minister Boris Pugo, Defense Minister Dmitri Yazov, and Prime Minister Valentin Pavlov, all of whom Gorbachev had appointed, some of whom were longtime friends. Effective immediately, they were taking over all governmental powers, reintroducing censorship, and banning all strikes and demonstrations. And there would be no new union of republics. Gorbachev could either support them or resign. If

he refused, he would remain in the compound under house arrest.

Back in Moscow, the plotters took to the radio to announce that Gorbachev was unable to perform his presidential duty for "health reasons" and ran television programs condemning his policies. They appeared on TV, declaring they were saving the country from a "national catastrophe." Glasnost and perestroika represented a "mortal danger" to the motherland. "The policy of reform initiated by M. S. Gorbachev . . . has, for a number of reasons, come to a dead end." While they were speaking, tanks were rumbling through Moscow. Thousands of Muscovites swarmed onto the streets to protest the takeover. Moscow hadn't seen anything like this since the Revolution. It was a situation tailor-made for Boris Yeltsin.

"HOLD ON, PAPA, NOW EVERYTHING DEPENDS ON YOU"

A big, blustery, hard-drinking, sixty-year-old, silver-haired politician from the Ural Mountains city of Sverdlovsk, Yeltsin had risen quickly to the top rungs of Soviet leadership. (In tsarist times, the city had been named Ekaterinburg. It was the last residence of Nicholas II and his family. After the Revolution, it was renamed Sverdlovsk in honor of Yakov Sverdlov, the Bolshevik official who had ordered the tsar's execution.) When Gorbachev came to power in 1985, he appointed Yeltsin head of the Moscow Communist Party and later made him a nonvoting member of the Politburo. Yeltsin made a name for himself as a plain-talking man of the people, often taking a city bus to his office.

When Gorbachev established the Congress of People's Deputies in 1989, Yeltsin was elected as the Moscow delegate in a landslide. In 1990 he quit the crumbling Communist Party in disgust and the following year was elected president of Russia, the largest of the territories within the Soviet Union, becoming the first popularly elected leader in Russian history. As such, he now acquired a power and legitimacy that no one else could match. After all, even Gorbachev himself had never been directly elected by a vote of the people.

On the morning of August 19, when Moscow radio began broadcasting news of the coup, Yeltsin was eating breakfast at his dacha outside the city. Soon he was joined by the entire leadership of the Russian Republic, under the guard of eight soldiers with submachine guns. Yeltsin and his colleagues called an emergency session of the Congress of People's Deputies, implored the Russian people to resist the takeover, and resolved to drive to the White House, the fourteen-story marble Parliament Building on the banks of the Moscow River. As Yeltsin strapped on a bulletproof vest, his daughter, Tatiana, told him, "Hold on, Papa, now everything depends on you."

Yeltsin arrived at the White House around 10:00 a.m. By that time, Soviet tanks and armored personnel carriers (BMPs) had taken control of key sites, including the City Council, State Bank, Ministries of Foreign Affairs and Defense, general staff headquarters, TV and radio stations, newspapers, and the Lenin Hills residential area. BMPs blocked Theater Square outside the Bolshoi Theater, and in Red Square, tanks pointed their guns at St. Basil's Cathedral and the Kremlin itself.

Tanks and artillery trucks massed in front of the White House, but they didn't stop Yeltsin's black limousine from pulling into the underground garage. Almost immediately he held a press conference. The committee was illegal, he declared, and was trying to pull off a coup. This was "madness" and must be stopped. His mandate to govern came from the people and could only be withdrawn by the people, not some arbitrary group. Gorbachev must be reinstated immediately. He asked the people of Moscow to demonstrate "in defense of democracy."

Suddenly an aide rushed over. "At least fifty tanks are on their way to this building," he whispered.

"Anybody who wants to save himself can do so," Yeltsin declared. "We are continuing to work."

With that, he walked outside and climbed onto a T-72 tank, shook hands with the flabbergasted crew, and turned to the crowds of troops and demonstrators. "Citizens of Russia," he bellowed. "The legally elected president of the country has been removed from power. . . . We are dealing with a right-wing,

THE SOVIET IMAGE

1905
1917
1927
1941
1953
1964
1984 -
1991
2005

THE LAST DAYS

reactionary, anti-constitutional coup. . . . We call on the citizens of Russia to give the organizers of the coup an appropriate response and to demand the return of the country to normal, constitutional development." To the troops surrounding him, he said, "You have taken an oath to your people, and your weapons cannot be turned against the people."

It was a powerful moment. The image of Yeltsin atop the tank was flashed around the world, instantly becoming the symbol of Russian resistance to lawlessness, reactionary tyranny, and its brutal past. And now, as the crowd cheered, ten tanks turned their gun turrets away from the White House toward the city. They now protected Yeltsin.

"IT'S OKAY NOW"

The next morning Yeltsin and his colleagues looked out the window to see some ten thousand people camping near the barricades outside the White House. There, standing guard outside his office, was the exiled cellist Mstislav Rostropovich, carrying a Kalashnikov assault rifle. He had flown in from Paris to lend his support. Yeltsin called on the people of Moscow to stage a huge demonstration against the coup.

In the center of Moscow, crowds were commandeering public buses and trucks to barricade streets and squares against a tank invasion. The armored vehicles already inside the city were being besieged by people offering food, cigarettes, water, ice cream. Babushkas went up to soldiers and asked, "Who have you come to shoot at? Your mothers? Is that what we have brought you up for?" Pretty girls offered flowers and suggested that perhaps the soldiers might prefer to come home with them.

By midmorning, 150,000 people had braved a persistent drizzle to amass in front of the White House. Speaking from a balcony, Yeltsin declared once again that democracy would triumph. Rostropovich made a brief appearance. "I love you," he told the sea of umbrellas below. "And I am proud of you." Elena Bonner, Sakharov's widow, reminded the crowd of the forgotten man in the drama, Mikhail Gorbachev. "I had my disagreements with Gorbachev, but he was the president of this country and we cannot allow a bunch of bandits to take over."

By afternoon the number of coup-controlled troops inside the city grew to fifty thousand. Rumors began to swirl about an impending assault, especially when the military commander of Moscow broadcast orders for a curfew from 11:00 p.m. to 5:00 a.m. the next morning. To Yeltsin and his supporters, that could only mean one thing: the conspirators were trying to get people off the streets so as to clear the way for an invasion.

Inside the White House gas masks were issued. Women were ordered to leave—few complied. As the evening wore on, the crowds outside grew more nervous and agitated. Up to one hundred thousand people lingered for hours in the rain, playing guitars and singing, arms linked, forming some forty concentric rings around the building. Inside, three hundred militia and three hundred veterans of the Afghan war prepared to defend Yeltsin. Finally, he and a few aides agreed to spend part of the night in an underground bunker with a twenty-inch-thick steel door. And the night wore on.

Only later did Yeltsin learn what the coup leaders were planning. Special obstacle-clearing vehicles would open a path through the barricades. Three tank companies would then open fire on the White House. While helicopter gunships supported the assault from above, elite troops would hack their way through the crowds and storm the building, blow up the doors with grenades, and make their way to Yeltsin's fifth-story office.

But it was not to be. As Yeltsin and the others inside the White House nervously passed the night, the plotters were losing heart. Drinking heavily, they assessed the situation. The coup hadn't gone as they planned. They hadn't received expected support, either from the army or the Soviet people. They hadn't reckoned on Yeltsin's courage and popular appeal. Three protestors had died that evening at the hands of tank troops very near the White House. Did they really want to murder their own people? Could they count on the army to follow orders and mount a strike? They had no comprehensive plan beyond taking the White House

and declaring themselves winners. How could they govern a populace that was proving to be stubborn and resilient beyond their reckoning? Finally, late into the night, Vice-President Yanayev turned to the other committee members and asked, "Is there really someone here among us who wants to storm the White House?"

With that, it was over. At 3:00 a.m., KGB Chief Kryuchkov called Yeltsin. "It's okay now," he said. "You can go to sleep."

"WE'VE GOT THE BASTARDS"

At eleven the next morning, with Yeltsin exulting, "We've got the bastards. They're on the run," the retreat began. The first tanks rumbled out of Red Square. To applause and cheers from the crowds, convoys of military vehicles spewed clouds of blue diesel smoke along the avenues out of the city, back to their barracks. Moscow, and the Soviet Union, returned to normal.

But not quite normal. A dramatic sea change had taken place. Just three days before, Mikhail Gorbachev presided over a Soviet Union careening, for better or worse, toward an undefined reform. Now power was in the hands of a broad-faced force of nature named Boris Yeltsin. When Gorbachev returned in the early morning hours of August 22, tired and shaken, proclaiming "I want to breathe the air of freedom in Moscow," Moscow was Yeltsin's city. (The same day, every one of the conspirators surrendered to the Russian police—with the exception of Interior Minister Pugo, who committed suicide.)

Yeltsin had saved Gorbachev, and the country, from a fate that, in the eyes of many, Gorbachev himself had facilitated. Every one of the coup leaders was a part of the Gorbachev ministry; he had personally appointed most of them. Was he so blind, or gullible, that he couldn't see what was happening under his nose? Yet Gorbachev acted as though nothing had changed. Without missing a beat, he continued to expound on his vision of a renewed party leading the Soviet Union into the new millennium. But now no one

was willing to listen. Even his closest and most loyal advisor, Alexander Yakovlev, was appalled. "The Party is dead," he told Gorbachev. "Why can't you see that? Talk about its 'renewal' is senseless. It's like offering first aid to a corpse!"

Yeltsin, who had turned his back on the Communist Party, was in a position to flex his muscles and leapfrog his former mentor to become the official as well as de facto power in the land. And it wasn't beneath him to humiliate Gorbachev in the process. At a meeting of the Russian Parliament, he forced Gorbachev to read aloud a transcript of his Council of Ministers pledging their support for the coup. Once that ordeal was over, Yeltsin flashed his broad grin and blurted, "And now, on a lighter note, shall we now sign a decree suspending the activities of the Russian Communist Party?"

"What are you doing?" Gorbachev said, shocked. "I haven't read this . . ."

Yeltsin duly banned the party, seizing all its property. On August 24, finally sensing the direction of the wind, Gorbachev resigned as general secretary of the Communist Party and dissolved its Central Committee. On December 25, Christmas Day, he resigned as president of the Soviet Union. And on December 31, 1991, the Soviet hammer-and-sickle flag was lowered from the Kremlin towers, to be replaced by the Russian tricolor.

With the final step of the former Soviet republics becoming independent states, after three-quarters of a century, more quietly than dramatically, the Soviet Union faded into history.

In its place arose the Democratic Federation of Russia—under the leadership of Boris Yeltsin.

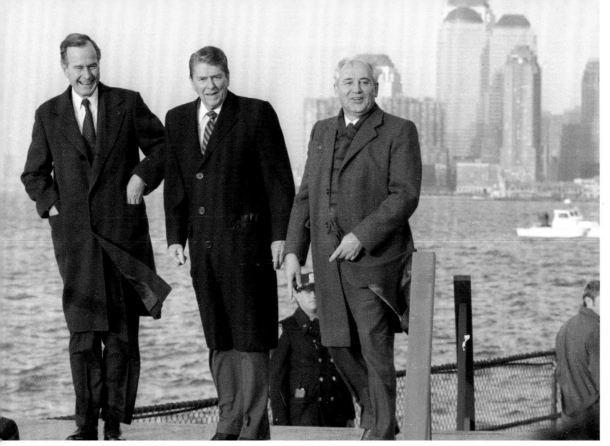

A Man with Whom We Can Do Business

Mikhail Gorbachev, at the height of his popularity in the West, jovially poses with U.S. President Ronald Reagan and Vice-President George H. W. Bush on Governors Island, New York, in 1988. His well-tailored dress and media-savvy manner were different from what the world had come to expect from Soviet leaders. Here was something new and promising.

Raisa

Raisa Gorbachev works the crowd in the city of Messina in Sicily in 1989. Stylish and poised, she often accompanied her husband on official visits around the world. (This was a major departure from the past—his predecessors' dowdy wives had stayed well in the background.) Her visibility ensured her popularity in the West but didn't sit so well at home, where she was often regarded as uppity and self-serving.

OPPOSITE
The Chernobyl Disaster

An aerial view of the destroyed fourth reactor at Chernobyl soon after the explosion in 1986. As a result of the blast, a surrounding area within a radius of almost twelve square miles was rendered radioactive. Soon only dead villages and neglected farmland remained, along with the "dead city" of Pripyat, where the engineers of the plant once lived. The neighboring country of Byelorussia suffered most from the disaster. Two-thirds of the radionuclides released from the explosion contaminated the territory of this republic. One in every five of the inhabitants, including more than half a million children, received a heightened dose of radiation.

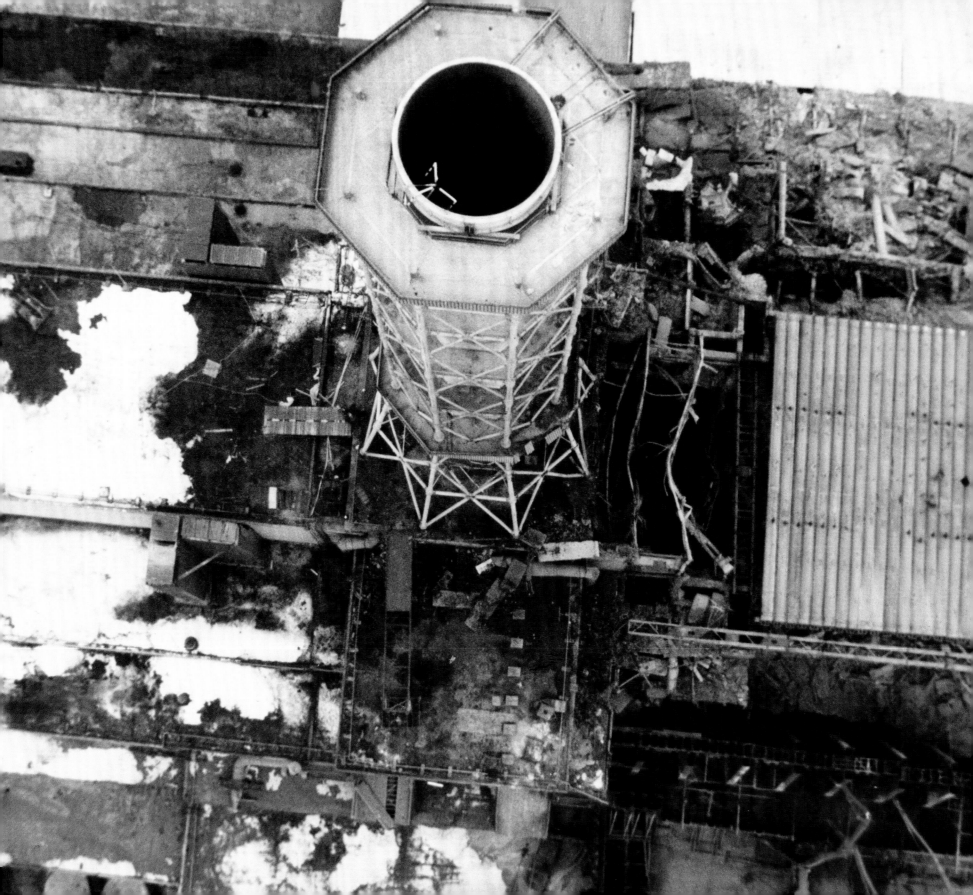

The Chernobyl Disaster

ABOVE, LEFT

The safest way to clean up the destruction was to let machines do the work. Technicians test radio-controlled bulldozers before sending them into the radioactive zone.

ABOVE, RIGHT

The explosion at Chernobyl devastated the nearby Mogilev region of Belarus. Thirteen of the region's twenty-one districts were contaminated. Here a resident sadly contemplates the prospect of bidding her home good-bye.

LEFT

During the Great Patriotic War, the invading Nazis hanged captured partisans from this cross-shaped tree. After the explosion at Chernobyl, many trees in the area were cut down because of radiation. This tree was saved, a memorial to the murdered patriots. This photo was taken in 1988.

OPPOSITE

Technicians patrol the grounds of Chernobyl in 1990, four years after the disaster.

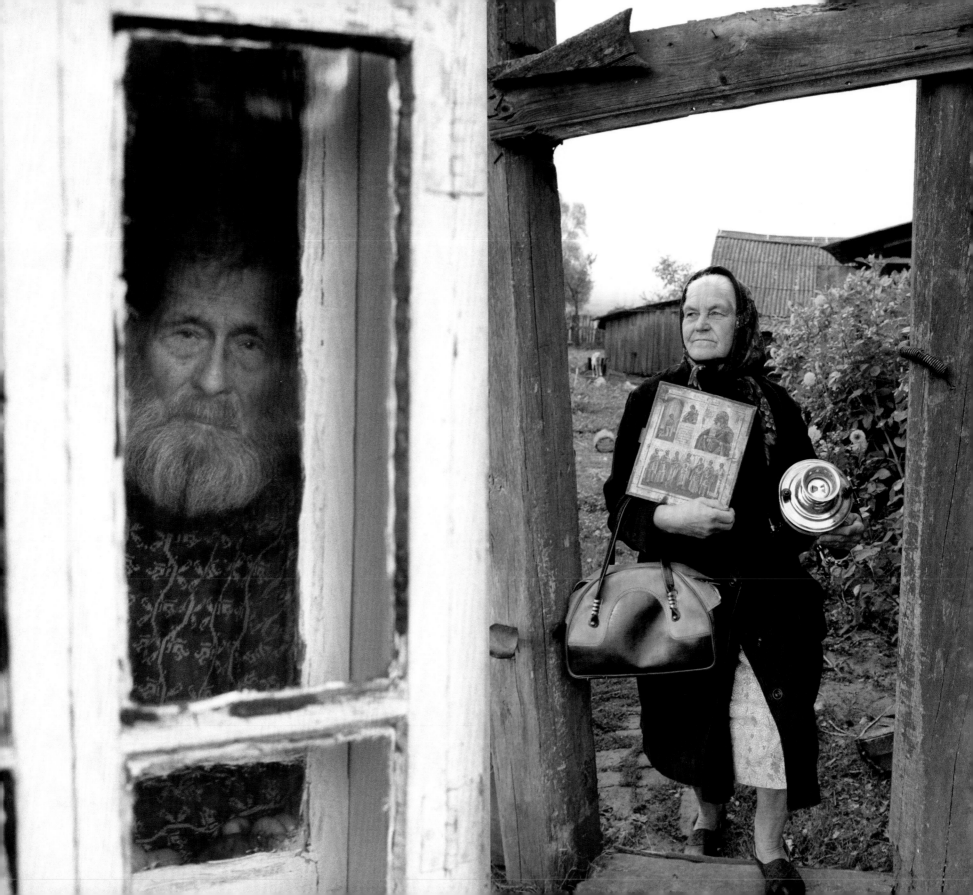

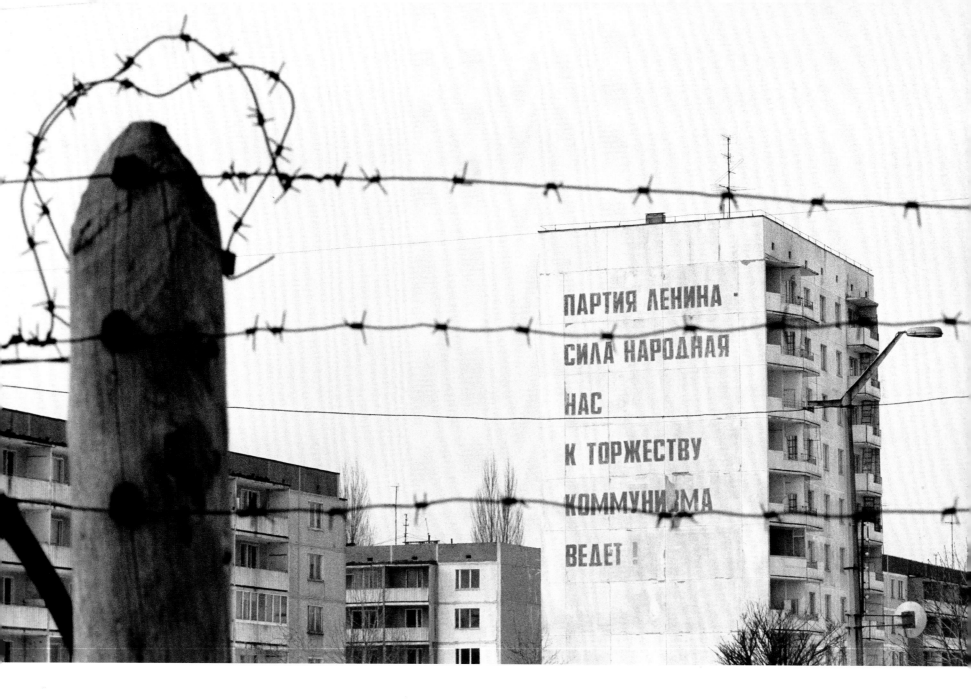

ПАРТИЯ ЛЕНИНА -

СИЛА НАРОДНАЯ

НАС

К ТОРЖЕСТВУ

КОММУНИЗМА

ВЕДЕТ !

The Chernobyl Disaster

OPPOSITE, LEFT
Karp Kruglikov, ninety-four years old, warily looks out from the window of
his house in the village of Svyatsk in Belarus, near the Chernobyl nuclear
reactor. Although Svyatsk was badly contaminated by the explosion,
Kruglikov refused to leave his home.

OPPOSITE, RIGHT
This resident of Svyatsk walks away from her home clutching two prized
possessions: a religious icon and a samovar.

ABOVE
The town of Pripyat stands deserted after the Chernobyl
catastrophe. The text on the building is from the National Anthem
of the Soviet Union: "O Party of Lenin, the strength of the people,
to Communism's triumph lead us on!"

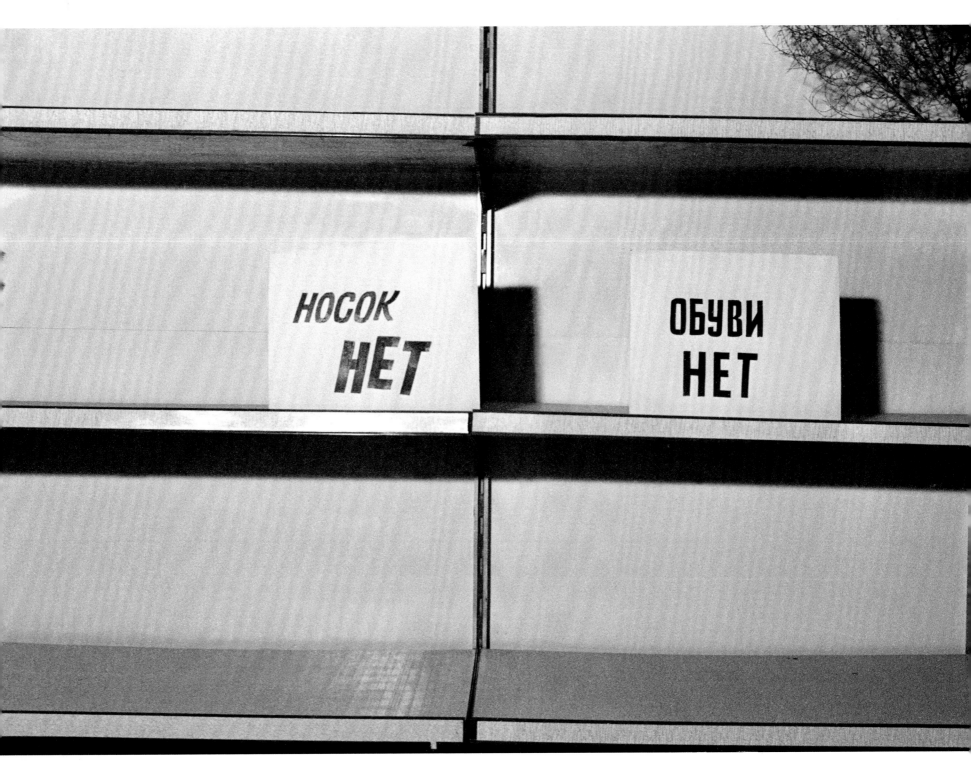

"No Socks," "No Shoes"
Empty store shelves in the city of Vladikavkaz, capital of the North Ossetia
region bordering Chechnya, in 1991. The signs read "No Socks" and "No Shoes."
The Soviet economy, long in decline, was at a standstill.

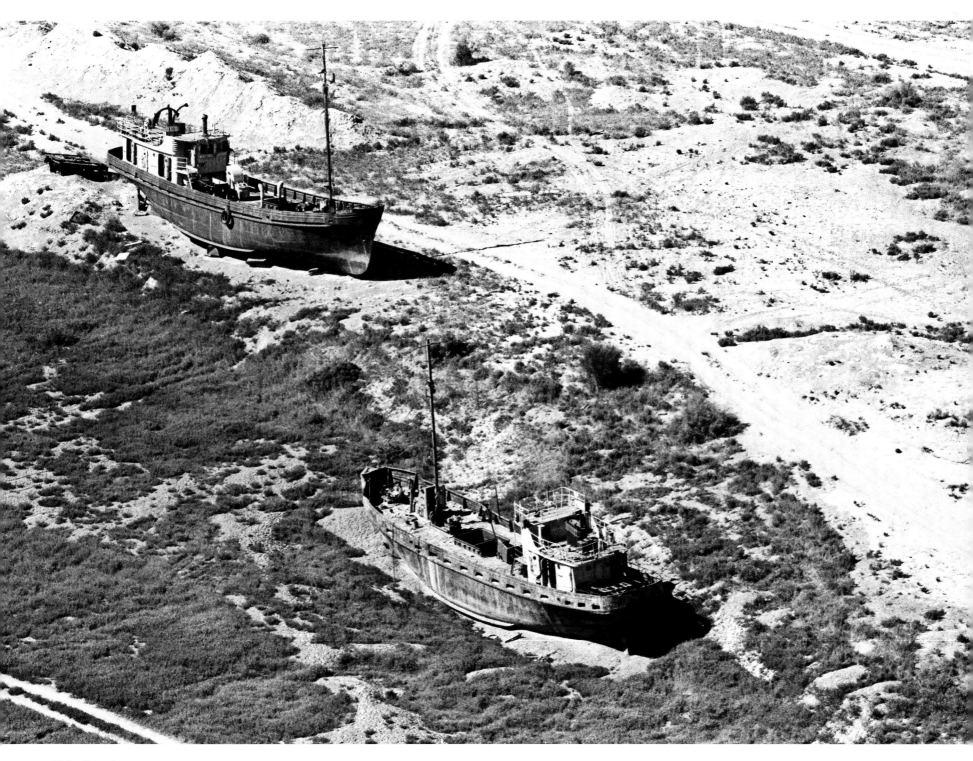

Ship Cemetery

Landlocked ships rest on the dried-up bottom of the Aral Sea, straddling the border between Kazakhstan and Uzbekistan. Formerly spreading over more than 26,000 square miles, the sea—by 1989, when this photo was taken—had shrunk to 60 percent of its size, the victim of a misguided Soviet irrigation project. The seafloor became a salt desert. (Today a new dam is helping to replenish the lake, bringing hope to the devastated region.)

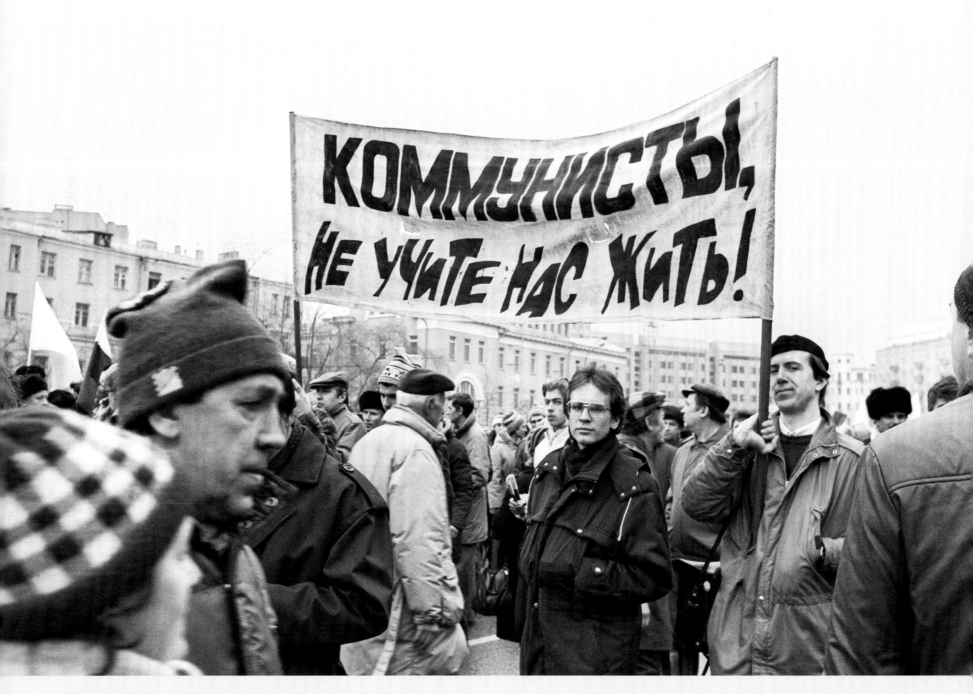

"Don't Tell Us How to Live"
Pro-democracy demonstrations in Moscow. The sign reads
"Communists, Don't Tell Us How to Live!" 1990.

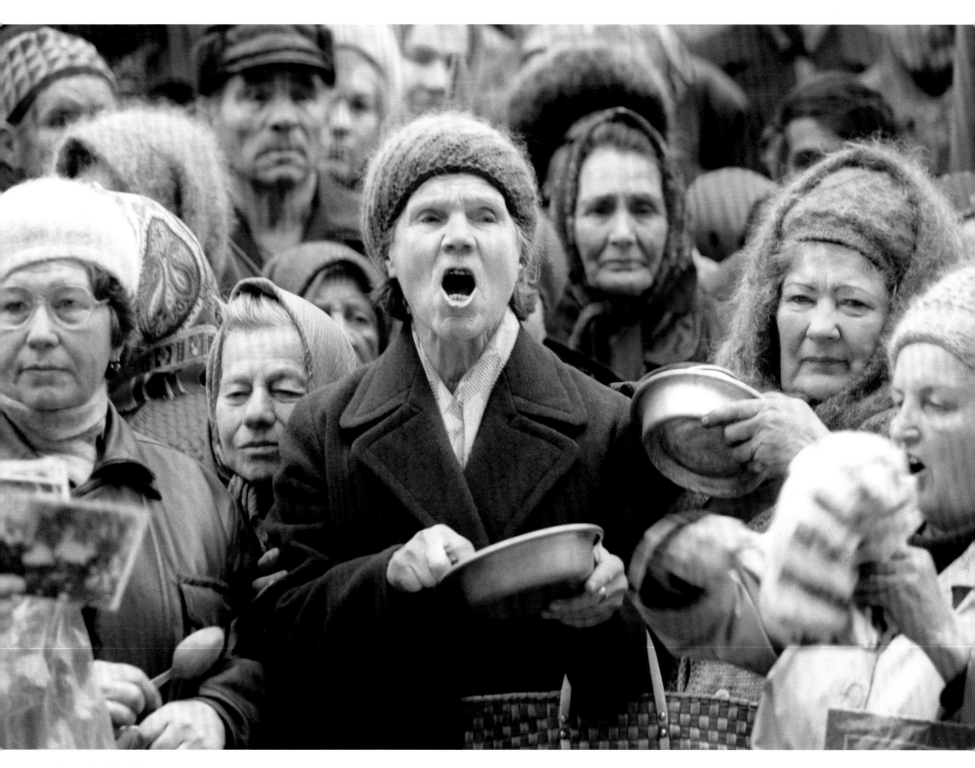

Unrest in the Mines
Miners and their families demonstrate against underpayments of salaries and pensions in the iron- and coal-mining region of Rostov, southwestern Soviet Union. 1988.

ABOVE
A Dancer Comes Home
In 1987, Rudolf Nureyev made an emotional visit to the Soviet Union, from which he had defected in 1961. Here he stands before his childhood home in the city of Ufa, in the western Ural Mountains region.

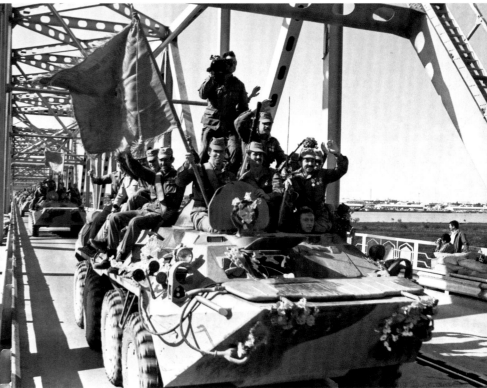

ABOVE
Pulling Out
Jubilant Soviet troops rumble over the Afghanistan-Uzbekistan Friendship Bridge on their way to the Uzbek city of Termez in 1988. By 1989 all Soviet troops would be out of Afghanistan.

OPPOSITE
A Walk in Space
Nineteen years after Valentina Tereshkova became the first woman in space, Svetlana Savitskaya became the second—and the first woman to perform a space walk. Here she braves the vastness of space outside the space station *Salyut 7* in 1984. She walked in space for three hours and thirty-five minutes.

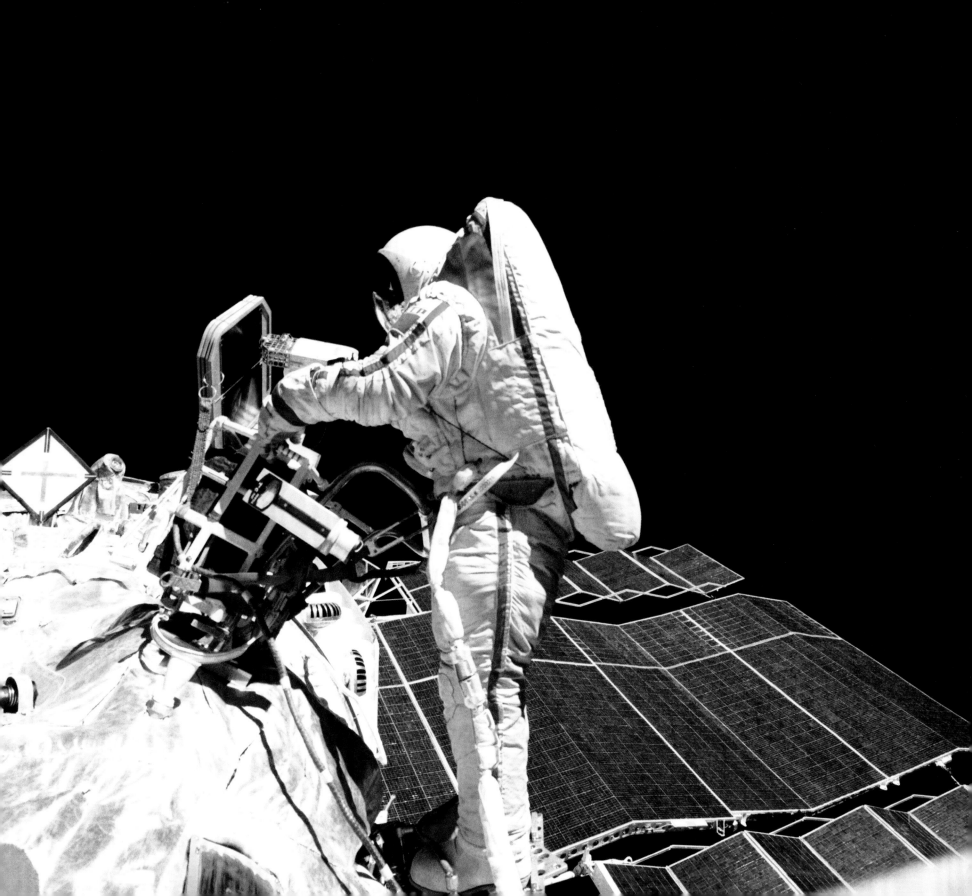

Keeper of the Flame

Dmitry Likhachev was a cultural conscience of Russia. A native
of St. Petersburg and a scholar of ancient Russian literature, he
crusaded to keep the flame of traditional Russian culture burning.
There "is an aesthetic principle inherent in ancient Russian music,
literature and icon painting," he said. "An author expresses not
himself, but a kind of national wisdom." In this photo, taken in
Leningrad in 1990, he was eighty-four years old. He died in 1999.

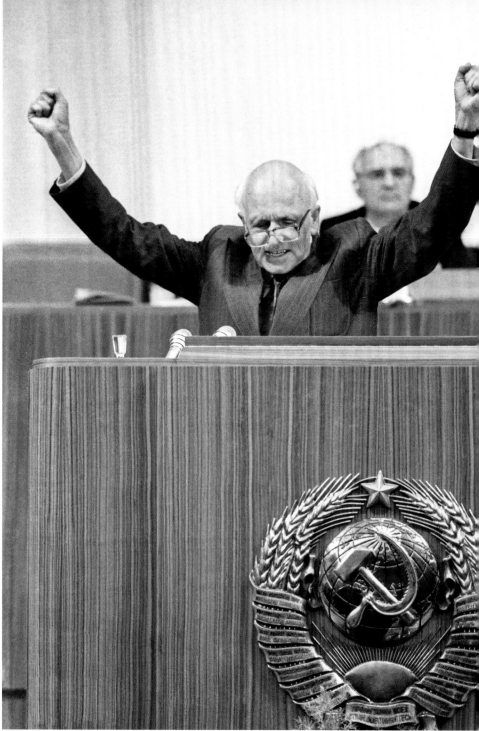

The First Speech

Andrei Sakharov, who Gorbachev had released from the Gulag
only three years before, triumphantly delivers the first speech
during the first session of the Congress of People's Deputies
of the USSR in Moscow in 1989. The Congress was the Soviet
Union's first democratically elected body.

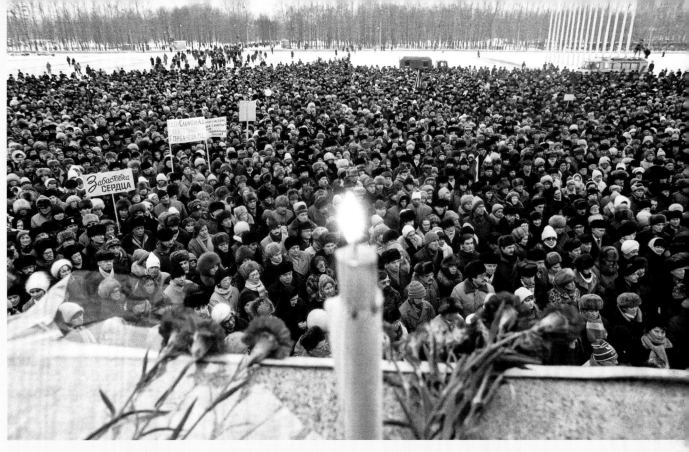

A Hero's Funeral

Some fifty thousand mourners attend Sakharov's funeral in Moscow on December 18, 1989. "He was a prophet, a prophet in the ancient sense of the word," declared one of the speakers. "That is, he was a man who summoned his contemporaries to moral renewal for the sake of the future. And like every prophet, he was not understood. He was driven from his own city."

Solidarity

In 1990, electrical engineer, activist, union organizer, labor leader, and Nobel Peace Prize laureate Lech Walesa became the first freely elected president of Poland in fifty years. Here, at a Moscow press conference, he declares, "We are facing the new era in relations between Russia and Poland." Moscow, 1992.

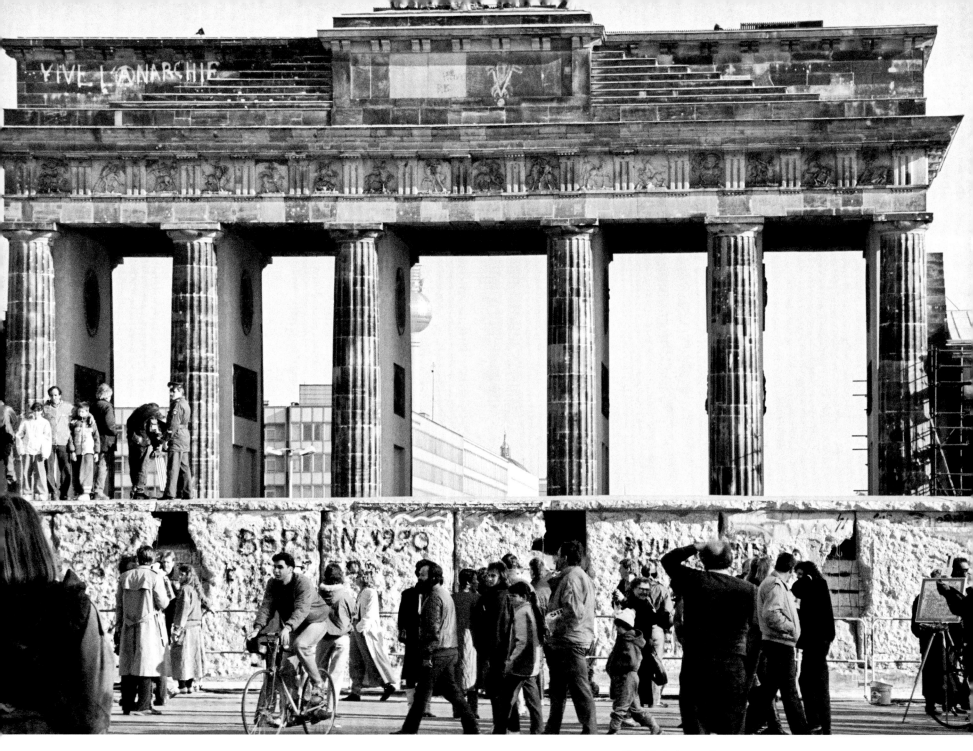

The Wall Came Tumbling Down
Last days of the Berlin Wall, looking from West Berlin toward the
Brandenburg Gate and the East. So long the forbidding symbol
of the city's separation, now the wall became an accessible part
of everyday life, to be torn apart, climbed upon, graffitied, and
ridiculed. At the top of the Brandenburg Gate, scrawled in French:
"Long Live Anarchy." 1990.

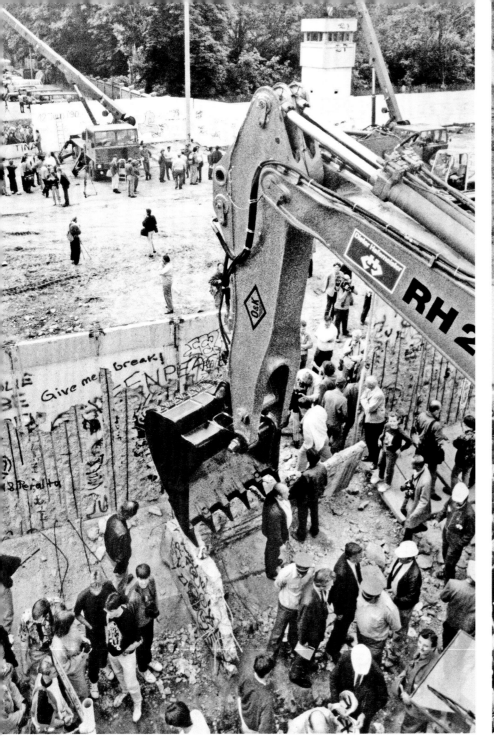

Destroying the Wall
Workers were faced with destroying almost one hundred miles of wall and reconstructing ninety streets. Berlin, 1990.

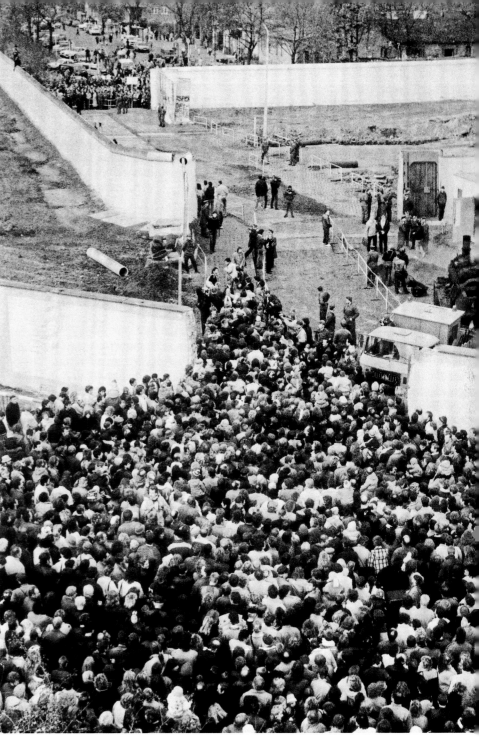

Bernauer Strasse
When first built, the wall at Bernauer Strasse was bordered by apartment houses on the East Berlin side and the nineteenth-century Reconciliation Church on the west. So many people tried to escape East Berlin by jumping from their apartment windows that the windows were walled up. Later the tenants were evicted and the buildings torn down. Reconciliation Church was closed soon after the wall went up. It was demolished in 1985. This photo shows the opening of the wall at Bernauer Strasse in 1989.

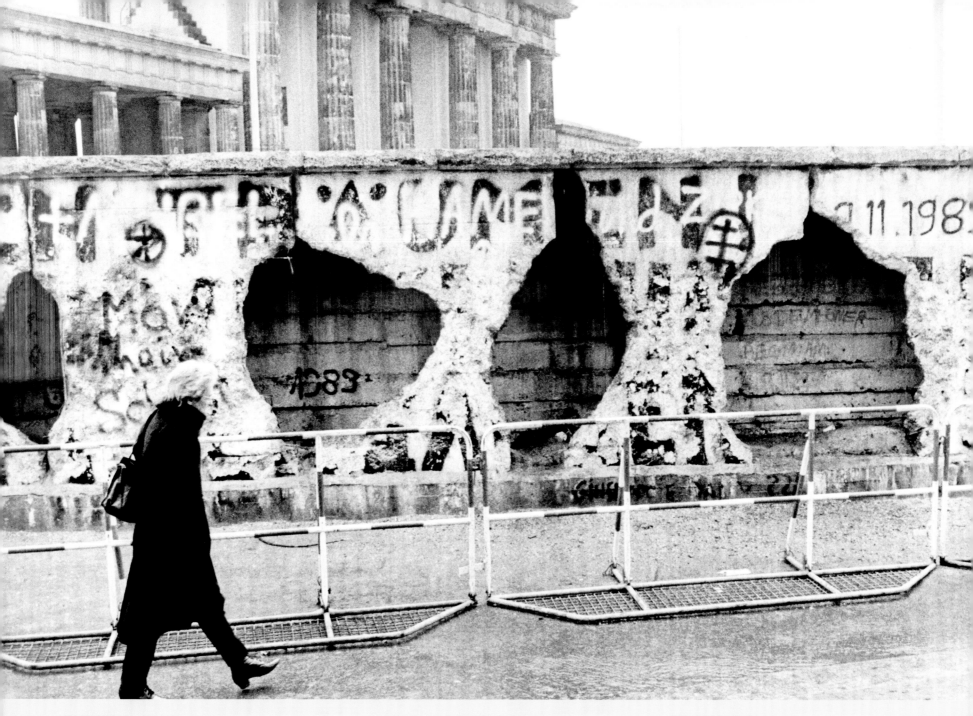

Remnants
The Berlin Wall stands bleak, defaced, and decayed, as though eaten away from the inside. Berlin, 1990.

Defying the Coup

Boris Yeltsin emerges from the White House, climbs atop a T-72 tank, and reaffirms the nascent Russian democracy. With the Russian tricolor flag to his left, he says to the antigovernment troops surrounding him, "You have taken an oath to your people, and your weapons cannot be turned against the people." Moscow, August 19, 1991.

50,000 coup-controlled troops patrol the city; 150,000 pro-democracy demonstrators mass in front of the White House. The outcome hangs in the balance. Moscow, August 20, 1991.

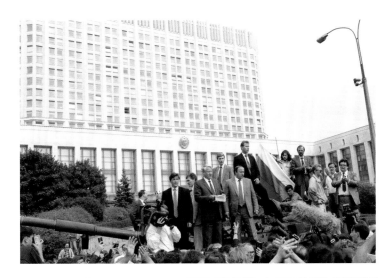

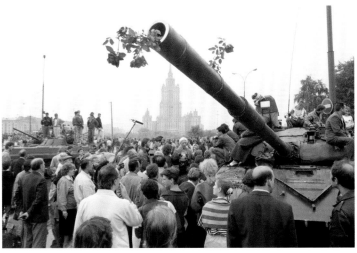

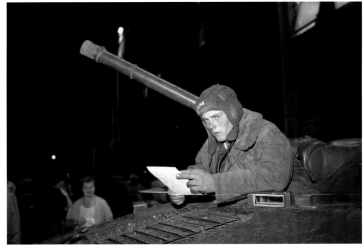

A tank crew member barricading the White House ponders his next move. Moscow, 1991.

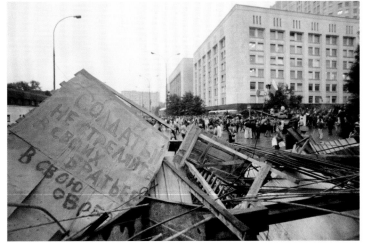

A barricade near the White House. The sign reads "Soldiers! Don't shoot your brothers." Moscow, 1991.

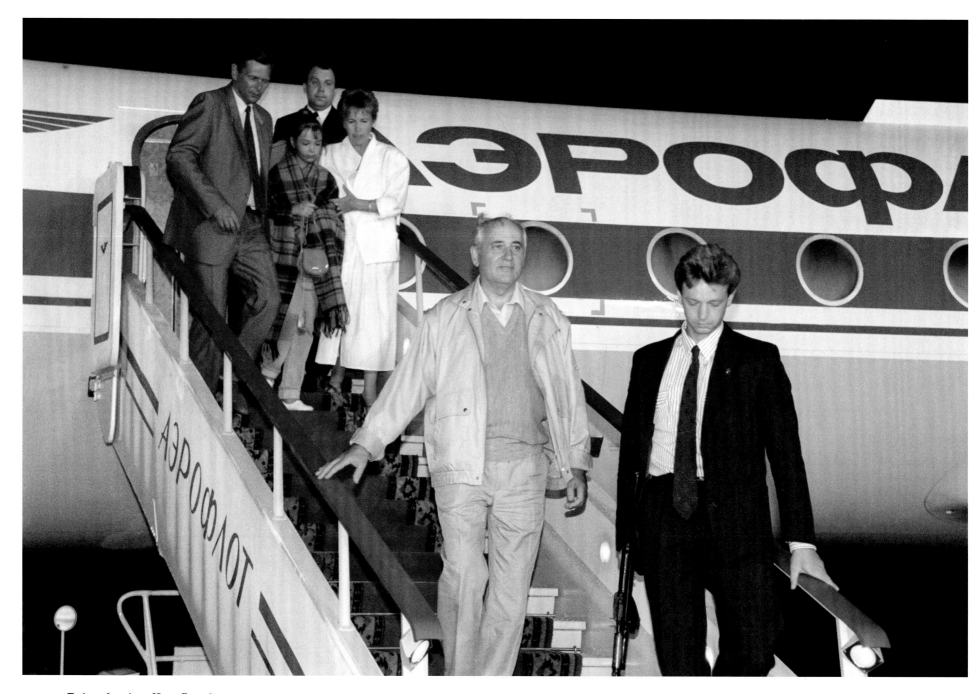

Returning to a New Country

Apprehensive and shaken, Mikhail Gorbachev and his family return to Moscow from the Crimea on August 22, 1991. Little did he know that Boris Yeltsin was now the force in the country. Within days, Gorbachev would resign, and the Communist Party, which had ruled Russia for seven decades, would be out of power.

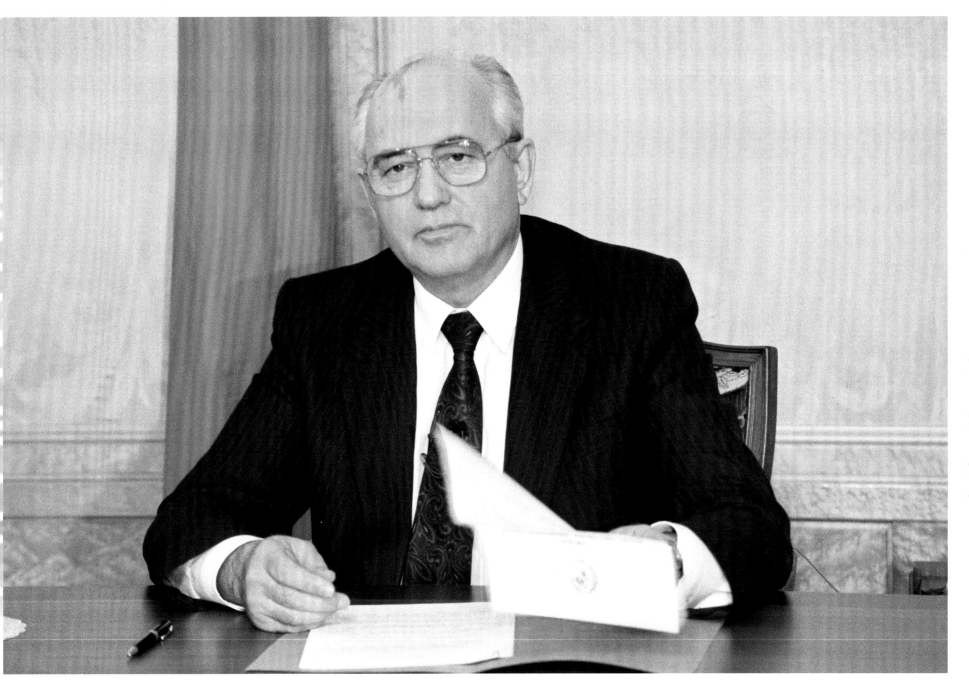

Resignation
Gorbachev resigns as president of the Soviet Union,
Christmas Day, 1991.

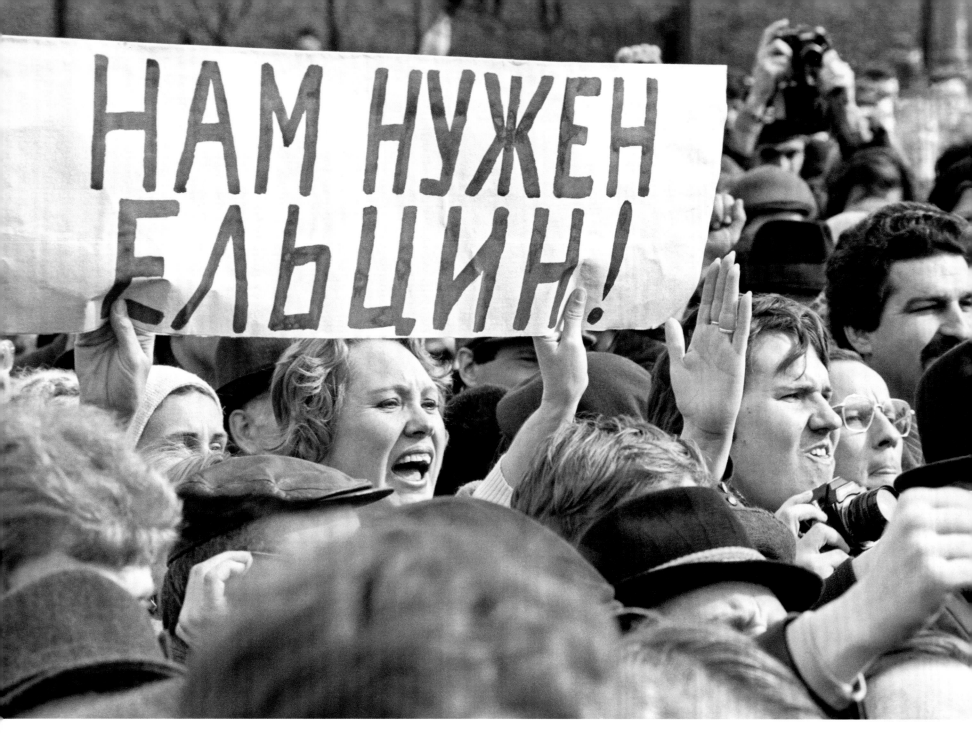

"We Want Yeltsin"
In 1990, before the election that raised Boris Yeltsin to the presidency of
the Russian region of the USSR, Moscow's 85,000-seat Luzhniki Stadium
was the site of a demonstration. The sign reads, "We Want Yeltsin!"

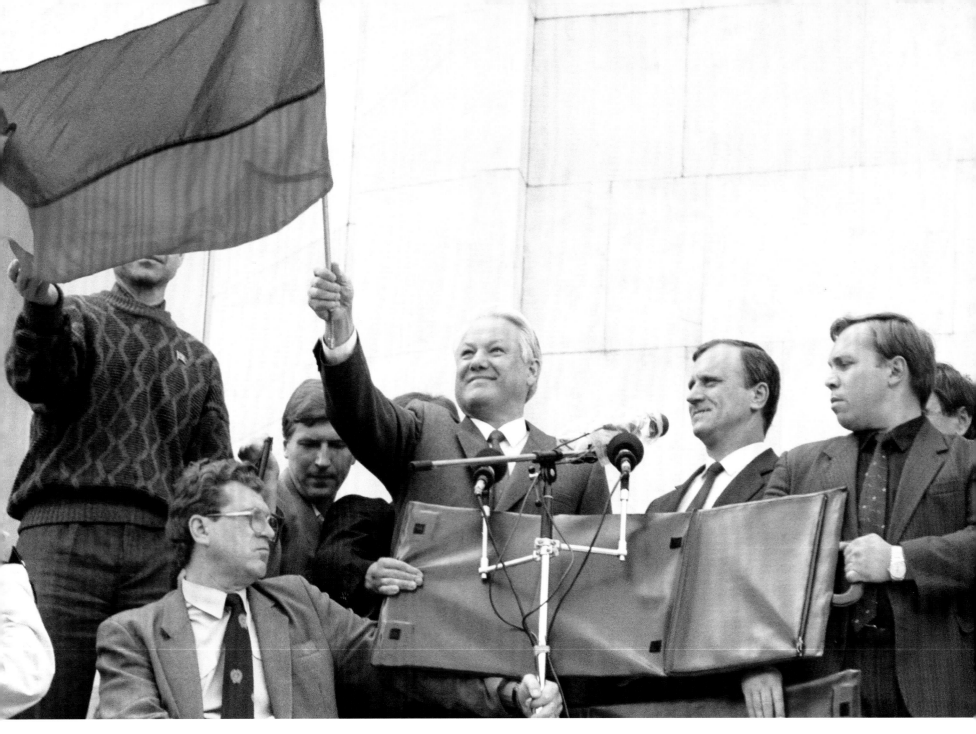

"We've Got The Bastards. . . !"
With democracy preserved, Yeltsin triumphantly waves the tricolor in front of the White House on August 22, 1991. It is his finest hour.

1905 – 19
– 1941 – 1
1964 – 19
– 2005

17 – 1927
953 –
84 – 1991

THE SOVIET IMAGE

1905

1917

1927

1941

1953

1964

1984

1991 –

2005

THE NEW RUSSIA

SEARCHING FOR AN IDENTITY

In the ten decades since the tsar's troops fired into the midst of Father Gapon's unarmed workers in St. Petersburg's Palace Square in 1905, provoking the massacre that became known as Bloody Sunday, Russia has moved from Europe's most rigid and hidebound monarchy to revolution; civil war; Communist Soviet Union; devastating world war; cold war superpower; doddering empire; nascent democratic nation; and—finally—vigorous, erratic, and enigmatic republic. All of this in a human lifespan.

Russian nonagenarian citizens still alive were born under Tsar Nicholas II, the last embodiment of a monarchy that endured for almost four centuries. Octogenarians were born in the time of Lenin and the beginnings of Soviet Russia, a regime that was supposed to last forever. Those from their fifties to their seventies took their first breath in the fearsome rule of Stalin; many can remember well the horrors of the Great Patriotic War.

But for many others, these people and events might as well be ancient history. The average age in today's Russia is thirty-seven years old. These people and younger came of age in the raucous atmosphere of Boris Yeltsin and Vladimir Putin's Democratic Federation. For them the somber terrors of the past may be more embarrassment than legacy, a hazily glimpsed nightmare that, like a nagging hangover, refuses to disappear.

President Vladimir Putin's background spans it all. He was born in 1952, the year before Stalin's death sent the country into convulsions of fear, anxiety, and relief. He grew up in St. Petersburg, the city of the Revolution. As a child, he heard stories of his paternal grandfather, a cook who served food to Rasputin, later prepared meals for Lenin, then toiled at one of Stalin's dachas for the Great Leader himself. Before moving into St. Petersburg governmental service, Putin was, for a decade and a half, an agent with the KGB. Upon being summoned to Moscow by Yeltsin in 1996, he briefly led the FSB (Federal Security Service of the Russian Federation), the successor agency to the KGB. In 1999, Yeltsin appointed him prime minister, then soon resigned and elevated Putin to become Russia's acting president. His emphasis on stability, law and order, and a firm approach to the conflict in Chechnya quickly earned him popularity. A 2000 national election officially voted him into the job with over 50 percent of the vote, against less than 30 percent for his nearest opponent.

The Russian Federation has sustained itself for more than a decade and a half. Putin is attempting to steer his adolescent republic in a political direction—democracy—in which it has no previous experience and in an economic direction—free markets—in which it has not participated since the time of the tsars. Russia enjoys enormous profits from its vast oil reserves, yet must contend with an inflationary economy that has made Moscow one of the most expensive cities in the world. While Western businesses invest in New Russia, and newly rich Russians flamboyantly ply the international scene, Soviet-era pensioners hawk heirlooms and bundles of produce at subway stations and underpasses in a desperate attempt to survive. With the cold war a memory, the nation must find its way in a world divided along new geographical and religious lines. It must contend with terrorism outside and inside its borders and resolve its excruciating conflict with the former Soviet Republic of Chechnya. What was supposed to be a brief slap on the hand to an unruly republic demanding independence has become an unremitting nightmare, with Russian forces reducing Chechnya's capital city, Grozny, to rubble; more than eighty thousand Chechens dead; and continuing Chechen terrorism unnerving the Russian population. While Putin attracts international criticism because of his increasingly authoritarian policies, policies that recall the specter of Soviet control and repression, his nation struggles to determine what degree of liberty and democracy will work in a country that has precious little experience with either. The road has not been smooth.

Today's national symbols illustrate a desire to come to terms with all of the Russian experience—a stance unfamiliar to the formerly secretive and cloistered country. Russia now incorporates the tsars' double-headed eagle as its official state seal. Ceremonial occasions include elegant military uniforms that hark back to the war against Napoleon

in 1812. Today's national anthem is the same as the former Soviet anthem, with new lyrics (for example, instead of the Soviet "In the victory of Communism's deathless ideals / We see the future of our dear Land," today's anthem sings, "Plenty of room for dreams and for life / The coming years are promising us"). The red flag of the Russian army recalls that of Soviet times. The logo of Aeroflot, the national airline, features the Soviet hammer and sickle. Yet the tricolor, the white, blue, and red flag of the Democratic Federation, is New Russia's own.

"GRANDFATHER LENIN CAN WATCH OUR EVERY MOVE FROM THERE"

Meanwhile, illuminated like a jewel in the midst of the cool darkness within the granite mausoleum in Red Square lies Lenin. He has remained there ever since Stalin ignored his wish for a simple burial next to his mother in St. Petersburg and embalmed him soon after his death in 1924. Stalin knew what he was doing. Stripped of their religion by the Revolution, Russians responded passionately to this state-authorized holy relic. During Soviet times, it was a place of pilgrimage, with the queue to the mausoleum snaking through, and out of, Red Square. The wait to glimpse the Father of the USSR lasted hours.

Today there's rarely a delay in visiting the remains. Muscovites will tell you that now tourists constitute the mausoleum's primary clientele. For a crisp hard-currency bill, formerly stern and unapproachable guards will cheerfully guide you through the cemetery of notables behind the mausoleum: Stalin, Brezhnev, Gagarin, Dzerzhinsky, and the American journalist John Reed, among numerous others. For many, Lenin has become an expensive irrelevance. It costs a reported $1.5 million per year to keep him on display, with embalmers periodically changing his suit and drenching the remains in preservatives, as they attempt to stem the body's inexorable decay.

In 1999, during his last year in office, Boris Yeltsin tried to remove Lenin from the mausoleum but ran into strong opposition from the Communist Party, which had legally resurrected itself in the new multiparty Russia. One left-wing group threatened to detonate a bomb if Yeltsin went through with it. In 2005 a former KGB officer and close friend of Putin's named Georgy Poltavchenko brought up the idea again, this time suggesting that Lenin and the other Soviet leaders interred near the mausoleum should all be buried elsewhere. "Our country has been shaken by strife, but only a few people were held accountable for that in their lifetime," he said. "I don't think it's fair that those who initiated that strife remain in the center of our state near the Kremlin."

"It is time to get rid of this horrible mummy," declared Valeria Novodvorskaya, the head of a small reform party called the Democratic Union. "One cannot talk about any kind of democracy or civilization in Russia when Lenin is still in the country's main square." An informal poll conducted by a Moscow radio station reported that up to 75 percent of responders agreed. "Grandfather Lenin can watch our every move from there," remarked a Muscovite passing by the tomb. "As long as he remains unburied, his soul will seek revenge. How else can you explain the mess our country is in?"

Others think differently. "Raising this issue smells of provocation and illiteracy," proclaimed Gennadi Zyuganov, the leader of Russia's Communist Party. He described those who wanted to remove Lenin as people "who do not know the country's history and stretch out their dirty hands and muddy ideas to the national necropolis."

Putin himself weighed in on the side of caution. "Many people in this country associate their lives with the name of Lenin," he said. "To take Lenin out and bury him would say to them that they have worshiped false values, that their lives were lived in vain."

Were they? With the heady, hopeful, chaotic days of Gorbachev and Yeltsin fading into memory, and Vladimir Putin, an ex-KGB officer who has called the breakup of the Soviet Union "the greatest geopolitical catastrophe of the century" having firmly established power, will New Russia ever be free of the cold shadow of its arduous past? Will Grandfather Lenin keep watch forever?

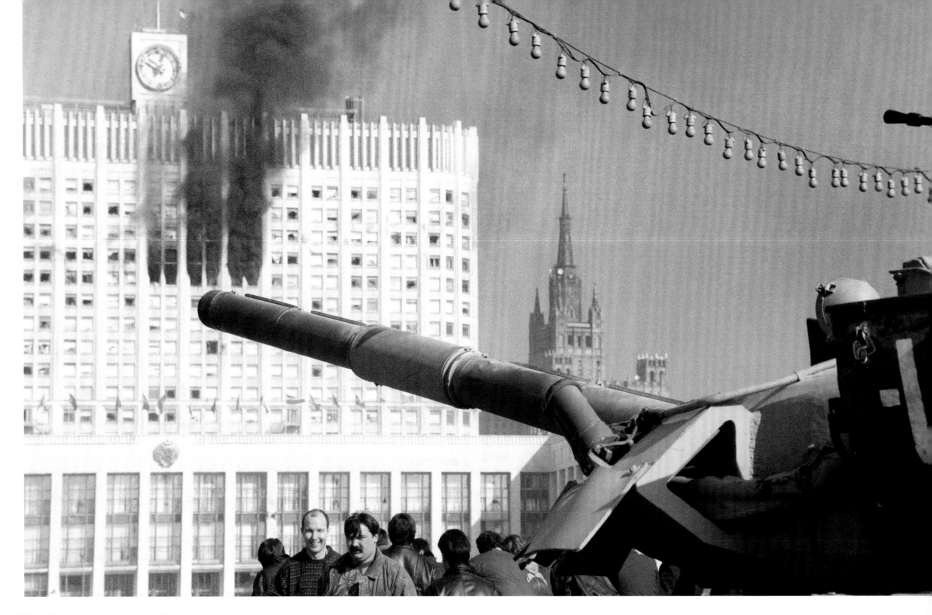

"Our Russia is in danger!"

After the high emotion and confusion surrounding the fall of the Soviet Union, the new Russian democratic government soon deteriorated into a fierce power struggle between reform-minded Boris Yeltsin and his conservative parliament. Yeltsin had felt it necessary to administer "shock therapy" to the foundering country, introducing unrestricted capitalism to a people that had never experienced it. He ended government production subsidies and price restrictions; soon the cost of living and inflation skyrocketed. He pushed privatization of public assets in a country where the idea of private assets and property had been anathema. The result was corruption and chaos (and later, the rise of fabulously wealthy oligarchs taking control of Russia's large industry).

The former Communists who comprised most of the parliament were wary of Yeltsin's reforms and put off by his increasingly arrogant manner; they grew hostile and belligerent. A gulf opened between the president and his government, and the struggle for power put Russia's fragile, fledgling capitalistic democracy on the ropes.

In March of 1993, Yeltsin barely survived an impeachment attempt; in September he retaliated by dissolving parliament. Undaunted, rebellious officials and armed supporters barricaded themselves inside parliament headquarters, the White House. Thousands of others took to the streets, some commandeering militia trucks and storming the national television building. From the White House, their leaders called for a siege of the Kremlin itself. Prominent citizens went on television to urge action. "My friends! Please don't sleep. Please, don't sleep tonight. Wake up!" pleaded actress Liya Akhedzhakova. "Our Russia is in danger. A horrible fate is in store. Communists are coming." Many thousands responded, crowding into the streets, circling bonfires, and chanting their support for Yeltsin, while the president himself tried to rouse the officially "neutral" army against his opponents.

On the morning of October 4th, Yeltsin addressed the nation. "Many of you answered the call of your heart and spent the night in the center of Moscow . . . tens of thousands of people risked their lives. . . . I bow low before you." Sensing that momentum had finally turned toward the president, the army came around. A dozen heavy T-72 tanks lumbered into position and fired on the White House. As black smoke poured from the building's top floors, army troops swarmed inside. Soon it was over.

Russia could finally draw a deep breath. It had narrowly averted a civil war—but at a high cost. Close to 200 were killed and more than 1,000 injured.

A Concert in the Square
Cellist Mstislav Rostropovich conducts his Washington, D.C.–based National Symphony Orchestra in Red Square in September 1993. The concert had been scheduled to honor the hundredth anniversary of the death of Tchaikovsky, but, as it coincided with the conflict between Boris Yeltsin and the Russian parliament, it became a show of support for Yeltsin from his musician friend. For two hours 100,000 people braved the cold to hear, among other rousing patriotic pieces, Tchaikovsky's "1812 Overture," complete with the booming of cannons and the pealing of bells from St. Basil's Cathedral (in the background of the photo).

Remembering the Dead
Thirteen years after the event, mourners remember the victims of the October 1993 parliamentary rebellion. Moscow, 2006.

Making Up His Mind

Boris Yeltsin explains to reporters at the airport in his hometown of Ekaterinburg in February 1996 that he has not yet made up his mind to run for reelection to a second four-year term. Battered by an attempted coup, a stagnating economy, a hostile legislature, a military debacle in Chechnya, and two heart attacks, he had seen his approval rating plummet to 6 percent. He had every reason not to run.

Taking the Oath

Yeltsin takes the oath of office during his inauguration ceremony in the Kremlin Palace in August 1996. That he ran for reelection to a second four-year term was a surprise—that he won, an even greater one. In his campaign he emphasized that, even though the road had been rocky, he—rather than his Communist opponent, Gennadi Zyuganov—was the only person who could continue to steer Russia toward free market reform and democracy. Faced with even greater uncertainty without Yeltsin than with him, Russians returned him to office in the second presidential election in their history.

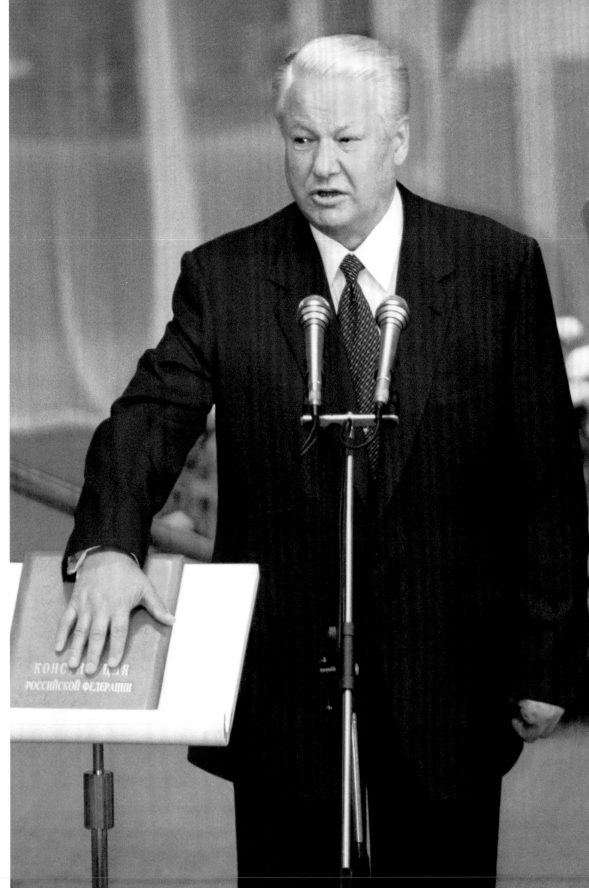

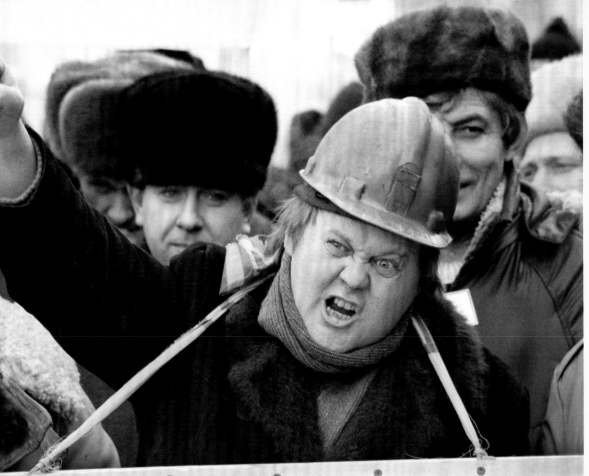

НЕПОЗВОЛИМ!

СДЕЛАТЬ

ИЗ НАС

СКОТОВ

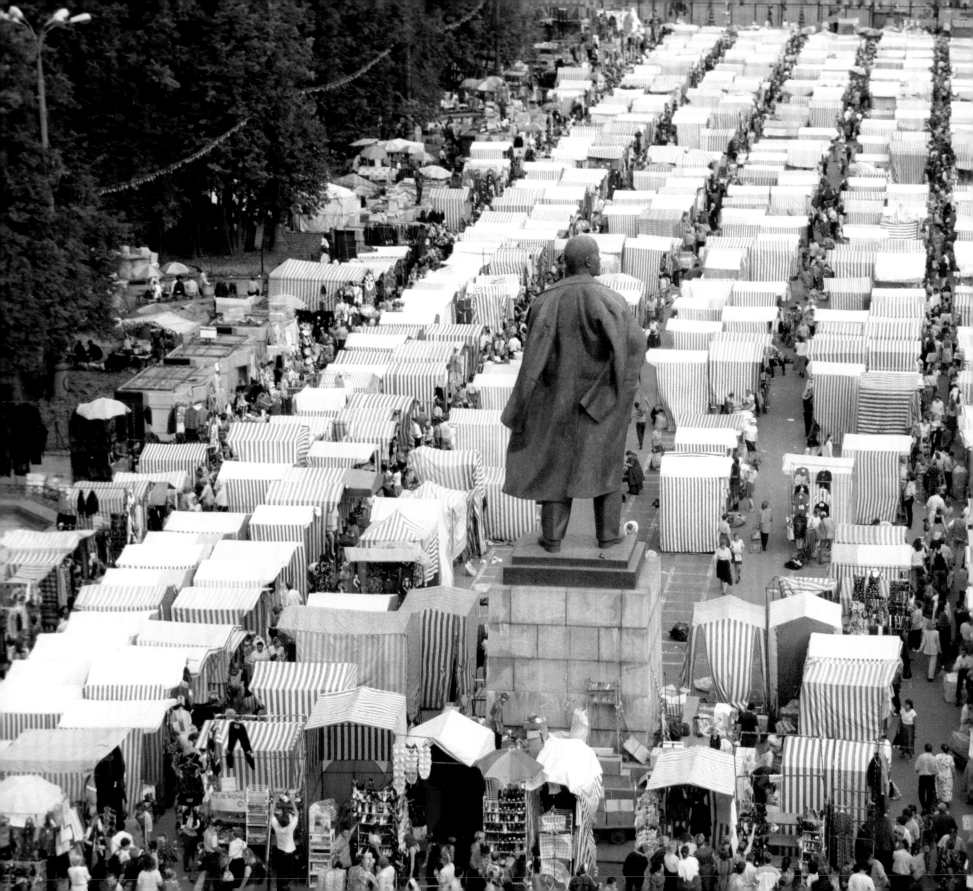

Market Economics
A monument to Lenin looks down on rows and rows of stalls
in an open-air market on the grounds of the Luzhniki Stadium.
Moscow, 1997.

Memoirs of a Dissident
Andrei Sakharov's widow, Elena Bonner, speaks at a news conference at Moscow's Russian-American press center on the occasion of the publication in Russia of her husband's memoirs. Moscow, 1997.

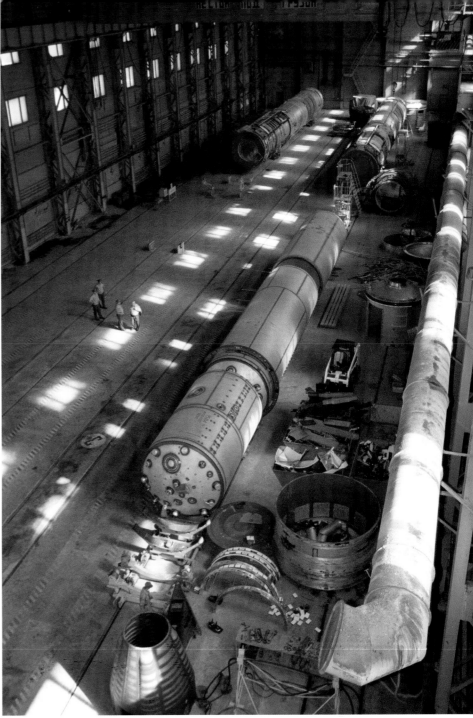

Peter the Great Sails the Moscow River

Artist Zurab Tsereteli's monument to Peter the Great rises 165 feet into the air above the Moscow River. Unveiled in 1997, the three-hundredth anniversary of Peter's founding of the Russian navy, the statue was controversial from its inception—not only for its enormous size and for what many have decried as its tastelessness but for the fact that Peter established his capital in St. Petersburg because of his hatred of Moscow. Moscow, 1998.

Satan

Technicians dismantle a fearsome SS-18 "Satan" missile in accordance with the Strategic Arms Reduction Treaty (START), which was signed by Mikhail Gorbachev and U.S. President George H. W. Bush in 1991. Russia's most powerful intercontinental ballistic missile, the Satan used to be armed with nuclear warheads aimed at the United States. It is now used to launch satellites into orbit. Nizhny Novgorod region, 1998.

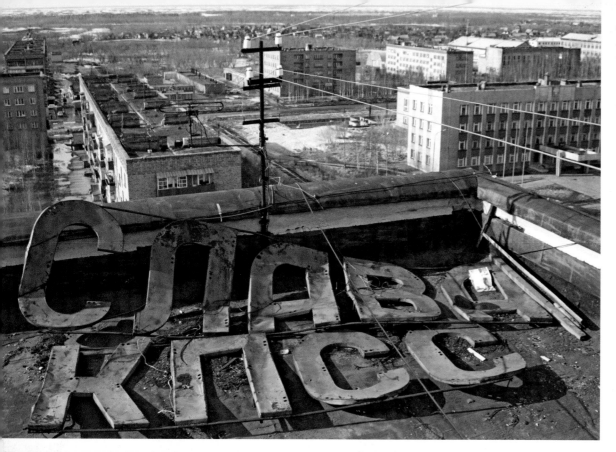

The Discarded Past

A sign reading "Long Live the KPCC [Communist Party of the Soviet Union]" lies discarded on a rooftop in the city of Inta in the Komi Republic, at the northwest extremes of European Russia. Inta was the location of a Gulag during the Soviet period, and the Komi region was largely settled by towns that grew up around Gulags. Here the past lies broken and rusting at the site of its most notorious and cruel consequences. Inta, 1998.

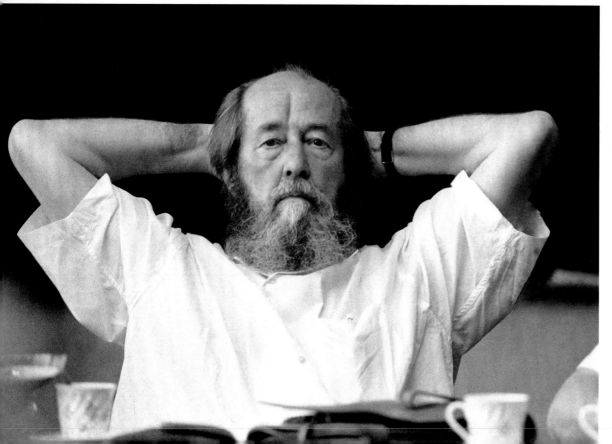

Bittersweet Homecoming

After twenty years in exile, Nobel laureate Alexander Solzhenitsyn returned to Russia. Shocked by what he saw—he described his country as "tortured, stunned, altered beyond recognition"—he went on to declare, "I know that your present life is extremely and unusually harsh, entangled in a myriad of mishaps, and that there is no clear future for you or for your children. These seventy-five years have been very hard, including these most recent times. But our people who have suffered so much deserve to see the light. I bow to you in respect and admiration." Solzhenitsyn has continued to be a harsh critic of present conditions and a champion of Russian traditional values. Novosibirsk, 1994.

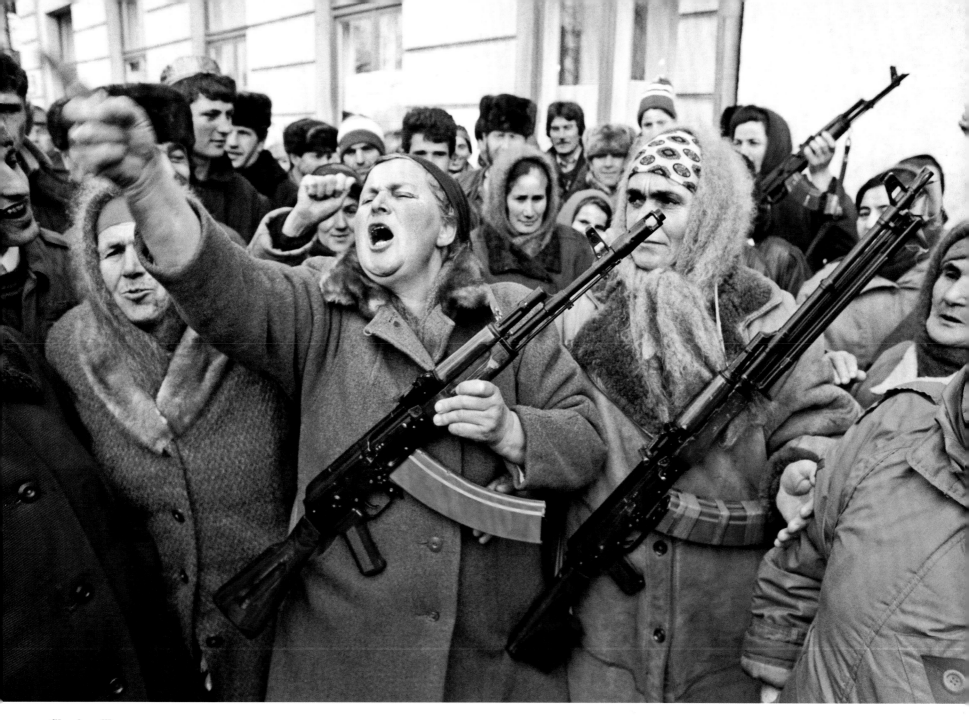

Chechen War

"Russians, Go Home!" Chechens demonstrate against the Russian invasion outside the Chechnya Parliament in Grozny. In *The Gulag Archipelago*, Solzhenitsyn wrote that of all the people he saw in exile, Chechens were from the "one nation which would not give in, would not acquire the mental habits of submission." Since 1994, when the Russia-Chechnya war began, both sides have experienced the truth of that statement. The war ended in 1996—officially, that is—but deadly conflict between the two countries, and Russian occupation of Chechnya, persists. 1994.

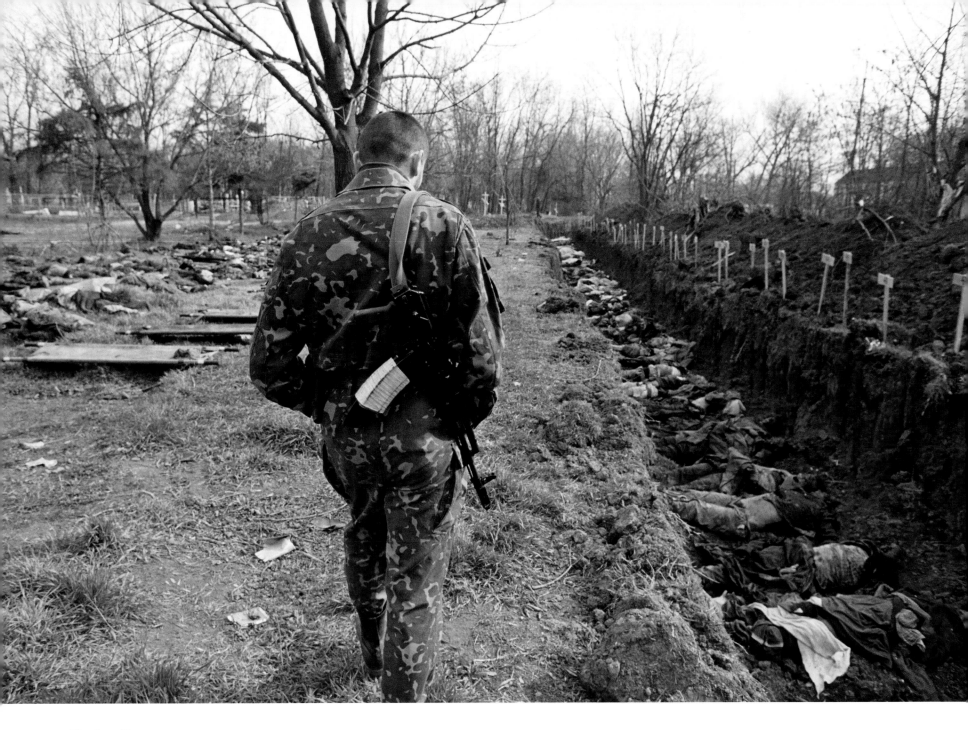

Chechen War

A Russian soldier walks by the mass grave of some two hundred Chechens in Grozny, the capital city of Chechnya. 1995.

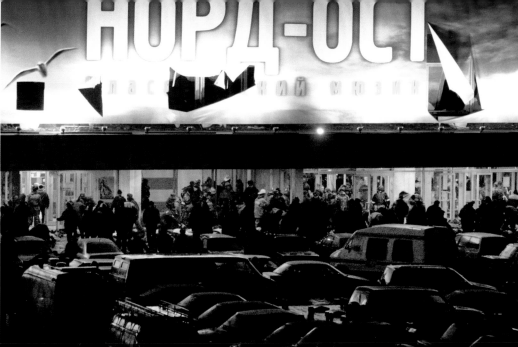

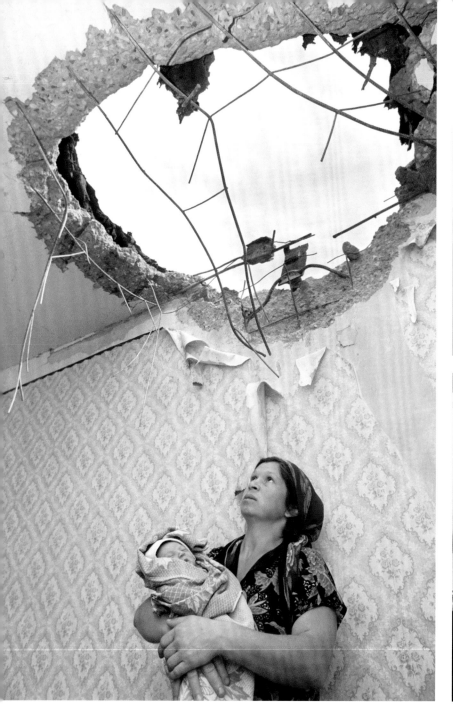

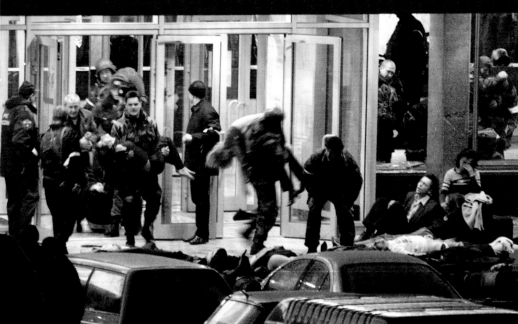

Chechen War

Raisa Adayeva holds her baby daughter under the bombed-out ceiling of her Grozny flat. 1996.

"We are Chechens! We are at war here!"

As Muscovites were heading to their seats after an intermission of the musical *Nord-Ost (North-East),* on October 23, 2002, more than fifty armed men and women stormed the theater and threatened to kill everyone unless Russia immediately withdrew from Chechnya. After releasing a powerful knockout gas, a 200-member Russian assault force shattered the theater's doors and swarmed into the building, killing all the Chechens. Within forty minutes they freed more than 750 hostages—but at least 90 theatergoers died in the assault. These photos show the aftermath.

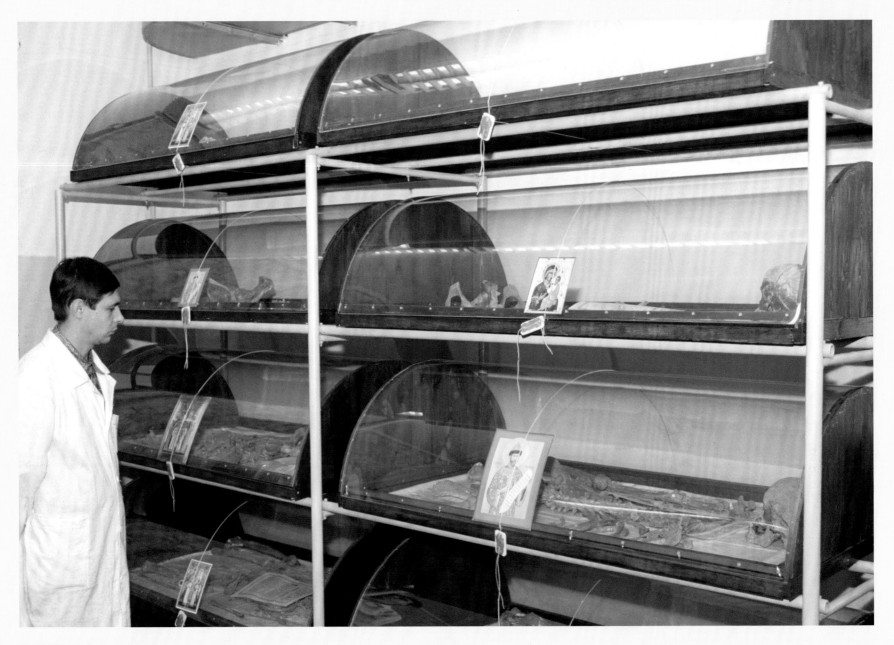

Royal Remains

Remains of Nicholas II and his family in Ekaterinburg. Genetic analysis of the
remains—including a test matching Romanov DNA to the DNA of Britain's
Prince Philip, a family cousin—seems to conclude that these remains are
indeed that of the royal family. But two of the family are missing: the tsarevitch,
Alexei, and one of the daughters, probably Maria. 1997.

Royal Burial

In July 1997, eighty years after they were executed, Nicholas II and his family were interred in St. Petersburg's Peter and Paul Fortress, the resting place of tsars. Conspicuously absent from the ceremony were representatives of the Russian Orthodox Church, which, DNA evidence to the contrary, does not consider these remains authentic. President Boris Yeltsin, however, did attend. "The burial of the remains of the Ekaterinburg victims is first of all an act of human justice. It's a symbol of the unity of the nation, an expiation of common guilt. We all bear responsibility for the historical memory of the nation. And that's why I could not fail to come here. I must be here, as both an individual and a president."

Place of Pilgrimage
Russian Orthodox patriarch Alexei II bows his head at the site where the bodies of Nicholas II and his family were burnt by sulfuric acid and destroyed in 1918. Located in the forest twelve miles from Ekaterinburg, it is often visited by those wishing to pay tribute to the last tsar. Ekaterinburg, 2000.

Revival
Sculptor Ernst Neizvestny, who designed the memorial at Khrushchev's gravesite, emigrated to the United States in 1976 after losing his legal right to work in the Soviet Union. Here he triumphantly returns to unveil a new work, *Revival*. Moscow, 2000.

The Conductor
Valery Gergiev, conductor, general director, and artistic director of the Mariinsky Theater and Kirov Opera, with his orchestra. Moscow, 1997.

Ballerinas
Prima ballerinas, spanning generations. A year before her death in 1998, Galina Ulanova, the great dancer of the Soviet ballet, chats with Diana Vishneva of the Mariinsky Ballet. Moscow, 1997.

"I Resign!"

On New Year's Eve, 1999, after almost four more difficult years as president, and continuing problems with his health, Yeltsin shocked Russia and the world by announcing his resignation. In the process he did something politicians almost never do: he apologized. "I want to ask you for forgiveness, because many of our hopes have not come true, because what we thought would be easy turned out to be painfully difficult. I ask you to forgive me for not fulfilling some hopes of those people who believed that we would be able to jump from the gray, stagnating, totalitarian past into a bright, rich, and civilized future in one go. . . . Today, on the last day of the outgoing century, I am retiring." In this photo, Yeltsin eyes his chosen successor, Vladimir Putin. Moscow, 1999.

On the Mat

Putin began studying judo at the age of thirteen and continues to practice today. He is a black belt, with the rank of sixth Dan. Here, during a 2000 visit to Japan, he takes to the mat.

Death Beneath the Sea

On August 12, 2000, two explosions ripped through the Russian nuclear submarine *Kursk* during maneuvers in the icy waters of the Barents Sea. The sub, with a crew of 118 aboard, sank to the bottom. More than a week later, divers opened the rear hatch of the sub to find no survivors. Named for the epic tank battle of the Great Patriotic War, the *Kursk* belonged to the largest class of attack submarine ever built. It was the height of a four-story building and longer than two football fields. The sub was thought to be unsinkable. Here the crew of the *Kursk* stands at attention atop the sub before its last mission. "I have this premonition that the world is caving in, that everything is crumbling," a nineteen-year-old bilge specialist named Alexei Korkin wrote to his mother before they set sail. "We would sink, that's for sure. . . . My snapshot would always hang on the wall at the headquarters of our division and the fleet. And the caption under the photo would read 'Awarded the title of Hero of Russia for heroism and courage—posthumously.'" Severomorsk, Murmansk region, 1999.

Last Goodbyes

Family members attend a funeral ceremony for the crew of *Kursk*. Many were furious that for days the Russian government neither acknowledged the disaster nor asked for foreign help in rescue operations. The behavior reminded many of Soviet denials and lies during the Chernobyl disaster fourteen years earlier and raised fears that for all its lip service to openness and truth, the new Russian democracy still retained Soviet habits of self-interest and secrecy at the expense of its people. Severomorsk, Murmansk region, 2000.

"Here Shall Be a Town"

The winter sun hangs low over the Peter and Paul Fortress. St. Petersburg, February 1998. In 1703, Russia's tsar, Peter the Great, first saw the wild marsh on the Baltic coast where the Neva River empties into the sea. Legend has it that Peter seized a bayonet from a soldier and cut two strips of turf, placed them atop one another to form a cross, and declared, "Here shall be a town." At that moment, a soaring eagle dipped over his head. That very spot became the gateway to a new city, St. Petersburg, named for the tsar's patron saint, St. Peter. In 2003, Russia celebrated the three-hundredth anniversary of Peter's city.

The Theater Will Decide

Bolshoi singers rehearse Vladimir Sorokin's opera *Rosenthal's Children*. An irreverent work featuring a scientist named Rosenthal who creates clones of the famous composers Mussorgsky, Tchaikovsky, Mozart, Verdi, and Wagner, the opera caused a brouhaha even before it opened. A member of parliament declared, "The Bolshoi Theater is a symbol of Russia. A symbol of Russia should not be defiled by such a production." "What kinds of times are we returning to?" responded Bolshoi general director Anatoly Iksanov. "The theatre will decide itself what it puts on, when, and with whom." On March 23, 2005, with more than two hundred protesters gathered outside shouting, "Sorokin! Out of the Bolshoi!" the Bolshoi defiantly premiered the work—to rave reviews: "*Rosenthal's Children* is the real thing. It's fresh, funny, and lively. It is probably the most original work the Bolshoi has produced in recent memory." Moscow, 2005.

The Dancer

Mariinsky ballerina Diana Vishneva dances *Swan Lake* at the Bolshoi Theater. Moscow, 2006.

The Bright Stream

Dmitry Shostakovich's ballet *The Bright Stream,* a lighthearted, good-natured spoof of
Soviet collective farms, opened in 1935—and immediately invoked the ire of the Kremlin.
"Artificial," "false," "lacks character," and "expresses nothing" were only some of the
official pronouncements. And, most damning: "The impression given is that Shostakovich
has written music to his own private thoughts"—thoughts that couldn't be controlled by
censors, didn't toe the party line, and smacked of individuality and freedom. *The Bright
Stream* quickly disappeared from the Bolshoi repertory, and the composer was ostracized—
he never wrote another ballet. In tribute, the Bolshoi has restaged and rechoreographed
The Bright Stream and other Shostakovich ballets. Moscow, 2003.

Celebrating Maya

Maya Plisetskaya performs a fragment of Maurice Béjart's ballet *Isadora* at the Bolshoi during a jubilee evening celebrating her seventy-fifth birthday. Moscow, 2000.

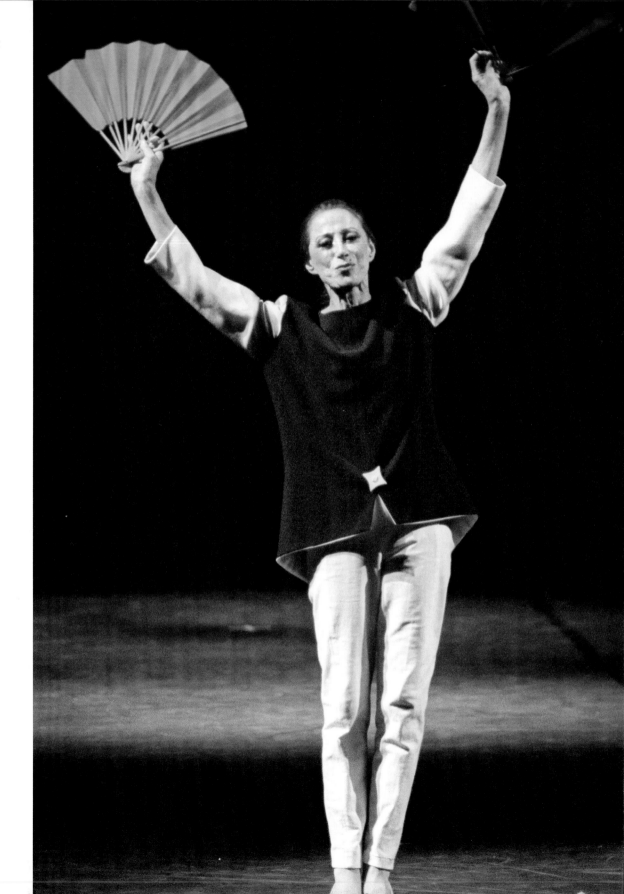

Haute Couture

LEFT, TOP
Russian designer Masha Tsigal poses at the opening of the Roberto Cavalli boutique in Moscow. 2004.

LEFT, BOTTOM
Jean Paul Gaultier opening a boutique in "Petrovsky Passage," an expensive shopping arcade in Moscow. 2005.

Sports Stars

The finest female pole-vaulter in history and an Olympic gold medallist, Elena Isinbayeva was the first woman to clear five meters (16.4 feet). Athens, 2004.

Wimbledon and U.S. Open champion Maria Sharapova during a quarter-final match in the German Open. Berlin, 2005.

Moscow City
Construction workers erect the Moscow International Business Center, or Moscow City. The goal is to build a city within a city—a business, entertainment, and living area in one. Moscow, 2005.

Restoring the Big Theater

The Bolshoi Theater in 2006, in the midst of a renovation scheduled to last at least three years. For all its grandeur, the 150-year-old building's foundation is unstable. Damage sustained during the Great Patriotic War has contributed to its deterioration (recently an unexploded bomb was found near the entrance to the theater). Cracks have begun to widen; walls have begun to list; no one knows the extent of the damage. The cost will approach $1 billion.

Christ the Savior

In 1931, Stalin destroyed Moscow's huge nineteenth-century Cathedral of Christ the Savior, built to commemorate Russia's victory over Napoléon. He planned in its place a gigantic Palace of the Soviets, higher than the Empire State Building and topped with a statue of Lenin taller than the Statue of Liberty. Instead, the swampy foundations lay neglected for forty-eight years, until Nikita Khrushchev built a large, heated, outdoor swimming pool. Now the pool has been scrapped and the cathedral rebuilt—but not to everyone's satisfaction. Says writer Igor Yarkevich, "During communism, the Soviet intellectuals used to say, 'There was a wonderful church here, and now there's a metro and swimming pool.' And after some time, the intellectuals will say, 'You know there used to be a wonderful swimming pool here, and now the new bosses have built a church'." Completed in 2006, here the cathedral is under construction in 1995.

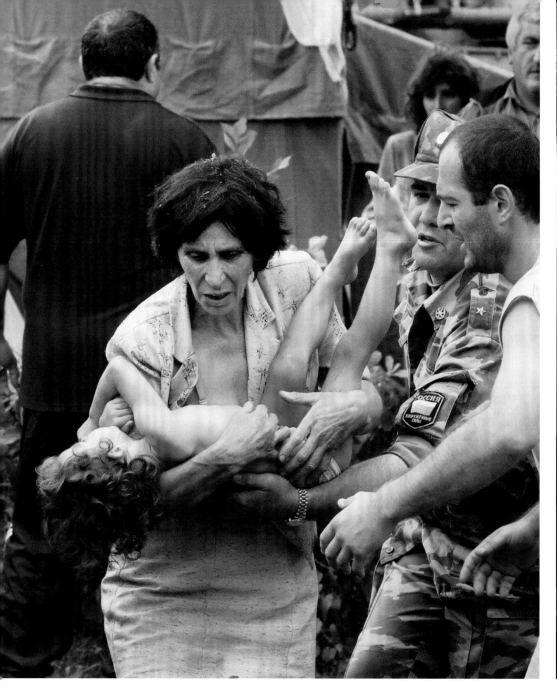

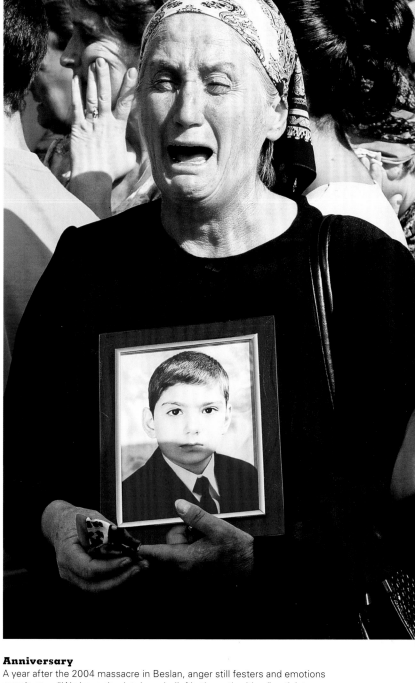

Beslan

In September 2004, Chechen terrorists attacked School Number One in the town of Beslan in North Ossetia, wiring the school with explosives and taking some 1,200 children and adults hostage. The consequences were devastating. Three days later, two explosions ripped through the school, prompting a chaotic, flame-throwing rescue attempt by Russian forces. More than 330 of the hostages died in the process, prompting widespread grief and angry accusations that the authorities brutally mishandled the situation. Here, rescuers safely remove a child from the school.

Anniversary

A year after the 2004 massacre in Beslan, anger still festers and emotions remain raw. "We have absolutely no belief in the authorities," activist Ludmilla Pliyeva declared. "They are not letting us find out the truth. . . . Why did our children burn to death, why did they get shot, why were no negotiations held?"

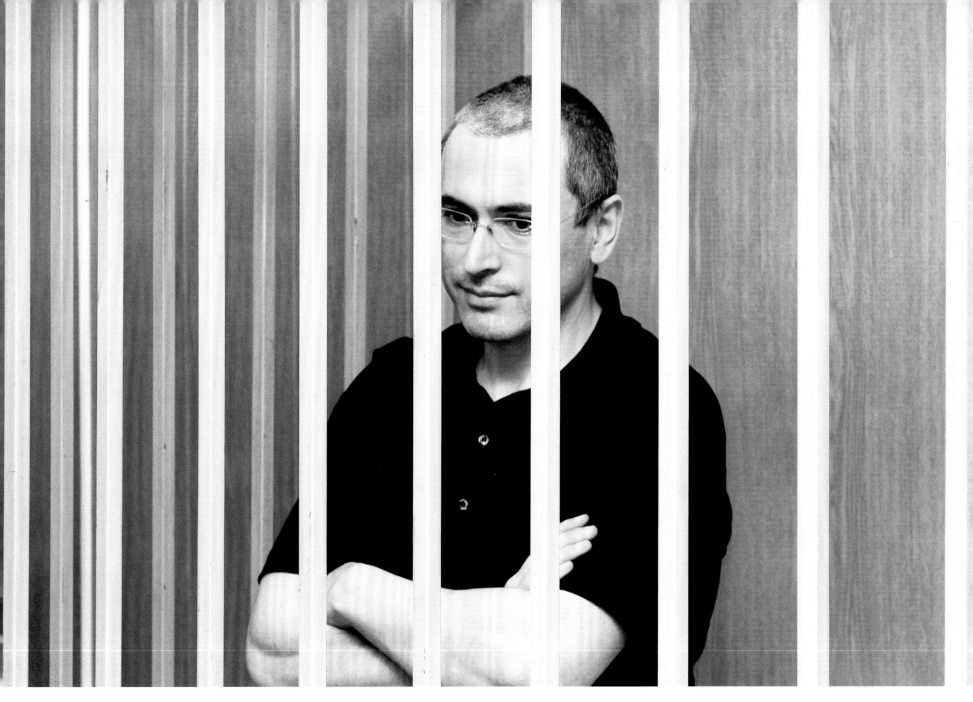

Behind Bars

Mikhail Khodorkovsky was once the richest man in Russia, the head of Russia's second-largest oil company, Yukos, with assets upward of $15 billion. Today he languishes in a Siberian prison. Like other super-rich Russian "oligarchs," Khodorkovsky acquired his company at a fire sale price during the privatization of state assets after the fall of the Soviet Union. In 2003, armed and masked FSB agents stormed his private jet and arrested him. In a trial few considered fair, he was convicted of fraud and tax evasion, and sentenced to nine years. Yukos itself faces paying back taxes of billions of dollars, while its assets have been seized by the state-owned oil company, Rosneft. However, the true reason Khodorkovsky is in prison, some say, was for funding media criticism of President Putin and hinting at his own entry into politics. In this photo, Khodorkovsky stands confined in a Moscow courtroom in 2004, a year before his conviction.

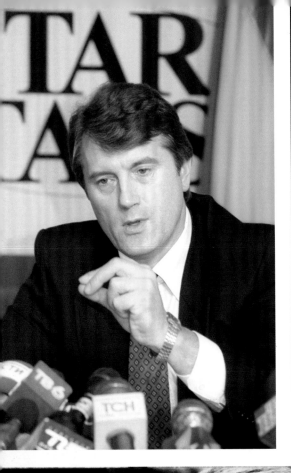

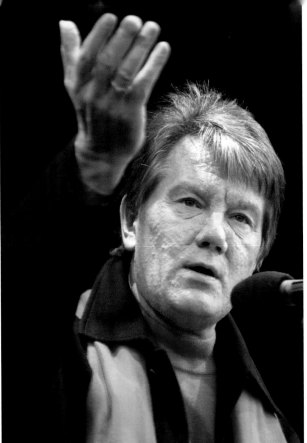

A Poisoned Election

Ukraine's 2004 presidential election between Moscow's preferred candidate, Prime Minister Viktor Yanukovych, and Western-leaning opposition leader Viktor Yushchenko was one of contentious high drama. It included accusations of widespread fraud—voter intimidation, assaults, destroyed ballot boxes—massive demonstrations by Yushchenko's orange-clad supporters (the color of his Our Ukraine party), and an eventual victory for Yushchenko. It was dubbed the "Orange Revolution." But the election may be most memorable for an attempt on Yushchenko's life, a gruesome poisoning with one of the most toxic chemicals known, dioxin. The guilty party has never been identified. Yushchenko's scarred face provides a living reminder.

FAR LEFT
Viktor Yushchenko during a press conference at ITAR-TASS headquarters in Moscow. July 19, 2000.

LEFT
A month after being poisoned, Yushchenko campaigns in Kiev. October 17, 2004.

"I have merely reported what I have witnessed . . ."

Anna Politkovskaya may have been at once the most admired and reviled journalist in Russia—and surely one of the most courageous. Her specialty was reporting on charged political subjects, in particular the horrors of what she called Russia's "dirty war" in Chechnya and its violation of human rights. Bluntly declaring, "I have merely reported what I have witnessed," she endured harassments, beatings, death threats, and at least one attempt on her life—until October 7, 2006, when she was discovered dead in the elevator of her Moscow apartment, shot in the head and chest. The murder pistol had been left at her feet, the arrogant signature of a contract killing. She was 48 years old. Here, in this 2001 photo, she conducts an interview in the Chechnyan village of Khatuni.

Energy Goliath

The largest natural gas company in the world, GAZPROM controls about 90 percent of Russia's gas production and about 20 percent of the world's. It is the prime example of the immensely powerful energy-based corporations that have arisen in Russia since state-owned utilities were privatized after the fall of the Soviet Union. As GAZPROM's majority stockholder is the Kremlin, itself, some see the firm as a business persona for Russia. Like its headquarters, pictured here, GAZPROM boldly and aggressively displays its preeminence and power. Moscow, 2005.

President Putin

In March 2000, three months after Boris Yeltsin's resignation, Vladimir Putin was elected the second president of the Russian Federation. Known primarily as a colorless administrator with a KGB background, he inspired almost as much curiosity as confidence. Four years later, he was reelected in a landslide, garnering more than 70 percent of the vote. Putin has proved himself a cool, controlled personality (in contrast to the blustery Boris Yeltsin) and a formidable leader determined to restore power and stability to Russia. Critics complain that stability comes at the expense of ever more authoritative and controlling measures—supporters argue that such is the price a newly evolving democracy must pay to escape the chaos of Russia's first post-Soviet decade. In any case, Putin may be the most powerful Russian leader since Stalin. Here he visits the city of Yaroslavl in 2006.

The Old and the New
On August 22, 1997, the Day of the State Flag of the Russian Federation, the Russian tricolor flies over the cupolas of the Kremlin. Old Russia and New Russia, for the time being at least, united.

SELECTED BIBLIOGRAPHY

Many books, journals, newspapers, and Web sites were consulted in the creation of *The Soviet Image*. The sources listed below offer further insight into the many aspects of Russian history and culture discussed in these pages.

Alliluyeva, Svetlana. *Twenty Letters to a Friend*. New York: Harper & Row, 1967.
A memoir by Stalin's daughter, published upon her defection to the United States in 1967. It is particularly interesting for her eyewitness account of her father's death.

Amis, Martin. *Koba the Dread*. New York: Vintage International, 2003.
A nonfiction book by fiction writer Martin Amis, who grew up in a household populated by Russian émigrés and experts, including Robert Conquest. *Koba the Dread* is a well-written editorial on and account of the Bolshevik Revolution, in particular Stalin, and its effects.

Aron, Leon. *Yeltsin: A Revolutionary Life*. New York: St. Martin's Press, 2000.
A thorough, sympathetic look at this outsize politician by the director of Russian studies at the American Enterprise Institute. Aron sums up Yeltsin in these words: "He made irreversible the collapse of Soviet totalitarian communism, dissolved the Russian empire, ended state ownership of the economy—and held together and rebuilt his country while it coped with new reality and losses."

Bullock, Alan. *Hitler and Stalin: Parallel Lives*. New York: Knopf, 1992.
A thorough chronological biography of Hitler and Stalin that compares their lives. The author, an Oxford University chancellor, sees great parallels between the two rulers. He particularly focuses on the ramifications of their relations, ending with the Russian occupation of Germany.

Conte, Francis. *Great Dates in Russian and Soviet History*. New York: Facts On File, 1994.
A comprehensive reference book with year-by-year listings of great events in various aspects of Russian and Soviet history, including politics, culture, and foreign affairs.

Crankshaw, Edward. *Khrushchev: A Career*. New York: Viking, 1966.
———. *The Shadow of the Winter Palace*. New York: Viking, 1976.
In both these books, British author and historian Crankshaw is less concerned with chronicling events—although he does that well—than with interpreting and commenting upon them. These are the insights of an experienced and urbane Soviet observer.

Dickson, Paul. *Sputnik: The Shock of the Century*. New York: Walker, 2001.
The events leading up to and following the launch of *Sputnik,* and the impact of the event, told in a down-to-earth, narrative style by Maryland-based writer Dickson. Full of useful, interesting information.

Dmitrenko, A., E. Kuznetsova, O. Petrova, and N. Fyodorova. *Fifty Russian Artists*. Moscow: Raduga, 1985.
A Russian art book focusing on painting and giving brief biographies of fifty of the greatest Russian painters.

Erickson, John, and Ljubica Erickson. *The Eastern Front*. London: Carlton, 2001.
A detailed account of the eastern front of World War II. Full of photographs, it is written by a University of Edinburgh military history professor. Although not offering any new analysis, it is a thorough overview of Nazi-Soviet relations and conflict.

THE SOVIET IMAGE

1905
1917
1927
1941
1953
1964
1984
1991
2005

SELECTED
BIBLIOGRAPHY

Figes, Orlando. *Natasha's Dance: A Cultural History of Russia*. London: Allen Lane / Penguin Press, 2002.
———. *A People's Tragedy: A History of the Russian Revolution*. New York: Viking, 1996.
Readable, lively, and thorough account by a professor of history at Birkbeck College, University of London. Figes's passion for Russia permeates and informs the writing.

Heppenheimer, T. A. *Countdown: A History of Space Flight*. New York: Wiley, 1997.
Space and technology writer Heppenheimer writes a detailed and authoritative history. Particularly suited for space buffs.

Karpov, Vladimir. *Russia at War, 1941–45*. New York: Vendome, 1987.
A Russian account of the Second World War, written by an eastern front veteran and Hero of the Soviet Union turned historian. This book is especially interesting for its many eyewitness accounts and anecdotes of the war.

Kenez, Peter. *History of the Soviet Union from the Beginning to the End*. Cambridge: Cambridge University Press, 1999.
An excellent overview by a historian who lived through some of the events he describes. Kenez, a professor of history at the University of California, Santa Cruz, is particularly skillful at delineating large movements and trends.

Khrushchev, Nikita. *Khrushchev Remembers*. Edited by Strobe Talbott. New York: Little, Brown, 1970.
It's remarkable that this book exists. After he was deposed, Khrushchev dictated some 250 hours of memoirs; then, in defiance of the KGB's demands that he stop, he smuggled the manuscript abroad. Part honest assessment, part mea culpa, part self-justification, part revisionist history, it's a fascinating book.

King, David. *The Commissar Vanishes*. New York: Henry Holt, 1997.
A unique book. Editor and photographer King calls on his extensive collection of Soviet art and photography to illustrate the Communists' practice of altering historical images, often crudely and brutally, to reflect the politics of the day.

Kurth, Peter. *Tsar: The Lost World of Nicholas and Alexandra*. Toronto: Madison, 1995.
A handsome, readable, lavishly illustrated look at the world of the last tsar and his family by a writer who also investigated the strange case of Anna Anderson, the woman who claimed to be Anastasia.

Lincoln, W. Bruce. *The Romanovs: Autocrats of All the Russias*. New York: Doubleday Anchor, 1981.
The late Lincoln, University Research Professor of History at Northern Illinois University, deftly chronicles three centuries of Romanov rule in this quick-moving, informative, thorough, and readable history.

Longworth, Philip. *Russia: The Once and Future Empire from Pre-History to Putin*. New York: St. Martin's Press, 2006.
An elegantly written overview of Russian history with a focus on the seizing and losing of empire by a long-time chronicler of Russia and Eastern Europe.

Lourie, Richard. *Sakharov: A Biography*. Hanover, NH: Brandeis University Press, 2002.
A thorough, moving biography of the great physicist and dissident by writer and translator Lourie.

Massie, Robert K. *Nicholas and Alexandra*. New York: Dell, 1967.
This book was a best seller, and it's not hard to see why. The story is compelling, and Massie's telling of it is thorough and authoritative without being stiff or dry, distinguished by his gentleness and empathy.

Millner-Gulland, Robin, and Nikolai Dejevsky. *Cultural Atlas of Russia and the Former Soviet Union*. New York: Checkmark, 1989.
A useful illustrated reference.

Montefiore, Simon Sebag. *Stalin: The Court of the Red Tsar*. New York: Knopf, 2004.
A colorful account of the life and times of Stalin by journalist, historian, and Russia buff Montefiore.

Putin, Vladimir. *First Person*. New York: Public Affairs, 2000.
Putin's modest and straightforward account of his life, in question-and-answer format.

Rayfield, Donald. *Stalin and His Hangmen*. New York: Random House, 2004.
This book, full of behind-the-scenes drama, focuses on Stalin and his various secret police chiefs and their crimes. Special attention is paid to the terror campaigns and the purges of the 1930s. The author, a University of London Russian and Georgian professor, gives a lively and detailed account of Stalin's chief executioners.

Reeder, Roberta. *Anna Akhmatova: Poet and Prophet*. New York: St. Martin's Press, 1994.
Teacher and editor Reeder has devoted much of her professional life to Akhmatova and admires her greatly. It shows in this extremely thorough account of her rich life.

Remnick, David. *Lenin's Tomb*. New York: Vintage, 1994.
————. *Resurrection*. New York: Vintage, 1998.
New Yorker editor Remnick was the *Washington Post*'s Moscow correspondent during the last days of the Soviet Union. He draws on this experience in these detailed and exhaustive eyewitness accounts, brimming with interesting interviews and deeply felt personal observations.

The Russian Chronicles. Orlando Figes, Lindsey Hughes, Robin Milner-Gulland, eds.; Sir Dimitri Obolensky, preface; Norman Stone, foreword; London: Greenwich Editions, 2001.
Readable, illustrated account of Russia from its beginnings as "The Land of Rus" to the Revolution.

Sakharov, Andrei. *Memoirs*. Translated by Richard Lourie. New York: Knopf, 1990.
Sakharov's memoirs, up to the end of his exile in Gorky. Translated by his biographer, Lourie.

Salisbury, Harrison E. *Russia in Revolution, 1900–1930*. New York: Holt, Rinehart and Winston, 1978.
A succinct narrative, punctuated by interesting photos and art from the times, by the late Salisbury, for many years the *New York Times*' Russian correspondent.

Service, Robert. *A History of Modern Russia*. Cambridge: Harvard University Press, 2005.
A long and detailed history of modern Russia by a well-known Russian historian and author, a Harvard professor.

Stephenson, Graham. *Russia from 1812–1945*. New York: Praeger, 1970.
Although dated now, Stephenson's book gives a detailed overview of late Russian and early Soviet history. The analysis of the relations of the various Bolsheviks is especially interesting.

Taubman, William. *Khrushchev: The Man and His Era*. New York: W. W. Norton, 2003.
Taubman, the Bertrand Small Professor of Political Science at Amherst College, presents an affecting portrait of Khrushchev and his times—that is, a large chunk of Soviet history. He illuminates the man thoroughly and evenhandedly.

THE SOVIET IMAGE

1905
1917
1927
1941
1953
1964
1984
1991
2005

SELECTED

BIBLIOGRAPHY

Vishnevskaya, Galina. *Galina: A Russian Story*.
San Diego: Harcourt Brace Jovanovich, 1984.
The acclaimed and courageous singer's auto-
biography, with an account of how she and her
husband, Mstislav Rostropovich, were stripped of
their Soviet citizenship and forced to the West.

Warnes, David. *Chronicle of the Russian Tsars*.
London: Thames and Hudson, 1999.
A useful, succinct, and accessible history, with
illustrations.

Yevtushenko, Yevgeny. *The Collected Poems, 1952–
1990*. New York: Henry Holt, 1992.
Perhaps the most visible and published Russian
poet of the last five decades, Yevtushenko offers a
cultural history of his country through his poems.

Youssoupoff, Felix. *Lost Splendor*. New York: Putnam,
1953.
The murderer of Rasputin, the extravagant Prince
Felix Youssoupoff (Yussupov) tells his story. He
writes as he lived—with excess.

Web Sites

The Amber Room in the Hermitage Museum:
www.amberroom.org/index-english.htm

Bolshoi Theater:
www.bolshoi.ru/en

Hermitage Museum:
www.hermitagemuseum.org

ITAR-TASS:
www.itar-tass.com/eng

Kremlin, in Moscow:
www.kreml.ru/main_en.asp

Lenin Mausoleum:
www.aha.ru/~mausoleu

Russian Museum:
www.rusmuseum.ru/eng

INDEX

Pages in italics indicate photos.

A

Abel, Rudolf, 158
Abuladze, Tengiz, 214
Afghanistan, invasion of, 191, 192–93, 214, *230*
Akhedzhakova, Liya, 246
Akhmatova, Anna, *73, 174*
Alexander II, Tsar (Russia), 87
Alexander III, Tsar (Russia), 52
Alexandra, Empress (Russia), 18–23, *24,* 25, 26, *27*
Alexandrovich, Sergei, 17
Alexei (Russian Orthodox patriarch), 261
Alexei II (Russian Orthodox patriarch), *260*
Alliluyeva, Nadezhda, 90
Andropov, Yuri, 193, *207,* 208
Antokolsky, Mark, *32*
Arafat, Yasser, *208*
Aral Sea, *227*
Attlee, Clement, *147*
Aurora, 54
Auschwitz, 125, 129

B

Babel, Isaac, 89, *113*
Ballet, *2,* 35, 72, 191–92, *206,* 261, *268–70*
BAM (Baikal-Amur Mainline), *199–200*
Baryshnikov, Mikhail, 192, 206
Bay of Pigs invasion, 158
Beria, Lavrenti, *111,* 150, 151, 152
Berlin, 125, *140,* 143, *146,* 159
Berlin Wall
 creation of, 159
 destruction of, 215, *234–36*
Beslan, *276*
Bessmertnova, Natalia, *198*
Big Fergana Canal, *98–99, 100*
Black Hundreds, 18
Bloody Sunday, 13, 16, 17–18, *42*
Bolsheviks, 17, 52–56, 61, 62, 63, *77,* 89
Bolshoi Ballet, 35, 191–92, 206, *268–70*
Bolshoi Theater, 123, *136, 198, 268–70, 274*
Bonner, Elena, 189, 191, 215–16, 218, *252*
Botvinnik, Mikhail, *176*
Brest-Litovsk, Treaty of, 55–56, 58
Brezhnev, Leonid, 161–62, 188–93, *194–97, 209,* 212, 245
Brezhnev Doctrine, 189
Brik, Lilya, 90, *104*
Brodsky, Joseph, 191, 214
Bronstein, David, *176*
Budapest, *165–66*
Bukharin, Nikolai, 89, 90
Bulgakov, Mikhail, 89–90, *104*
Bulganin, Nikolai, 150, *163*
Bulgaria, free elections in, 215
Bush, George H. W., *220,* 253

C

Carter, Jimmy, 192
Castro, Fidel, 158, 160, 161, *182*
Cathedral of Christ the Savior, *275*
Chagall, Marc, *205*
Chaliapin, Fyodor, 54
Chamberlain, Neville, 120
Chechnya, *79,* 244, *255–57,* 276, 278
Cheka, 55, 57–58
Chekhov, Anton, *31*
Chernenko, Konstantin, 193, *207, 208*
Chernobyl disaster, 212–13, *221–25*
Chess, *176*
Chukovskaya, Lydia, 174
Churchill, Winston, 52, 121, 125, *146,* 147
Cliburn, Van, *178*
Cold war, 125, 146, 153, 157
Collectivization, 87–88
Communist Party
 banning of, 219, 238
 creation of, 55
 resurrection of, 245
Congress of People's Deputies, 214, 215, 217, *232*
Cossacks, *30,* 55
Cuba
 Bay of Pigs invasion, 158
 Castro and, 158, 160, 161
 missile crisis, 160–61, *182*
Czech Legion, 56, 58
Czechoslovakia
 democracy in, 215
 Prague Spring, 189, 215

D

Denikin, Anton, 56, 58, *78*
Détente, 188, 193
Diaghilev, Sergei, *72*
Dissidents, 189–91
Dobrynin, Anatoly, 161
Dubček, Alexander, 189, 215
Duncan, Isadora, *72*
Dzerzhinsky, Felix, 53, 55, 58, *65,* 245
Dzhugashvili, Yakov, 90–91

E

Edward VII, King (Great Britain), *26*
Eisenhower, Dwight, 125, 158
Ekaterinburg, 56–57, 259, 261

THE SOVIET IMAGE

1905

1917

1927

1941

1953

1964

1984

1991

2005

INDEX

F

Fadeyev, Alexander, *131*
Finland, 120
Franz Ferdinand, Archduke (Austria), 20
Frunze, Mikhail, 116
FSB, 244
Furtseva, Ekaterina, *205*

G

Gagarin, Yuri, 159, *181,* 245
Gapon, Georgi, 16
Garst, Roswell, 157
Gaultier, Jean Paul, *271*
GAZPROM, *279*
George V, King (Great Britain), *25, 26,* 56
Gerasimov, Gennadi, 215
Gergiev, Valery, *261*
German-Soviet Non-Aggression Treaty, 120
Germany
 Nazi, 120–25, 136, 138, 143, 147
 reunification of, 215
Gide, André, 89
Glasnost, 213–14, 216, 217
Godunov, Alexander, 192, *206*
Gorbachev, Mikhail, 193, 212–19, *220, 238–39,* 253
Gorbachev, Raisa, 193, 216, *220, 238*
Gorky, Maxim, *32, 33,* 37, 89, 113
Great Patriotic War. *See* World War II
Great Purge, 88–90, 91
Grozny, 244, *255, 256–57*
The Gulag, 87, 88, 120, 150, 156, 177, 254

H

Havel, Václav, 215
Hermitage Museum, *144*
Hitler, Adolf, 91, 120–21, 123–25, 126
Hungary
 democracy in, 215
 uprising in, 154, *165–66*

I

Iksanov, Anatoly, 268
Inber, Vera, 133
Isinbayeva, Elena, *272*
ITAR-TASS Photo Agency, history of, 12–13
Ivinskaya, Olga, 156

J

Johnson, Lyndon, 159, 179

K

Kaganovich, Lazar, 86–87, *163*
Kalinin, Mikhail, *116*

Kamenev, Lev, 88–89, 90
Kaplan, Fanya, 57
Karalli, Vera, *34,* 35
Karpov, Vladimir, 122, 125
Karyakin, Yuri, 214
Kennedy, Caroline, 181
Kennedy, John F., 158–59, 160–61, *182*
Kennedy, Robert, 161
Kerensky, Alexander, 52–55, 56, *62, 63*
KGB, 152, 162, 188, 191–92, 193, 214, 244
Khachaturian, Aram, *175*
Khodorkovsky, Mikhail, *277*
Khrushchev, Nikita, 87, 150–62, *163, 164, 174, 178,*
 179, 181, *182, 184, 185,* 188, 190, 216, 275
Kirov, 191–92
Kirov, Sergei, 88, *110,* 111
Kishinev pogrom, *36–37*
Kissinger, Henry, 188, *197*
Knox, Frank, 121
Kolchak, Alexander, 56, 58
Komsomol, *97,* 108, 152, 155
Kornilov, Lavr, 53
Korovin, Konstantin, *32*
Kremlin, 152, 153, *280*
Krenz, Egon, 215
Kronstadt Naval Base, 57, 59
Krupskaya, Nadezhda, *80,* 81
Kryuchkov, Vladimir, 216, 219
Kshesinskaya, Mathilde, 52
Kuibyshev, Valerian, *116*
Kulaks, 87, *96*
Kursk (nuclear submarine), *264–65,* 266
Kursk, Battle of, 124–25

L

Ladoga, Lake, 122, *132*
Landau, Lev, *205*
Larionov, Alexei, 157
Lenin (nuclear-powered ship), 170, *171*
Lenin, Vladimir, 17, 52–59, *60,* 61, *64,* 67, 70, *80–81,*
 83, 86, 87, 89, 90, 153, *209,* 245, *250–51*
Leningrad, Siege of, 122–23, *131–34*
Lenin Mausoleum, *116,* 151, *172, 182, 184, 207,* 214,
 216, 245
Likhachev, Dmitry, *232*

M

Magnitogorsk, *169*
Makarova, Natalia, 192
Malenkov, Georgi, 150, 151, 152
Mamontov, Savva, *32*
Mandelstam, Osip, 90, *113*
Mao Zedong, 121, 153, *182*

Marx, Karl, 108
Mayakovsky, Vladimir, 90, *104*
May Day, 70, *93, 114–17, 183–84, 207,* 216
Mensheviks, 17
Mercader, Ramón, 90
Mikoyan, Anastas, *163*
Molotov, Vyacheslav, 120, 121, *126,* 150, 152
Monroe, Marilyn, 158
Moscow
 attempted coup, 216–19, *237, 240–41*
 Battle of, 123, *135–36*
 Bolshoi Theater, 123, *136, 198, 268–70,* 274
 as capital, 56
 Cathedral of Christ the Savior, *275*
 Moscow Art Theatre, *31*
 Moscow City, *273*
 parliamentary rebellion, *246–47*
 Red Square, 59, *60–61, 62,* 70, *82,* 89, *101,*
 114–17, 144, 159, *172, 182, 183–84,* 216, *247*
 street scenes, *38, 39, 48–49, 68–70, 93*
 subway system, 86–87, *170*
 White House, 217–19, *237, 241,* 246
Moscow Human Rights Committee, 190
Munich Pact of 1938, 120

N

Nabokov, Vladimir, 214
NATO (North Atlantic Treaty Organization), 160
Neizvestny, Ernst, 155, 162, 185, *260,* 261
Nicholas II, Tsar (Russia), 12, 16–23, *24–27,* 43, *47,*
 56–57, *66,* 67, 217, *258–59,* 261
Nixon, Richard, 158, 188
NKVD, 120
North Pole, *107*
Novodevichy Cemetery, 162, *185*
Novodvorskaya, Valeria, 245
Nuclear weapons, 157, 160–61, 190, *253*
Nureyev, Rudolf, 191, *230*

O

Obolensky, Alexander, 214
October Manifesto, 18
Operation Barbarossa, 121–22

P

Papanin, Ivan, *107*
Partial Test Ban Treaty, 190
Pasternak, Boris, 90, 155–56, *174,* 214
Pavlov, Ivan, *106,* 107
Pavlov, Valentin, 216
Perestroika, 213–14, 216, 217
Peter and Paul Fortress, 54, *259,* 266, *267*
Peter I (the Great), Tsar (Russia), 253, 266

Petrov, Yevgeny, *131*
Plisetskaya, Maya, 151, *206, 270*
Poland
 democracy in, 215, 233
 invasion of, 120
 protests in, 154
Politkovskaya, Anna, *278*
Poltavchenko, Georgy, 245
Potemkin, 17, *38*
Potsdam Conference, *147*
Powers, Francis Gary, 158, *179*
Prague Spring, 189, 215
Prokofiev, Sergei, *175*
Pugo, Boris, 216, 219
Pushkin, Alexander, 30
Putin, Vladimir, 244, 245, *262–63,* 277, *279*
Pyatakov, Georgy, 89

R

Rachmaninov, Sergei, *34,* 35
Radek, Karl, 89
Rasputin, 20, 21–22, *44–45*
Reagan, Ronald, *220*
Red October, 54, 90
Red Square, 59, *60–61, 62,* 70, *82,* 89, *101, 114–17,*
 144, 159, *172, 182, 183–84,* 216, *247*
Red Terror, 57–58, 65
Reed, John, 86, 245
Repin, Ilya, *32*
Rodzianko, Mikhail, 23
Romanov family, 19–20, 23, *24,* 25, 56–57, *258–59*
Roosevelt, Franklin Delano, 121, 125, *146,* 147
Rostropovich, Mstislav, 191, 218, 247
Rusk, Dean, 161
Ruslanova, Lydia, *130*
Russian Revolution, 22–23, 52–54
Rybakov, Anatoly, 214
Rykov, Alexei, 89, *110,* 111

S

St. Petersburg. *See also* Leningrad, Siege of
 Bloody Sunday, 13, 16, 17–18, *42*
 founding of, 266
 Hermitage Museum, *144*
 Neva River, *94–95*
 Peter and Paul Fortress, 54, *259,* 266, *267*
 street scenes, *40–41, 43*
 Winter Palace, 16, 20, *42,* 53, 54
Sakharov, Andrei, 154–55, 189–91, 214, 215–16,
 232, 233, 252
Samizdat, 189–90
Savitskaya, Svetlana, 230, *231*
Semichnasty, Vladimir, 155

THE SOVIET IMAGE

1905
1917
1927
1941
1953
1964
1984
1991
2005

INDEX

Serov, Valentin, *32*
Seven Sisters, *169*
Sharansky, Anatoly, 190
Sharapova, Maria, *272*
Shepard, Alan, 159
Sholokov, Mikhail, *104, 131*
Shostakovich, Dmitry, 123, 131, *204,* 269
Siberia, 199, *202*
Sikorsky, Igor, *35, 105*
Smith, Samantha, 207
Sobchak, Anatoly, 214
Solidarity, 215
Solzhenitsyn, Alexander, 88, 104, 156–57, *177,*
 190, 191, *254, 255*
Sorokin, Vladimir, 268
Space race, 159, *179–81*
Sputnik, 159, *179*
Stalin, Josef, 52, 53, 55, 59, 86–91, *92, 110–11,*
 113, 116, 123–25, *126,* 130, 142, 145, *146, 147,*
 150–53, *163,* 169, *170,* 175, 184, 192, 245, 275
Stalin, Svetlana, 90, *111,* 151
Stalin, Vasily, 90, 150, 151
Stalingrad, Battle of, 123–24, *137,* 144
Stanislavsky, Konstantin, *31*
START (Strategic Arms Reduction Treaty), 253
Stasov, Vladimir, *32*
Stravinsky, Igor, *72*
Surikov, Valeri, *32*
Sverdlov, Yakov, 53, 56, *67,* 217
Sverdlovsk, 217

T

Tamm, Igor, 155
Tchaikovsky, Pyotr, 247
Tereshkova, Valentina, *181,* 230
Thatcher, Margaret, 193
The Thaw, 153–57, 162
Tito, Josip Broz, *194, 195*
Tolstoy, Alexei, 54
Tolstoy, Leo, 17, *33*
Trotsky, Leon, 18, 52–54, 57–59, *62,* 86, 89, 90, 111
Truman, Harry, *147*
Tsarskoe Selo, 16, 18, 19, 22, 56, 144
Tsereteli, Zurab, 253
Tsigal, Masha, *271*
Tsiolkovsky, Konstantin, *106,* 107
Tukhachevsky, Mikhail, 89

U

U-2, 158, 160, 161, *179*
Ulanova, Galina, *175, 261*

V

Versailles, Treaty of, 120
Virgin Lands project, *2,* 152, 157, *164*
Vishneva, Diana, *261, 268*
Vishnevskaya, Galina, 191
Viskovsky, Vyacheslav, 42
Vlasov, Yuri, 214
Vlasova, Ludmila, 192
Von Paulus, Friedrich, 124
Von Ribbentrop, Joachim, 120
Voroshilov, Kliment, *126*

W

Walesa, Lech, 215, *233*
Wanderers, 32
White House, 217–19, *237, 241, 246*
Whites, 56–58
White Sea Canal, 86, *99*
Winter Palace, 16, 20, *42,* 53, 54
World War I, 20–21, *46–49,* 55–56, 78
World War II, 89, 91, 120–25, *126–47*
Wrangel, Peter, 58, 77

Y

Yakovlev, Alexander, 219
Yalta Conference, 125, *146*
Yanayev, Gennady, 216, 218–19
Yanukovych, Viktor, 278
Yarkevich, Igor, 275
Yashin, Lev, *203*
Yazov, Dmitri, 216
Yeltsin, Boris, 156, 213, 217–19, *237,* 238,
 240, *241,* 244–47, *248,* 259, *262*
Yesenin, Sergei, *72*
Yevtushenko, Yevgeny, 155, *176*
Young Pioneer movement, *93,* 97, 108
Yudenich, Nicholas, 56, 58
Yukos, 277
Yurovsky, Yakov, 56–57
Yushchenko, Victor, *278*
Yussupov, Felix, 21–22, 54, 58

Z

Zaitsev, Vasily, 124
Zhukov, Georgi, 122, 123, 130, *143, 145*
Zinoviev, Gregory, 89, 90
Zyuganov, Gennadi, 245, 248